THE HISTORY OF PAINTING IN CANADA

Toward a people's art

THE HISTORY OF

PAINTING IN CANADA

Toward a people's art

by Barry Lord

NC PRESS / TORONTO / 1974

THIS SONG by Peter Flosznik, a member of the Canadian Liberation Movement, suggests the spirit in which this book has been written, and in which many people have helped in its preparation.

A large number of dedicated people have worked long hours on the production of this book. Members of an Editorial Committee, supporters and members of the Canadian Liberation Movement, particularly the National Executive of the Movement, along with others concerned for the development of a people's art in Canada, have given selflessly of their time and knowledge to advise on revisions of the manuscript. And still another group have come forward to make the book possible through their gifts and loans. My thanks to all these people can only be expressed in the book itself, and in the contribution it makes to the growth of our people's art.

I also wish to thank those who generously made photographs of works in their possession available for reproduction. All artists among them who are members of our national artists' organization, Canadian Artists' Representation, have been paid for these reproductions according to the CAR fee schedule.

Our art history has long been "distorted and suppressed." The art of our people past and present is only beginning to be rediscovered. The publishers and I wish to invite all those who know of examples of historical or contemporary people's art, Canadian, Quebecois or of our native people, to bring them to our attention by writing to: NC Press, Box 6106, Station A, Toronto, Ontario.

We are especially concerned to find more paintings related to the War of 1812-14, the Revolution of 1837-39, the Rebellions of 1871 and 1885, and paintings of our working people from all periods. We also invite your comments and criticism to the above address. In this way our understanding of our history will improve, and many more people may share in the revision of future editions.

In addition, NC Press wants to make further contributions to the growth of a people's art by publishing reproductions of outstanding works and making them available in large numbers at the lowest possible price. Artists or others who have suggestions for such reproductions are also asked to write to this address.

Our people's art is growing, along with the struggle for the liberation of our country. This book is respectfully dedicated to all those who will help to build a new Canada and a new world. "Can you hear the stream?"

Three Hundred Years a Nation

PETER FLOSZNIK

Three hundred years a nation
And a colony we are still,
But listen, can't you hear the stream
Among the distant hills?
Rushing from the hills it comes,
The fulfilment of a dream,
Well, soon this tiny stream will grow
And sweep away the chains.

Refrain:
It's the stream of liberation,
See, the river running strong,
The sky is red there in the east,
It's revolution's dawn.

Three hundred years of history
Distorted and suppressed,
Imperial powers have decreed
We shall not know our past,
But when we look, each century
More bitter than the last,
Canadians have fought and died
For the freedom of our land.

Refrain

Allied with the Quebecois
We fight for liberty,
Together, three hundred years
Of struggle to be free,
In the fields and factories
And in the mines and mills,
The river's rising, flowing stronger
From the distant hills.

Refrain

Well, now we see the working class
Arise to take the lead,
We'll fight imperialism
Til our nation has been freed,
Build a new Canada,
Socialist and free,
And help to build a new world,
Can you hear the stream?

Refrain

Repeat Verse 1

Refrain

Any portion of this book may be used free of charge by anyone serving the cause of Canadian liberation or the cause of the working people in any country. Credit should be given to the author and to NC Press.

Teachers! Course outlines and slide sets are available. Writie to NC Press for further information.

NEW CANADA PUBLICATIONS
a division of
NC PRESS LIMITED
Box 4010, Station A, Toronto, Ontario, Canada

ISBN 0-919600-12-3 paper
ISBN 0-919600-13-1 cloth

Printed in Canada by Union Labour

Contents

COLOUR PLATES

I
Anonymous Native Artist, Human Face Mask, collected in Skeena River area by A.Y. Jackson, 1926
painted on wood, 9" high, McMichael Canadian Collection, Kleinburg, Ont.

II
Anonymous, Votive Painting of the Three Shipwreck Victims of Levis, *(Ex-voto des trois naufrages de Levis),* 1754
oil on panel, 12¾" x 20½", The Museum, Sainte-Anne de Beaupre.

III
Joseph Legare (1795 - 1855), *Cholera Plague, Quebec,* about 1837
oil, 32 3/8" x 43 7/8", National Gallery of Canada, Ottawa, Ont.

IV
Anonymous, possibly Elizabeth Ladds, *Micmac Indians,* painted in the 1820's
oil, 18" x 24", National Gallery of Canada, Ottawa, Ont.

V
Ozias Leduc (1864 - 1955), *Le Repas du Colon,* ("The Settler's Meal")
oil, 14" x 18", National Gallery of Canada, Ottawa, Ont.

VI
Tom Thomson (1877 - 1917), *Autumn Birches,* 1916
oil on panel, 8½" x 10½", McMichael Canadian Collection, Kleinburg, Ont.

VII
Tom Thomson, *Moose at Night (Moonlight),* 1916
oil on panel, 8½" x 10½", National Gallery of Canada, Ottawa, Ont.

VIII
Frederick H. Varley (1881 - 1969), *For What?,* 1918
oil, 58" x 72", Canadian War Memorials Collection, Canadian War Museum, Ottawa, Ont.

IX
Frederick Varley, *Stormy Weather, Georgian Bay,* 1920
oil, 52" x 64", National Gallery of Canada, Ottawa, Ont.

X
J.E.H. MacDonald (1873 - 1932), *The Solemn Land,* 1921
oil, 48" x 60", National Gallery of Canada, Ottawa, Ont.

XI
Rita Briansky (born 1925), *Dr. Norman Bethune in China,* 1953
oil, Dr. Charles Lipton, Montreal.

XII
Emily Carr (1871-1945), *Reforestation,* 1936
oil, 44" x 27", McMichael Canadian Collection, Kleinburg, Ont.

XIII
John Boyle (born 1941), *Midnight Oil: Ode to Tom Thomson,* 1969
oil on board, 8 feet high, London Public Library and Art Museum, London Ont.

PHOTO CREDITS

Grateful acknowledgement is extended to the various galleries, museums and other owners of paintings for making photographs of the works available. Credits for photography should be given to these institutions and individuals. We would also like to recognize the work of the following photographers: John Ayriss (fig. 202, colour plate II); Neuville Bazin (fig. 20, 26, 136); the staff photographer of Brigdens of Winnipeg (fig. 85); Luc Chartier (fig. 34, 47); J. Dow (fig. 197); W.B. Edwards (fig. 27, 36, 49, 50); John Evans (fig. 29, 195); the staff photographer of the London Free Press (fig. 204a); Ian MacEachern (fig. 199); Ron Nelson (fig. 204b); John Porter (fig. 16, 22); Pruitt (fig. 195a); Victor Sakuta (fig. 67); Gabor Szilasi (fig. 178, colour plate XI).

INTRODUCTION

Toward a people's art

This book aims to fill a real need. It is a complete history of our painting, and can be used as a text for any course on the history of art in Canada. All of the major artists are discussed here, together with the movements, issues and organizations that affected them. This is the only book of its kind that begins with the art of the native peoples and ends with the present day.

But this book is more than that. For over 300 years our country has been a colony. In the days of the Sun King, Louis XIV, Québec was New France. When Brittania ruled the waves, British North America was her prize possession. And under U.S. imperialism today, Canada is the prime colony. We have always been the No. 1 colony of the world's leading imperial system.

One result is that our art history, when it is taken seriously at all, is studied strictly as a colonial appendage to these imperial cultures. Even a clearly independent Canadian school like the Group of Seven is questioned as to its "originality". The writer or teacher rejoices when the advent of U.S. abstraction delivers him or her from the necessity of having to talk about colonial subject matter. Our art is seen as a succession of imported styles, which our artists are privileged to follow.

Yet over these 300 years the people of Canada have fought fiercely for liberation. The native people maintained a heroic resistance over many generations. In 1775 and again in 1812-14 Canadians, Québécois and native forces defeated U.S. invasion attempts. The revolution of 1837-39 brought our first great liberation struggle to a peak. In 1871 and 1885 the Métis people fought for self-determination. In 1919 Canadian workers rose up in a nation-wide General Strike. The patriotic people of this country have shown themselves ready to make the necessary sacrifices, and have fought hard.

In each generation, however, there has also been a small elite who have profited by selling us out to the imperial masters of the day. This elite is the same group of people who have controlled most of our art, and our art history. They are the ones who like to see painting in Canada as merely a reflection of one imperial style after another.

In his book *More Poems for People*, Milton Acorn, the Canadian people's poet, refers to this "famous quatrain by the younger and better Irving Layton:"

"A friend tells me I should not write
About the workers and their plight
For poetry like dress admits of fashion
And this is not the year for passion."

Acorn comments on Layton's poem:

"For years I could not tell Irving or anyone else why I didn't like those undoubtedly memorable lines. Only recently did I realize that 'fight' also rhymes with 'write'".

Acorn's rule of thumb is that art begins to matter when the artist goes beyond describing the plight of the people, and actually joins in the fight with his art. This book pays special attention to artists who have done just that.

The last great upsurge of people's art came at the end of the Depression and during World War II, when Canadians were united in fighting fascism. After 1945, the Liberal government stepped up the sell-out to U.S. imperialism. The result was an inundating wave of U.S.-style abstract art, from which we have only been recovering in the past ten or twelve years.

But today there is an art of the people again, an art that reflects our people and places, and is sometimes consciously anti-imperialist in its outlook. A renewed struggle for national liberation is growing all over the country, and many of our artists are joining in it.

It is the needs of this mounting struggle that this book aims especially to fill. Our rulers have kept us ignorant of our proud history, and even less informed about the history of our culture. This is no accident: a nation without a culture has no future at all. Knowing the history of our art as a part of the heroic struggles of our people is a powerful weapon in the hands of a colonial people. It helps us to understand what we are fighting for. This book is intended as such a weapon.

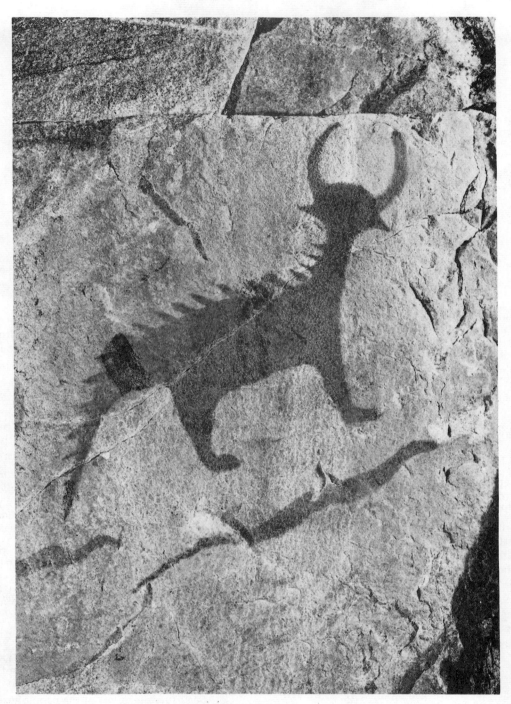

Fig. 1: Ojibway Rock Painting of Mishipeshu,
 Agawa, Lake Superior Provincial Park

Painting of the native peoples

Our country has been inhabited for tens of thousands of years by people who form the indigenous national minorities. We call them indigenous because they were here when the first Europeans arrived.

Their societies ranged from wandering families of hunters to the large permanent villages of the Pacific coast. Their cultures we know mostly from examples produced about the time of European contact or after, and from objects interpreted by archaeologists.

All of these peoples have suffered severely from oppression at the hands of a series of imperialist rulers. But they have fought and survived; and today they are in the forefront of the struggle for control of our land.

We can learn a great deal about the native peoples by coming to understand their painting as a reflection of their ways of life. The best place to begin is outdoors, where we find their vivid paintings on rock.

At Agawa, in Lake Superior Provincial Park, 90 miles north of Sault Ste Marie, there is a steep path down the cliff and a railing along the narrow rock ledge that overhangs the choppy waters of Lake Superior. On the face of the cliff along that ledge is a group of paintings that the Ojibway people have left there. (Fig. 1)

Agawa is one of over 200 sites, from the St Maurice River in Québec to the Great Slave Lake in the Northwest Territories, where paintings like these have been found. They are almost all painted on the steep faces of cliffs on a lake, and many can only be seen (and were obviously painted) from a canoe.

The largest single figure in this group is astonishing. It's a three-foot-long monster with horns on its head and spines all down its back and its tail!

What is this monster doing on the north shore of Lake Superior?

If we turn from the painting, look out across the lake, and imagine ourselves paddling a canoe out to the horizon, we can begin to understand.

The monster is *Mishipeshu,* which means "Great Lynx." It is an imaginary or spirit animal (called a *manito*) in Ojibway story-telling. It lives underwater, and is half lynx, half sea-serpent.

The tail of the monster is what counts. One lash of that scaly tail and the canoe full of paddlers that the native artist has painted just to the left of the manito would be dumped into the icy waters of Lake Superior. Mishipeshu is the spirit-animal that symbolizes the danger of deep or turbulent water.

There are five canoes in the whole painting, spread out over the rocks at Agawa. Four circles smudged in the same rusty-red pigment symbolize four days' passage (four suns), and the two lines under them represent the water of the lake.

According to a story told to Henry Schoolcraft, an American Indian Agent around 1850, this painting tells the tale of an heroic four-day crossing of Lake Superior by a war party of five canoes. This interpretation is supported by an inscription on one of the birchbark scrolls that the Ojibway keep for ceremonies of a cult group in their tribe called the *Midewiwin* Society.

These paintings were done by *shamans,* men who were considered gifted enough to be admitted into the secrets of this group. The shamans used the red iron-ore pigment available in the rocks and soil of the northland, and appear to have used gull's eggs or bear grease as a binder, so that their paintings have lasted for hundreds of years in spite of being exposed to the weather. This was an impressive technical achievement for a supposedly primitive people.

This particular painting at Agawa, according to the story, was done in the early 1800s by a shaman named Myeengun (meaning "Wolf"). Some of Schoolcraft's informants suggested that it may even commemorate a manoeuvre during the war of 1812-14, when the Ojibways were

allied with Canadian forces against the U.S.

Whatever the exact details, the painting on the rocks at Agawa records a triumph over the forces of nature. The war party had successfully completed the dangerous journey from the south to the north shore of Lake Superior, and this victory is what gives the shaman-artist such confidence to paint Mishipeshu so boldly.

Ordinarily, shaman or not, he would have been as cautious about Mishipeshu in his art as he and his people would be of the waves of Lake Superior and the rapids of the Sault that Mishipeshu represents. But here he outlines the muscular spring of the tail, the pounce of the legs, the alert twist of the neck and head, and the pointed curl of the horns, each with one sweep of his paint-dipped fingers, or with a stick or moose-hair brush. The two water serpents that he paints below underline his exultation in victory, because they symbolize swiftness and power.

The shaman's *subject matter* here (the Mishipeshu, the canoes, the serpents, the suns) is all drawn from the traditions of the Ojibway.

These people had to contend with the dangers of the lakes and rivers in order to hunt and fish for their food—that was their struggle for production. Their culture, which includes their legends and symbols, the rites of their Midewiwin society, the traditions of their shaman-painters, and this particular painting at Agawa, is part of the *superstructure* of their society. In any society the superstructure includes culture, religion, politics and social organization. It reflects the conflicts, dangers and tensions that people experience in the struggle for production.

What the Agawa painting is really about, its *content,* is the people's mastery over the forces of nature that they had to combat in order to live. This victory is also reflected in the *form* of the Mishipeshu, and in the artist's bold style in painting it.

If we compare this Agawa painting with a painting on buffalo cowhide done by the Sarci artists of the prairies (Figs. 2 and 3), we can see a different struggle for production leading to different specific subject matter, but quite similar content.

Here the subject centres on people and horses, an animal that the Spaniards had first brought to the plains and prairies, but which had become as essential to the native people's hunting of the buffalo as the canoe was to the Ojibway's hunting and fishing. The buffalo hunt was the crux of the Sarci economy: not only was it a chief source of food, but the buffalo's skin served as shelter, clothing, and something to paint on.

The Sarci artists here record in red and blue symbols the story of a hero of their people who captured many horses, while the hero himself (at age 79) sits beside them, recalling his exploits. Both stories and painting are clearly part of the superstructure of Sarci society, based on a real conflict they encountered—the need to get horses—in their struggle for the production of life's necessities. The painting's content, like that at Agawa, is a celebration of a victory in this

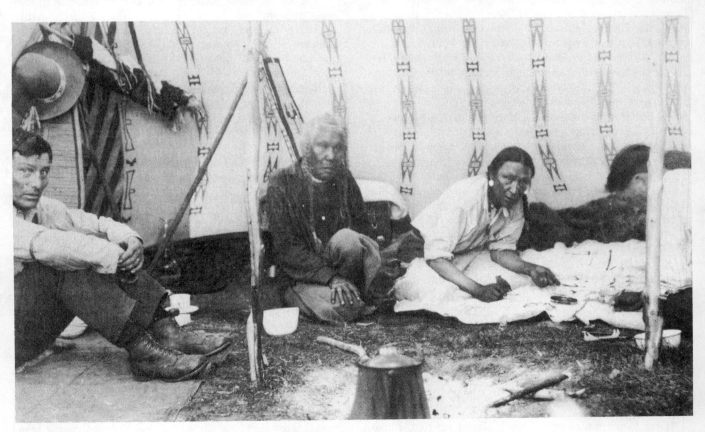

Fig. 2: Sarci artists at work on the prairie while the hero whose exploits they are painting sits at the left, aged 79, and re-tells his story, 1929.

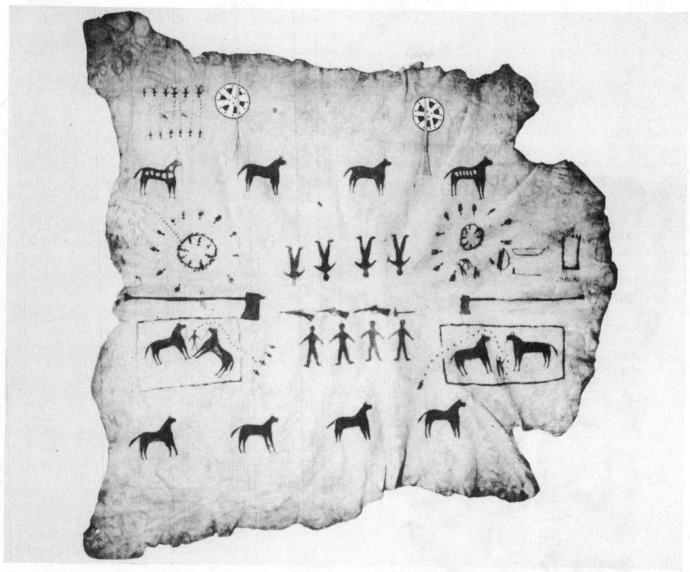

Fig. 3: The finished Sarci painting, now in the National Museum of Man, Ottawa.

struggle.

Most of the rock paintings are not as clear in the story they tell as is the Agawa example, but they appear to be associated with great events. The prairie painters on buffalo skins similarly celebrated the prowess of their great warriors and hunters.

The native peoples had migrated into this country from Asia some 30,000 to 40,000 years ago. Hunting bison and other large mammals, they had spread out over the whole continent, and through South America as well. Some 12,000 years ago, due to changes in climate and other factors, the large mammals began to die out. On the prairies there were still enough to continue living from the buffalo hunt, but on the west coast salmon-fishing became central. To the east a combination of fishing, gathering plants and hunting smaller game was the only way to get by.

In southern Ontario, plant-gathering was rewarding enough that it led to the beginnings of agriculture, which was further developed by influences from native peoples to

the south. About 3000 years ago pottery was introduced also from the south. Some two thousand years later the cultivation of corn provided a surplus that made possible a large increase in population and a more complex social system, although it was not a social system in which painting as such held an important place.

Whatever forms their cultures took, the art of the native peoples before contact with Europeans was almost invariably confident, powerful and impressive. This reflected not only their achievements in the struggle for production but also the fact that at this time they had real political power. After contact, all these societies—hunting, fishing, plant-gathering, agricultural—were almost completely destroyed by the French and British fur traders' exploitation of their country. Only the determined struggle of the native peoples has kept their cultures alive.

One of the last to be affected by such contact was the complex society developed by the native peoples of the Northwest Pacific coast. Their famous totem poles, painted

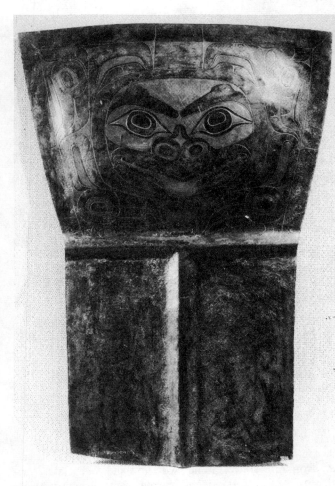

Fig. 4: Copper inscribed with the Bear clan's crest, Royal Ontario Museum, Toronto

housefronts, panels and chests (Figs. 4-7) at first may not seem to have an obvious relation to their way of life. An almost abstract organization of faces and eyes peers out at us, human and animal shapes with the joints of their bodies sometimes seen as if through an X-ray. Certain body parts are exaggerated, and the animals are often split down the middle, with one half of the figure to either side.

A human face mask collected in 1926 by Group of Seven artist A.Y. Jackson in the upper Skeena River area (Colour Plate I) has the characteristic ovoid and curvilinear forms painted in symmetrical patterns on the cheekbones and forehead. Unpainted areas provide relief for these blue shapes; traces of chalk-white set off the red of the lips and the flare of the nostrils. The mask is designed to surprise, as its wearer would leap from behind the carved and painted panel that served as a stage set in the lodgehouse, and join in the dancing and dirges that told of the origins of his clan.

This is a culture that reflects not only a people's struggle for production, but also their complex social organization. In this society people were organized to take different roles in producing and distributing life's goods.

For the native people of the Pacific coast, the struggle for production was fairly easy. The climate in what is now B.C. is milder and much damper than the rest of the country. Rainhats and robes had to be woven from cedar roots or fibres, but otherwise most of the people would go barefoot and naked for most of the year, except in the northernmost part of the coast.

Food was plentiful. Fish were fairly easy to catch in large numbers with the skilful harpoons, fishing weirs, nets, hooks, clubs and ocean-going canoes these tribes had developed. Salmon was king: it swarmed from the ocean to its spawning-grounds upstream every year at the same time. So by controlling the mouths of the rivers and inlets people could always count on a good supply of food in return for an intensive effort for only a few weeks of the year.

Shelter was also no problem. Cedar and other trees were all around: the people of the Pacific coast built the greatest architectural and sculptural environment in wood that the world has ever seen.

Because their economy yielded a surplus of life's necessities, a complex social organization and culture flourished.

A surplus can be traded for other goods. If a village controls fishing rights to the eulachon (a Pacific fish that the native people prized), eulachon oil can be traded for a semi-precious metal like copper that can be beaten into a shape that is used in the village's ceremonies. (Fig. 4)

But this trading economy depends on the ability to maintain the surplus. It must keep control of the fishing rights.

So this surplus led to two key ideas in the superstructure of their society:

● The idea of social *class* to define who has the rights to control the resources; and
● the idea of *property.*

Not private property of the individual as we understand it under capitalism, but property rights in land, fishing, clam-digging and even berry-picking and beach-salvaging

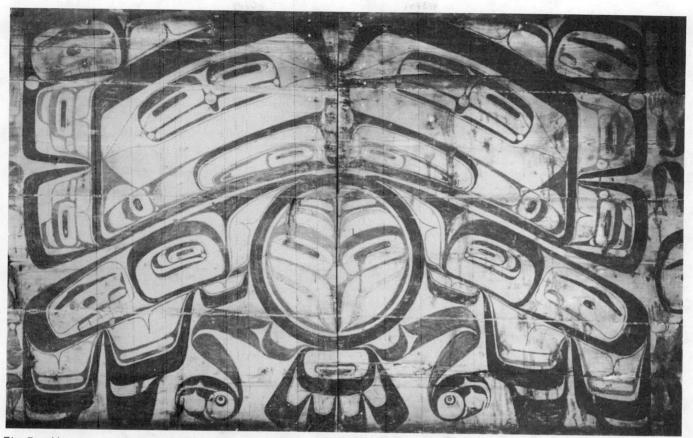

Fig. 5: House partition painted with a huge dragonfly in the centre, Tsimshian, about 1850, taken from the Skeena River, B.C. in 1924 by Marius Barbeau, National Museum of Man

that belonged to a given village.

Rivalries for these rights and competition in trade led to warfare. Warfare (mostly murderous sneak attacks at night on one village by another) brought captives, and the idea of property as well as the idea of class applied to them. So they became slaves. They did the drudge work and could be bartered, borrowed or given away, just like any other piece of property. They could even be killed if their owner thought they should be.

Slaves were not the only class. A few people got to make the decisions about the village's use of its fishing and other rights, determined whether or not to go to war, what ceremonies should be conducted, and so on. These were the chiefs, one for each large house and a main one for the whole village.

Everyone else had a rank, too. They were part of the Bear clan or Beaver clan or Raven clan, and that clan had certain rights and a whole history to recite to 'prove' how it had won and kept those rights.

This is where the artist came in. The native peoples of the Northwest Coast produced some of the world's greatest carvers to create their sculpture and architecture in wood; and they also were almost alone among native peoples in Canada in developing brush painting to a fine art. This is one of the many hints that suggests strong Asian influences on them, going back to the Chinese. Just as the Vikings contacted Labrador and Newfoundland, there appears to be good evidence for Asians crossing the Pacific to our shores in relatively recent time.

The main job of the artist was to produce *crests* for the clans. These crests identified who owned the objects, whose house or village you were in, and what their rights were. They also told the legends of the clan that supposedly justified how it got those rights.

Like our trademarks, labels, corporate symbols or union 'bugs' today, these crests had to be on everything connected with the people who had the right to use them: chests, boxes, rainhats, rattles, housefronts, houseposts, totem poles, blankets and canoe prows. This means lots of work for the carver and painter and weaver.

Like trademarks or union bugs, the crests had to be standardized. You couldn't paint just any old bear on a housefront. It had to be *the* representation of a bear that signified the Bear Clan. So certain attributes (things everyone would recognize them by) came to be used—the prominent nostrils, big mouth and protruding tongue of the bear, for example, or the beaver's front teeth and tail (Fig. 4).

And since they had to be spread over almost everything, no matter what shape or size they were, the way of painting these crests also had to be standardized. The animals are always seen either in profile or full face, and usually split down the middle so one half can go on one side, one half on the other. If the artist is telling the clan's history, he will

have to put one animal inside or on top of another as in the totems or on some of the painted panels. (Fig. 5)

The painter began by dividing up his space, no matter how large or small, with thick black *form-lines*—outlines that narrow and swell into the forms themselves. He used curves, ovals and U-shapes everywhere, and added detail in red, often enjoying the fun of putting an eye or a face into an elbow-socket or a knee-joint.

If he was painting a chest he would carve out some of the areas enclosed in the form-lines, and often paint these

The Northwest Coast chiefs could see these stylistic qualities too. Being traders, they were willing to put up the best of their artists' work in exchange for something else they wanted more. So the Haida carvers and painters were encouraged to combine elements of various crests on their much-sought-after chests, and the Tlingit women did the same with their Chilkat blankets (Fig. 7). This eclecticism and increasing stylization went hand in hand with greatly intensified trade; these clan insignia were losing their original social significance, and becoming objects for barter.

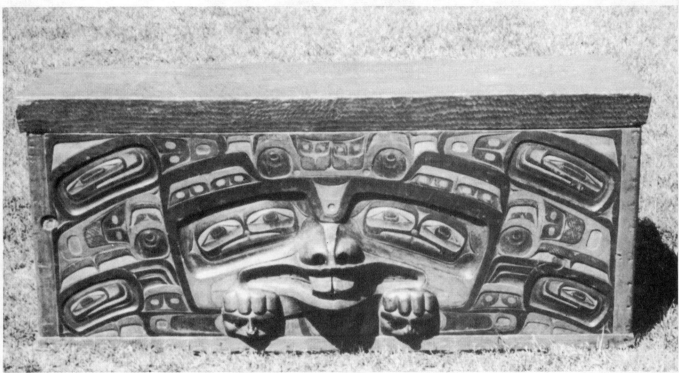

Fig. 6: Chest from a Tsimshian tribe at Gitawanga, possibly carved and painted by a Haida artist, National Museum of Man

areas and others in a fine light blue (Fig. 6).

Originally, these colours were vegetable and animal dyes and minerals. After contact with European and American traders they quickly became standard house paints or oils, and were much more freely used. They could be applied boldly in strong blues, reds, whites and blacks, as we can see in the startling and powerful mask from the Skeena River. (Pl. I)

The graphic brush-painting style following these conventions was developed to its highest point among the northern tribes, while a dramatic use of colour on expressively carved masks was more popular farther south, around the northern end of Vancouver Island and on the adjacent mainland. The mask from the Skeena River is from a Tsimsian tribe, and therefore reflects the northern style; but the painted graphic forms are fully integrated with the sensitively modelled facial features they overlay, so that the mask is an effective combination of the painting and carving traditions. The conventions of the painting are restrained to a fine dramatic point.

These objects, and particularly the shaped and incised sheets of copper, were especially popular in the Potlatch trading ceremonies, where the purpose was to show how wealthy a chief was, and how many rights and privileges he controlled, by giving away as many valuable things as he could to his guests. In the bitterly contested Rivalry Potlatches he went so far as to destroy precious objects to show that he was richer and of a higher class than the family he had invited.

Through the 1700s and well into the 1800s the native peoples of the North West Coast continued to hold effective political power over their area. The first traders were not numerous or strong enough to wrest this power from them, so the tribes were able to continue their traditional way of life. Since the chiefs were accustomed to trade, they soon set up a thriving commerce, and altered their traditional hunting patterns to provide the European ships with cargos of sea otter skins. The trade initially stimulated the artists with new techniques and materials such as steel carving and cutting tools and commercial paint.

Totems were now easier to make, and with the new trade, the Potlatch culture flourished. The artists of the Northwest Coast reached new heights. They created most of the major works we see in museums today between the years 1850 and 1880 in the north, and even later, lasting until about 1920, in the central part of the coast and on the north end of Vancouver Island.

But by that time the devastating negative effects of this contact outweighed any advantages, as they had long since in all the rest of the country. The trade contained the seeds of the native peoples' destruction: the sea otter was soon depleted, and the old self-sufficiency of their villages was gone. The oppressors were now numerous and strong enough to assume real political power along the coast.

Missionaries had already taken groups of their converts away to set up separate communities where the old culture was forbidden; and in 1884 the federal government's Indian Act made the giving of potlatches a criminal offence. The oppressor was out to take over the fisheries, and he needed labour for his fishing boats, canneries, and lumber camps. The native peoples' ability to resist these incursions was rooted in their social and political organization. The potlatch was vital to that organization so the potlatch had to be destroyed.

In 1922 the RCMP seized over 600 objects of the Kwakiutl culture in a raid on an illegal potlatch at Alert Bay on Vancouver Island. They divided the spoils between the Royal Ontario Museum in Toronto and the National Museum of Canada in Ottawa. The Kwakiutl have only recently succeeded in wresting back these stolen goods from the National Museum for a museum of their own in B.C.; the R.O.M. in Toronto is still holding on to its confiscated treasures.

A painted caribou-skin coat from the Naskapi people of Northern Québec and Labrador (Fig. 8) shows us one of the rare instances where European and native traditions could

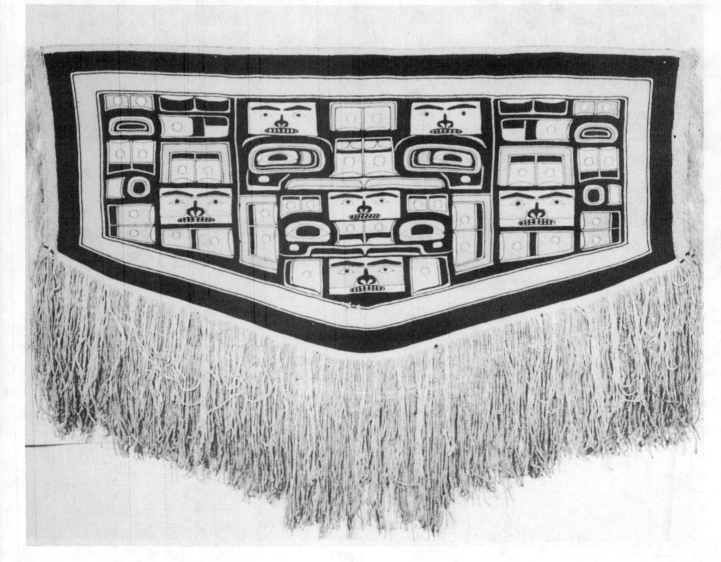

Fig. 7: Chilkat blanket,
woven from a painted pattern board, National Museum of Man

Fig. 8: Back of a Naskapi caribou skin coat painted with the eastern Algonkians' double-curve design, Royal Ontario Museum, Toronto

be combined to good effect by the native artist. The cut of the coat, its cuffs and collar and the long pleat-like triangles painted on its skirt show that its design is based on a French aristocrat's frock-coat, probably a second-hand one worn by some *voyageur*. But the delicate lines and curls painted in red, brown and yellow dyes on all the borders and up the 'pleats' with precise antler-horn painting tools are from the decorative tradition of the Naskapi. They shared with most of the eastern Algonkian peoples of the Maritimes and Québec the use of a 'double-curve' design: two curling lines that look a little like two canoe-prows meeting each other.

This pleasing combination of the two traditions was *not* at all typical. Nor does it reflect the Naskapis' overall experience of contact with their oppressors. Today they are among the native people of northern Quebec who are organizing to stop the plans of Consolidated Edison and the collaborating Quebec government to ruin their fishing and hunting grounds near James Bay for the sake of supplying

still more electricity to the factories of New York State. The attempted annihilation of the native people's civilization is continuing in our own time, under the direction and for the profit of American imperialists.

The French, British or U.S. regimes have proceeded in each case by removing the basis of the people's struggle for production—despoiling or denying to them the necessary hunting and fishing territory, the transport routes, or the good farmland they need to live on. In its place they put a new economic base, one that suits them. Historically, this has meant some branch of the fur trade, but today it includes casual employment as hunting and fishing guides, the carving-and-curio trade, and pressure to move to the cities to look for construction or factory jobs, or to join the ranks of the permanently unemployed. People without economic control cannot achieve political power; without political power, they cannot regain their indigenous rights.

Dismantling of their culture is an important part of this destruction of the native economy. The churches and the

Fig. 9: Norval Morriseau, Untitled painting,
Department of Indian and Northern Affairs, Ottawa

school system work together to undermine what is left of the people's confidence in a culture that no longer has much material base, nor the political power needed to protect it. Then, especially with the younger people, pop music, western movies and Coke do their job.

From the beginning, the native people have fought back. Vastly outnumbered and outgunned, they maintained heroic resistance campaigns and very often went over to the offensive. On the prairies in 1871 and again in 1885 they founded provisional governments of their own which they fought to defend. They were eventually defeated by the more powerful social organization that capitalism made possible.

Today, the movement to regain the lost lands and to restore confidence in being a native person, has made great gains, most recently with the armed occupation of Anicinabe Park, near Kenora, by the Ojibway Warriers' Society. Native people have been organizing to demand their indigenous rights, especially against the U.S. imper-

ialist oil and gas corporations in the north, and by persistent struggle and solidarity they have won some real victories. They are setting Canadians and Québécois an example in the fight to regain control of our economy.

The cultural aspect of this movement has two sides to it. On the one hand, the native people's rejection of racism and recovery of pride in themselves is a vital step in their liberation struggle. Native children must be able to learn the language, history and culture of their people, and this culture must be strengthened and enriched by contemporary artists. The Ojibway painter *Norval Morrisseau*, for instance (Fig. 9) has produced many pictures re-telling the legends of the past, bold paintings in strong colours depicting manito spirit-animals.

But the difficulty with the painting of thunderbirds and other early legends is that the traditions being revived no longer have much material or social base. The tail of the Mishipeshu cannot mean to an Ojibway living in Winnipeg today what it did for an artist who understood it as

Painting of the Native Peoples 19

representing the dangers of deep or fast water for his canoe. The canoe is no longer essential to his people's livelihood.

The result is that the legends tend to be appreciated for their 'spiritual,' aesthetic or formal significance alone. The original material meaning is lost, even to the artists who re-paint them. The pictures end up on the living room wall of some collector, and in recent years have even been sponsored by various government projects and grants specifically encouraging this kind of cultural nationalism.

The best-known government exploitation of native peoples' artistic abilities in a cultural project is among the Innuit (the 'Eskimo'). This has been primarily in the area of carving rather than painting, but beginning in the early 1950s it was extended to include prints, and still more recently, drawings.

Some of the seal-skin stencil prints and lithographs (printed from ink on a stone) by the Innuit are among the finest pictorial products *formally* of any of the native artists. The famous print of a hunter poised at a seal-hole by *Niviaksiak,* (Fig. 10) bursts with the same energy and sweep as the manito at Agawa. We sense the massive strength of the hunter, his adroit balance of his harpoon and his patient vigilance at the seal's breathing-hole.

But Niviaksiak, who died in 1959, was one of the last of the artists for whom the hunt was central as a way of life. More representative of the best of recent Innuit print-making are the brilliant lithographs by *Kenojuak* reviving the legends of the past, such as *The Enchanted Owl* (Fig. 11). But again, Kenojuak is among the last native artists for whom the legends have much material significance based on

Fig. 10: Niviaksiak (1920-59), *Hunter at Seal Hole,*
print, Department of Indian and Northern Affairs

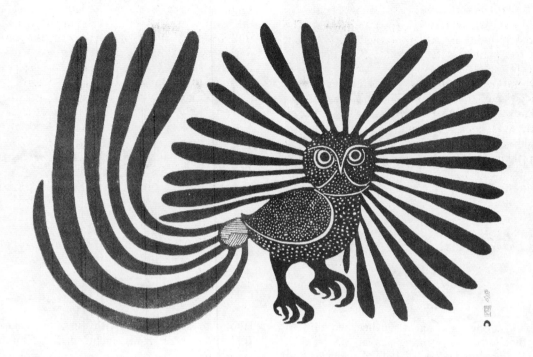

Fig. 11: Kenojuak, *The Enchanted Owl,* 1960
stone cut print, 24" x 26", Department of Indian and Northern Affairs

the traditional way of life in which they took shape.

Lacking a basis in any struggle for production outside the sculpture trade itself, much Eskimo art by full-time professional Innuit artists has become repetitive in subject matter, re-arranging figures and groups that are known to appeal to the buyer down south. It is largely due to the carvers' regard for their materials that the occasional piece is still bold in conception and powerful in execution.

Many other cultural projects have been initiated by the native people themselves. Typically, a group of young people set out to rediscover some part of their culture; through a series of grants and subsidies the government then takes them over, and their project becomes simply another aspect of the government's policy of attempting to control the native peoples.

The underlying problem with all programmes of cultural nationalism, is that they fail to raise the demand for *political power.* If the native people do not organize for political power they will be unable to recover any real control of their lands, their economy or social organization. Cultural projects then become only a cover for continued oppression.

In his style the native artist may draw on his own tradition as well as any others he cares to. But the critical question is one of subject matter: how is it to arise from the conflicts, dangers and victories the people experience?

For one thing, the demand for political power can only be realized finally in alliance with the anti-imperialist movements of Canadians and Québécois. Native people cannot achieve liberation in a country under the yoke of imperialism, nor can Canadian and Québécois gain any real independence as long as the indigenous national minorities remain oppressed.

An alliance must be forged, as it has been in the past. In the War of 1812-14, for example, the guerrilla tactics of the native warriors allied with Canadian forces were indispensable in administering a crushing defeat to the invading U.S. army. Together, our movements for national liberation can win.

Mastery of the natural environment has long been one of the strengths of the native people, as we have seen in their art. In the struggle to come, this knowledge may once again prove instrumental. It may also provide a recurring theme for the native artist as he seeks to *re-new* (rather than revive) his traditions by giving them new meaning based on this struggle.

Whatever direction progressive native artists take, it is clear that the question of an art that will serve the native peoples is also part of the larger question of an art that will serve the people generally. We will therefore return to it in the conclusion to this book. But first we have to examine the history of Québécois and Canadian painting.

II Painting in Quebec: French and British regimes

When we look at the painting of Québec, we have to keep in mind that we're not looking just at the art of a province or region of Canada. We are looking at the art of a *nation*.

A nation is a large group of people that have certain things in common:
- they are a stable group—that is, they're not just together for a generation or two, like many immigrant groups in Canada;
- they have been living together for a certain historical period of time;
- they occupy a distinct geographical area of the world;
- they speak the same language;
- they have a common economic base for their continued existence;
- on that basis they have developed a common culture and a common way of looking at things;
- they are aware of their identity as a nation.

If a group has some of these things in common but not all (like the Italian-speaking community in Canada, for instance), they may form a *national minority*. But if they have all these characteristics, as the Québécois obviously do, they form a nation.

1. The Art of the Church and the Art of the People

The history of art in Québec, like the history of Québec itself, starts in aggression, oppression and bloodshed, and the struggle against them. One of the very first drawings made by a European in New France shows the artist himself slaughtering the native people.

The 'artist' was *Samuel de Champlain,* who had set up the colony as a fur-trading post for the king of France in 1608. In the following year he joined the Hurons, Montagnais and Algonquins, whom he was using as cheap labour to supply him with furs, to make war on the Iroquois, whose lands included some of the best fur country.

Champlain drew a sketch of himself in the centre of the battle (naturally), drawing the trigger on his arquebus and scattering the Iroquois with this deadly weapon that must have astounded them. In 1613 a French printmaker produced an engraving of Champlain's drawing, so that everyone could see how brave the great explorer was (Fig. 12).

From the beginning the native peoples hunted and *coureurs de bois* transported the colony's raw material, furs, while a company with a monopoly granted by the king shipped them to France and took the profits. *Habitants* were brought in to clear and till the fields, but their lands were owned by the *seigneurs,* in what was basically a feudal system. These seigneurs, mostly associates of the company or former military officers, collected rent and taxes and raked off one-fourteenth of the grain each habitant ground at the seigneur's mill.

To justify this system of oppression (and to help carry it out), the Church was brought in. And with the Church came the first paintings—paintings as religious and imperial propaganda.

France Bringing the Faith to the Indians of New France (Fig. 13), for example, must be one of the most obvious pro-imperial pictures ever painted.

There, in the artist's imaginative depiction, stands the female figure of France, possibly the Queen Regent Anne herself, dressed in a silken robe decorated with fleurs-de-lis, with a wide ermine collar and an under-sized crown perched on her head. She seems to have just stepped ashore from the French ship anchored off to her right in the St Lawrence. With one hand she points to the 'heavens' in the clouds above the river, with the other she presents a painting to an 'Indian' who kneels, full of reverence and

awe, before her.

Behind the native, who has also covered his nakedness with a fleur-de-lis robe, is a mission station, the crosses prominent on the gable-ends of the buildings. The 'heavens' above show God passing the orb, representing power over the whole world, to Jesus, while the painting that the native is so gratefully accepting completes the imperial circuit by showing the same 'spiritual' light beaming down on the same company as in heaven, the Holy Family.

From God to Jesus to the Holy Family to the king of France to the colony, with the native people getting it in the end, that's the chain of imperial power. And it's all brought to us courtesy of the Church's mission to 'convert' the people of the whole world if possible—wherever the ships and guns of France can go. As propaganda for empire, the painting could hardly be clearer.

It is also quite an advertisement for the powers of the artist, especially among people who may never have seen an oil painting before. It suggests that a painting, such as the one the Queen is holding, can show us what's happening in heaven, as she indicates by pointing to the sky.

The bishops of New France hardly needed to be reminded. The Church had been trying to keep down rebellions of peasants in Europe for centuries by putting 'the fear of God' in their hearts with pictures of heaven and hell. If there was trouble with the native people, the habitants or the coureurs de bois in New France, why not try the same time-tested methods?

And if the bishops could propagate fantasies of worshipful 'Indians' kneeling before pictures of their heaven, they could also use the other stereotype of the native peoples—'the blood-thirsty savage'—for their picture of hell. At the far right of the *Martyrdom of the Jesuit Fathers in Huronia* (Fig. 14) is another mission station, looking a lot like the one in *France Bringing the Faith,* with crosses on the roofs above the doors. But this mission station is on fire.

Instead of kneeling in reverence and awe, these 'Indians' have dragged the Jesuits out of their mission, stripped them and bound them to stakes, and are torturing them to death. One 'savage' is about to pour boiling water (a mock baptism) over one of the priests, who in spite of his agonies looks steadfastly out at us. Off to the left another Jesuit kneels in prayer with two of his converts, while a couple of 'barbarians' stand ready to send them to heaven with hatchets.

The *Martyrdom* is based on actual historical events. It puts together on one canvas the stories of ten martyrs in all, mostly Jesuits, who had been attacked at their outposts of

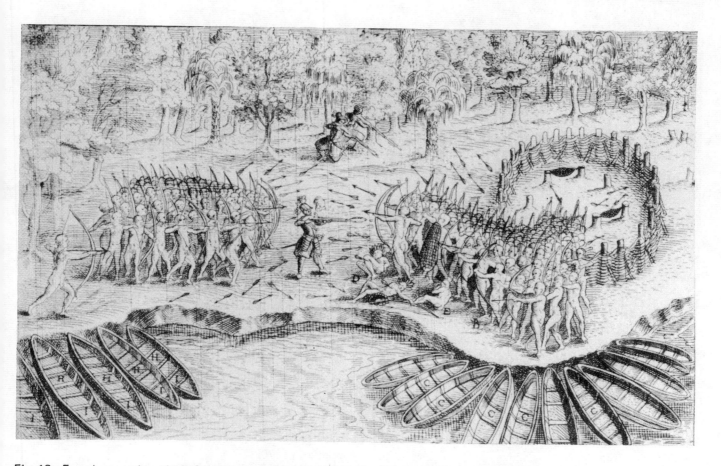

Fig. 12: French engraving of 1613 based on an original drawing by Champlain of his 1609 battle with the Iroquois, Public Archives of Canada, Ottawa

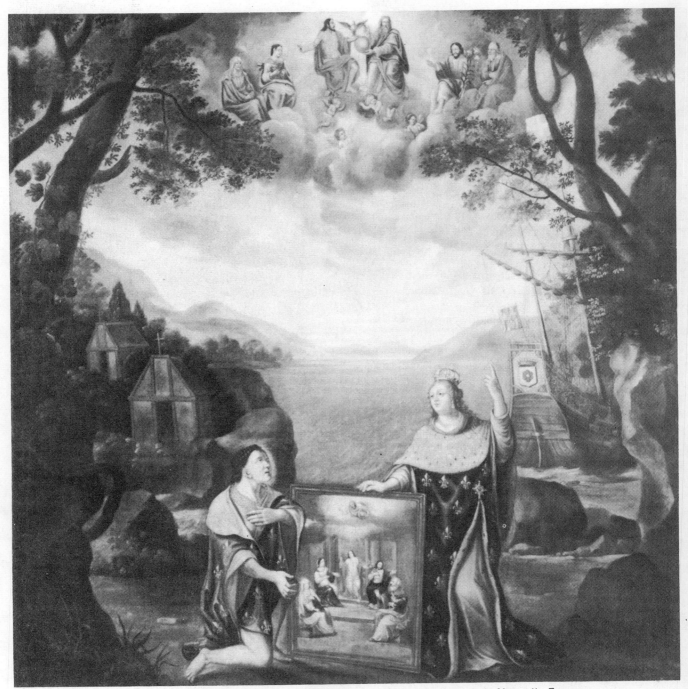

Fig. 13: Attributed to Frère Luc (1614-85), *La France apportant la foi aux Indiens de la Nouvelle-France*,
France bringing the Faith to the Indians of New France, oil, 89 1/2" square, Ursuline Convent, Quebec City

empire, their mission stations in the Huronia region of what is now southern Ontario between Lake Simcoe and Georgian Bay. The 'marauding natives' in the picture are actually the Iroquois counter-attacking against the French. Champlain had depicted his victory over the Iroquois, but in this painting the Iroquois are winning. They succeeded in driving the Jesuits out of the Huronia area for many years by fighting back.

We're not sure who painted either of these pictures, but we have a fairly good guess about both. *France Bringing the Faith to the Indians* of New France was probably done by a friar named *Frère Luc (Claud François* before he went into the clergy), who had been one of the well-known painters of Paris for several years. He came to New France for 15 months in 1670.

The *Martyrdom of the Jesuit Fathers in Huronia* is based on a print made in Paris in 1664 by a French artist named Grégoire Huret, who had probably never seen an Iroquois.

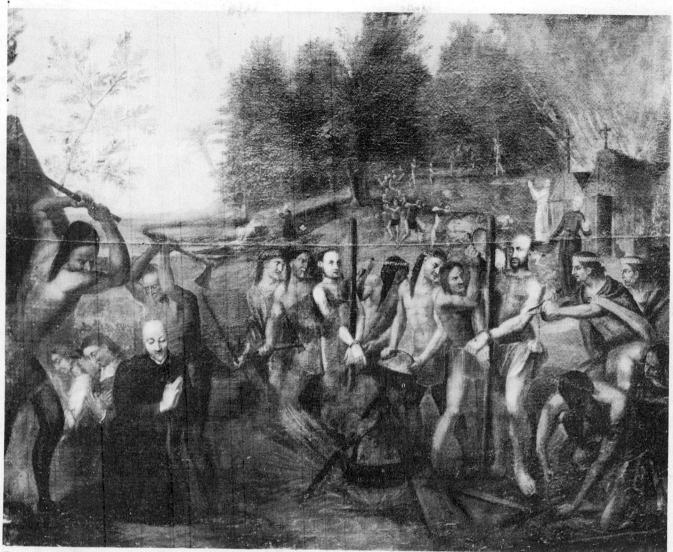

Fig. 14: Attributed to Hugues Pommier (about 1637-86), *Martyre des Pères Jésuites chez les Hurons,* about 1665-70
Martyrdom of the Jesuit Fathers at Huronia, based on a 1664 engraving by French artist Gregoire Huret
oil, 40" x 60", Hotel-Dieu, Quebec City

It may even have been painted in France and shipped to the colony. But it is just as likely that it was done in New France by the very first painter to come here, a young priest named *Abbé Hugues Pommier.*

Pommier had been encouraged to come to the colony, and Frère Luc was heartily welcomed, by the *Monseigneur de Laval.* This ambitious bishop knew better than any of the others how important the arts and education could be in his plans to make New France into as much of a theocracy (a country ruled by the Church) as he could. At St Joachim in 1668 he had already founded a school of the arts, and while Frère Luc was in town (1670-71), Laval asked him to design the building for another educational institution he needed—the Quebec Seminary.

The Seminary was built after Frère Luc had left. Laval liked it so much that after his retirement he moved into it himself, and the governor complained that the bishop was better housed than he was. Laval also had his portrait

painted, another picture that may be by Frère Luc (Fig. 15).

Much of this art of the Church was simply a direct import of religious hocus-pocus from France, painted to encourage oppressed habitants and coureurs de bois to think of miracles from heaven instead of getting rid of the system of land-owning seigneurs and rich fur merchants here on earth. Frère Luc's *Assumption of the Virgin* (Fig. 16), for instance, shows us a slightly stiff and heavy Madonna being wafted heavenwards from her tomb by a band of rosy-cheeked cherubs. Today we can recognize the mannered pose and the sweeping gestures as typical of French painting of the late 1600s; but in New France in 1671 it was certainly the most impressive painting anyone had ever seen.

The struggle for production in the colony had been organized into a definite class system controlled from the imperial centre. The paintings we have been looking at are

The Art of the Church and the Art of the People 25

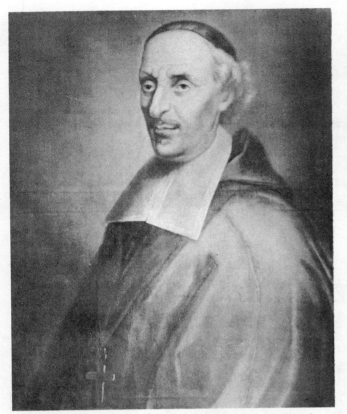

Fig. 15: Attributed to Frère Luc, *Monseigneur de Laval,*
about 1671-72, oil, 34" x 28",
The Seminary, Quebec City

part of the superstructure that reflected this system. The
king had delegated his authority over the economic life of
the colony (the material base) to the chartered fur
company that monopolized trade, and over its cultural life
(the superstructure) to the Church, which tried to
monopolize ideas.

Protestants were forbidden to settle. The Church was
given full charge of the colony's morals, education and
culture. Everyone was organized into parishes, and the
Church, especially under Laval, imposed itself upon every
aspect of the Canadiens' day-to-day life, gaining even more
control than it had in France.

Of course the Bishops were also very much interested in
the economic base. They were empowered to collect a
tithe, a tenth of all the habitant farmers could produce;
they also received a subsidy from the fur-trading company
and regular contributions from the land-owning seigneurs.
In addition, they secured land grants from the king
whenever they could. Of course this land rightfully
belonged to the native peoples who had lived on it for
thousands of years, but the king of France handed it out
anyway, while the Church was converting at least some of
'the savages' to the love of God. By 1763, at the end of the
French regime, the love of God had gained the Church in
Québec over two million acres of land—a quarter of all the
land the king had granted.

So it's not surprising that most of the painting that was
done in New France was done for the Church, or that the
painters were obliged to produce the religious and
pro-imperial progaganda that the Church wanted people to
see. What is surprising is that under these conditions the
artists managed to paint anything else.

Yet they did. The *votive* or *Ex Voto* paintings of
Québec, most of which were painted during the French
regime, were pictures commissioned by people who had
overcome mortal danger, to commemmorate their
deliverance, show their devotion and give thanks for their
salvation. But since the danger, in most cases came from
people's struggles to get their work done and enjoy
themselves a little, and since the 'salvation' was actually due
to their ingenuity, hard work and daring, not a saint's
intervention, these pictures give us a lively view of
daily work and play in Quebec.

One votive painting on a wooden plaque by an
anonymous artist, possibly *Paul Beaucourt,* (Fig. 17) tells
the story of two young men, Jean-Baptiste Aucler and
Louis Bouvier, who were out paddling on the St. Lawrence
River at two o'clock in the morning on June 17, 1754,
when their canoe overturned. (Colour Plate II)

What they were doing out on the water, or how they
tipped over, we don't know. But they and their three
girl-friends, Marthe Feuilleteau, Marguerite Champagne

Fig. 16: Frère Luc, Assumption of the Virgin (L'Assomp-
tion de la Vièrge), oil, 81" x 62", Altarpiece in
the Hôpital Général, Quebec City

(aged 20) and a woman named Chamar (21 years old) were all pitched into the river. The two men managed to get onto the overturned boat and save Marthe; but the other two women drowned.

Between the inscriptions that tell us these details, the artist has included St Anne in a cloud. After all, the painting was commissioned for the church vestibule, and is supposed to show how 'divine intervention' saved at least one of the women. But the painter is obviously much more interested in the realistic details of the scene. The churches are familiar landmarks on either side of the St. Lawrence, one being the church for which the painting was done. One of the men is wearing his good red frock-coat; the other, with a feather in his cap, is using a paddle to drag Marthe back to the canoe. It is only the two drowning girls who appeal to St Anne so imploringly—and in vain.

In another votive, it is even more obvious that the hero is not St Anne, but a worker's dog. (Fig. 18) Dorval, a Saguenay bush-worker, in an accident familiar to all fallers, has been pinned to the ground by the tree he has just brought down. Unable to move but thinking quickly, he has dipped a bit of bark in his own blood and given it to his dog. The dog is just about to leave for help.

When the dog arrived at Tadoussac near the mouth of the Saguenay, a group of Dorval's fellow workers recognized his pet, saw the blood on the bark and followed the dog back to the injured lumberman. Afterwards, Dorval paid a painter, perhaps again Beaucourt, to record his adventure for the church foyer.

There these paintings would hang for years, where the people waited before and after Mass. People could explain

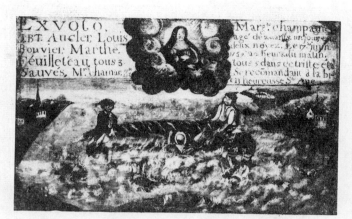

Fig. 17: Anonymous, *Ex-voto des trois naufragés de Lévis,* (Votive of the Three Shipwreck Victims of Levis), 1754, oil on panel, 12 3/4 x 20 1/2", The Museum, Sainte-Anne de Beaupré

them to their children, recall the events, and talk about the friends and relatives shown in them.

Votives were especially popular in the small villages and in the country, where they were often painted by a local artist. In the bigger cities they might be commissioned by the owner of a ship that had been wrecked, or by a wealthy family that had been on board; but in the smaller country and village parishes they more often reflected the life of workers like Dorval.

If we compare these votives with the official paintings of the Church, we can see that in the final analysis they were actually more realistic. Both *France Bringing the Faith to*

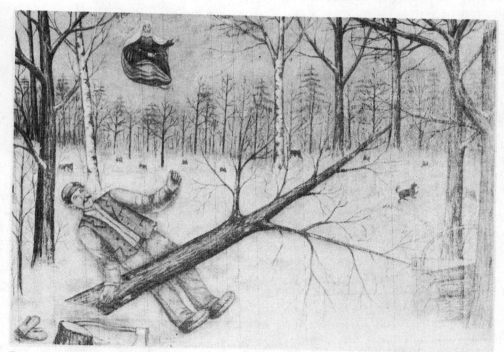

Fig. 18: Anonymous, possibly Paul Beaucourt (1700-56), *Votive Painting of the Bush-Worker; Dorval,* oil, 16" x 22", The Museum, Sainte-Anne de Beaupré

the Indians and the votive of the over-turned canoe depict scenes on the St Lawrence, with saints in the sky. But the official painting is a falsification of how the native people received the French empire and the Church, while the votive is a realistic treatment of how people overcame hardship.

Contrast the mannered poses of *France Bringing the Faith* (and moreso the *Assumption of the Virgin*) with the direct and convincing action of the votive. Also, look at the way the two painters have treated the landscape. The official painter, presumably Frère Luc, certainly knows how to paint the receding horizon of a river valley with its hills and islands. His water is believably deep, and the trees that frame his fictitious little scene could have grown in any picturesque European villa. Even though its artist was probably in New France, this is not an observed landscape, but a demonstration of the stylistic conventions of the French academy of art. The artist has gone through the schools and met the standards of the Paris of his day.

The painter of the votive, on the other hand, doesn't know these conventions. He is inept at perspective and placing his figures in spatial depth. But he does know that he has to communicate the drama of his subject matter. So he simplifies his colours. He manages to suggest both the 2:00 a.m. time of the disaster and the danger of the waves by painting them in as agitated white flecks on his brown-and-buff ground. For his horizon he simply lightens to a cream, while his foreground is darker brown. The same brownish tones serve for the earth of the shores, and a darker brown for the roofs of the white buildings. A restless flicker of light and dark, sustained in the clouds around St Anne, plays over his entire landscape and conveys the urgency of the moment.

The style is not unlike that of votive paintings in some other Catholic countries. The point is not that it is uniquely 'Québécois,' but that it is based on the artist's need to tell his story. He knows he has something important to say, and he finds an effective and powerful way to say it.

A similar contrast can be made between the Dorval votive and the *Martyrdom of the Jesuit Fathers in Huronia*. Here again the votive painter has gone directly to his subject matter, and has forcefully presented his main figure, Dorval, and the dog setting out. His composition, aside from the obligatory St Anne in the sky, is convincing as a document of what actually happened.

The *Martyrdom*, however, is not a documentation of the fate of the Jesuit Fathers, even though it is based on actual incidents. It conveys its main point by allowing the highlights to fall on the faces and hands of the priests, again using a stylistic convention of academic painting of the period in Europe. This is really just the other side of the imperial coin of *France Bringing the Faith*. It is propaganda presenting the Iroquois counter-attack as savage butchery, while the Jesuits, who were agents of an empire bent on destroying the native people's civilization, are shown as pious martyrs with their serene faces and folded hands cleverly emphasized by a stylistic device.

The message of the votives, by contrast, even though they are painted for church foyers and so have to include a saint in the clouds, is that artists should paint the real struggles of the people among whom they live and work. *Style* is developed as needed in order to express the drama and intensity of that struggle, but this subject matter has to come first.

This approach leads to a fresher, more original way of painting, as well as to *content* that matters. In a colony, imported styles and conventions cannot lead to art that is anything more than second-hand. But if the colonial artist creates with the materials he knows better than anyone else, his own people in his native land, he can produce significant painting. These are the emerging qualities of a people's art.

2. Social Classes in Québec: A Portrait of Québec Society

Under the French regime almost all the art was produced for the benefit of the Church and the empire it served, and to help keep the native peoples, the habitants and the coureurs de bois, under control. Some such system of control is required by all societies that have a class character.

Patronage is the way a system of this kind is maintained in the arts. A patron is anyone who pays the artist to do his work. During the French regime the Church was almost the only patron; artists were able to begin developing an art of the people only because their patrons for the votive paintings were not bishops and priests but the people who had overcome disasters.

After the British conquest of Québec (1759), the social system set up by the new British ruling class changed the patterns of patronage. The Church continued to commission paintings, but the new expanding market was for *portraits*. From about 1780, one generation after the Conquest, until about 1860, when photographers began to put them out of business, artists in Québec worked primarily as painters of portraits for those classes that could afford to commission them. And although the working people were not among these patrons, they did appear in a different way in the pictures of people in the city and countryside that also became popular at this time.

In his book *The History of Québec*, Léandre Bergeron has done an excellent class analysis of this period, in which he uses the term *Canayen* to refer to the 70,000 French-speaking people who now came under British rule. This is because the word *Canadien* came to refer to English-speaking Canadians as well. The portraits of Québec are virtually an illustration of Bergeron's class analysis, so we will follow his terms as well.

This class structure was very much a reality for the artists—they depended on their reputation with the patron classes for their livelihood as portrait painters, while they had their own patriotic and class loyalties that they wanted to express in their paintings. By studying their subjects as examples of the class make-up of Québec at this time, we can best understand the many fine painters of this period.

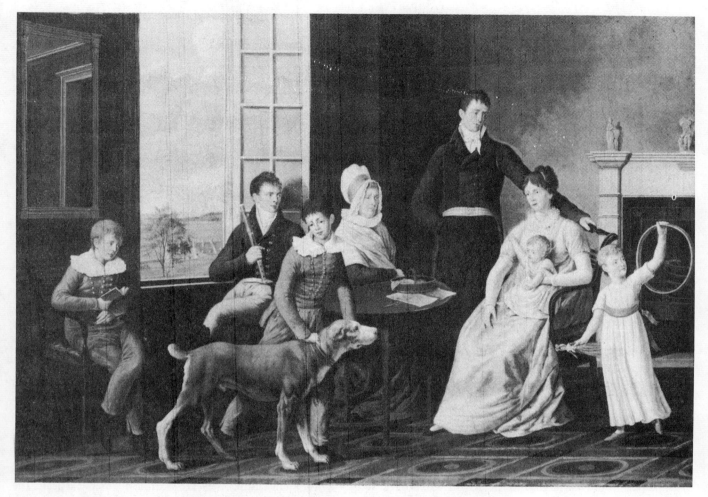

Fig. 19: William von Moll Berczy (1749-1813), *The Woolsey Family,* 1809,
oil, 23 3/4" x 34 1/4", The National Gallery of Canada, Ottawa

THE BRITISH RULING CLASS

In Medieval Europe there were extremely few portraits of individuals as such. Even kings and nobles appeared infrequently, and then mostly as participants in the real or imagined events being depicted. Persons were not conceived as individuals but as representing their positions in life.

Towards the end of the middle ages, however, the *bourgeoisie* (the ruling class in the capitalist system that we still live under) had to fight for the rights of private enterprise and individual initiative—the right of individuals to exploit others, and the 'right' of the others to have their labour exploited. The concept of the individual was built into the capitalist or bourgeois view of the world.

So wherever banking and the cloth trade began to flourish, in northern Italy, southern Germany and Flanders, painters began to get commissions to do portraits of individuals. And such is the force of an idea in the cultural superstructure when it has the strength of a rising class behind it, that bishops and aristocrats, some of them opposed to the rise of the bourgeoisie, also began to get their portraits painted.

By the time the bourgeoisie began to achieve state power, as in the Netherlands in the 1600s, the portrait of individuals and their families was fully developed as an art form of bourgeois culture. Painters like *Rembrandt* and *Franz Hals* are still famous for their portraits today.

Soon the bourgeoisie had amassed enough wealth to begin setting up mercantile empires all over the world, from which they could make more profits by taking out raw materials from the colony and shipping back manufactured goods from their imperial centre. To do this effectively, some of the bourgeois had to go to the colony and take their culture with them.

The French had done this in New France by setting up the fur trade and bringing the Church along. But from the mid-1700s onward, the British empire was by far the most powerful. In Québec following the conquest the British exploited the fur and lumber resources, and took control of all important trade. British merchants and administrators, together with the soldiers needed to protect them from the people, moved into Quebec City and Montreal.

This is the basis for the smug confidence that we can see in *The Woolsey Family,* a portrait painted in Quebec City in 1808-09 by an artist named *William von Moll Berczy* (Fig. 19). A whole British family is gathered in a British

drawing room furnished in the British style of the day. Out the window we can see the rooftops and walls of old Québec, and a bit of the St Lawrence River. But if the window were closed, we might think we were looking at a drawing room in London.

Berczy was a painter who had learned to serve the imperialists well. Born in Saxony in 1749, son of the German ambassador in Vienna, he had been educated to be a diplomat. He refused to follow in his father's footsteps, and after a period of wandering around Europe and painting the families of aristocrats, he got a job teaching drawing to the daughters of the Earl of Bath in England.

The Earl at this time was making money by buying up cheap land or getting land grants in the New World and 'developing' it for a profit with colonists. One of his groups of customers being German, his German-speaking drawing-master was persuaded to become a land agent. He sailed for the United States in 1790.

Berczy found that the bourgeoisie of upper New York State had their own ideas about how their land ought to be exploited, so he decided to move his colony to Upper Canada. He chose Markham Township, not far from York, which is now the city of Toronto.

There he began to paint portraits again, and after a return visit to England (during which he was jailed due to financial difficulties over the Markham land), he moved to Montreal, where there were enough British patrons to provide him a living as a full-time painter. Von Moll Berczy must have put his Viennese diplomat's training to good use among the British officers and fur traders and the Canayen seigneurs and Mothers Superior who were his patrons. His son married the daughter of a seigneur and his whole family became part of the 'cultured' ruling-class circle of Montreal.

As a drawing-master in England, Berczy had been friends with another German painter in London, *Johann Zoffany*, who was famous for his portraits of the British royal family. This was the kind of painting Berczy had in mind when he set out to flatter the Woolsey family with this group portrait.

He also shows the influence of a style called *neo-classicism*. This was a revival of what were thought to be classical (ancient Greek and Roman) ideas of how things ought to look. It emphasized clear, simple outlines and a rational, even geometrical, composition. In the design of buildings, furniture and other useful objects the neo-classical artists also directly imitated Greek and Roman examples.

We can recognize *The Woolsey Family* as neo-classical right away, from the marble copies of ancient Greek statuary on the mantlepiece, and from the sides of the mirror that look like Roman columns. But we can also see it at a deeper level if we analyze the geometry Berczy has used in his composition.

Start at the head of the young master of the house, and follow the incline of his head and the glance of his eyes down the line of his left arm, through the head of his wife to the rung of the chair back and the elbow of his young daughter, who holds up her hoop to provide a circular right end to the line.

Now start at Woolsey's head again and see how Berczy has balanced that fairly short and sharp line with a longer, lesser angle off to the left. It passes through the head of his brother, holding the flute at the window to show us how musical he is, to the head of the young brother-in-law, ending in the boy's elbow, which is bent to hold a book

The oval of grandmother's sewing basket on the circular table and the reflection of angles in the mirror continue the geometrical organization of the picture. Even the angle of the baby's arms, the curl of the dog's tail and the way the little girl holds her doll straight out from her thigh have been planned to lock together and balance off parts of the composition.

The mirror, the window, the shadows of the corner and the mantle make a series of strong verticals across the canvas, and the figures are spaced out at intervals, linking one vertical area with another. Berczy has added many secondary lines to offset his basic triangle and dominant vertical series—such as the sequence that connects the sharp rectangles of the window through the angle of the flute and the forearm of the boy with the collar of the dog; the line of the dog's body continues along the curving edge of the table, which brings our eye back to the softer flowing forms of the grandmother's clothes.

There are also many design elements here that are distinctively neo-classical. The mantlepiece, table and chairs are types designed by British artists of the late 1700s who based their work on similar ideas of geometrical proportion, and on Greek and Roman models. The circle-in-square tile on the floor is based on a Roman mosaic. The figures are lined up as if on a shallow stage, or as they would be if they were carved across the front of a Roman building. Even the hair-do and clothes they are wearing are 'neo-classical'. The young girl with the hoop, for example, wears a dress modelled on the simple flowing robe (called a *chiton*) of the ancient Greeks.

Why did the British bourgeoisie in Québec want to make themselves and their surroundings look as much like Greeks and Romans as possible? In the first place, this neo-classicism had been associated with the rationality of the French philosophers whose ideas helped to sweep away the pretentions of the French kings and feudal aristocrats. In painting, the style had been given a strong impetus by *Jacques-Louis David,* who in addition to being the outstanding artist in Paris, was also a leading participant in the French revolution of 1789, in which the people threw out these kings and aristocrats. The appeal that neo-classicism still has for many people today is rooted in this revolutionary sweep, the re-ordering of the world on simple, clear, rational principles.

But by the time Berczy painted *The Woolsey Family* in 1808-09, Napoleon had seized control of France on behalf of the bourgeoisie. He appointed David his court painter, and through neo-classical styles likened the empires of the ancient world—Egyptian, Greek, Roman—to his own. By then the neo-classical style had become the mark of oppression rather than reason and revolution.

In England the British ruling class had fancied this kind of neo-classicism since the late 1700s. They quite con-

sciously compared the British with the ancient Roman empire. Since rational principles were supposed to have been a virtue of the Greek and Roman ruling classes, the British would now have to cultivate them too. So British ruling-class children studied Latin, took trips as teenagers to visit the monuments of ancient Greece and Rome, and if they had to go to the colonies took as much of this imperial culture with them as they could.

This is why Von Moll Berczy, the ambassador's son, has flattered his clients by painting them in this neo-classical manner. Faithful servant of his imperial patrons, he has surrounded them with their imperial trappings in an imperial way. Berczy tells the Woolseys and us in this painting that their family has succeeded in implanting in the wilds of Lower Canada (peeping through the window) the rational virtues that once were Greek and Roman but now 'belong' to the British ruling class. The family is obviously part of the 'cultured' elite of the colony. Their culture is imperial culture.

The Woolseys were delighted with the painting, and paid Berczy ten pounds apiece for each figure. He threw in the dog for free.

THE COMPRADOR CLASS

In English we might call them 'sell-outs.' In French it's *vendus*. The Portuguese word *comprador* (meaning 'buyer') was first used for the Chinese manager or senior employee in Portugal's commercial establishments in China, and has now come to refer generally to that class of people in a colony who *buy* status and profit for themselves by helping the imperial power to exploit their fellow colonials.

In Québec under the British regime the compradors were (a) the seigneurs, and (b) the clergy.

The Seigneurs

The portraits of *Eustache-Ignace Trottier dit Desrivières* (Fig. 20) and his wife *Marguerite Trottier dite Desrivières* (Fig. 21) depict a class in decline. Their very name (meaning that their real name was Trottier but that they chose to call themselves by the more aristocratic-sounding Desrivières) proclaims how pompous their lives were.

The artist, *François Malepart de Beaucourt,* portrays the decadent couple at a typical moment. The husband, flesh of his face under one eye sagging, sits playing cards at his gambling table in his French aristocrat's waistcoat and silk vest with gold trim, old-fashioned lace carefully arranged at his collar and cuffs. Mrs. Trottier *dite* D. plays hostess beside her expensive tea urn; she makes sure we see the golden box she is holding, and the miniature portrait in the locket she is wearing, to remind us of her own family connections.

De Beaucourt—the 'de' in his name indicating his own aristocratic pretensions—was just the man to paint these seigneurs. Son of painter and engineer Paul Beaucourt (without the 'de'), he was born at Laprairie near Montreal

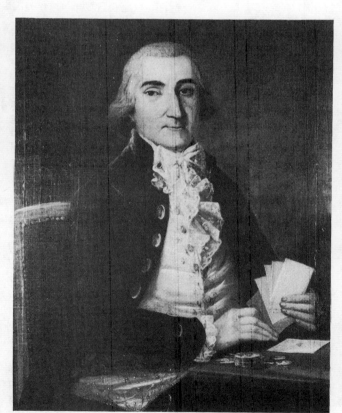

Fig. 20: François Malepart de Beaucourt (1740-94),
Eustache-Ignace Trottier dit Desrivières, 1793,
oil, 31 1/2″ x 25″, Québec Museum, Quebec City

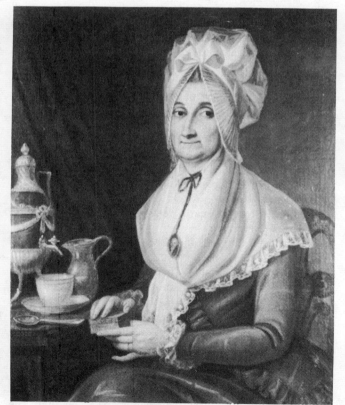

Fig. 21: Francois Malepart de Beaucourt,
Marguerite Trottier dite Desrivières, 1793,
oil, 31 3/8″ x 25 1/8″, Québec Museum

in 1740 and he worked in France before the revolution, possibly for as long as 15 years, between 1771 and 1786. There he had learned the *rococo* style of painting, which is as suitable for these two portraits as the neo-classical is for *The Woolsey Family.*

'Rococo' may have been adapted from the Italian word *roccioso*, meaning 'rocky' and referring in particular to the convoluted shapes of the rocks along the Mediterranean shoreline in parts of Italy. As a stylistic term it came to be used for the convoluted shapes that the declining aristocracy of Europe liked to see in their paintings and decorative objects and even in their buildings around about 1750. It was really just a further development of the extravagance of the 1600s, but it lacked the force and conviction of the absolute monarchies of that century behind it, and so became over-decorative, fussy, in some cases even giddy. This preoccupation with style showed the decadence of the aristocracy.

Beaucourt's rendition of the rococo is restrained—what else would you expect in a colony? The convolutions are limited to the fussy costumes of the sitters, and the artful clutter on the tables. Beaucourt enjoys the sophisticated interplay of colour and texture that these details allow him, and poses his figures at a three-quarter turn from their tables, painted at an angle as if in an off-hand moment, according to the rococo portrait convention.

These conventions were long since out of date in France. Neo-classical simplicity and reason had displaced the rococo as early as 1760 among the more advanced circles in Paris, and David was producing his neo-classical paintings all through the 1780s. But how was a provincial painter from Québec to know? Beaucourt had accepted the style of the establishment because that's what he had gone to France to learn—the imperial standard by which his work would be judged. The fact that the imperial standard might change could only be an irrelevant distraction to him. He brought back what he thought was the latest style, and used it to serve the class that shared his faith in that standard.

These were seigneurs in Lower Canada pretending to be French aristocrats. Yet the date of de Beaucourt's paintings of the Trottiers is 1793! This is four years after the beginning of the French revolution, and the very year of 'the Terror' when the Jacobin party in France is bringing down the people's revolutionary vengeance on aristocrats and their sympathizers.

The British ruling class had been worried that the French revolution might spread to Québec. They had captured a French ship in the English Channel, which was said to have been bound for Lower Canada with 20,000 muskets. Habitants had tried to break into the prisons. In 1794 there were riots against the Roads Act, which proposed to build highways with their forced labour, and rumours kept circulating about a French fleet that was supposed to deliver arms to the Canayens.

The Trottiers *dits* D., with their card games and tea parties, tried to keep up appearances, but they were frightened. After the Conquest they had made a deal with the British. In the Quebec Act of 1774 the British insisted on the rights of their own bourgeoisie to buy and sell and

Fig. 22: Louis-Chrétien de Heer (about 1750-1808), *Monseigneur Hubert,* 1786, oil, 31 1/2" x 28", Hôpital Général, Quebec City

inherit land according to British law, but allowed the seigneurs to keep their inherited estates and the habitants who worked on them. This meant capitalism for the British, who could now start profiteering from land speculation, and feudalism for the Canayens. Since the basis of power was now capital, not landed wealth, seigneurs like the Trottiers could no longer claim to be in the real ruling circles. The cards and tea continued, but the British had found more effective sell-outs. They turned to the faithful compradors they had been using from the beginning—the Catholic clergy.

The Clergy

"It does not suffice that we be loyal and faithful subjects. If the habitants who are entrusted to our care allow themselves to be seduced by the enemies of peace and good order; if they lose sight of the rules of dependence and subordination that the Christian religion prescribes for them and that are responsible for their special happiness and for the maintenance of harmonious relations between subjects and ruler: then, we believe it to be more than ever our duty to impress upon the people, either in public instructions or in private conversations, how closely they are obliged to uphold the loyalty they have sworn to the King of Great Britain, to prompt obedience to the laws, and to avoid any spirit which might inspire them with the ideas of rebellion and independence, which have caused such sad ravages in recent years, and from which it is so much to be desired that this part of the globe ever be preserved."

So wrote *Monseigneur Hubert* to his priests in 1796. His letter is a little masterpiece of comprador prose. Notice how he treats the habitants like children. They had been "entrusted to our care" not by God but by the British: "the rules of dependence and subordination" are the rules of oppression. The greatest threat to the bishop and the British is that fighting "spirit which might inspire them with the ideas of rebellion and independence."

In 1786, ten years earlier, the bishop who wrote these lines had had his portrait painted in Quebec City by an artist named *Louis-Chrétien de Heer* (Fig. 22). Hubert was obviously a big man, who must have used his considerable bulk to be physically imposing over any parish priest of lesser stature who was the least bit reluctant to serve the British so faithfully. His heavy jowls don't soften the look of determination on his well-fed comprador's face.

His painter, de Heer, had been born in Alsace, the province between France and Germany, and may have served with the French troops who had come to the aid of the American revolution. By 1783 he was living in Montreal, and by 1787 had opened a studio in Quebec City.

De Heer advertised in the *Quebec Gazette* that he could paint portraits as close to reality as anyone could wish. But if we compare the 1786 portrait of Hubert with that of *Monseigneur de Laval* (Fig. 15), dated 1671-72, it would appear at first glance that the standards of reality in bishops' portraits have fallen off during the century between the two paintings. While Laval is a convincingly three-dimensional figure who turns in believable space with light behind him and falling on him, Bishop Hubert comes alive only in the face, and even it has a leathery quality and seems to be set against the flat patterning of the bishop's robes like a mask. We can sense the mass of Hubert's body, but his robes lie flat, without volume, and there is no believable space or light around him.

There had, it is true, been a loss of certain qualities in Québec painting during this period. Painters like Berczy and de Beaucourt had their training in Europe, but for artists who had not learned their craft in the imperial centres there was a kind of diminishing return as they copied engravings or religious art proudly imported by the Church, and tried to learn at second or third hand technical means of execution or effects of style.

Since the clergy sat for portraits in both regimes, we can see this happening if we look at a series of pictures of them. *La Mère Juchereau de Saint-Ignace*, for example (Fig. 23), dates from 1684. It may have been painted by *Jean Guyon*, the son of an habitant and our first native painter; Laval had recognized his talent, sent him to the Seminary, and had taken him back to France, but he died there before Laval could make any further use of him. Whether he painted *La Mère Juchereau* or not, she was probably modelled on the picture of a Mother Superior that the Ursuline nuns had brought over with them. Her face is painted sensitively enough, but the artist is relying on the starkness and simplicity of the nun's habit to fill out the rest of his picture, and his background is without light.

Pierre Le Ber, another native-born artist, taught painting in the first art school in Montreal from 1694 to 1706, and

Fig. 23: Possibly Jean Guyon (1659-87), *La Mère Juchereau de Saint-Ignace*, about 1684, oil, 27" x 21 1/2", Hôtel-Dieu, Quebec City

in 1700 painted *Marguerite Bourgeoys* (Fig. 24) who had founded a convent in Montreal. While she was alive she thought portraits too vain for a nun, but the sisters (who obviously didn't take her opinion on portraits too seriously) paid Le Ber to paint her after she died. This may partly explain the starkness of her portrait, painted entirely in white, black and shades of ochre; but it is also clear that this teacher of painting has a very limited knowledge of how to render the texture of flesh and cloth, and how to make his subject look believably like a solid volume in three-dimensional space.

A generation later, in 1721, the portrait of the *Abbé Joseph de la Colombière* (Fig. 25) again lacks a sense of volume in the figure, and his face also has a leathery rather than fleshy texture. It may have been painted by *Michel Dessaillant de Richeterre*, a Québec-born painter who had studied at the School of Arts and Crafts that Laval had set up at St. Joachim. Or it may be one of the hundreds of portraits with these qualities by unknown artists that begin to appear about this date.

What in fact had happened well before the Conquest is that Québec artists had found their own ways of solving their technical problems. This was not a loss but a gain. Look back at the three portraits and you can see that their strengths lie in the same areas as their apparent weaknesses—the simplicity and order of *La Mère Juchereau*, the dramatic impact of the death portrait of *Marguerite Bourgeoys* and the expressive face of the *Abbé* are all helped,

Fig. 24: Pierre Le Ber (1669-1707), *Marguerite Bourgeoys*, 1700, oil, 24 1/2" x 19 1/2", Collection of the Sisters of the Congregation of Nôtre-Dame, Montreal

not hindered, by the somewhat crude and direct technique of their artists. The same can be said for the bulk of de Heer's *Monseigneur Hubert*, which is conveyed as well through the big flat areas of dark colour and design as it could be through any more sophisticated means.

These qualities of dramatic expression by means of strong contrasts of light, colour and decorative shapes at this point begin to emerge as distinctive of Québécois art in general. We can see them most clearly in the powerful Le Ber portrait: the flat patterns and crisply outlined folds of the nun's habit create a tension of forms clustered around the shadow that completely surrounds her face, so that the gravity of her face in death is striking. The contrast of white and black is relieved only by the ochres; the artist concentrates on light as his means of direct and moving expression.

Although the palette is not always so reserved, the tendency to direct expression in precisely these terms recurs throughout the history of Québec painting. Vivid colour, dramatic light contrasts, and evocative shapes seen as an over-all dynamic pattern—these are the formal qualities of this emergent tradition. Indeed, we have already encountered them in the votive of the over-turned canoe, where the dramatic play of light conveys the excitement of the drowning and rescue. The unknown painters of many of these portraits and the anonymous artists of the votives must have been the same people.

What these artists had accomplished was the development of a *Québécois* tradition of painting. This was by no means a style in the positive and conscious sense that the artist would have seen it as an alternative to the neo-classical and rococo portraits he saw around him; on the contrary, he could only see it as a limitation due to his lack of European training. As long as his subjects remained bourgeois and comprador portrait sitters and religious themes, this tradition could not be much more than a Québec artist's way of getting the job done. But it did provide a basis for the young artist to develop his talents with or without the tricks of the trade as practised in the imperial centre.

The importance of this tradition increased with the Conquest, and still more after 1789 when the British ruling class tried to isolate the Canayens from any possible contact with the revolutionary ideas of France. From the revolution in 1789 until the fall of Napoleon in 1815, the British tried to keep the people of Québec in strict quarantine.

The artist who put the Québécois tradition to its best use in portraiture was *Jean-Baptiste Roy-Audy*, who was learning to be a painter at just this time. Born at Charlesbourg in the early 1780s, he studied in the late 1790s under *François Baillargé*, a master craftsman and designer who had been to France before the revolution and had brought back a French version of neo-classicism. This influence can

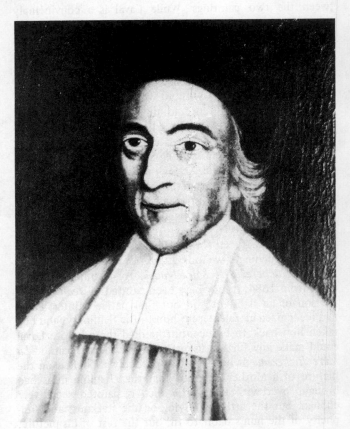

Fig. 25: Anonymous, possibly Michel Dessaillant de Richeterre, *Abbé Joseph de la Colombière*, 1721, oil, 24 1/2 x 18 1/4", Hôtel-Dieu, Quebec City

be seen in Roy-Audy's insistence on a clear outline in portraits like his *Monseigneur Rémy Gaulin* (Fig. 26). But all the rest of his characteristics must have been learned from what he could see in the Québec tradition of paintings that had been done before him.

Roy-Audy was a carpenter's son, married the daughter of a blacksmith, and began as a carpenter himself before he began his career of travelling from town to town painting portraits. In his portrait of Gaulin, the bishop of Kingston, he brings the exacting eye and careful hand of the skilled workman to the job of portraying this well-fed sell-out. We can see every book in his theological library, examine the detailed decoration on his sleeve, and almost read the letter he points to with his left hand. As with earlier works in this tradition, there are difficulties in relating the life-like head and hands to the rest of the body, and in making us believe that we are seeing an actual three-dimensional figure seated in the space provided. Light turns to shadow abruptly in the face, and the figure remains wooden, as stiff as the books and the arm of the chair.

Roy-Audy was a disciplined craftsman with a demanding eye for realistic detail. But until this Québec tradition was used to depict subject matter rooted in the lives of the people rather than nuns and bishops, it could not lead to major works of art. Led by the petit-bourgeoisie, and given its strength by the habitants and other working people, a strong national consciousness with a need for such subjects was now on the rise. The date of Roy-Audy's portrait of Gaulin is 1838—one year after the outbreak of the very revolution that Bishop Hubert had tried so hard to prevent.

THE PETIT-BOURGEOISIE

The class of people that does the essential productive work in our society is called the *proletariat*. The class that does not do the productive work but owns and controls the means by which the proletariat produces (factories, mines and mills, for instance) is called the bourgeoisie.

In between is another large class of people who either both own and produce (such as farmers, fishermen, small self-employed businessmen), or else neither own the means of production nor themselves do essential productive work directly (such as students, teachers, civil servants and professionals). Since the first group operates bourgeois enterprises on a small scale, and the second is hired by the bourgeoisie out of their profits to work for them, this class is called the *petit-bourgeoisie*, the 'little-bourgeoisie.'

At the time of the Conquest in 1759 the petit-bourgeoisie in Québec did not include a great many lawyers, civil servants or professionals. Under the French regime the clergy had monopolized education and settled minor disputes. Now British merchants and administrators were moving in to take over business and government work.

But the measures that had to be taken by the British ruling class to buy off their comprador seigneurs and bishops resulted in a substantial growth of this section of the Canayen petit-bourgeoisie. The Quebec Act allowed civil suits to be settled according to French law (while criminal offences remained under British), and permitted

Fig. 26: Jean-Baptiste Roy-Audy (about 1783-1845), *Monseigneur Rémy Gaulin,* 1838, oil, 33 3/16" x 28", Quebec Museum, Quebec City

Catholics, unlike Catholics in England at the time, to work in the civil service.

This meant that the Church could maintain control of the education of this section of the petit-bourgeoisie. The portrait of *Cyprien Tanguay* painted in 1832 by *Antoine-Sébastien Plamondon* (Fig. 27) shows a typical petit-bourgeois of the time in training. At 13, Tanguay is hard at his studies in the Quebec Seminary, the educational institution that Laval had founded. He was to become Dominion Archivist in Ottawa and to publish a *Dictionnaire des familles canadiennes* that listed Canayen family trees.

The artist who painted him in 1832 was also a young man. Not yet 30, Plamondon had returned only two years before from his studies in Paris, where he had learned French neo-classicism from *Paulin Guérin,* a teacher who had been a student of David. His portrait of Tanguay was Plamondon's outstanding work to that date; with its triangular solid geometry, its clear outlines and careful modelling of the figure, its even, controlled light, and the realistic details of the foreground on the table contrasted with the simplicity of the background behind the figure, it shows clearly the influence of neo-classicism on the young painter.

Before going to France, Plamondon had been apprenticed to *Joseph Legaré* and painted in what we have called the Québécois tradition. There may be something of that influence left in the definition of line and the directness of Tanguay's gaze; but the portrait is definitely, as Plamondon advertised when he set up his studio in Québec in 1830, in the official French style of neo-classical painting. This was

the kind of neo-classicism that had long since ceased to be a revolutionary force and was now firmly aligned with reaction: as David had become court painter to Napoleon, his pupil Guérin was court painter to Charles X in the restored monarchy that tried to rule France until another revolution brought it down in 1830.

Plamondon had sided with the monarchists in that revolution, so when the monarchy was overthrown he came hurrying home. But Lower Canada in the 1830s was even more revolutionary than the France he had left.

The habitants and other working people through these years were gathering their strength to achieve independence from British rule. In this patriotic struggle for national liberation they looked to their lawyers, doctors, newspaper editors and notaries to lead them. From 1791 onward, after the British had yielded to pressure for an elected Legislative Assembly, the majority of the delegates chosen by the Canayens to represent them came from this petit-bourgeois class.

The class interests of the petit-bourgeoisie at this time also lay in opposing the British and their comprador allies in the colony. Genuinely patriotic and democratic, the petit-bourgeois took on the responsibilities of leadership. With the people pushing them from behind, they went all the way to attempting an armed anti-imperialist revolution in Québec in 1837-39. At the same time, they had aspirations to join the big bourgeoisie, and to get more power for themselves.

Their leader was *Louis-Joseph Papineau,* a notary's son who became a lawyer, was elected to the Assembly, and in 1815 at the age of 28, was elected Speaker of the House. In the course of the next 15 years he gathered over 87,000 signatures on petitions of protest to London in his sustained campaigns for greater power for the elected representatives of the people and less for the appointed agents of the British bourgeoisie. By 1833 he was calling on the Canayens to boycott British merchants' goods and to withdraw their savings from the British-owned Bank of Montreal.

Plamondon's portrait of him painted in 1836 (Fig. 28) shows the *Patriote* leader at the height of his power, just one year before the outbreak of the armed struggle. His pen in the inkwell, he turns from his lawbooks to look at us with resolute conviction, confident that he has the power of the people behind him.

But is this man about to lead a popular armed revolution? He is dressed to remind us that he is a lawyer. The setting he chooses, his legal library, is for the same purpose. Behind him, Plamondon hangs a swath of plush velvet curtains from his studio, complete with pull rope and tassel, which gives the whole portrait a slightly pompous and highly official character. Is this a man of the people, or a man anxious to impress us with his learning and the high office he has attained?

The portrait of *Julie Papineau and her Daughter* that Plamondon painted at the same time (Fig. 29) only con-

Fig. 27: Antoine-Sébastien Plamondon (1804-95), *Cyprien Tanguay,* 1832, oil, 28 1/2'' x 23'', Museum of the Seminary, Quebec City

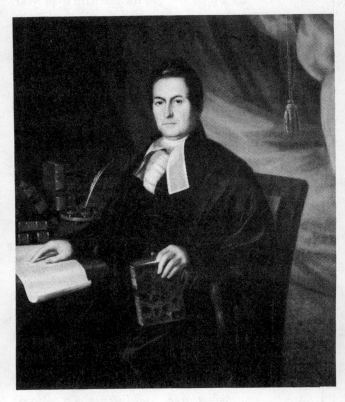

Fig. 28: Antoine-Sébastien Plamondon, *Louis-Joseph Papineau,* 1836, oil, 48'' x 42''

firms our misgivings. With her ornamented hair-do and jewelled crucifix, Mme. Papineau, showing off her expensive silk gown and embroidered lace, is even more anxious than her husband to impress on us that she, the daughter of a merchant, is from the very highest level of the petit-bourgeoisie. She makes sure that we appreciate that her daughter, equally expensively dressed, is a musical girl, and that the family of this ambitious lawyer-politician is a 'cultured' one. Plamondon, who obviously enjoyed turning from the sobriety of his male subjects to the sumptuous elegance of his female patrons, sets her off with some more hanging drapes and adds a bouquet of flowers to fill out this picture of gracious living.

This is the family of a man who is to be called on within the year to lead the military campaign of an inadequately armed people against the greatest imperial power in the world at that time. Will such a family encourage him to stand and fight, or to escape with his life and hope to earn his way back into British favour at a later date? Papineau had already turned down an attempt to buy him off by appointing him to the Executive Council; but the fact that the offer had been made, and that he had been so well received in London with his petition, must have given him and his well-dressed wife confidence in the possibilities of 'working within the system.'

When the struggle for national liberation intensifies, the contradiction between the two directions within the petit-bourgeoisie also intensifies. In the fall of 1837, after an economic depression that had greatly increased the suffering of the people, the British began to take repressive measures, called in reinforcements and incited gangs of armed thugs to attack Patriote meetings. Yet as late as October 23, Papineau was still urging a crowd of 5000 Patriotes in St Charles to keep things "constitutional" and limit their actions to the boycott.

On November 16 a warrant was issued for Papineau's arrest, and he was forced to flee to Patriote-held territory along the Richelieu River. On the 22nd of November, at the very outset of the first full-scale battle there, he ran away. By the time the news came of the Patriote victory at St Denis, he was on his way to safety in the United States.

So the bravado in his second portrait (Fig. 30) is a sham. After the defeat of the revolution in 1839 he had left the United States for France, where he wrote his account of the history of the uprising. This second portrait was painted about 1845, when he had decided to accept the British government's offer of amnesty and return to Lower Canada. It shows us a spirited but noticeably ageing Papineau, nine or ten years later, sporting a bright red bow to symbolize his radical *Parti Rouge*. The bow looks good, and the party did issue a manifesto attacking British rule, but this time the bourgeoisie knew exactly how far the party's leader was willing to go.

We're not sure who painted this second portrait. It may have been *Théophile Hamel*, Plamondon's star pupil, who had followed his teacher's advice and gone to Europe to

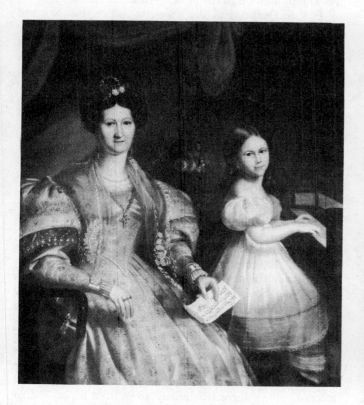

Fig. 29: Antoine-Sébastien Plamondon,
Julie Papineau and her Daughter, 1836,
oil, 48" x 42"

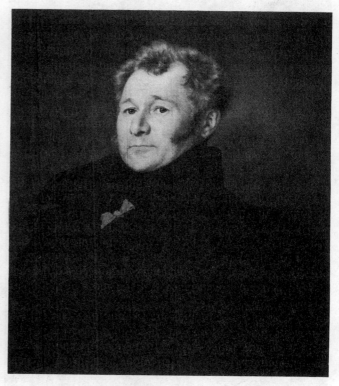

Fig. 30: Attributed to Théophile Hamel (1817-70),
Louis-Joseph Papineau, about 1845, oil, 24" x 20",
Collection of Andrée and Maurice Corbeil, Montreal

improve on his style. The clear outline of Papineau's figure against the simple background and the careful modelling show the results of the many lessons in neo-classicist technique that Plamondon had to teach. But the romantic flair of the portrait, with Papineau acting the part of the hero he wasn't, suggests the temperament of Hamel, and especially the effect on him of the *romanticist* painters he had seen in France.

Romanticism was a widespread European movement that developed in reaction against the rationality of neo-classicism when it became the oppressive style of Napoleon's empire. In poetry, music and painting the romanticists in Germany, England and Spain (all countries whose people were fighting Napoleon) stressed the emotions, an appreciation of nature and the concept of the romantic hero. The artist himself was seen as a romantic hero, a further development of the concept of the individual that had begun with the bourgeoisie. His feelings, his personal view of the world, and his struggle for self-expression became the centre of attention. After the fall of Napoleon *Eugène Delacroix* introduced romanticism to French painting, associating his impassioned use of colour with the bourgeois-democratic revolution of 1830, the same revolution that Plamondon and the rest of the monarchists had opposed.

Hamel does not appear to have been attracted directly by Delacroix, but by earlier painters whose use of colour

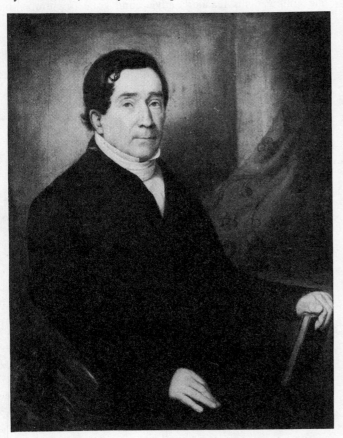

Fig. 31: Théophile Hamel, *Judge Jean-Roch Rolland,* 1848, oil, 37 1/2'' x 29'', McCord Museum, Montreal

Delacroix emulated, such as the Flemish artist *Peter-Paul Rubens.* At any rate, he brought home a suitably restrained colonial version of the romanticists' ideas in 1846, when he came back to Canada East (as Lower Canada was now called) and set up a portrait studio just as Plamondon was retiring to a farm.

Hamel's warmer flesh colouring could be employed to good effect. But in the colony after the defeat of the revolution, most of his sitters couldn't even pretend to be romantic heroes.

In his portrait of *Judge Jean-Roch Rolland,* for instance (Fig. 31), Hamel effectively contrasts the warm pinks of the face and hands with the cool blue-grey in the shadows. Underlying his colour is the decisive outline he had learned from Plamondon, along with a certain tightness in the drawing and awkwardness in the figure that suggest Hamel's origins in the Québécois tradition.

But Hamel's sitter is a traitor. This is the judge who sentenced Papineau (in absentia) and other Patriotes in 1837. At that time a total of 506 were imprisoned. The following year, when Rolland was paid off by being appointed to the Court of Queen's Bench, 155 more were jailed on charges of treason. In 1839 twelve of these *real* heroes of the Québécois people were publicly hanged after being convicted by British army officers under martial law, while 58 others were deported to the British empire's penal colony in Australia. Hamel's picture of Rolland was painted in 1848, one year after the traitor had received a further reward, promotion to the position of Chief Justice.

Few in Québec had this much to answer for. Nor had they all deserted at the first sound of battle. *Robert Shore Milnes Bouchette,* for example, son of the colony's Surveyor-General, not only fought along the Richelieu River but also tried to lead a force of 200 Patriotes back into Québec from the United States. Wounded and captured, he was exiled to Bermuda. While in prison he managed to paint a watercolour picture of himself in his cell (Fig. 32).

Bouchette's little sketch pictures his personal imprisonment, and by implication his people enslaved. But it includes as well a note of hope for the future, a symbol of the spirit with which he and his people will be able to endure their oppression.

Bouchette may have had lessons in composition from his father, *Joseph Bouchette,* who liked to sketch on his surveying trips. He has chosen a most unusual and effective viewpoint for his painting, forcing us to look at his room from behind his bed, so that the ropes it is hanging from divide the whole room. He suggests the cramped, confining nature of his cell by drawing in each vertical line of the floorboards and walls, but interrupts almost all these lines with a random clutter of objects and furnishings in the room, most of which we see at an angle. The walls converge on the barred window.

Bouchette himself is not posed as a portrait sitter in an interior, but is turned obliquely away from us, on a chair seen from behind and at a strange angle. His attention, and therefore the interest of the picture is focussed on the symbol of hope, the little bird that is perched on his finger.

Fig. 32: Robert Shore Milnes Bouchette (1805-79), *Imprisonment of R.S.M. Bouchette*, 1837, watercolour, 12 3/4" x 16 1/4", Public Archives of Canada, Ottawa

He has ensured that it will be seen clearly by darkening the wall behind the bird, but he has also made sure that it will not be too obvious to British censors' eyes: the bird is contained and almost concealed by the two converging ropes from which the bed is suspended.

"Stone walls do not a prison make, nor iron bars a cage." Just above Bouchette's head, in the thick stone well of the barred window, the door of the bird-cage is wide open. As Bouchette meditates on the defeat of his people, so the open door of the cage shows his confidence in final victory. The little bird in prison is the great bird of hope for the liberation of the Canayen people.

Bouchette had fought bravely. But he and the other leaders of the revolution had essentially failed as commanders of an armed stuggle. What was needed was a strategy of protracted guerrilla warfare based on the habitants' control of the countryside combined with continued agitation in the cities. But to conduct such a struggle a profound faith in the power of the people was required.

Papineau revealed his lack of faith in the Canayen people completely in 1854. This ambitious petit-bourgeois became a feudal lord; he accepted a seigneury and retired there for the rest of his days. After he died, *Napoléon Bourassa* memorialized him with a plaster relief (Fig. 33) that showed him as a Roman emperor, against a background of maple leaves and acorns.

After the Act of Union with Canada West (Ontario) had set up a new administrative system of British oppression in 1841, many of the petit-bourgeoisie were able to become 'little-compradors.' Rolland got his promotion, Papineau got his seigneury, and even Bouchette got a job as Commissioner of Customs of Canada!

Of course most of these professionals and civil servants were not ready to admit their compromised position to themselves. Unwilling to continue the struggle for independence, they turned to fighting a rearguard action for the French language and French civilization. They clung to the notion that as professionals and intellectuals they were somehow the representatives of 'French civilization' in North America. The Church, which still had charge of their

Fig. 33: Napoléon Bourassa (1827-1916),
Louis-Joseph Papineau, painted plaster relief,
National Gallery of Canada, Ottawa

Fig. 34: Antoine-Sébastien Plamondon,
The Flute Player, perhaps 1855, oil,
21 5/8'' x 17'', Quebec Museum, Quebec City

Fig. 35: Louis Dulongpré (1754-1843), *Self-Portrait,*
pastel, 9 1/8'' x 8 1/8'', National Gallery of Canada

education, encouraged this *cultural nationalism* which ac-
tually affected the Canayen as a conservative tendency,
keeping the forms of life French while the reality remained
British rule.

Napoléon Bourassa, who painted the seigneurial portrait
of Papineau (and married his daughter) was a leading ex-
ponent of cultural nationalism. A pupil of Hamel, he tried
to introduce into Québec church decoration a more 'spir-
itual' kind of painting he had picked up in Europe; in 1877,
he went to France to learn how to organise art education in
Québec.

This cultural nationalism had a wide spread influence. It
even attracted Antoine Plamondon, in his retirement, as we
can see in his painting the *Flute Player* (Fig. 34).

The old master has posed his nephew and pupil *Siméon
Alarie,* playing the flute as he did in the family's musical
evenings, against a gorgeous sky that is reflected in the St
Lawrence River. The poetic concept of the painting, its lush
colour and evocative light show the influence of roman-
ticism on the ageing neo-classicist. The ship in the river
behind Alarie is *La Capricieuse,* which in 1855 became the
first French warship to sail into Québec waters since the
Conquest. Plamondon's canvas, repainted in 1866, was in-
tended as a salute to this occasion.

But the reason the warship was there was the alliance
between British and French imperialism in the Crimean War
against Russia. It was an advantage for the British to have
La Capricieuse in the St Lawrence River, and certainly it

was no help to the Canayen people. But for Plamondon and all the others who rejoiced at its arrival, it was enough that the warship had come from France. *La France* and all things French began to take on an almost mystical significance for artists and intellectuals, a significance that had very little to do with the realities of that country itself, past or present. Sponsored by the Church, a full-scale falsification of the 'glorious past' under the French regime began to be taught as Québec history. Paintings like *The Flute Player* were part of this campaign.

The artist himself is a petit-bourgeois, a man in the middle with patriotic and democratic tendencies to resist his oppression on the one hand, but with pressures to serve the ruling class that offers him most of his patronage on the other. So it was not surprising that he was attracted by the facade of cultural nationalism.

The self-portrait of *Louis Dulongpré,* for instance, (Fig. 35) shows us a man who identified with the most conservative traditions of his time. Born in France in 1754, he always insisted on wearing the white powdered wig, knee breeches and silver-buckled shoes of pre-revolutionary days in France. In his style of painting he clung to the rococo manners of that period, and in pastel portraits like this one he was continuing a preference for the sensitivity of pastel that had characterized the French court before 1789.

Yet he was a friend of the Papineau family and other Patriotes. And he certainly suffered the oppression of a petit-bourgeois in a colonial economy: in 1830 he lost all his savings in a bank failure due to one of the periodic slumps of the British imperial system that affected the colony much more drastically than the imperial centre. His wife had died, his two daughters moved to the States, and the conservative old gentleman ended his days penniless and alone, filling Church commissions for religious paintings.

There is usually a great gap between the ideals of the petit-bourgeois artists and intellectuals, and the reality of their lives in a system of class oppression. The contrast can be seen clearly in three self-portraits by Hamel (Figs. 36, 37, and 38), painted about 1837, 1846, and 1857 respectively.

The earliest picture (Fig. 36) shows us Hamel the young Romantic. Hardly 20 years old, he sits with his brush and portfolio in a landscape that reflects the European river valleys he had seen in engravings and copies of European paintings in Québec. The idea of painting his portrait in a landscape was a highly original one, and he shows us his responsiveness to nature in his face and his carefully painted fingers. The portrait is certainly ambitious for a young artist, and his combination of the Québécois tradition with the sophistication he had acquired from Plamondon allow him to communicate this lofty, romantic notion of the artist in nature.

In the second picture (Fig. 37) Hamel the portrait painter gets down to business. This is probably the first canvas

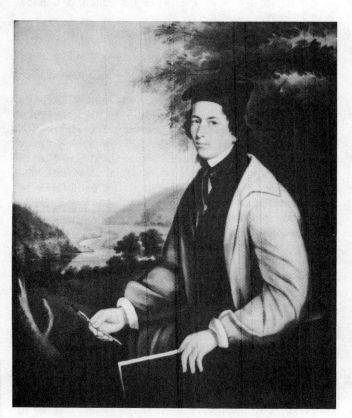

Fig. 36: Théophile Hamel, *Self-Portrait,* about 1837, oil, 48'' x 40'', Museum of the Seminary, Quebec City

Fig. 37: Théophile Hamel, *Self-Portrait,* about 1846, oil, 19 1/2 x 15'', Quebec Museum, Quebec City

Fig. 38: Théophile Hamel, *Self-Portrait,* about 1857, oil, 26" x 21 1/4", National Gallery of Canada

Fig. 39: Théophile Hamel, *Georgiana Hamel,* about 1857, oil, 26'3/4" x 20 7/8", National Gallery of Canada

he painted after returning from his European study tour, and it is intended as an advertisement of his talents. The warm glow of light, the rich flesh tints in the face, and the strength of colour in the red painting jacket, black cap and the oils on his palette all show the influence of romanticism and of painters like Rubens on him.

But he had come home broke, so his self-portrait (which he would probably hang in his studio waiting-room) is also designed to attract customers. In the left background is the portrait of a British army officer in uniform, and on the right is a large religious painting: Hamel has his most likely clientele in mind. His expression is enough to convince any businessman that he can be entrusted with an advance on his commission. The portfolio of drawings behind the easel reminds us of his skill in that department, while on the easel itself another portrait in the oval format is shown in progress, to suggest that the customer consider a fashionable variation from the standard rectangular canvas. He has turned from the vision of himself in the landscape that we saw in his earlier portrait to the interior of his studio in a commercial office building. He already shows signs of becoming a formula painter, for he has simply transferred the pose from the earlier painting, substituting palette and brush for his portfolio and sketching pen.

Hamel's customers were not ready to support his ambition to paint portraits in the landscape. In industrialized imperial centres like England the patron classes encouraged artists to depict the landscape in this romantic and nostalgic way, excluding the factories that were destroying the land,

and ignoring the struggles of the rapidly growing working class against the horrors within. But in the colonies, where most of the working people were peasants and industrialization had scarcely begun, Hamel's bourgeois clientele paid strictly for portraits of themselves.

Under these conditions, Hamel was hardly likely to maintain the warmth of colour and life of his early works. After many hours with sitters like the traitor Judge Rolland, he found himself automatically producing dreary repetitions of sell-out politicians and businessmen. Most of them came to sit for their portraits in dark suits, and wanted to be shown in dark boardrooms or libraries, so Hamel's interest in colour and light didn't get very far.

His third self-portrait (Fig. 38) shows the effects. With the companion portrait of his wife Georgiana (Fig. 39), it is a competent reasonably pleasant example of the mid-Victorian husband-and-wife portrait. The light is sensitively handled as always, even if the straightforward pose and lack of a setting give it little play.

But the inspiration is gone. These are bland pictures of comparatively little interest. Hamel may be painting himself and his bride for their wedding, but his mind is still in the boardroom.

Towards the end of his life Hamel was charging $100 to $200 per portrait for paintings like these, and was giving drawing lessons at convent schools, 50 cents each. Time was money for both painter and sitter, so Hamel learned to work fast. He could start a portrait at eight in the morning and finish by noon. Although he died at the age of 53 and

was often ill, he still left behind over 2,000 paintings. The sensitive young artist in the idyllic landscape had achieved his goal: he had become a successful businessman.

This is a pattern we are familiar with today—the youthful idealist artist or writer who aspires to produce major work ends up as a commercial hack. The root of it is individualism: the young artist only wants to be concerned with his art, he doesn't want to give his attention to the problems of his people. Hamel's first self-portrait was painted about 1837: at the very time when his own people were rising in revolution, he paints himself in a far-away landscape. He thought he could become a great painter without involvement in the struggles of his people. His bourgeois patrons taught him a lifelong lesson that an artist who does not serve his people inevitably must serve their oppressors.

There was in fact no way Hamel could have produced major work without taking his own people and their struggles as his subject matter. Forsaking his bourgeois and petit-bourgeois patrons at least on some occasions, he would have had to paint pictures that showed both the land itself and the real driving force in the land, the working people.

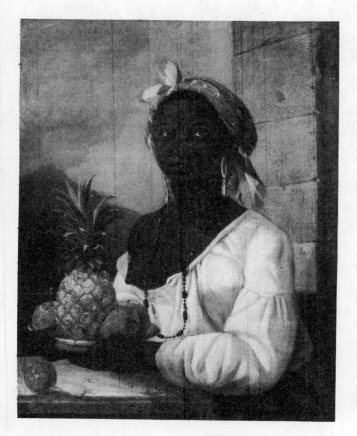

Fig. 40: François Malepart de Beaucourt, *Portrait of a Slave,* 1786, oil, 28 3/4" x 23 1/2", National Gallery of Canada, on extended loan from McCord Museum

THE WORKING PEOPLE

The people who actually did the productive work in Québec were obviously not in a position to pay the rates of $100 to $200 that Hamel was charging for a portrait. Scratching out a living as habitants, or cutting trees and hauling lumber to British-owned ships for transport to factories in England, they were lucky if they could meet the basic cost of living at the best of times.

Nor were the working people as a class particularly interested in getting their portraits done. Their strength lay in collective action, not in the self-centred individualism that drove the bourgeoisie. So even if they had the money, they would not have used it to commission portraits of themselves as individuals.

Accordingly, there are not very many portraits of the working people. And the few that do exist indicate the nature of their oppression more than their fight against it.

François de Beaucourt's portrait of his black slave (Fig. 40) reminds us that at the very lowest level of the social scale in the late 1700s was a relatively small number of black people working as domestic slaves. The institution of slavery was not abolished in the Canadian colonies until 1807.

De Beaucourt's slave is certainly exploited to the full in his picture of her, painted in 1786. Like Hamel's second self-portrait, this painting was probably intended to advertise the artist's talents to prospective clients, just after de Beaucourt had returned from Europe and was seeking customers.

We can picture a patron of de Beaucourt, such as the card-playing comprador Trottier *dit* Desrivières (of Fig. 20), ogling the young girl's body as he waited to arrange for his own portrait. The ageing seigneur might reflect that he was evidently dealing with an artist who could afford such fashionable and attractive help. If the tea-pouring Mme Trottier (Fig. 21) saw the picture, she probably would have noticed the pineapple and other tropical fruits, expensive to import. So de Beaucourt effectively advertises that he shares the class outlook of his oppressor patrons, and that his prices will be high.

He is also proclaiming once again the virtues of the rococo style of portraiture that he had brought back from France. Posing his subject at an angle in an open window, he fills the canvas with sensuous texture, from the swirls of the marble table top through the lush still life on the plate to the contrast of the dark brown flesh with the patterns of light and shade in the deep folds of the white blouse. This is further enhanced by the bright blue sky and the warm light falling on the wall behind her. The solid forms of architecture and the woman's body are offset by the spiky pineapple leaves and the spines that catch the light, the uneven falling line of her open blouse making her exposed nipple the compositional centre of the painting, and her earrings and beads and jaunty kerchief.

There is something more. We know that this woman was living and working for de Beaucourt in Montreal. She was still living there in 1832, many years after the artist had died. Yet he has painted her as if she were on a Caribbean

island, with a deep green volcanic mountain peak rising into the blue sky behind her!

Why is this foreign setting necessary? Along with the imported fruit and the colourful costume, it helps to make the subject *exotic,* unfamiliar, yet appealing. To imperialists and to their comprador allies like the Trottiers, the working people of the colonies always appear as exotic, and it is one of the artist's services to them to picture colonial people in this way. Tourist agencies and airlines today still exploit colonial people as exotic in their full-colour ads for faraway places.

There are other ways that de Beaucourt has established this *distance* from the subject that is essential to the exotic. For one thing, his sitter is a slave; his patrons would see her as valuable property.

He has also bared her breast, as he wouldn't have done with a white woman. Since she is a slave, he is free to treat her in the same way as pornographic magazines now treat all women. The decadence of the master is revealed in the degradation of the slave.

The patron classes prettify the reality of being an oppressed colonial. The exotic appeal of colourful costumes in the picturesque setting of the colony is a sight to delight the eye of any ruling-class patron, since it reinforces his notion of the superiority of his own 'civilization' to the quaint customs he is looking at. To him, these are not real people.

Lord Durham, for instance, was convinced of the superiority of "the great race which must, in the lapse of no long period of time, be predominant over the whole North American Continent" as he wrote in his famous Report that was Britain's answer to the revolutions in 1839. He meant, of course, the British "race". But while in the colony he purchased a portrait by Plamondon of *Telariolin,* who was said to be 'the last of the pure-blooded Hurons' on the reservation at Lorette near Quebec City. Plamondon's portrait, for which he was awarded a medal by the Quebec Literary and Historical Society, has since disappeared, so we can't see exactly what Durham bought. But the sitter, who went by the name of 'Zacharie Vincent' in Quebec social circles, became interested in painting while posing for the portrait, and after a few pointers from Plamondon taught himself how to paint landscapes and portraits.

His *Self-Portrait* (Fig. 41), an unusual combination of exotic subject matter painted by the exotic subject himself is a proud self-assertion of the native people's strength even when conquered. Telariolin had a great talent for vivid colour, and he emphasizes outline in his powerful, direct expression even more than Plamondon would have. The landscape behind him is one of the first attempts by an artist born in the colony at painting in Québec bush as it is, with strong colours and texture, and we can see that Telariolin thought of himself as a representative of his people in the land that was rightfully theirs.

Yet the headband, earrings, breastplate and bracelets that he has put on over his native costume are all Indian trade silver, trinkets that had been presented by French and British fur traders to his ancestors in exchange for the enormous profits in furs taken from their land. Around his

Fig. 41: Telariolin (Zacharie Vincent) (1812-96), *Self-Portrait,* oil, 29 1/2" x 22", Château de Ramezay Museum, Montreal

neck he has hung a medal of Queen Victoria, and over his head he displays a British flag. Even his tomahawk is painted in bands of red, white and blue to show his allegiance to the British crown in the event of war.

Judging from all these symbols we would gather that Telariolin-Vincent was the kind of 'assimilated Indian' Durham would have approved. Only when we look again at the stern lips and facial muscles can we appreciate the underlying content of the painting—the bitterness and inner pride of a man whose people have been betrayed.

Of course it was not only the native peoples whom Durham and the rest of the British ruling class considered 'exotic.' In his Report Durham had described the Canayens themselves as "a race of men habituated by the incessant labour of a rude and unskilled agriculture, and habitually fond of social enjoyments"—that is, a bunch of stupid farmers who are always getting drunk! The attempted revolution had been crushed, but the British ruling class had been given a real scare, and they now had to reassure themselves with this chauvinistic image of the fun-loving jolly habitant of Québec.

The image was developed gradually as the market for this kind of painting grew in the 1840s. In the first year of that decade, for example, a Glasgow merchant who was making big profits from the labour of Canayen lumbermen commissioned a painting of *Wolfe's Cove,* the harbour from

which his ships sailed for Scotland, to be hung in his head office.

The painting, by British-born artist *Robert Clow Todd* (Fig. 42), shows us the logs in the harbour and a ship in dry-dock on the far shore at Sillery. Other ships wait to be loaded with lumber in the St Lawrence River on the right. But in the left foreground the artist has included a group of workers on a wharf, among them two sailors perched on a lifeboat and a Canayen raftsman with his distinctive tuque talking to the sailors. The incidental character of these figures provides the distance by which the ruling-class patron was able to reassure himself that these working people were no threat to him.

This is the earliest canvas that we know of by Todd, who had immigrated to Quebec about the age of 25 some five or six years before it was painted. His incidental inclusion of 'local colour' was soon to be replaced by a more dramatic story-telling use of such 'picturesque' figures. Todd stayed on in Quebec, painting pictures of horses for their owners, but about 1853, when *Cornelius Krieghoff* moved to the capital, he left for Toronto.

Krieghoff was just the man to supply the British ruling-class patrons with pictures of the 'exotic' Canayens. Born in Amsterdam in 1815, he had grown up in Germany, where he had learned a narrative way of painting—an art that told

little stories—that was then popular in Düsseldorf and other German cities.

In addition to portraits of themselves, the bourgeois from the beginning liked to see pictures of incidents in their everyday life. The Church had been telling them for centuries that only spiritual events really mattered, and the aristocracy favoured historical paintings of battles, but the bourgeois patrons were more interested in pictures of people at their daily work and play, the 'real' world that the bourgeoisie made its profits from—dressed up for show, of course, and with a joke thrown in for good measure.

This type of painting had been developed with a great deal of wit in the Netherlands in the 1600s by artists like *Jan Steen,* when the Dutch bourgeois trading empire was at its height. It was continued in France in the 1700s, and is usually known by its French name, *genre* painting. In the bustling bourgeois trading and industrial centres of northern Germany in the first half of the nineteenth century, where Krieghoff got his training, an especially theatrical version of genre painting was in vogue.

Krieghoff brought this kind of genre painting with him when he first came to Québec in 1845. He had emigrated to New York eight years before, had fought in the U.S. Army's war of aggression against the Seminoles in Florida, and had moved north with his Canayen bride Louise, whom

Fig. 42: Robert C. Todd (born 1809, died after 1865), *Wolfe's Cove,* 1840
oil, 29 1/4" x 47 1/2", Collection of Sir John Gilmour, Liverpool, England

Fig. 43: Cornelius Krieghoff (1815-72), *Merrymaking,* 1860
oil, 34 1/2" x 48", Beaverbrook Canadian Foundation, Beaverbrook Art Gallery, Fredericton, N.B.

he had met in New York. After periods in Rochester and Toronto, the couple first moved in with Louise's parents at Longueuil, near Montreal, and then set up a studio in a tiny two-room apartment in the city.

Krieghoff got a job teaching art at "Miss Plimsoll's" school for the children of the rich, and sold paintings door-to-door in the business district for $5 and $10. In 1847 a series of four prints of his work were sponsored by the British Governor-General Lord Elgin, and the artist painted a portrait of Elgin and a picture of his trophy room.

But it was especially after John Budden from Quebec City 'discovered' Krieghoff in 1851 that his genre pictures of daily life in the colony, featuring the 'colourful' native people and the 'amusing' habitants, really began to sell to British army officers and businessmen at auctions in Quebec. Two years later Krieghoff moved there to be closer to his market, and by 1854 he and his wife could afford a prolonged visit to Europe.

Merrymaking (Fig. 43) is typical of the paintings with which Krieghoff established his reputation. It shows us the scene at the Jean-Baptiste Jolifou Inn (the name on the sign

on the roof) as the party breaks up. The typical Québécois over-hanging balcony is crowded with departing guests, including a boy who is pelting snowballs at someone below from the right end of the porch, a woman who covers her ears and turns away as a man blows a horn in her face, and several figures who are dropping or pulling down blankets and wraps for the people who are being bundled into their sleighs to go home.

The painting is full of fun, and we can continue to find amusing details for a long time. One man on the balcony raises his arms above his head as he dances drunkenly, holding a bottle aloft in one hand. Another, a bit further gone, sits sorrowfully on the steps with his head in his hands. Below him, someone else seems to be challenging everyone in the hotel to a fight, with his sword raised high, while two men on snowshoes at the foot of the stairs get in the way of the stable-boy pulling a horse onto the road while they try to make up their minds which way is home. On the road to town at the left a drunken driver has managed to dump the first sleigh and its passengers into the snow.

The setting for all these activities is a fine landscape.

Overhead the long night is ending at last, and in the distance we can see the bright light of dawn. From the trees in the foreground to the rooftops of the village down the road, the whole scene is presented as if it were a tableau on stage, an effect that is enhanced by the rounded upper corners of the frame. Light and shadow spotlight the figures and certain exaggerated stock gestures tell the story. All these effects are typical of the highly theatrical style of genre painting Krieghoff had learned in Germany.

When we remember Durham's description of the Canayens, however, and reflect that paintings of this subject were sold repeatedly at auctions in Quebec to *British* patrons, our smiles of amusement fade. For here is Durham's "race of men habituated by the incessant labour of a rude and unskilled agriculture, and habitually fond of social enjoyments." These carousing drunkards are fit only to play the role of comedians to their 'civilized' British rulers, who paid Krieghoff well to paint them in this scene again and again. They are equivalent to the minstrel shows in which black people at this time were presented as clowns to white audiences.

The same point can be seen in another popular Krieghoff

subject, *The Toll Gate* (Fig. 44). Again, a beautiful winter landscape provides the setting, like a theatrical backdrop, for the action, which is conveyed by a set of gestures and expressions. Three young Canayens are lashing up their horse and thumbing their noses at the gatekeeper as they dash through the toll gate without paying. He shakes his fist in vain, as the horse heads for a hole in the snow-covered road.

The toll on the roads was a tax imposed by the government, and evading it was a small act of resistance that spirited Canayens like the young men in the sleigh would certainly enjoy. But that isn't why the subject was so popular with Krieghoff's customers.

"Isn't that just like them?" we can hear its British buyer chuckling. "They're such fun-loving folk, and so irresponsible when it comes to something like paying a toll."

Responsible government is just what the Canayens had been fighting for in 1837-39! The British ruling class required such an art to 'justify' their denial of responsibility and independence. Still another favourite Krieghoff subject showing a Canayen family breaking Lent, combines the image of irresponsibility with the 'quaint' religious customs

Fig. 44: Cornelius Krieghoff, *The Toll Gate,* 1861
oil, 13" x 18", National Gallery of Canada

of this exotic Catholic colony.

After over 20 years of supplying canvases and prints to this market, Krieghoff ended his days in Chicago, where he had gone to live with his daughter. His paintings, however, have continued to sell at high prices at auctions in England and New York to ruling class collectors. The ones that are in museums and galleries, such as the two we have shown here, are often reproduced on calendars, in magazines, or as postcards. They are certainly valuable to us insofar as they reproduce details of the day-to-day life of the working people; but they are dangerous and misleading because they help to keep alive among English-speaking Canadians this chauvinist attitude toward the Québécois as a jolly 'Jean-Baptiste'.

The best way to correct that chauvinist image is to turn from Krieghoff to a painter who is far less well known, the artist who advanced the Québécois tradition of painting furthest towards a conscious national art during this period, the Patriote painter, *Joseph Legaré.*

Born at Quebec in 1795, Legaré today is still something of a mystery in the history of Québécois painting. His father was fairly well off, and some accounts of his life maintain that he went to Europe to study art as soon as the British permitted Canayen contact with France again after the fall of Napoleon in 1815.

But we can't prove this. And his paintings suggest on the contrary that he was primarily a self-taught painter who came to maturity as an artist in the generation that followed the carpenter-painter Roy-Audy, who was bringing the Québécois tradition of painting to its highest point of realistic and dramatic expression to date.

If this is so, the apparent European influences on Legaré can be explained by reference to the Desjardins Collection, a hoard of European paintings that an Abbé named Desjardins and some others had smuggled out of the monasteries and churches in Paris during the French revolution to save them from the wrath of the French people. Many of the paintings were copies and others were unimportant; but there were some interesting originals and a valuable set of engravings. When the collection was auctioned at Quebec in 1817, Legaré used some of his father's money to buy most of it. He then set to work, aided a few years later by his pupil Plamondon, to improve his style by copying and restoring the canvases in the collection.

Fig. 45: Robert Auchmaty Sproule (1799-1845), *The Market Place, Upper Town, Québec,* 1830
monochrome watercolour, 11" x 15", McCord Museum, McGill University

48 Painting in Québec: French and British Regimes

In 1828 Legaré won an award given by the Montreal Society for the Encouragement of Science and Art for the best 'historical' painting of a massacre of the Hurons by the Iroquois. Whatever we may think of the Society's choice of subject matter, Legaré's early success as a history painter shows that he was not an artist to be content with routine portrait commissions and church decoration. He was ambitious to paint subjects that mattered to his fellow Canayens.

The events of the 1830s in Lower Canada were to provide him with plenty of opportunities. He is said to have painted at least one picture of the Patriote forces in action, the battle of Ste Foy, but the canvas has disappeared. Evidently it was dangerous to paint these subjects, particularly since Legaré was a dedicated Patriote.

This was especially true in the capital, where the British army and administrators maintained a very close surveillance on the population. When the revolution broke out in 1837 Legaré was one of only five known Patriotes whom the authorities found it necessary to arrest at Québec (compared with 501 in Montreal). He may have fought at St Denis and St Charles. He certainly spent five days in jail before his family's money and his father's guarantee for his good conduct could get him out.

Whether *Cholera Plague, Québec* (Plate III) was painted before or after Legaré's arrest we're not sure. It used to be dated in the earlier 1830s, but recent research suggests that it may very well have been painted in the year 1837. As opposed to Krieghoff's grinning drunkards it shows us the reality of life for the working people in the colony, indicates one of the ways in which people actually suffered from imperialist oppression, and implies an important political statement on the revolution as well.

Cholera, at that time an uncontrollable disease, was first brought to Québec in 1832; it swept the city repeatedly in the 1830s, and from Lower Canada spread to the whole continent. On each occasion of plague, the British rulers would leave town for the relative safety of the countryside, along with everyone else who could afford to go. The working people and the poor were left behind to fight the plague as best they could. Children and older people especially died in great numbers.

These deaths could be attributed by the people directly to British imperial policy. Cholera had come from another

Fig. 46: Joseph Legaré (1795-1855), *Cholera Plague, Québec,* about 1837
oil, 32 3/8″ x 43 7/8″, National Gallery of Canada

British colony, India, and had spread to the whole of Europe. The British (then as now) had a problem in Ireland, where their refusal to allow Irish industry to develop and their insistence on maintaining a feudal system of landlords owning all the land had impoverished large masses of the Irish people. By imperialist logic they were now trying to solve two colonial problems at once—by putting large numbers of Irish immigrants into ships and sending them to settle in Lower Canada. This, they hoped, would ease the pressure of 'the surplus population' in Ireland, while at the same time 'drowning' the Canayens in a 'sea' of English-speaking immigrants.

British merchant ships were accordingly encouraged into the Irish immigrant trade. But since their profits were based on the number of bodies they could pack into their boats, they usually sailed with the holds over-crowded with immigrants. With sanitation poorly provided, it's not surprising that diseases like cholera should break out on the long voyage. Many died on shipboard; others brought their illnesses to the landing stations. And despite doctors' attempts to quarantine these stations, the diseases easily spread to nearby cities like Quebec.

One result was the atrocious scene of intense suffering that Legaré has painted in *Cholera Plague.* A group of the sick and dying are seen in the marketplace. Some of the faces show the characteristic choleric expression, and a corpse is being lifted into a cart. It is night; the pale light of the moon gleams above.

The other source of light that flickers over the agitated scene is the row of burning pots of sulphur that the Canayens have placed in front of their houses. Left behind by the British, the people have had to improvise their own means of prevention. Cholera was transmitted in water and food rather than through the air, but this attempt to stop the spread of the infection is typical of the mass struggles against disease that eventually led through trial and error to their remedies.

Legaré undoubtedly saw the burning sulphur pots, and must have witnessed scenes of agony like this himself. The buildings, however, he has not painted from direct observation. Although the actual market square was close by his studio, he appears to have copied his setting from an 1832 lithographic print that had been made from a monochrome watercolour view of the square painted in 1830 by an Irish immigrant artist, *Robert Auchmaty Sproule.*

If we compare Sproule's picture with Legaré's (Figs. 45, 46), we can see that Legaré has used exactly the same background in every detail, but has transformed the picture from Sproule's picturesque daytime genre scene, with shoppers in the butcher stalls and British troops on patrol, into the night-time horror he depicts. Legaré has even used a similar horse and cart, but now it has a much grimmer purpose.

Did the artist, having copied from the Desjardins Collection prints and paintings so often, simply find it easier to work in this way? Or, knowing that many of his viewers would also be familiar with the lithograph (printed in London but distributed from Montreal), did he intend just such an acid comment on the false allure of these genre scenes of the 'exotic' colony, which always covered up the actual suffering and real struggles of his people?

We may never know for sure. Until very recently, Legaré (unlike Krieghoff) has been practically hidden from the people of Québec. Lately, due to the rising struggle in Québec, a number of studies and exhibitions of his work are being prepared, so that we may in the near future have more knowledge of him.

About another interesting detail of the painting, however, we can be more certain: on the road that leads off to the right of the picture, separate from the Canayens who are ranged across the foreground, is a long column of mourners marching behind a horse-drawn hearse. This, as anyone at the time would have recognized, is an Irish burial custom. Legaré is reminding his viewers that the Irish immigrants were victims of the plague too.

The Patriotes knew that many of the new arrivals from Ireland hated the British imperialists just as much as they did. They also valued the support of oppressed English-speaking people already in the colony. O'Callaghan, Ryan, Nelson and Brown were among the names of the leaders they followed.

In *Cholera Plague* Legaré's brush is not aimed at pleasing British buyers in an auction, as was Krieghoff's, but at conveying to his own people the realities of life and death in the colony, seen from their point of view. His charged use of colour and light shows the effect of contemporary romanticism, as well as the influence of earlier European painters of emotional scenes such as *Salvatore Rosa,* who was represented by six paintings in the Desjardins Collection.

But if we look at the fleeing figure in black with a conical cap and a satchel in the left foreground, or the group at left centre whose choleric faces appear ghastly white, the only fitting comparison in European painting is another artist who identified strongly with his people and their struggle for national liberation—*Francisco Goya* of Spain. Indeed, the group of people lifting the corpse into the wagon in Legaré's painting could have been taken almost directly from Goya's famous *Disasters of War* series of prints based on the Spanish people's resistance to Napoleon's French empire.

Whether Legaré had actually seen Goya's 1810 etchings or not is less important than the fact that the comparison is apt. In this painting Legaré has taken the dramatic expressiveness of the Québécois tradition of painting, combined with various European influences, and has made it the vehicle of an original art of the people. Although it is not nearly as well known, *Cholera Plague* holds a significance for the people of Québec today parallel to the importance Goya's famous *Third of May* painting of the execution of Spanish patriots has for the people of Spain.

How was Legaré, of all the artists working in Lower Canada, able to take this step forward at this time? Certainly the crucial factor was his commitment to the Patriote cause. Without that involvement he would not have been able to paint the sufferings of his people concretely—from 'inside.'

Because of that commitment Legaré could also see the

Fig. 47: Joseph Legaré, *Cascades de la rivière St-Charles à Lorette,* oil, 22 1/2'' x 35 15/16'', Quebec Museum, Quebec City

possibility of a new patronage. As long as the artists were tied to imperialist and comprador patrons, they would be unable to make this decisive advance. In 1838, one year after his imprisonment and while the attempted revolution was still in progress, Legaré opened his studio as a public gallery. There, next door to the Ursuline Convent, people could come to see the Desjardins Collection of European paintings and prints, as well as considering pictures by Legaré for possible purchase.

Whether *Cholera Plague* was shown there or not, we don't know. But it was the kind of painting that the new project required: pictures that reflected the real struggles and interests of the people who might come as visitors. This was the first public art museum in the Canadas, and Legaré's role in creating it shows how conscious he was of the need for the artist to serve the people in his day.

Had the revolution succeeded, Legaré undoubtedly could have gone on to become the first great painter of the independent nation. He would have been encouraged to progress from painting the sufferings of his people to recording their victories.

As it was, with the revolution defeated and openly pro-Patriote painting impossible, Legaré turned increasingly

to the land the Canayens lived in as his subject matter. His views of rushing rivers and waterfalls (Fig. 46) have in some cases been painted over by a later hand, so we are not always sure how much is Legaré and how much has been added. But it is obvious that he had a strong feeling for the landscape of Québec. He must have seen it as an important part of the artist's task to convey the colours, textures and shape of the land to the people, by painterly means appropriate to his wild, turbulent subject.

In this respect Legaré is not only a romantic landscape artist and "the father of Québec landscape painting" as he has been called, but even directly anticipates the national school of landscape painting in Canada. Certainly no other early painter in either of the Canadas so closely approaches the spirit of *Tom Thomson* as does Legaré in a few of these waterfall and river views.

Other subjects that must have been popular in the studio-gallery were Legaré's documents of his people's struggles to surmount difficulties. On May 28, 1845, for instance, the Quebec suburb of St Roch burned to the ground. Holocausts were common enough in the cities of those days; working people's houses especially were constantly being levelled as the flames leaped from roof to roof

in their streets. But Legaré recorded this fire (Fig. 47) and the ruins after it (Fig. 48) in a pair of remarkable paintings that employ the full range of romantic colour and light effects to draw out all the excitement of the scene.

Three years later one of the many rockfalls along the shoreline at Cap-Aux-Diamants (Cape Diamond) near Quebec wiped out a whole row of houses built into the cliff-side. Again Legaré was there, and presumably made sketches which he then worked up into a canvas (Fig. 49).

In each of these pictures we can recognize Legaré's intimate knowledge of the streets and buildings people live in, and we always see people working together, trying to put out the fire, haul away the injured, or save what they can to rebuild. Legaré's paintings are always vigorously on the side of the afflicted people. In his landslide picture he even takes care to show Canayens doing all the rescue work while British troops stand idly by at their posts. He also favours an eerie light for these scenes, even in the daylight painting of the landslide, that conveys the emotions the people feel.

In these three pictures, in his landscapes and especially in *Cholera Plague,* Legaré has expressed the suffering and

the spirit of the Canayen people. Caught up in their revolutionary movement, he has taken the Québécois tradition of painting to a new and higher level of social significance. If we compare the votive picture of the overturned canoe with *Cholera Plague* (in the colour plates), we can see at once how Legaré has made his considerable accomplishment a part of the Québécois tradition: a similar passion, expressed by dramatic contrasts of colour and light, leaps from both paintings. Legaré's documentary works are in a sense secular votives, recording the disasters that befell his people and their determined struggles to overcome them.

Like Goya, Legaré combines his realism with the romanticist's flair for feelings evoked in vivid, painterly terms. By making socially responsible subject matter his first concern, he had begun the creation of an art of true international stature, comparable with the very best painting of his day. The way to an art that is genuinely a match for the most progressive painting elsewhere lies not through the adoption of international styles imported from the imperial centre, but through placing art at the service of the people and putting colonial subject matter first.

Legaré had made tremendous advances; but the revolu-

Fig. 48: Joseph Legaré, *Les ruines après l'incendie du Faubourg Saint-Roch,* (The Ruins after the Burning of St-Roch), 1845 oil, 37 1/2" x 49 1/2", Sigmund Samuel Canadiana Collection, Royal Ontario Museum, Toronto

Fig. 49: Joseph Legaré, *Eboulis du Cap-aux-Diamants,* (Landslide at Cap-aux-Diamants), 1848
oil, 32" x 44", Museum of the Seminary, Quebec City

tion had failed. In the long years of compromise and retreat that followed the defeat, as we have seen, cultural nationalism and other reactionary tendencies were rife. Born of a wealthy family, Legaré had been basically a bourgeois sympathizer with the *plight* of his people, not a man convinced of the necessity to *fight* to the death if necessary to end their oppression. In this period, accordingly, his underlying bourgeois outlook gradually came to predominate in his work and he was dragged even further backward than many others.

His studio-gallery, for example, had been a great idea. But after the defeat there was no way the new patronage could develop; these were the years when British officers and businessmen were buying Krieghoffs at auction in Quebec City. Whether Legaré had to make a living from his painting or not we aren't sure, but he did turn out a number of portraits and as many as 100 religious canvases, mostly copies from works in his Desjardins Collection. He painted processionals in front of churches, and on one occasion did the history of a nunnery in pictorial form.

His continued reliance on the Desjardins Collection for compositions this late in his career is surprising. As late as 1849 he was still basing his *Election Scene near Château Richer* (Fig. 50) on a similar theme in a genre painting in his collection by a Dutch painter of the 1600s, *Adriaen van Ostade.* This appears to be a spirited and witty comment on the election, paralleling the children chasing sheep in the foreground with the crowd that appears to be chasing one or more of the candidates over the bridge near the village. The action is lively, and the scene is characterized by Legaré's customary familiarity with the buildings and landscape of his native country.

But in fact the theme is closely copied from the Dutch master. The problem is not simply the influence of another artist; *Cholera Plague* had also been based on an earlier source, the print made from Sproule's watercolour. The question is not how 'original' the artist is, but what he *does* with the influences that inevitably affect him. In this case Legaré shows that he is drawing further and further away from the people: instead of documenting an actual incident in the election, he simply copies an amusing theme from his Dutch model.

By this time Legaré had become an enthusiastic adherent

Fig. 50: Joseph Legaré, *Une scène d'élection au Château-Richer,* (Election Scene at Château-Richer), 1849
oil, Laval University, Quebec City

of Papineau's Parti Rouge. In 1848 he had gone so far as to paint an imaginary monument to Wolfe in a landscape, with a native warrior paying it homage, which he then included in the paintings he offered at a public lottery to raise money for the Party. This incredible instance of pandering to British ruling-class patrons' taste comes as less of a surprise when we learn that he also copied portraits of Queen Victoria and George III on commission.

The 1849 election that was the occasion of the Château Richer view was the one in which Legaré and a number of other former Patriotes went all the way over to endorsing the Annexationist Manifesto, preferring annexation by the United States to continued British rule. This again reveals the reactionary and even traitorous character of the politics that Papineau and his Parti Rouge were advancing under the name of 'reform.'

In 1855, just one year after Papineau was granted his seigneury, Legaré got the final ironic reward for his bourgeois sympathies by being appointed to the Legislative

Council. A few months later he was dead.

The level to which he had taken the Québécois tradition of painting could not be sustained by others after his death. A successful revolution might have led him to a conscious grasp of what he had done, related to the need for a new national art; but he does not appear to have realized his achievement consciously, especially after his bourgeois outlook became dominant. Under the conditions of repression and backward-looking cultural nationalism that ensued, no-one else was prepared to recognize it either. We will not see the Québécois tradition again until the work of *Ozias Leduc* in a later chapter, and then only in a suppressed and inward-looking manner.

Characteristically, Legaré bequeathed his collection of his own and his European paintings to Laval University for future generations to see; but the only new patronage on hand was the cultural-nationalist petit-bourgeoisie. The Canayen people had suffered a severe setback: there was to be no possibility of a national art rooted in the working

people for a very long time to come.

A new class force was on the rise, however. Until now industrial wage earners, aside from a few iron foundries and the Montreal rope works, had been limited to the sawmills and shipyards that were based on the colony's chief raw material, lumber. But beginning in the 1840s the organized labour of oppressed colonials started producing enough profit for the imperialists and their comprador allies that they were able to invest in new transportation facilities. These in turn would allow them to get at still more resources and markets.

In the Canadas, this meant canals. The pencil sketch of the entrance to the Lachine Canal drawn by the Irish immigrant artist *James Duncan* (Fig. 51) is a quiet note on which to introduce this boisterous new element in the society of Canada East. The sidewheeler fitted with a smokestack in the harbour among all those sailing ships reminds us of the transition to steam power in the shipping industry; but it appears to be a slow-moving day, perhaps a Sunday afternoon, with a few figures strolling along the piers or at work on the boats.

Yet in March of 1843 over 500 construction workers from this canal marched on the city of Montreal that we can see in the distance, and demanded higher wages and better working conditions. Some 1300 of them in all had been working on the canal every daylight hour for two shillings a day, living in shacks provided by the company and forced to buy their provisions at company stores. The government frantically ordered troops to disperse them, but by sticking together the workers eventually won a raise of an extra shilling. It was an early demonstration of the power of the *working class* that these industrial projects were creating. But there are no paintings of this major event, because there was no patronage for them.

Three years later, on completion of the canal, the government made industrial sites and the rights to water power along the canal available to manufacturers, and by the 1860s there were iron works and large flour mills located here. Meanwhile the railway boom of the 1850s had taken the place of canal construction, and led in turn to far more industry.

Duncan did drawings like his canal scene for the *London Illustrated News,* where prospective immigrants might study them to see what kind of a country they were coming to. From 1840 to 1857 close to 35,000 immigrants entered Canada East every year, and since the seigneurial system

Fig. 51: James Duncan (1802-81), *View from the Entrance of the Lachine Canal, Montreal*
graphite on buff paper, 14 1/2" x 20 15/16", National Gallery of Canada

Fig. 52: William Raphael (1833-1914), *Behind Bonsecours Market, Montreal,* 1866
oil, 26 1/2" x 43", National Gallery of Canada

kept most of them from getting land, those who stayed in the colony were practically forced into the construction projects or the new factories. Like Duncan himself, most of the canal construction workers were Irishmen—so many, in fact, that the government unsuccessfully tried to break up their strike by setting Irish workers from one district against those from another.

Meanwhile the sons and daughters of the habitants faced chronic unemployment on their farms; in the seven years before 1837 alone, over 20,000 had moved to the United States, and now thousands more were being lost every year. This forced departure of large numbers of Canayens combined with the mass importation of a labour force from Europe suited British imperial policy very well, and helped to keep wages down too.

William Raphael was a German-born Jewish artist who joined the flood of immigration, coming to New York in 1856 and moving on to Montreal in the following year. His 1866 painting *Behind Bonsecours Market* (Fig. 52) gives us a good look at the changing population of Montreal. In the left foreground an old habitant in his tuque sits tapping his foot as a fiddler entertains; on the right, a bearded man in a bowler hat pushes a wheelbarrow up the road. At the far right edge of the picture a rich bourgeois with high hat and cane leans back against the rail as he talks with two well-dressed women, while in the busy group in the centre a recently-arrived immigrant appears to have brought a candelabrum and a portfolio to market, perhaps heirlooms

from Europe with which he hopes to get some ready cash.

It is a fine summer day behind the market, and patterns of sunshine and shadow enliven the background of brick buildings, and the steamship and sail on the river. The 'exotic' appeal of some of Raphael's picturesque figure groups is balanced by his realistic treatment of the scene as a whole, a way of painting that he had probably learned at the Berlin Academy where he got his training.

In the centre foreground of his picture Raphael has placed two young boys in a solid little triangular composition, one sitting in the sunshine with a bird in a cage beside him, the other lounging in the shadow of a market building with his head in one hand and the other flung affectionately over his pet dog. Listening intently to the violin music, they are momentarily sunk deep in thought. They represent the second generation, the children of the immigrants who will grow up into a lifetime of social struggle and change.

With the widespread use of photography that had already begun at this time, the portrait painter was to find less and less work, and the comprador capitalists' preference for pictures from the imperial centre of Europe would gradually drive the painter in Québec and Canada to a much more marginal position in society than Plamondon, Krieghoff and Legaré had enjoyed.

But it is already 1866, one year before Confederation. It is time now to review the progress towards a people's art made in the other nation beside Québec living under the British imperial regime—Canada.

INTERLUDE:

An American in England paints the conquest of Quebec

The Death of Wolfe (Fig. 53) combines in one canvas all three regimes that have ruled the Canadian and Québécois people: the British army's conquest over the French, painted by an American. Needless to say, this most un-Canadian picture is one of the best-known paintings in Canada.

This scene has been widely reproduced, even in Canadian history textbooks, as if it resembled what actually took place on the Plains of Abraham in 1759: it does not. What it does represent is a master stroke by an ambitious and self-confident American artist who established his reputation in 1771 with this large canvas that reflected precisely the rising awareness of their empire among the British ruling class of the time.

Benjamin West, a Pennsylvania Quaker, came to London after three years of study in Italy. He made sure that his reputation as the "American Raphael" preceded him, and soon set up a highly profitable studio. In 1770 he let it be known that he was preparing a controversial painting for the Royal Academy exhibition of the following year, and even started a rumour that *Sir Joshua Reynolds,* the leading British painter of the day, was opposed to its conception. He later invented a conversation with Reynolds for his biographer, in which he had Reynolds admitting that "Mr West has conquered."

With this kind of calculated publicity, West's painting was sure of attention. He proclaimed that it was the first painting to represent a recent historical event as it actually occurred, in the uniforms of the period instead of in the Greek or Roman costume that had conventionally been used to depict such events, to associate them with the empires of the past.

In fact, there was no substance to the American's claims. Other artists in England had already painted recent history in these terms, and some had even chosen the death of Wolfe as their subject matter. What's more, West's own painting was completely inaccurate, and he knew it.

As far as can be determined, only four or five British soldiers were actually on hand at Wolfe's death. West shows 13, of whom only one was actually among those who were there!

Brigadier Robert Moncton, for instance, who stands clutching his chest wound and gazing at Wolfe, had been wounded all right, but so badly hurt that he was on board a ship at this time, getting medical attention. Behind him, with kilt flying in the wind, is the red-headed Colonel Simon Fraser of Fraser's Highlanders; but his battalion was being cut to shreds elsewhere on the battlefield when Wolfe died. And behind Wolfe kneels his Adjutant-General Isaac Barré, who had actually been shot in the face earlier that day!

These are not mere errors on West's part. A letter written years later by the daughter of General John Hale, who had fought at Quebec but is not represented in the picture, explains; referring to the engraving that was widely distributed a few years after the painting's success, she writes:

> *"General Hale's portrait is not included in that fine print of Wolfe's death, and why? Because he would not give the printer the sum of 100 pounds, which he demanded as the price of placing on a piece of paper what his own country knew so well: that he fought in the hottest of the battle of Quebec, whether the printer thought fit to record it or not."*

The letter lays the blame on the printer, but in fact the engraver simply followed West's original. It was West who demanded the £100.

Even more shameful, he put the face of the one soldier who was present at Wolfe's death in shadow, because this Lieutenant Henry Browne, the man seen clutching the flag, refused to or was unable to pay the bribe! West couldn't cut out this lower-ranking officer entirely, since he needed

Fig. 53: Benjamin West (1738-1820), *The Death of Wolfe*, 1770 oil, 59 1/2'' x 84'', National Gallery of Canada

at least one authentic figure in the painting, so he foreshortened and darkened the area around the face as much as he could.

Given that West's painting was so inaccurate, and wasn't really the first to represent recent history in contemporary dress, why was it such a great success? Lord Grosvenor bought it right away at the Academy show, and the king had to order a second version for himself. West painted two other versions on commission as well.

The reason is that West has assembled his cast of paying customers in a composition that is stolen directly from a number of classical and religious paintings: this has the effect of ennobling or dignifying these 'heroes' of the British empire. The grenadier standing at the right, for example, bears the expression of "Compassion" exactly as the French classicist painter *Charles Lebrun* had decreed that emotion ought to be depicted; the face has been copied by West from a book of engravings based on Lebrun.

The groupings of the figures echo a number of religious and classical compositions. The most obvious and important one is Wolfe himself, who dies in direct imitation of Christ taken down from the cross, as seen in many paintings of the Deposition. The group around him is exactly like the biblical figures clustered around Christ in a typical lamentation at the foot of the cross. Even the native kneeling in the foreground assumes a pose borrowed from one of the Marys before the tomb in an earlier religious painting.

These religious and classical associations were just what the British aristocrats wanted to see. They linked the bloody battles for empire with their religion and the ancient regimes. In neo-classical history paintings like West's, they could see their dying generals as martyrs in a cause that was both British and Christian, and envisage their empire as carrying on some abstract values that they attributed to the empires of the ancient past.

West has driven this point home by representing Wolfe as dying at the moment when news of the British victory is at hand. At the far left edge of the canvas we can see a British officer racing excitedly toward the group with the captured French colours, and behind him in the dust of battle we can even make out the French general Montcalm falling from his horse. The martyr may be dying, but Britannia has prevailed.

West's painting was enormously influential, especially when prints of it circulated so widely. The engraver had made £6000 to £7000 from its sales on the European continent alone, when pirate editions published in Paris and Vienna began to take over his market. Neo-classical history painting was taken up by a number of European painters, including Jacques-Louis David, who put it at the service of the French revolution in his painting *The Death of Marat*.

West set up a school for American artists in London. The painter who learned to imitate him best was *John Trumbull*, whose well-known canvases of the battles of the American revolution were painted with a similar disregard for historical accuracy and a tendency to arrange American generals in classical poses and compositions.

It is a mark of the colonial status of Canada that none of our artists embarked on such history painting. Neo-classicism was applied to portrait painting in the works of Von Moll Berczy, but only an independent nation could have provided the patronage for the painting of our own history in such grandiose terms.

The Death of Wolfe in its numberless reproductions (even on plates and glassware) has been used as a symbol of the alleged greatness of the British empire and the aristocratic officers who led its armies.

It eventually came to Canada for a particularly appropriate reason. By arrangement through that arch-imperialist Lord Beaverbrook, it was presented to this country by a descendant of its original owner in recognition of the services Canada had rendered to Britain during that great inter-imperialist conflict, World War I.

III Canadian painting: The British regime

One fishing season about the year 1690, the fleet from the southwest coast of England set sail for the Grand Banks with a painter named *Gerard Edema* on board. This Dutch-born artist, who had been living in England for about 20 years, had already sold paintings of landscapes in Norway to British merchants who traded there. Now he would do the same for traders and nobles who took their profits from the fisheries off 'the New Found Land' as they called it. All summer he sketched, and when he got back to England he was able to paint good-sized canvases based on the drawings he had made.

One of these landscapes, *A Fishing Station in Placentia Bay, Newfoundland* (Fig. 54), gives us a rare look at one of the rough little 'factories' the fishermen worked in during the season. Two dories are drawn up on the shore below the drying racks and storage sheds that were left deserted when the fleet sailed back to England every year. To the left on a long table the fishermen are drying their catch of cod and preparing it to be packed. On the right between the sheds three men can just be made out, rolling three big barrels across the ground.

Edema couldn't paint figures, so the fishermen we see in this landscape were probably added by a friend of his named Van Wyck, who had never been to Newfoundland. Edema himself had studied under *Allart van Everdingen,* a Dutch painter of fantastic mountain landscapes, whose influence is apparent in the picturesque waterfall and the fir trees and foliage on the imagined crag at the left edge of the picture. The rock formation behind the sheds and the placid pond of the bay itself are also due much more to the conventions of Dutch landscape painting than they are to the inspiration of Newfoundland terrain.

So from the very beginning in Canada we find ourselves looking at a landscape in which the figures have been added as an afterthought, and in which the style favoured by the patron classes in Europe acts as a kind of screen through which we try to perceive the face of the land. From the very beginning, too, we can see that the landscape is as much a bourgeois art form as were the portrait and genre painting.

For the feudal lords of medieval Europe, land had certainly been a source of power; but it was inherited, and could only change hands otherwise if it was captured in warfare or by a fortunate marriage. European artists at that time included landscapes in their paintings only as settings for crucifixions or the events in the life of a saint, if they painted the land at all.

For the bourgeoisie, including Edema's patrons, lands and buildings were an important focus of property values. Land became real estate, something that could be bought and sold for a profit. From the end of the middle ages forward, as the power of the bourgeoisie was on the rise, artists accordingly began to take more of an interest in the qualities of the land as a subject for painting in itself. By the time of Edema's Dutch masters, like Van Everdingen, they had developed this interest into the specialized art form of landscape painting.

In each of the nation-states of Europe artists served the bourgeoisie by evolving ways of representing that nation's land in their paintings. These styles in landscape painting were partly based on differences in the land itself: the mountains of central Germany suggest a far different landscape from the lowlands of Holland. Like styles in portraiture, these approaches to landscape were also part of the superstructure that reflected changes in the material base of the whole society; styles of painting like romanticism that accompanied such widespread changes in social organization affected the landscape art of the whole of Europe.

In the colonies, the imperialist and comprador classes always imported these stylistic ideas. By their very nature serving the empire, they were incapable of generating any such original ideas; nor would they honour new ways of looking at the colonial landscape when they saw them. They would applaud and support only landscape styles that

Fig. 54: Gerard Edema (born about 1652, died about 1700), *A Fishing Station in Placentia Bay, Newfoundland,* about 1690 oil, 32" x 39", Sigmund Samuel Canadiana Collection, Royal Ontario Museum, Toronto

made the colonies look as much like the imperial centre as possible. And since ideas of how the land ought to be depicted were always changing in the centre as part of the changes in the superstructure there, a succession of imperial styles inevitably swept over landscape painting in Canada.

In Québec the principal patron of the arts at the outset was the Church, which commissioned religious figure paintings and portraits. The seigneurial system of land tenure, essentially a feudal system, was not fully abolished until a widespread popular campaign succeeded in 1854. As earlier in Europe, this feudal conception of the land generated little or no landscape painting as such. The painting of Québec was primarily an art of the portrait and the figure. The first Québécois painter to take the landscape seriously was Legaré in the late 1830s and 1840s, by which time the struggle to end the seigneurial system was already raging.

In Upper Canada and the Atlantic Provinces, however, semi-feudal forms of land tenure remained in only a few places, such as Prince Edward Island. For the most part the land was granted, bought and sold in a highly profitable system of capitalist speculation. For both the pioneer settlers who worked to produce them and the land company directors who profited from them, property values were of the utmost importance. Correspondingly, landscape painting was as central for Canadian art as the portrait was in Québec. The fact that the landscape could only be interpreted through this succession of imperial styles was therefore of critical importance.

So a major challenge was set for the Canadian painter, a challenge directly related to Canadians' struggle to throw off colonial domination and develop an independent nation here. How were Canadians to develop a strong national consciousness when they could not even see their own country represented in their art, except through one imported style or another?

Fig. 55: Thomas Davies (born about 1737, died 1812), *A View of the Plundering and Burning of the City of Grymross,* 1758 monochrome watercolour, 14 9/16" x 21", National Gallery of Canada

1. The Struggle for the Landscape

A View of the Plundering and Burning of the City of Grymross (Fig. 55) is a powerful reminder that the British regime, like the French, began in violence. The British built their empire by force of arms. Resolute soldier-artists like *Thomas Davies,* who painted this picture of the burning town after having helped to set it on fire, were part of their bloody company.

Grymross (now Gagetown, New Brunswick) was the capital of what were supposed to be neutral settlements in the Saint John River valley during the Seven Years' War between the British and the French. But in 1758 the French fortress at Louisbourg on Cape Breton Island had finally fallen, and the British decided that there were to be no more neutrals in this war between empires. On the moonlit night that Davies depicts, they stole up river and burned the defenceless town to the ground. Its French-speaking inhabitants saved themselves by withdrawing to the hills.

Lieutenant Davies, commander of one of the burning and plundering platoons, was by no means the only British officer who could paint. The British army and navy had

found that they were constantly in need of reliable pictures of the unfamiliar and often unexplored places they had to fight in to extend the empire, if only to blast those places to bits. So from the time the Royal Military Academy was first founded at Woolwich, England in 1741, drawing and painting were part of every artillery officer's training. They considered the subject important enough that in 1768 they nearly doubled the drawing master's salary (to £100), so that the Academy could hire the outstanding British water-colour painter of the day, *Paul Sandby,* to teach the artillery cadets.

Called *topographical* painting because it surveyed the topography (surface features) of the country, this was really a reconnaissance art of military intelligence, directly and literally in the service of the British empire. The *Plan of the Attack* on White Plains, New York, a topographical drawing attributed to Davies from the British campaign against the American revolution (Fig. 56), shows how useful this skill could be. A commander could line up his guns with the aid of such a sketch, take account of the surface cover of foliage that might conceal enemy forces, and identify the points that would have to be held. In this drawing a lettered guide has been added to show the points of interest; Davies himself commanded a brigade of guns in the British victory.

Fig. 56: Thomas Davies, *The Attack on White Plains, 1776*
monochrome, 8" x 12 3/4"

Davies had been a Woolwich Academy cadet in 1775, too early to have studied under Sandby. But the two men almost certainly met when Davies returned to Woolwich during his postings home. They definitely shared the same values in art.

Sandby's son later wrote that his father had tried to paint "the appearance of nature . . . with truth in the re-flected lights, clearness in the shadows and aerial tint and keeping in the distance and skies." Officers like Davies, having learned these skills for topographical purposes, could then go on to apply them in views painted for their own or other people's enjoyment as well. Even though *Burning of Grymross* is a most unnatural subject, we can recognize Sandby's naturalistic values in it: the light of the flames is reflected on the waves, great clouds of smoke billow into the dark sky in the moonlight, the shoreline recedes to a distant horizon and the ships at anchor in the river are rendered with exact detail.

Artists acquire a style as they develop their technique, by practising the art of painting. In most cases, though, they begin by studying the works of other artists. Paintings by artists they respect tell them what painting should be, how it should make the world look, and what the standard of good painting is. We have already seen how various European styles of painting influenced the portraits of Québec.

The same is true of landscape painting. The world didn't 'naturally' look the way Davies depicted it. He had develop-ed this style to serve a certain very definite viewpoint, namely that of the British army. As we saw in the Québec section, styles of painting reflect different class outlooks; they rise and fall as the social organization of the various classes is altered in the struggle for production.

Davies' style, which had been of such great service to the British military, was the first of a long series of styles to be brought from the imperial centre to the colony. It was certainly well-adapted for depicting detail and perspective. And Davies was a sensitive, acute observer. "The variety of Colours in the Woods shew the true Nature of the Coun-try," he wrote in the margin of a sketch of Niagara Falls. Although he had painted *Grymross* at night in grey mono-chrome, in most of his subsequent pictures he succeeded more than any of his fellow officer-artists in recording the brilliance and range of hues in the Canadian landscape.

There were two problems with Davies' way of painting, however, as there are with any style imported from an imperial centre. In the first place, it reflects the viewpoint of the ruling class in the far-away centre; this viewpoint may be shared as much as possible by the imperialist and com-prador classes in the colony, but it cannot be identical due to the different conditions in the two places. And of course it directly conflicts with the viewpoint of all other classes in

Fig. 57: Thomas Davies, *Montreal,* 1762
watercolour, 13 15/16" x 21 1/8", National Gallery of Canada

the colony.

Secondly, the technique that goes with any style imported from the centre has been developed in practice by painting the land in the centre, not the colony. The neat British countryside with its cultivated fields, its deciduous trees and its damp, mild climate is not Canada, with its rugged terrain, harsh light and brilliant colours.

We can see both of these limitations clearly in Davies' work. In his view of *Montreal from St Helen's Island* (Fig. 57) he has done everything possible to transform the scene into a picturesque bit of British parkland. The couple are posed under two trees on the island, which form an arbour above them. Vines cling to all the tree trunks and hang down from the boughs, to soften the effect. The shattered stump of a tree graces the left foreground. The city of Montreal, just captured by Davies with British troops two years before, is rendered accurately enough, but if we did not recognize the buildings or Mount Royal behind it, we might think we were along some English riverbank, looking across at a British city. Indeed, the two natives paddling their canoe along the shore may very well have been added as an afterthought, for the express purpose of situating the picture in the New World.

This vista of Montreal was painted in 1762, when Davies was just 25. If we compare it with the scenes painted in the 1780's, on Davies' last tour of duty, we can get an even sharper impression of the conflict between style and subject

matter. One of his finest watercolours is his scene *On the River La Puce* (Fig. 58), painted in 1789 when he had risen to the rank of Lieutenant-Colonel and was in command of the artillery detachment at Québec. It shows us a famous beauty spot in the area, the rushing rapids of the little Sault-à-la-Puce River near Château-Richer, with the thick forest on either bank and a hunter and his dog on one side, a bear just emerging between the trees on the other.

It is a sensuous painting, and shows a profound appreciation on Davies' part of the attractions of the colonial wilderness. But with his one-leaf-at-a-time attention to detail, the British artillery commander has been driven to paint the Québec bush as if it were a tropical jungle. He was an avid botanist, but many of his branches in this painting look like the fronds of huge ferns in this hillside of lush foliage. He has also adapted his brush to larger areas of flat colour with dark outlining to depict the slabs of rock in the foreground, and has developed a decorative system of rhythmic lines to suggest the surge of white water.

What we are looking at in fact is a contradiction between colonial subject matter (the actual landscape) and the imperial style (the topographical art) with which Davies has learned to paint. The rocks, river and trees just refuse to behave according to the rules of British military painting. If Davies applies those rules, as he does in the leaves, he ends up with a tropical jungle. If he alters them, as he does for the rocks and river, he transforms his style into something

Fig. 58: Thomas Davies, *On the River La Puce,* 1789
watercolour, 13 3/8" x 20 1/4", National Gallery of Canada

very different.

Because he was trained to careful observation and realistic depiction, the struggle between subject and style in Davies' case results in vivid, unique paintings. Yet so extreme is this contradiction that since his work was rediscovered at a British auction sale of a large collection of his paintings in 1953, various writers have even compared Davies with the French 'primitive' painter, *Le Douanier Rousseau,* a self-taught artist who painted similar lush jungles from his imagination. Nothing could be further from the disciplined naturalism of the Woolwich Military Academy than the riotous jungle fantasies of Rousseau, yet so altered was Davies' painting by the challenge of the rugged colonial landscape that the comparison actually holds.

We have no evidence that Davies was particularly conscious of this contradiction in his painting. He remained a professional soldier who liked to paint, serving in turn at Louisbourg, in New Brunswick, on Lake Champlain, along the St Lawrence River to Montreal, at Boston and New York during the American Revolution, to Gibraltar, the West Indies, back home in London to help suppress a riot, and finally at Québec, sketching wherever the empire sent him. The style of the *La Puce* painting was undoubtedly for

him a natural development that he had hardly been aware of over the years.

Proof that his style had been based on the landscape of England, however, can be seen in the views he painted around Plymouth Sound a few years after he had returned to his native country for the last time in 1790. These British landscapes have none of the excitement of the *La Puce* scene, and are much closer in style again to the naturalism of Sandby and the Woolwich Academy. They are just as picturesque as Davies had made Montreal look 30 years before.

There are clearly two factors at work here: one is the climate and topography of England itself, which allowed this kind of treatment; but the other, more crucial consideration is exactly what patron class point of view the artist took. Divergent outlooks within the ruling class in the imperial centre resulted in a variety of landscape styles there. Only one would be dominant at any one time, but the artist did have alternatives, both in the imperial centre and in the colony.

George Heriot was another graduate of Woolwich, and had even studied under Sandby, but the view he painted of the mouth of the *Chippewa Creek* (Fig. 59) shows us a very different British interpretation of Canadian scenery. Heriot

Fig. 59: George Heriot (1766-1844), *Chippewa,* 1810 or 1816
watercolour, 4 1/4'' x 7 3/4'', McCord Museum

came from the lowlands of Scotland, and hated the army almost as soon as he began his training. For either or both of these reasons, he rejected Sandby's naturalism, and turned to a style that was more popular among British aristocrats, but would have been quite useless for military reconnaissance purposes. This was the so-called 'southern' style of British watercolour painting, associated with atmospheric views of classical ruins in Italy that British nobles liked to visit in their youth.

As we can see from the view of Chippewa, this style employed full wet strokes of the brush to evoke much more 'poetic' effects than the official British army style permitted. Heriot had managed to get himself appointed to the paymasters' corps, so his painting was completely unrelated to the topographical assignments of an artillery officer like Davies. He arrived in Quebec City in 1791, just one year after Davies had left the colony for good.

After the year 1800 Heriot was able to indulge his fancy still more. He had been named deputy postmaster-general for the Canadas. In this job, finally free of the army, he was able to travel wherever his duties took him, from Quebec to the Niagara peninsula, and east to the colony of Nova Scotia. For 16 years he filled his sketchbooks with limpid little scenes of whatever caught his eye.

Yet although Heriot's work shows a different British ruling-class outlook, it is just as far from the reality experienced by the Canadian people. He shows the Chippewa fort on the left, and the bridge on the road to Fort Erie crossing the creek where it empties into the Niagara River. It was painted in either 1810 or 1816, just before or just after Chippewa was the scene of an important battle in the War of 1812-14, in which an invading American force was defeated by Canadians. Throughout this entire period it was the scene of intensive military activity, and continued preparedness for defence.

But this is not what Heriot's imported style had taught him to watch for. Instead, he sees a languid afternoon with a few people out strolling. The old man and the boy coming home from a day's fishing are borrowed directly from the views of the ancient ruins, where they would summon up poetic notions of the shortness of human life.

Heriot is also attracted by the tonal effects he can accomplish among the patterns of sunlight and shadow in the foliage and tree trunks. His technique here, brushing the darker colours on and leaving the paper itself to suggest the highlights, is called a *wash.*

One reason Heriot favoured this style was because it is particularly well-suited to the aquatint etching process by which he distributed some of his views as prints of 'picturesque' Canada. These were comparable to sets of prints of the classical ruins, which were as far away in time as Canada was in space for their British ruling-class buyers. Both subjects had to do with empire, since one showed the remains of earlier empires with which the British could compare, while the other indicated how far British rule prevailed.

Fig. 60: John Poad Drake (1794-1883), *View of Halifax Harbour*
oil, 53 3/4" x 73 1/2", National Gallery of Canada

Heriot took this print distribution a step further. In 1804 he published *A History of Canada* and in 1807 *Travels through the Canadas*, illustrating both volumes with aquatint etchings made from his sketches. This was certainly a progressive step. It shows that the patronage for these prints was spreading from the imperialists themselves to Canadian merchants who distributed British goods and to small businessmen and professionals as well.

So it came about that the classes who could afford to buy pictures at all were encouraged to see their own country in terms of these imperial styles. Sometimes, in fact, we can hardly recognize the colony at all.

John Poad Drake arrived in the Maritimes from England in 1819, and probably painted his *View of Halifax Harbour* (Fig. 60) in the following year. But Drake was evidently an enthusiast for the romantic school of landscape painting that *Joseph Mallord William Turner* had recently introduced in England, and like Turner harked back to the harbour paintings of a French artist of the 1600s known as *Claude Lorraine*. As a result, we see a large canvas painted with the splendid light effects of a Turner, and with the reflections on the still water, the cluster of sails and groups of picturesque figures, and even an ancient galleon, that are all ultimately drawn from the paintings of Claude. Only in the left foreground corner is there a matter-of-fact Micmac canoe, and in the distance the buildings of Halifax almost lost in the romantic haze.

Drake brought a new and much more aggressive approach to patronage in the colonies by importing a huge painting he had done of Napoleon on his way to exile, and advertising it as a show in Halifax and Charlottetown. This sounds something like what Legaré was to do a few years later in Québec by opening his studio and collection as a gallery; but the subject matter of Drake's attraction belies at once that this was no contribution to the advance of popular consciousness, but a huckster from the imperial centre out to peddle his wares to the colonials. First overwhelming them with a larger painting than they had ever seen, representing a subject that they had no direct knowledge of, he could then try to get them to accept his view of their own harbour as 'interpreted' by his style.

BEGINNINGS OF A CANADIAN LANDSCAPE ART

We can appreciate how far Drake's view is from reality if we compare it with the anonymous landscape that was found hanging in the revolutionary leader William Lyon Mackenzie's home at his death (Fig. 61). This canvas appears to represent the Don River valley around what is now Riverdale Park in Toronto. On the slope of the ravine at the left, half hidden by the trees, are the buildings and smokestack of one of the industries Mackenzie encouraged in Toronto. The houses, fences, the bridge at the right, the farmer with his horses and wagon on the road, the boys fishing in the stream and the man walking his dog at the far left all contribute to an animated but pleasing landscape, as close to his vision of an industrious, happy land as Mackenzie was to come. It was probably painted in the 1830s, and suggests again that a realistic approach to landscape painting was being developed by Canadian artists about this time.

Obviously these artists were influenced by the 'official' view painters and the styles they had brought to the colony. Some were just as British in manner—*Charles Fothergill*, for instance, painted views around his home in

the Rice Lake district of Ontario as if they were arcadian scenes by *Richard Wilson*, the British landscape painter of the 1700s. But for the most part, it is their habit of making realistic depiction of subject matter their first concern that gives them distinction today, and suggests that these largely unknown artists should be considered as the true initiators of painting in Canada that could serve the people. In their works for the first time we see Canadians depicting our land in their own terms.

Many of the paintings we have by them are in watercolours. One delightful exception (discovered only in 1964) is *Good Friends* (Fig. 62), a remarkable oil-on-canvas landscape by *Ebenezer Birrell*, a Scottish immigrant who came to Pickering, Ontario in 1834. Under a brilliant sun breaking from behind a cloud at the top of the painting, surrounded by trees painted in the richest rusts, oranges and deep greens of Ontario's early autumn, and contained by a well-built pioneer rail fence, stands a magnificent herd of horses and cattle, their coats gleaming in the sunlight. Sheep graze in the middle distance with a goat and a flock of geese at the side.

Anyone familiar with the well-known "Peaceable Kingdom" paintings by the American Quaker artist *Edward Hicks* of about this same period might think of comparing Birrell's painting with Hicks' religious pacifist visions of the

Fig. 61: Anonymous, *Landscape,* probably of the Don Valley near Toronto oil, Mackenzie House, Toronto

Fig. 62: Ebenezer Birrell (1801-88), *Good Friends,* 1834
oil, 23" x 28", Art Gallery of Hamilton

far-off time in which 'the lion will lie down with the lamb' as foretold in the book of Revelations in the Bible. But the Canadian painting lacks any pictorial reference to Revelations, and is much more a realistic conception of the domestic animals of Ontario's farmlands dwelling together as "Good Friends" in one big pasture. There were at least a dozen 'peace societies' formed in Ontario by 1826, but Birrell was both a militia commander and a leading agriculturist of his day, so it is likely that he was more interested in the animals for breeding purposes than as symbols of any visionary peace. He exhibited pictures in the Agricultural Society's annual Provincial Exhibitions, and certainly his subject in this work would have been immediately understood there.

Living in Pickering, Birrell would certainly have known Peter Mathews, "a jolly, hale, cheerful, cherry-cheeked farmer of Pickering, who lived on his own land, cultivated his own estate, and was the father of fifteen children," as William Lyon Mackenzie described him. Mathews was a leader of the people in the revolution against British imperialism and its local representatives, the Family compact, in Upper Canada in 1837. In April of 1838, despite the signatures of over 30,000 Canadians on petitions opposing the executions, Mathews and fellow Patriot leader Samuel Lount were hanged in Toronto.

Had this revolution been successful in achieving its avowed aims of establishing Canada as an independent nation, these early Canadian painters undoubtedly would have developed into a full-fledged school of Canadian painting. Birrell's direct approach to his subject matter, his vibrant colour and his ability to capture the texture and play of light in the early autumn foliage mark him out as a fascinating forerunner of Canadian landscape painting. And there were others, including the youthful *Paul Kane.*

But if we compare these artists with their Canayen contemporaries in Lower Canada, national consciousness

Fig. 63: John O'Brien (born about 1832, died 1891), *Yacht Race, Halifax,* about 1850
oil, 11 1/2" x 16 1/2", National Gallery of Canada

was evidently far more developed there. Not only did
Upper Canada not have a Legaré, but even the conditions
under which one might appear were lacking. Canadian
painters still had to struggle to see our own country in our
own terms, let alone think of painting our history.

Yet there was widespread popular support for the
revolution. Farmers, blacksmiths and other working people
all over the colony for years organized meetings, signed
petitions, ran election campaigns, and drilled in preparation
for armed uprising. What was lacking was any class that
could take power. The working class was scarcely formed
and the leadership they got from the petit-bourgeoisie dis-
integrated under fire. At the same time, due to the per-
vasive control of the Family Compact, few independent
national-bourgeois interests had been able to develop. In
politics, this eventually meant the defeat of the revolution;
in art, it meant that no patron class was on hand to en-
courage the development of a Canadian school of painting.

'PRIMITIVE PAINTING' AND THE IMPERIAL STANDARD

This pro-imperialist bourgeois patronage was character-
istic of all the colonies. In Halifax, for instance, about
1850, a group of merchants discovered a talented artist
about eighteen years old who was making his living by
painting pictures of their ships at sea. So they took up a
collection to send young *John O'Brien* to make a grand
tour of Europe, because they thought he had to see what
European marine painting really looked like.

O'Brien's *Yacht Race, Halifax* (Fig. 63) is an exciting
painting, done just about the time of his trip. With the skip
of its waves, the fine handling of atmosphere in the sky,
with light and wind in the sails, it goes right to the spirit of
this popular sport.

After his return from his sponsored tour of the
European galleries, however, O'Brien tried to tone down his
bright colours, closer to the greys and more restrained hues
he had seen in the Flemish marines that were much admired
in England. At first all went well, and he tried some more
'ambitious' compositions with the British naval squadron at

sea; but as the years went by the strain of trying to interpret this subject matter that he knew so well in terms that were not his led him to trite, formula paintings. He tried to recover his original vivacity again, but the effect was simply garish and his paintings gradually got worse. O'Brien's was by no means the only career to be ruined by the comprador notion that art in the colony has to 'measure up' to the 'international' standards of the imperial centre.

In Ontario, what had been the promising beginnings of a popular Canadian landscape tradition became simply a 'quaint' primitive form of painting without a growing patronage or public. The *View of Penetanguishene* (Fig. 64) painted by *William Buck* in 1840, for example, offers a lively panorama of the little Ontario town and its inhabitants. The paddlewheel steamer *Gore,* which began its service to towns on Georgian Bay, Lake Huron and Lake

Erie about this time, is seen sailing by from a different perspective than the town. The artist, unknown except for his name, has simply combined the two parts of his painting by using one horizon line for the steamship and another for the landscape as a whole.

Primitive painters, or folk artists as they are sometimes called, are seldom able to handle perspective. They usually depend on a direct linear presentation of their subject, with the most important elements clearly emphasized, and fill out the rest of their picture with details of the scene.

This is a widespread type of popular painting that recurs wherever untrained artists set to work. Its strength is that it is a direct expression of the people, usually not bound to a patron class when it first appears, and therefore reflects a broader, more popular base than professional painting. Artists can learn a lot from it, especially about putting subject matter before considerations of style.

Fig. 64: William Buck, *View of Penetanguishene,* 1840
oil, 30" x 36", National Gallery of Canada

The limitation of this kind of painting is simply that it remains at an unconscious level, uncritically or empirically reflecting the contemporary scene. This is because in its origins it has no patronage, and therefore reflects no viewpoint other than the artist's in his desire to record what he sees. As soon as most primitive painters begin to sell, they either develop away from primitive painting toward a trained, conscious and selective art, or else they begin to repeat certain 'primitive' stylistic traits or motifs that are favoured by their wealthy patrons. Either way, they acquire a viewpoint, a conscious style, and are no longer primitive in the original sense. The strength of their painting, its candour especially, must be incorporated in any people's art: but that can only be done by artists who consciously choose to serve the people.

Buck's is a fine canvas, full of life. But contrast it with the *View of Hamilton* (Fig. 65) painted in 1853 by the British-born artist *Robert Whale*. It's almost as if we've passed from one continent to another, instead of between two Ontario town views of about the same period. Whale, probably like Buck, was largely self-taught; the difference is that he had the opportunity to study and copy paintings by British artists of the 1700s, including Richard Wilson who is influencing him here. Whale was also affected at first hand by the ideas of English romanticism before coming to live in the village of Burford, near Brantford, a year before he undertook to paint this very romantic view of Hamilton.

There are two horizons here also, but Whale, using the lessons he has learned from Wilson, skilfully takes our eye back from the foreground world of the escarpment (Hamilton's 'mountain') to the distant ridge of land beyond Burlington Bay, in an airy, light-filled recession and opening of space. In the foreground he has indulged in a good many of the romanticists' conventional symbols of the 'drama of nature spent'—the gnarled roots, an uprooted stump and tree trunks blasted by lightning. Anyone familiar with the verses on nature by British Romantic poets such as Shelley, Byron or Keats will recognize the wild woodland that Whale wants to create.

Whale's picturesque figures are more believable than Drake's. And in the middle distance is a quite recognizable and realistic 'portrait' of the city of Hamilton as it was in

Fig. 65: Robert Whale (1805-87), *View of Hamilton,* 1853 oil, 35 3/4'' x 47 1/2'', National Gallery of Canada

Fig. 66: Robert Whale, *The Canada Southern Railway at Niagara*, about 1870
oil, 23" x 40", National Gallery of Canada

1853, far more precise than Drake's Halifax. Whale painted this view for the annual Provincial Agricultural Exhibition (forerunner of the Canadian National Exhibition), where every year he and his brother, who also painted, entered every category to win as much prize money as they could. He undoubtedly hoped to attract the eye of a prosperous Hamilton businessman as well, who might just be convinced to buy the painting because he could practically identify the exact location of his house or business. Whale may have had in mind someone like Isaac Buchanan, the Hamilton merchant and industrialist who in 1857 was shown by a government inquiry to have laid out $100,000 in bribes alone, in his efforts to get control of the Woodstock and Lake Erie Railroad.

"Railways are my politics!" avowed Sir Allan MacNab, the veteran comprador capitalist of Hamilton. Whale could see that railways were certainly where the money was, so "Railways are my art!" he might have replied. Buchanan's Woodstock and Lake Erie merged with the Amherstburg and St Thomas Railway to form the Canada Southern, which the Vanderbilts, who already controlled the New York Central and Michigan Central systems, added to their empire to give them a direct route through Canada from Chicago to New York. U.S. imperialism was well on its way, but in the meantime Robert Whale, the British-born romantic landscape painter of Burford, Ontario with a wife and six kids to support, set out to paint pictures of railways.

Many times over he contrived to combine his flair for romantic nature scenes with the rapacious railway capitalists' demands for exact documentation of their properties by 'posing' the trains in front of the most romantic landscape of all—Niagara Falls! The result, as we can see in *The Canada Southern Railway at Niagara* (Fig. 66) is really two paintings in one. In the background is a dramatic view of the falls, with the mists rising above the cataract and the eddies of the torrent receding down the gorge, to satisfy the romanticism of both Whale and his viewers. By this time (about 1870), he had visited the United States and had seen similar pictures of the Hudson River valley. Even in his background, however, he has to make room to display another feat of industrial engineering of the time, the Niagara Falls suspension bridge, and the buildings on either side of it.

In the foreground is a picture with a quite different spirit, a painstakingly realistic depiction of an engine and three cars of the Vanderbilts' railway. Whale has allowed himself two 'curtains' of foliage to either side, but his picturesque figures have now been reduced to two people who stand stiffly, hemmed in by the right-of-way fence, as the train goes by. On a rock in the lower left foreground Whale has noted that he painted the actual train in the Canada Southern yards at St Thomas.

It is ironic to observe that in order to achieve the kind of meticulous detail that his prospective capitalist patrons obviously required, down to the name of the railroad and the numbers on each car, Whale has had to resort to precisely the kind of 'primitive' painting that artists like

Fig. 67: Daniel Fowler (1810-94), *Dawn on Amherst Island,* 1875
watercolour, 17 1/2" x 25 1/2", Agnes Etherington Art Centre, Queen's University, Kingston

Buck employed. Whale had found nothing in the paintings of Richard Wilson, nor in the romanticists' approach to nature, to help him paint trains with this kind of detail, so he turned back to the simplest means and the most direct approach to his subject that he could manage.

The style of most of the British artists who came to Canada at about the same time as Whale, was the romantic English watercolour painting of landscapes and flowers. The best by far was *Daniel Fowler,* who settled on a pioneer farm on Amherst Island near Kingston, Ontario in 1843 for reasons of health, but didn't resume the watercolour painting he had practised in England until after the stimulus of a return trip home in 1857.

Like Thomas Davies, Fowler improved his English art by faithfully recording his careful observation of the colour and light in the Canadian landscape around him. He abandoned the habit he had learned in England of drawing with a pencil first and tinting on muted colours mixed in the studio afterwards, and began to paint boldly outdoors and directly in strong colours the Amherst Island landscape he had come to know so well in his years of farming it. "I had yet much to learn when I began to study from nature assiduously;" he wrote, "but constant communion with her

and the practice with still life and flowers, had given me discoveries, and produced confidence in colour. There was soon a full proportion of landscapes among my exhibited drawings."

One of these landscapes was *Dawn on Amherst Island* (Fig. 67), painted in 1875. Fowler's English roots may still be evident in this quiet scene of a woman walking the cows down a lane by the water's edge, with a farmhouse and a few ships in the distance. But when we consider the solidity of his shapes, the way he can put greens on greens to establish precisely the colour and spatial position of leaves, and his sure sense of the early morning summer sunlight and shade, we can appreciate the extent of Fowler's achievement. These are discoveries in form that parallel those the impressionists were making at exactly the same time in France, but they are founded on Fowler's complete understanding of his subject and his insistence on being true to it. The challenge of his subject, the colonial landscape, had transformed the style he had brought from the imperial centre. Certainly there were few British watercolour painters who were making any such formal discoveries at this date.

THE LANDSCAPE OF CONFEDERATION

On July 1, 1867 we were supposed to become a new country. There were also great changes in technology: photography had just been introduced, new printing and reproduction processes were becoming available, and the railways were constantly expanding east and west. But our capitalists had just made another arrangement with the British; so the problem for colonial artists didn't change much either.

Photography meant that for the first time pictures were available to large numbers of people who could never have afforded a painting. This was a great step forward in distributing pictorial art to the masses. For the painter, however, it had other consequences. No longer could he claim to be the only visual recorder of reality; in many cases he would not be the best.

The first to feel the effects of this new competition directly were the portrait painters, most of whom lost their livelihood. Aside from teaching, artists now became dependent for their living primarily on sales of pictures, mostly landscapes and genre painting, the other two bourgeois art forms. The old relation of craftsman and client that painters like Hamel had known in their portrait studios disappeared. In its place the bourgeoisie began to organize the sale and distribution of works of art much more extensively.

At first rather casually, as friends or advisers of the artist, private dealers in art began to appear. Public institutions also began to appear: in 1860 the Art Association of Montreal (now the Montreal Museum of Fine Art) was set up by the English-speaking compradors of that city to provide local patrons with an annual standard-setting sales exhibition.

The status of a work of art under capitalism as a commodity for sale was now revealed more clearly than ever. A sharp class distinction between the photographer as a purveyor of mass-distributed low-price pictures and the painter as a producer of luxury commodities for ruling-class patrons from this point forward made it still more difficult for the painter to serve the people. Photographers were expected to work for a photography firm, but painters were driven to a more marginal position in society than they had held before.

One group of artists decided to join the photographers. They were hired for the tedious job of tinting colour onto photographs, or the laborious one of making composite pictures of large groups of people (social or sporting clubs, for instance) by assembling photos of individuals together, painting in a background, and then taking a picture of the composite whole. (Fig. 68)

In the firm of William Notman & Son, founded by a Scottish immigrant to Montreal, Canada had one of the world's most successful and innovative photography companies. "Photographer to the Queen" Notman advertised himself. His firm's photographs were given the best exhibiting space and received prizes at a series of World's Fairs, and Notman was put in charge of all photographic work at the international exposition held in Philadelphia in 1876.

John Arthur Fraser, another British immigrant, had arrived in the eastern townships of Québec as a young man with his parents in 1856. Four years later he went to work for the Notman photographic studios in Montreal. The Notman firm was especially famous for its composite photographs; it hired artists on both a full-time and part-time basis, and sent them to various cities as it opened up branches across the country. The firm was growing fast, and a bright young man who watched his chances could quickly get ahead. Fraser was soon an associate in the Toronto branch, which was called "Notman and Fraser."

Fig. 68: Wm. Notman & Son, composite photograph with painted background, McCord Museum, Montreal

At that time the comprador capitalists and their imperialist friends in England and the United States were making much bigger profits by manipulating their investments in Canadian railways. In 1885, after prodigious labour by workers across the country, the last spike was driven at Eagle Pass in the Rockies, and the British imperialists had the longest railway line in the world at their disposal—the Canadian Pacific Railway. In the following year Sir William van Horne, the Montrealer who used a tiny portion of his enormous profits to form the largest private collection of art ever assembled in Canada to that date, decided that pictures of the mountains would be just the thing to help drum up trade. So he announced a policy of free passage for artists who were willing to paint the Rockies for the CPR. Fraser, who had gone to live in the States three years before, came back to Canada to take him up on his offer.

The Rogers Pass (Fig. 69) is one of the paintings Fraser produced from the trip. Based on a watercolour sketch made from the peak of the Selkirk Range in British Columbia, it shows some of the most difficult terrain that the heroic railway construction workers managed to build the line across. The pass had only been discovered a few years before, "greatly to the satisfaction of the syndicate that had undertaken the construction of the railway," as a contemporary writer commented.

Fig. 69: John Arthur Fraser (1838-98), *The Rogers Pass,* 1886
oil, 22" x 30", National Gallery of Canada

Fraser has adapted his British watercolour training to oils to paint the upper ranges of the mountains in broad, flat areas of colour, with a conventional romantic scumble of foliage in front. But his years at Notman and Fraser show, too: evenly lighted, his version of this awesome scene is really just a large backdrop, exactly the kind of background he might have painted in the shop for a composite photograph of a mountain climbers' or skiers' club.

There can be no doubt about what class this painting was intended for, however. "Painted for Sir Edward Watkin of Northenden, Cheshire, England" Fraser has inscribed on the back, and it was originally in the collection of Watkin, who was president of the CPR for six years. It was intended to hang in an English drawing room, where it would certainly strike an 'exotic' note, as a symbol of one of its owner's biggest profit-making ventures in the colonies.

What in fact had happened is that as the imperialists and their comprador allies had extended their exploitation of the colony into the west, they had also, by acts of 'patronage' like Van Horne's, extended the making of picturesque views of the colonial landscape all the way to the Rockies. The imperialists' seeing the country as a subject for art only in these 'picturesque' terms had come a long way from the British army officers' sketches, but it was essentially the same thing.

We can see this link even more clearly in the watercolour *Scene in the Rockies* (Fig. 70) painted a year after Fraser's canvas by another of the many artists who took the Van Horne 'free passage' offer, *Lucius O'Brien.* The mists of the mountain glaciers provide the perfect setting, and the picturesque figures in the foreground return, on horse-back this time, complete with blasted tree trunks and overturned stumps in a rocky, romantic foreground. We may be a long way west of Hamilton, Ontario, but in his approach to the scenery O'Brien is really no different from Robert Whale, who had painted a similar romantic fore-ground in his view of that city (Fig. 65) 34 years before.

In continuing the pro-imperialist tradition of the pic-turesque, O'Brien reaches back even further than that. In 1882 he was art editor of a big two-volume book called *Picturesque Canada,* for which the earliest comparison in Canadian art history would have to be one of Heriot's two books, *Travels through the Canadas* of 1807. For *Pictures-*

Fig. 70: Lucius O'Brien (1832-99), *Scene in the Rockies*, 1887, watercolour over graphite, 18" x 26", National Gallery of Canada

que Canada, a much larger project, O'Brien commissioned a long list of Canadian and Québécois artists of the day, including Fraser, William Raphael, and many others, to produce paintings from which woodcut illustrations could be made. (Fig. 71). He even commissioned some American illustrators who had worked on the model volume, which was of course *Picturesque America*.

Widely distributed in the 1880s, with contributions from Canadian authors like Charles G.D. Roberts, *Picturesque Canada* strengthened a growing consciousness of Canadian nationhood 'from sea to sea.' Confederation was a more efficient way of continuing British imperial domination of the economy, and the railways were certainly opportunities for gross profit-taking and scandalous speculation by the imperialists and the compradors in the colony; yet these were also unifying achievements of the Canadian people, and in the 1870s and '80s there was a surging sense of pride in the nation, even among the bourgeoisie. In 1871 a young lawyer named W.A. Foster had published a pamphlet entitled *Canada First, or, Our New Nationality*, and around it there had gathered a whole movement of bourgeois and petit-bourgeois nationalists.

But if *Picturesque Canada* was a pictorial and literary expression of this bourgeois nationalism, the book also illustrated its limitations. The Canada First movement had no clear idea of its goals, and the nationalist sentiments of a few of the Canadian bourgeoisie were not rooted in any real control of the country. Nor were they linked to the patriotism of the working people, which had continued unabated since 1837. *Picturesque Canada* only helped to confirm in the minds of the bourgeois and petit-bourgeois Canadians who could afford to buy it this notion of our land as a scenic attraction for tourists from one imperial centre or another, not as a place where a real people are working and struggling. Such uncomfortable *realities* as the oppression of the Métis people on the 'picturesque' prairies, for instance — a people who had risen in armed rebellion in 1871 and would rise again in 1885 — were left out of account.

Lucius O'Brien (no relation to John) was just the man to

be art editor. Born in a village on the north shore of Lake Simcoe called Shanty Bay in 1832, the son of a retired British colonel with good British ruling-class connections, he had been educated at Upper Canada College, the training ground for the comprador class in the colony, and had worked as an architect and surveyor. Two years before *Picturesque Canada*, he had been chosen to be leader in still another project designed to submerge the new current of nationalism under the continued reality of British imperial control — the Royal Canadian Academy.

Canadian artists had been organizing themselves for a long time. As early as 1834, the year that York was incorporated as the city of Toronto with William Lyon Mackenzie as its first mayor, the Society of Artists and Amateurs of Toronto had been formed, and held its first exhibition in the Parliament Buildings on Front Street. That exhibition was ruined because the city was swept with cholera on the day it opened (the plague had spread to Toronto and many other Canadian and U.S. cities that year). But again in 1847 a Toronto Society of Arts was formed, and a similar society began gathering in Montreal.

By the 1860s two factors were leading artists to think of organizing on a broader basis. With the new wave of national consciousness around the time of Confederation a short-lived Society of Canadian Artists was formed. But

Fig. 71: Lucius O'Brien, *A Canyon on the Homathco, B.C.* from *Picturesque Canada* 1882

Fig. 72: Homer Watson (1855-1936), *The Stone Road,* 1881
oil, 36'' x 51 1/4'', National Gallery of Canada

even more compelling was the need to organize to protect the artists' interests in the sale of paintings, now that portrait commissions were disappearing and sales at exhibitions were so crucial. An exhibiting organization with an annual picture-selling show was the answer: in 1873 the Ontario Society of Artists was founded.

The Society held its first exhibition, suitably enough, in the photography showroom of Notman and Fraser on Toronto's King Street; since the photography business had driven them to such reliance on sales of paintings, they might as well use the photographers' gallery to sell in. It was a great success. A few years later the Society was able to found the Ontario School of Art, an institution that was to become today's Ontario College of Art.

The trouble with the Society was that it was not independent. In order to ensure sales, Fraser, the successful photography businessman, had insisted on a constitution according to which the president had to be a bourgeois patron. The highest office an artist could hold was vice-president. Fraser served as first vice-president himself.

In 1878 the latest envoy of empire, the Marquis of Lorne, arrived to take up the role of Governor-General.

Especially since Confederation, the imperialists and the comprador capitalists in the colony no longer required much more than official appearances from this titular representative of the British crown; on the other hand, with the Canada First movement and other signs of this new Canadian nationalism particularly affecting writers and other intellectuals, it was time to take a hand on the cultural front. If Canadians were going to have national cultural institutions, it was up to Lorne to see that these institutions were as British as they could possibly be.

This he did by setting up colonial copies of two institutions by which the ruling class in England successfully controlled culture there. Britain had a Royal Academy, so Canada must have a Royal Canadian Academy. Britain had a National Gallery, so Lorne created the National Gallery of Canada. He got that Upper Canada College alumnus, O'Brien (who looked good because he was Canadian-born) to be first president of his new Academy, and he got the Academicians to start the National Gallery's Canadian collection by donating one painting each. Fowler, Fraser, O'Brien, William Raphael and old Antoine Plamondon were among them.

Like *Picturesque Canada,* the Academy and the Gallery did have their progressive aspects. The Academy provided a national organization for Canadian artists, and its early exhibitions held in various cities around the country strengthened Canadians' awareness of our national culture, as well as giving the artists an important opportunity to exhibit and the chance of a sale. The National Gallery was also to prove an important force in fostering the development of the national school of landscape painting during and after World War I.

The trouble was that these institutions, like the provincial and civic societies, tied the artist to his patrons. As the Academicians elected new members and their executives appointed juries for the exhibitions, they quickly became an elite of those who were most proficient at serving their imperialist and comprador patrons. Lorne started the system off by buying no less than three works by O'Brien for the Queen's collection from the first R.C.A. exhibition. Two years later the painter from Shanty Bay was one of two Canadians exhibited at the 'prestigious' Burlington Galleries in London, and in 1886 O'Brien and others got their just reward by being included in the "Colonial and Indian Exhibition" in the empire's capital. The Academy was functioning smoothly as a system of pro-imperial patronage, a way for the ruling class to try to make sure that the artists of Canada would serve them, not the Canadian people.

There was one young artist in the original Royal Canadian Academy exhibition in Ottawa in 1880 who was deeply rooted among the Canadian people, although Lorne might not have realized this from the painting he had entered. Twenty-five-year-old *Homer Watson* of Doon, a little village that is now part of Kitchener, Ontario, had sent in a canvas called *The Pioneer Mill.* Besides the old water-wheel mill itself, the painting was full of the usual romantic and picturesque details—tangled foliage, a blasted tree trunk, the tiny figure of an old man by a waterfall, and mountainous cliffs overhanging a rock-strewn stream. Lorne bought it, sent it to Queen Victoria, and she liked it so much that she ordered another one right away! Watson was the surprise sensation of the first Academy show.

The Stone Road (Fig. 72), included in the Ontario Society of Artists exhibition of the following year, gives us a little better idea of what Watson's early painting could be, when he was not allowing himself to be carried away by the woodcut illustrations he had seen in books and magazines. This is a straightforward document of the old Dundas road, south of Doon, and we can immediately recognize in it that Watson's early work came from the slightly primitive but realistic Canadian tradition that had been so promising in the first third of the century. It is close in spirit to the Don Valley landscape that Mackenzie had hung in his living room.

The vista across the fields to the right and the effects of light in the sky suggest the influence of the American landscape painter *George Inness,* whom Watson had visited on a trip to New York five years before. And he had definitely improved his talents by working with the artists at Notman and Fraser's in Toronto for two years in the mid-1870s. But basically this is a painting by a man with the conviction and confidence to record the land he knows by whatever skill he has. Here again is painting in which the landscape subject matter decidedly comes first. The young painter may have some difficulty with his perspective along the road, but the landscape as a whole, especially in the trees, is painted with a passionate fidelity that reflects the regard in which the land was held by Watson and the farming community he lived in.

Queen Victoria's enthusiasm for his more picturesque modes of expression, however, was only the beginning of the influences and advice Watson would have to contend with from the British imperial centre throughout his long career. In 1882 the British author and wit Oscar Wilde came to Toronto on a lecture tour of the colonies, and pronounced Watson "the Canadian Constable" after seeing a few of his forest scenes with heavy weather effects.

Watson later complained bitterly about being saddled with this comparison to the English romantic landscape painter *John Constable* so early in his career, and pointed out that there was no way he could have seen a Constable at this time. But Wilde was an astute observer, and the similarities were real enough. Both Constable and Watson were based in the small-village life of rural counties, and painted for patrons whose tendency to idealize and romanticize the land reflected their strong sense of property values. Given that there was a greater likeness between Constable's Valley of the Stour River and Watson's Grand River Valley than there is between most parts of England and Canada, it is not surprising that the same class outlook about land and painting in the two places should have led independently to closely comparable results.

Even if Watson's work had not already resembled that of Constable and other European artists all that closely, it soon would. If we compare *The Stone Road* with *Landscape with Sheep and Wheat Fields* (Fig. 73), painted two years after Wilde's remark, we can see the effect that the combined patronage of British royalty and British literary figures was having on him. Although his over-all approach is still one of respect for his subject matter, he is beginning to play with the light and shadow effects of a turbulent, cloud-filled sky, the kind of weather Constable was famous for painting. The rushing stream in the foreground is painted in an over-dramatic way with highlights of 'white water' that reinforce another comparison with a European master that some of his patrons were making, the Dutch painter of the 1600s *Jacob van Ruisdael,* whose pictures were very popular with bourgeois collectors and widely reproduced in magazines at this time.

Watson was now selling his paintings through a Toronto dealer named James Spooner, who liked to write him letters full of advice. Still living in Doon, Watson tended to take seriously most of the advice he got from patrons, dealers and critics and to some extent he tried to paint what was expected of him. By 1887 he had saved enough from his sales to be able to go to England to see for himself the 'imperial standard' by which he was constantly being measured.

He did well there. He made friends with some leading

Fig. 73: Homer Watson, *Landscape with Sheep and Wheat Fields,* 1884
oil, 24'' x 35 1/2'', Art Gallery of Hamilton

British artists, and a London dealer began to sell his paintings. He could have become a successful landscape painter of the English school. It is to his great credit that in 1890, despite many inducements to stay, as a patriot and as a painter he saw clearly that he had to return home to his subject matter in Doon.

Watson himself later wrote:

"It is said art knows no country but belongs to the world. This may be true of pictures but great artists are no more cosmopolitan than great patriots, and no immortal work has been done which has not had as one of its promptings for its creation a feeling its creator had of having roots in his native land and being a product of its soil."

This is a remarkable perception for a Canadian artist of any time. It shows that Watson saw clearly the necessity for a national art of the Canadian landscape, and that he intended his work as a contribution to that end. His understanding that this was the resolution of the contradiction between colonial subject matter and imperial style was founded solidly on the patriotism of the Canadian farmers among whom he had long lived and worked. Certainly he did advance the struggle for the landscape

further than any artist had before him. The tragedy of his career is that all the advice he accepted about style made it impossible for him to achieve his objective completely.

Having passed the test of the imperial standard once again, Watson back in Canada found that his paintings now began to sell at good prices to the comprador art collectors of Montreal. The circle of capitalists around the Bank of Montreal, the railways and the big industries collected works of art for investment as well as pleasure. They bought 'old master' canvases from Europe that they knew were safe investments, especially Dutch paintings of the 1600s. They also bought paintings of their own time that looked like they might have the same staying power financially. Since Watson painted landscapes that looked something like the Dutch, and since he had so clearly been approved at British imperial headquarters, they figured it was safe to invest in Watson. In 1894 the painter of Doon won first prize at their Art Association of Montreal exhibition, and Lord Strathcona himself bought the canvas. One patron pulled some strings in London to help get an article published about Watson in the leading British art magazine, *Art Journal* in 1899.

Yet these were precisely the years when, back in Doon,

the artist was trying to conceive and execute what he envisaged as the major work of his life, an epic series of paintings that would chronicle the settlement of Waterloo County.

Watson was never to complete this project satisfactorily. The closest he came to it in spirit is his enormously popular canvas of 1900, *The Flood Gate* (Fig. 74). Painted at his grandfather's mill pond in Doon, it does incorporate many of the values he was aiming at in these works. It vividly portrays the fundamental struggle for production of man with nature, as the farmer labours to control the flood waters while the storm rages around him. And it is for this reason, because it depicts the heroism of the toiling masses in one of the basic struggles for production, that Canadians have made it one of our best-known paintings.

In style, however, the painting is a complete capitulation to the romantic effects of Constable, as even Watson later admitted. Ironically, just when he had achieved the full implications of his subject matter, Watson turned completely to the dramatic contrast of darkness and light, the thick texture of paint, and the full range of atmospheric effects that he had observed in Constable's paintings in London. He had long since lost sight of the fact that his original realism might have carried this epic message better than these imported stylistic devices. The result is a somewhat stagy, pretentious and overblown picture of what could have been represented more effectively with stark simplicity.

In many ways, Watson provides an artistic parallel to Sir John A. MacDonald. The two men had similar scope and daring in their plans. Yet both combined their ambitions for the Canadian nation with continuing subservience to the British empire. Accordingly, their accomplishments, while setting out to be national in character, ended up serving British imperialism in a new and more advanced way.

Fig. 74: Homer Watson, *The Flood Gate,* 1900
 oil, 32 1/2″ x 46 3/4″, National Gallery of Canada

2. A Nation of Canadians

"Canada" was originally the word the Hurons used to refer to a collection of their houses. Jacques Cartier thought they meant the whole territory when they pointed to a village and used that word, so he called the country itself Canada. By the late 1600s the habitants were already thinking of themselves as *Canadiens.*

When the British took over from the French, they passed the Quebec Act. "Quebec" is what the colony remained until 1791, when the Constitutional Act divided the country into Upper and Lower Canada, corresponding to Ontario and Québec today.

There were already English-speaking people living in what are now the Atlantic provinces, as well as the French-speaking Acadians and the native people. Together with the Canadas, these colonies made up "British North America".

In the 1800s an English-speaking nation first became visible to ourselves and to the rest of the world in what is now Ontario and the Maritimes. The terms "Canada" and "Canadians" still included Québec, in fact they were often used just to refer to the French-speaking nation. But in the War of 1812-14 and again unmistakably in the revolution of 1837-39, it was evident that an English-speaking nation as well had arisen. This was the beginning of the nation of Canadians that today lives beside the Québécois in this country Canada.

The painting of people among this English-speaking nation in the 1800s reflected this development. Yet there is not, as there was in Québec, a rich variety of portraits painted by a whole school of professionals competing with one another for commissions. As we shall see, there was not enough patronage in Muddy York in the first decade of the 1800s, nor in Halifax in the second, to sustain the accomplished portrait painters who happened to be in the two cities at the time. A little later, *Richard Coates* was commissioned to paint symbolic murals of *Peace* and *Plenty* for a pacifist religious sect in the Sharon Temple at Uxbridge, Ontario; but there was so little other encouragement to paint that Coates reverted to operating a mill and finally retired to a farm. *Nelson Cooke,* a well-known portrait painter in Toronto in the 1830s, had to go to New York State to find steady patronage.

British ruling-class headquarters for North America was in Lower Canada, first in Québec City and then in Montreal, so the portrait painters who served the bourgeoisie settled there. Travelling portrait artists like Roy-Audy from Québec and numerous American painters visited cities like Kingston and York to take commissions well into the 1830s. Most of the 18 painters who exhibited with the 1834 Society of Artists and Amateurs of Toronto displayed copies, but of the five who showed portraits we know several who either came from or travelled constantly in the U.S. It is not until the following decade, until after the revolution of 1837-39, that we find full-time professional portrait painters permanently resident in Toronto. The revolution had definitively established the new nation.

Their attitude toward portraits tells us a great deal about the early ruling class in these colonies. They thought of themselves as provincials within the British empire, not as builders of this new nation. They were therefore willing to accept portraits by visiting artists from larger cities like Montreal, Québec or (in the Maritimes) Boston. Until well into the century, they saw no particular need to develop their own portraiture, and by the time they did the camera was already well on its way to taking over the portrait painter's trade.

The people, however, felt very differently about their new country. Already by the War of 1812-14 (much to the astonishment of the U.S. army), they showed that they thought of themselves as citizens of a new nation that they were ready to defend. By the 1830s this patriotism was manifest in the petitions, meetings, organizations and campaigns all over Upper Canada that culminated in the revolution of 1837-39. Similar feelings were shown by New Brunswickers in the Aroostook War against U.S. lumber barons on the upper St John River, and by Prince Edward Island farmers in their successful struggle against absentee British landlords.

This widespread popular consciousness was reflected in paintings that set out to document Canadians in our own country. These pictures were painted mostly by amateurs, or by trained painters who had little hope of becoming full-time professional artists. Their patronage was limited in most cases to a circle of relatives and friends, or they painted for their own enjoyment.

There is seldom the drama or social tension of a *Cholera Plague* about these paintings. Farmers and other working people in Upper Canada and the Maritimes had comparatively greater opportunities than did the Canayens; even under the Family Compact. Despite the Church of England's profiteering off the land reserves granted to it by the government, as if it were the people's only church, Canadian society was less rigidly structured than that of Québec. There was not the total domination by one Church, the direct repression by a foreign-speaking army of occupation nor the actual day-to-day presence of the colonies' leading imperialists and compradors.

For the most part, therefore, these early pictures simply document the lives of the native peoples, the settlers and the working people of the new nation. They do not form a continuous tradition, but persistently reappear at different times and places all over the country. Many of them are still being rediscovered; the colonial mentality of many of our art historians and museum curators has led to a neglect of this kind of painting, or at best a condescending approach to it as 'folk art', so that we are only now beginning to appreciate these pictures as the art of the people.

It is clear, however, that these pictures were not really genre paintings. Even when the native people were the subject matter, as in the picture of the Micmacs (Plate IV), the artist's concern is to document, not to tell droll stories. There was genre painting in these early years, principally

Fig. 75: James Peachey (active 1774-97), *Encampment of the Loyalists at Johnston,* 1784
watercolour, 5 1/2" x 13 3/4", Public Archives of Canada

in the works of *Paul Kane.* But Kane's paintings are not a part of this popular documentary art; they were painted for bourgeois patrons, and consciously intended to be 'high art' superior to anything that had been produced in the colony up to that time.

It is in fact instructive that the parallel to Québec's Krieghoff in Canadian painting should be Kane, whose subject was not the Canadian farmer but the native people of the Northwest. Canadian farmers mostly spoke English, and many came from the same homeland as the British ruling class. They could not, therefore, become the exotic subjects of picturesque genre paintings like Krieghoff's jolly habitants. The chauvinism of the British imperialists would not allow them to see these English-speaking colonials that way. Canadian landscape might be picturesque, but never English-speaking Canadians!

Even the officer-painters of the British army treated Canadian settlers naturalistically. The view that officer and surveyor *James Peachey* painted of the *Encampment of the Loyalists at Johnston* (now Cornwall, Ontario) in 1784 (Fig. 75) represents the figures of the newly-arrived colonists as they actually appeared to Peachey engaged in their work.

Many of these families of the conservatives and reactionaries who had opposed the revolution had come from the comfortable town houses of the American cities along the eastern seaboard; now they found themselves living in tents, fishing for food rather than sport, and cooking over an open fire. Peachey, who had had the usual topographical training, drew their camp with a sharp eye for detail. He also made sure to give his scene a suitably refined air by using soft warm colours, a radiant light from the June sky, and pleasant shade in the foreground.

The leaders of these Loyalists did not remain long under these conditions. They had mostly been successful compradors in the American colonies, and they were determined to render some comparably profitable service to the Empire

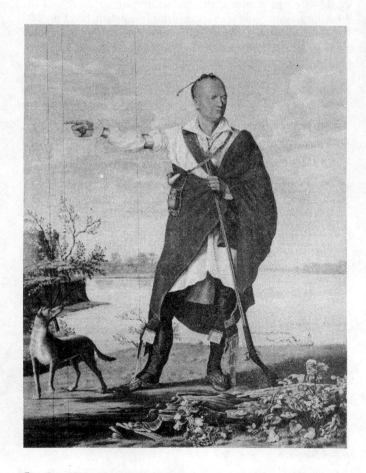

Fig. 76: William von Moll Berczy, *Joseph Brant,* 1797
oil, 24" x 18", National Gallery of Canada

here. They soon moved to the towns, and began to administer the British land grants that were the chief source of revenue in the colony.

By the time the artist-turned-land-agent William von Moll Berczy brought his group of German immigrants to Markham Township near Toronto in 1794, these compradors were already forming up their interlocking interest groups that led to the Family Compact. They were beginning to develop their practice of holding back land while settlers developed the surrounding countryside, and then selling it at a greatly increased profit.

When Berczy began to paint portraits again in the following year, he found one of the Loyalist leaders an ideal subject. The Iroquois chief *Joseph Brant* (Fig. 76) had allied with the British against the American settlers who had been encroaching on his tribe's territories. After the defeat of the British, he and his band had moved from their homes in upper New York State to a land grant on the Grand River in southern Ontario near what is now Brantford. While most of them built simple log houses there, Brant himself erected a 'Mohawk castle' in which he lived with some 30 servants including black slaves as much like an English gentleman as he could. He translated the Book of Common Prayer into Mohawk, and Peachey illustrated the edition for him. By 1792 a British guest could write in praise of the tea service, an organ recital of English hymns, and the comfortable English bedding his host had provided. "The house belonging to Brant's family resembles that of a petty English farmer," another British visitor judged.

This completely assimilated Mohawk chief undoubtedly admired the portrait of him that Berczy painted about 1797. He stands in full regalia in front of Berczy's idea of the Grand River, and points to the site for his people's new homeland. Berczy, whose neo-classical severity of line is less convincing in this simulated landscape than it is in the drawing room of *The Woolsey Family* (Fig. 19), has treated the Iroquois leader just as if he were a British aristocrat pointing out his ancestral domain, or a British general indicating the scene of his most famous battle.

The painting is as much in the spirit of contemporary British ruling-class portraits as Berczy could make it, and he might have supplied the entire comprador patron class of Upper Canada with similar works; but the town of York at this time was little more than a string of houses, and the concentration of wealth in the colony in only a few hands further limited the number of families who could afford to commission such canvases. When Berczy set out to make his living from his portraits in the early 1800s, he moved to Montreal to do it. There was simply not enough patronage for his purposes in Upper Canada. The money and the power was concentrated in Montreal.

We can get some sense of what life was like around the Fort York barracks in 1804 from the watercolour sketch painted by another of the topographical officer-artists in the British army, a Captain with the memorable name of *Sempronius Stretton* (Fig. 77). Like Peachey, this British officer with the Roman imperial name does not see the

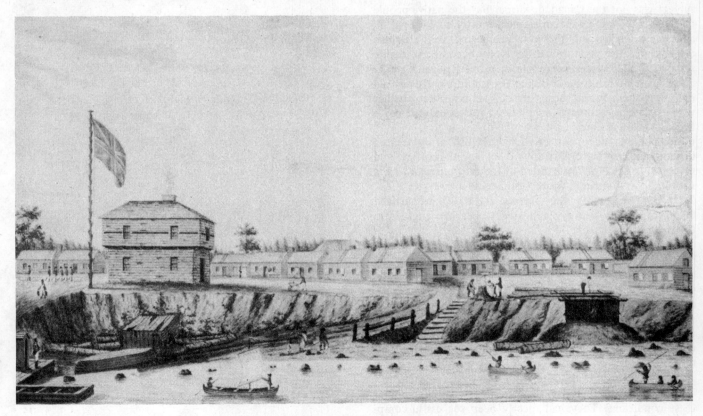

Fig. 77: Sempronius Stretton (1781-1824), *York Barracks, Lake Ontario, Upper Canada,* 1804 watercolour, Public Archives of Canada

English-speaking Canadian civilian settlers as exotic; he represents them quite naturalistically, along with the British soldiers on parade or at their posts.

He does, however, show us an imperialists' view of the class character of colonial society. The British troops are marching or standing guard under an over-sized Union Jack. The Canadians are literally hewers of wood and drawers of water: by the steps in the centre one group is removing a stump; while at the right two others are installing a well. One worker lugs buckets of water up the steep incline at the far left, another pushes a wheelbarrow toward the blockhouse.

In the foreground Stretton has also included some native people. A group at the right is spear-fishing in Lake Ontario. A family who have just beached their canoe are walking up the road to the fort, the father dragging a large fish for sale to the soldiers. The destruction of the native people's self-sufficiency and their consequent dependence on the imperial forces is clear.

By the trees that crowd around the barracks we can also see that the fort is only a clearing in the wilderness. It is little wonder that Berczy did not find enough patronage here to stay.

THE VICTORY OF 1812-14

The lack of sufficient patronage was also a problem in Nova Scotia up to this date. Before the American revolution, the first Haligonians had looked to Boston for their pictures. Afterwards, a painter from Edinburgh named *George MacCrae* had begun to paint portraits professionally. But it was not until the arrival of the British-born artist *Robert Field* in 1808 that portraits really became a vital part of the ruling-class culture of Halifax.

The year before, the British navy had begun to insist on its right to board U.S. ships and seize contraband cargo as part of its blockade of Napoleon's France. These and other activities connected with the war made Halifax a much busier port, and drew to the city a large number of naval officers and administrators who, along with the resident merchants, could constitute for the first time a fully-developed patron class.

Field may have been attracted to the city by this new market and the lack of much competition for it; or he may have seen the signs of the impending war with the United States, where he had lived for 14 years, and decided that he wished to maintain his allegiance to the British crown. For whichever reason, he broke off his successful career painting portrait miniatures and canvases in the American coastal cities, and moved on to Halifax from Boston.

Four years later, timing the invasion to coincide with Napoleon's entry into Russia so that British troops would be tied up in Europe, the United States attacked Canada. Although at first there were Canadians who looked on the invasion as a deliverance from British oppression, the aggressive behaviour of the American troops soon convinced everyone that we were faced with an invading army whose expansionist ambitions had to be stopped. The hard-pressed British army and navy suffered serious set-

backs, but the enthusiastic participation of colonial and native peoples' forces in the war proved decisive, and the struggle ended in a victory that immeasurably strengthened our young nation. The U.S. government had told its soldiers that the taking of Canada would be "a mere matter of marching"; instead, they had found a unified people, ready to defend their homeland from the east coast to the middle of the continent.

At Halifax, for example, the sea battle that was to be the turning point of the Atlantic naval campaign was the taking of the U.S. frigate *Chesapeake* by H.M.S. *Shannon* on June 1, 1813. Until that date American ships had been winning most of the naval engagements, and the *Chesapeake* was considered the chief American prize sailing out of Boston Bay. In the short but bloody battle for its capture, the two superior British officers on the *Shannon* were put out of action by their wounds, and it fell to *Lieutenant Provo William Parry Wallis*, the 21-year-old Haligonian who was third-in-command, to take over direction of the British ship and tow the vanquished *Chesapeake* back to Halifax harbour.

Nova Scotians were jubilant, especially when they heard that a native son was hero of the day. Wallis was soon sent to the rooms above Morrison's Bookshop on Granville Street, where Field had his studio, to have his picture painted to commemorate the great victory.

Field's painting (Fig. 78) shows a serious young man wearing the single epaulet of a lieutenant, posed before the glare and smoke of battle as a far more senior officer ordinarily would be. With his hair tousled in the fashion of the period, this early Canadian naval hero looks at us with the confidence of a man who has faced and met the challenge of combat. He probably thought of his victory, however, primarily as one for the British navy rather than for Canada: despite his colonial birth he was to go on to become an Admiral of the British Fleet, and eventually to retire, like so many other British admirals, to an estate in the south of England.

His portrait is just as British in character. Field had studied at the Royal Academy in London about 1790, and his approach to portrait painting is very close to that of the English artists prominent at that time. The influence of Sir Joshua Reynolds is evident in many of Field's canvases; in this painting, with its warmth of colour, its flash of drama and treatment of the subject as a romantic hero before a turbulent sky, he comes closest to the example of *Sir Thomas Lawrence*. This artist was still a very young man and widely discussed when Field was studying in London. Lawrence in fact was commissioned by the Prince Regent (later George IV) to paint portraits of all the leaders of Europe who were allied against Napoleon. Field's portrait of Wallis (which is one of his best) may be taken as a modest colonial version of such a subject.

Field did not stay in Halifax to develop this kind of painting much further. A few weeks after the taking of the *Chesapeake* came news of another decisive victory, the capture of an American force of about 500 men at Beaver Dams in the Niagara peninsula by several hundred native warriors who had been concealed in the woods, and a

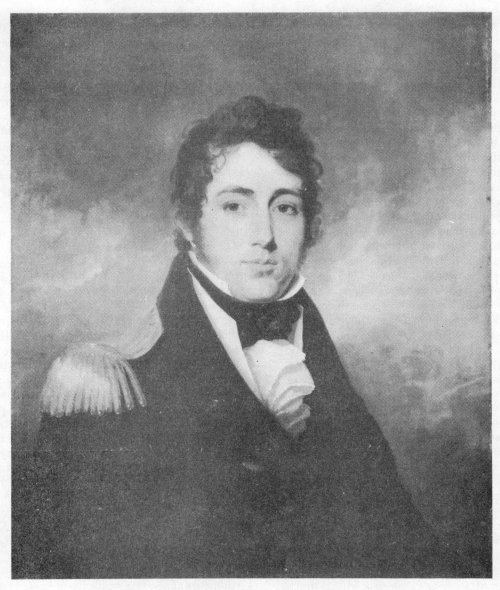

Fig. 78: Robert Field (born about 1769, died 1819), *Lieutenant Provo William Parry Wallis,* 1813, oil, 30" x 25", National Gallery of Canada

guerrilla band of 50 'Green Tigers' (so called for their Irish-green uniforms) who had been alerted to the advance of the U.S. army by the Canadian heroine Laura Secord. The Canadian people had obviously become a most effective fighting force: already repulsed at Stoney Creek, the Americans now fell back to Fort George at the mouth of the Niagara River, were forced to abandon it at the end of the year, and finally surrendered their own Fort Niagara on the opposite shore. By 1814 the first imperialist venture of the United States, the taking of Canada, had been stopped. One year later Napoleon was in exile, and life in the port of Halifax began to slow down. The patron classes were no longer numerous or rich enough to provide Field with sufficient patronage, so in 1816 he moved on to another British colony, Jamaica, where he died of yellow fever shortly after.

It was in the War of 1812-14 that the English-speaking settlers of British North America first came to see themselves as Canadians. Yet the colonial ruling classes did not reflect this advance in consciousness by commissioning portraits of the heroes and heroines of the war, or historical paintings of the battles. Laura Secord was painted years later as an old woman, not at the time of victory; leaders like Sir Allan MacNab and Colonel James Fitzgibbon (commander of the Green Tigers) seem to have been portrayed only as part of the Family Compact, not on the battlefield. General Isaac Brock had been painted on canvas and in miniature in England, but it was not until after the revolution of 1837-39 that the Family Compact finally had an historical portrait painted of him in Canada. A completely inaccurate British print depicting the Battle of Queenston Heights was meanwhile given wide circulation.

This has been a continuing problem in Canadian history: our people have achieved patriotic victories, but the caretaker ruling classes for the various imperial regimes have been afraid to acknowledge these victories in their patronage of the arts and in education. Even today the War of 1812-14 is usually presented as either a stalemate or a victory for the British military rather than the Canadian people. Yet the American invasion was clearly stopped, and it was fear of the Canadian peoples' and native warriors' guerrilla tactics that kept U.S. forces bottled up in Fort George in the latter part of 1813, for example. Not only in the lack of heroic portraits and battle pictures, but in the whole treatment of this war in our history we can recognize signs of our colonial heritage. One of the aims of our national liberation struggle has to be the reconstruction of our history!

BEGINNINGS OF AN ART OF THE PEOPLE IN THE LANDSCAPE

Berczy in Toronto and Field in Halifax had started portrait painting on a decidedly colonial note. Both had brought styles of portraiture acquired in the imperial centre, London. Both had associated almost exclusively with the imperialist and comprador ruling classes. Their departure from the two·cities sharply decreased direct contact with these imported styles, and since they were not replaced on a permanent basis for a generation and more, local artists in the colonies were able to begin developing their own approaches to the painting of people, and to widen the range of classes represented in their pictures.

Some of these artists, like portrait painters *William Valentine* and *Joseph Comingo* in the Maritimes, are known to us at least by name. Others are anonymous, being the same group of artists who were painting the first home-grown views of Canadian landscape at this time. They were humble people who did not think of themselves as artists, but their products are very valuable to us. One of their strongest paintings is an unsigned depiction of the Micmac native people that may have been done by a Halifax woman in the 1820s (Colour Plate IV).

This vividly animated scene is radically different in spirit from the ruling-class portraits we have been examining. Unlike Brant gesturing in imitation of British nobility before a studio-backdrop landscape, these Micmacs are engaged in their real everyday struggle for production, rooted in a believable landscape along the Nova Scotia shore. Several raise their guns in the hunt; others are paddling their distinctive low-prowed canoes. Inside the wigwam a woman sits beside a pot hung over an open fire, tending a baby in a cradleboard. Many details of the material base and cultural superstructure of the Micmac people are deliberately documented—the toboggan and snowshoes are included even though out of season, the wigwam opening is carefully rolled back to reveal its construction and the interior, the way a blanket can be rigged as a sail for a canoe is shown, and the magnificent beadwork and quillwork of the Micmacs is recorded on every item of clothing and on the little birchbark boxes inside the tent. Even the Micmac use of dogs is noted, as one peers over the gunnels of a canoe at another in the foreground, swimming to retrieve its master's fallen prey.

It's possible that this splendid canvas was done by *Elizabeth Ladds* of Halifax, one of a number of Nova Scotian women who were taking an interest in painting at this time through the 'finishing schools' and the art classes at Dalhousie College. The documentary and even scientific accuracy of the picture probably also reflects the growth of another educational institution of the period, the Mechanics Institutes that were pioneering adult education with night classes for 'mechanics' (working people, although others also attended) in the growing cities of Halifax and Saint John.

Whoever painted it, and for whatever reasons, they evidently knew how to combine a wealth of descriptive detail into what is still a well-balanced picture. A few withered tree trunks are included to either side, showing the slight influence of English romantic landscape conventions; but the scene has basically been composed of two inter-related parts designed to show us the Micmacs' way of life on land and on water, connected by the two horizontal shorelines. For this purpose the wigwam has been painted closer in perspective and with greater detail than would actually be observable. The artist has also 'caught' a moment of action in the hunt by painting the birds as if arrested in flight at the instant of a gun going off. His or her over-riding concern has been to convey content, and stylistic means have been developed as needed to accomplish this clearly conceived purpose.

At about this same time, far to the west of Halifax, on the banks of the Red River near what is now Winnipeg, a remarkable young Swiss immigrant artist named *Peter Rindisbacher* was busy documenting the social reality around him with a similar attention to detail. Beneath his pen-and-ink sketch of *Colonists on the Red River in North America* (Fig. 79) the 16-year-old Rindisbacher even added a guide to the figures in his drawing: left to right, they are "a Swiss colonist with wife and children from the canton of Berne, a German colonist from the disbanded Meuron regiment, a Scottish highland colonist" and "an immigrant colonist from French Canada."

The young artist has selected his characters carefully. The Scot is undoubtedly one of the original pioneers of the Selkirk settlement, conceived by the British-owned Hudson's Bay Company as a source of food for its trading posts in the west. The "immigrant colonist from French Canada" is probably not one of the *Métis* descended from the intermarriage of the *coureurs de bois* and the native people, but a more recently-arrived Québécois settler; the Montreal-based North West Fur Company, which had wanted to keep the prairies as a fur-bearing (and profit-making) wilderness, had opposed the Selkirk settlement for ten years, and had incited the Métis and native people against the Scots. The German ex-soldier would have come to the colony a few years before with the De Meuron regiment, a band of mercenaries hired by the British for the War of 1812-14 and

Fig. 79: Peter Rindisbacher (1806-34), *Colonists on the Red River in North America,* about 1822
pen and ink, 16.3 x 22.3 cm., Public Archives of Canada

Fig. 80: Peter Rindisbacher, *Men Paddling Canoe,* late 1820s or early 1830s
pencil on cream paper mounted on card, 5 1/2'' x 9 1/2'',
Glenbow-Alberta Institute, Calgary

Fig. 81: John Howard (1803-90), *Toronto Bay from Taylor's Wharf*, 1835
watercolour, Colborne Lodge, Toronto

brought to the Red River by Selkirk to fight for the Hudson's Bay Company side. The Swiss colonists may represent Rindisbacher's own family, part of a large group of Swiss immigrants who had been encouraged to come to Red River by one of the De Meuron regiment's officers acting as a land agent for Selkirk.

Rindisbacher was also perceptive of the class differences in the colony. In another sketch (Fig. 80), he shows one of the Hudson Bay Company's transport canoes with the Canadians doing all the work paddling, while the British company agents sit stiffly upright, one in a top hat, maintaining imperial decorum in the wilds! This sketch, like many of Rindisbacher's drawings, was the basis for a watercolour painting of the same scene. The strong outline was so that he could trace the sketch repeatedly for different versions.

For most of his patronage Rindisbacher had to rely on the Hudson's Bay Company officials, along with a few British army officers and the local chaplain, who was also maintained by the Company. He got a job as a clerk in the

Company's post, Fort Garry, and for several years supplemented his family income by selling his pictures there. In 1826, however, a devastating spring flood combined with an overnight grubworm invasion wiped out both homes and crop not only of the Rindisbachers but of most of the Swiss-Canadians. Many of them, the Rindisbachers included, saw this setback as a final blow and left for the United States, hoping for a kinder climate. This talented young pioneer artist of the west died there suddenly eight years later, still only 28 years of age.

Meanwhile, in Upper Canada also, the desire to depict the growing society of the colonies was leading to other instances of documentary picture-making. Architect and artist *John Howard*, who had arrived in Toronto in 1832, sketched numerous scenes of the city's buildings and inhabitants, and in the winter of 1835 painted three views of the activities on frozen Toronto Bay.

One of these (Fig. 81) offers a lively cross-section of the people who were living in Toronto about the time of the anti-imperialist revolution of 1837-39. For surely the fat

man and his wife in the well-appointed one-horse sleigh must be members of the infamous Family Compact, while the two couples passing them in the two-horse rig may be petit-bourgeois, perhaps high-ranking civil servants and their wives, probably dependent on the Compact for the slightly lesser degree of wealth they can display. The artist and his wife may be pictured on the wharf at left. To the right are the working people, cutting ice blocks from the bay and hauling them home on rough sleds. These are the people, along with the farmers and blacksmiths in the countryside, from whom the revolutionary Patriots were to draw their strongest support.

THE REVOLUTION OF 1837-39

Howard had good reason to be a fairly sharp observer of class differences in society. His first winter in the colony had been spent in abject poverty, living with his young bride in a single room with a tiny unheated attic above it that let in as much snow as it did light. It was only after he had met 'the Honourable Peter Robinson,' a prominent member of the Compact, that Howard began to prosper. Robinson introduced him to the British governor, Sir John Colborne, and Colborne saw to it that Howard was appointed drawing master at Upper Canada College, the comprador boys' training school that Colborne had founded. A year later Howard began to receive his first government architectural commissions.

So the imperial ruling class and its local lackeys used their near-monopoly of offices as well as land values and capital in the colony to get control of certain elements of the petit-bourgeoisie. Architect-painter Howard was so obsequiously grateful that he named the house he built for himself "Colborne Lodge" in what is now Toronto's High Park, after his British benefactor. He moved in on December 23, 1837, just two and a half weeks after he had enthusiastically joined the reactionary force mustered to oppose the Patriots' march on Toronto.

Obviously not all the petit-bourgeoisie could be so easily controlled. "At one-and-twenty I might have united with them," wrote *William Lyon Mackenzie*, referring to the Family Compact, "but chose rather to join the oppressed, nor have I ever regretted that choice, or wavered from the object of my early pursuit." Mackenzie had started in the colony at first as a surveyor and then as a merchant, but had taken the leadership of all the progressive and anti-imperialist forces as editor of his newspaper *The Colonial Advocate,* founded in Queenston in 1824 and subsequently moved to York. Although the poorer settlers and working people formed his main fighting force, there were also small merchants, other professionals and even a few local industrialists among his supporters, all opposed to the British monopoly of trade and the Compact's control of land. Their goals included many needed reforms such as public education and health services, civil liberties and religious equality for all, and responsible democratic government.

For over ten years the Scottish-born editor agitated and organized this widespread popular resistance. In 1826 a gang incited by the Compact dumped his press into Toronto Bay; in Hamilton six years later they tried to assassinate him. Five times over his constituents in York had to re-elect him to the Assembly, and each time the Compact contrived some way to expel him. By 1833 Mackenzie and others had begun to differ from the more moderate petit-bourgeois leaders of his Reform party by demanding outright independence from British rule.

The portrait we have of him (Fig. 82) is said to have been painted a year later, when he was elected first mayor of the newly incorporated city of Toronto. It shows a red-haired man of 39, with the directness of expression that earned the wary respect of his enemies and the admiration of his tens of thousands of followers. The portrait has darkened with the years, but what we can see of it still proclaims its sitter's complete lack of any pretentiousness or arrogance of office.

The contrast between this portrait and the much more 'official' painting of Louis-Joseph Papineau painted by Plamondon two years later (Fig. 28) is a visual reminder that, although the two leaders were allied, Mackenzie was much closer to the farmers and workers who were the revolution's main source of strength. This divergence in class orientation is also apparent in their differing responses to the test of armed struggle: while Papineau fled before the first battle and later returned to ingratiate himself with the bourgeoisie, Mackenzie led the inadequately-armed march down Toronto's Yonge Street on December 6, 1837, and refused the offer of a compromise with a resolute demand for "Independence, and a Convention to arrange details!" Papineau eventually accepted a seigneurie from the ruling class, but Mackenzie's house for his last years was bought with donations from his supporters.

The companion portrait of *Isabel Baxter Mackenzie* (Fig. 83) is even more revealing of character. After the defeat of the march on Toronto this courageous woman joined her husband and the others at the headquarters of their Provisional Revolutionary Government on Navy Island in the Niagara River, and with her own hands produced cartridges and other munitions for the Patriot troops. In this picture painted three years before, the earnest intelligence of her glance and the firm set of her lips foretell the dedication and perseverance she was to show under fire. Again, the contrast with Papineau's pampered wife and daughter (Fig. 29) is significant.

Who painted these unsigned portraits of the first Mayor of Toronto and his wife? They are sensitive and accurate depictions of character, and definitely of the period, but in the present state of our knowledge they have to remain anonymous. They might be by one of the itinerant artists who travelled from town to town selling likenesses; or they could conceivably be by Nelson Cooke. The fact that they are unsigned suggests that these two fine portraits should be considered as outstanding examples of the popular painting of talented and mostly anonymous artisans. Like so much else about this revolutionary era, they hold a promise that was never to be fulfilled.

Fig. 82: Anonymous, *William Lyon Mackenzie,* oil, said to have been painted in 1834, Mackenzie House

Cooke was definitely the artist involved in another official portrait of the time. In 1837, in a desperate attempt to solicit some sympathy for the hated British governor, Sir Francis Bond Head, the Family Compact commissioned Cooke to do a portrait of him. They then sent the picture to England to have engravings made for 'popular distribution.' But they over-reached themselves. Knowing that the project would not be widely supported in the colony, they asked young Queen Victoria to allow them to dedicate the engraving to her, as was usual in such cases. The Queen was advised that the Canadian people detested her governor, so she wisely decided against allowing her name to be used on his likeness. The proofs of the prints arrived in December, just before the armed uprising, so the whole project had to be dropped!

While the Patriots gathered north of Toronto, a large force was being raised in the area around London, Ontario; it turned back only after hearing news of the defeat on Yonge Street. In the next two years there were repeated battles not only at Navy Island but at Windsor, Kingston, Prescott and elsewhere. The only views of these battles or their sites that remain to us were painted by British officers who were stationed here to defend the Empire. If the Patriots drew or painted them, their pictures must have been burned or destroyed by the British and the comprador ruling classes, who were thoroughgoing and vicious in their efforts to stamp out all signs of the people's resistance. The same is true of portraits of the Patriot heroes, although

Fig. 83: Anonymous, *Isabel Baxter Mackenzie,* said to have been painted in 1834
 oil, Mackenzie House, Toronto

there is said to be a portrait of Peter Matthews hopefully still in existence. Anyone who knows of it or other Patriot art could be of great service to the people by making such paintings public.

After the revolution, the comprador patrons of portrait painting grew even more reactionary, just as they had in landscape painting. In the 1840s they returned portraiture to the colonial status it had held in the days of Berczy and Field, by giving almost all the official commissions to two recently-arrived European artists who had the proper credentials. Their names, and many other details about them, are well known.

One of them *Hoppner Meyer,* came from a German family of artists who were well established in London; the other, *George Theodore Berthon,* claimed even higher imperial associations. Son of a French court painter to Napoleon who had studied with Jacques-Louis David during the neo-classical master's period of service to the French emperor, Berthon himself had taught drawing for several years to the daughters of a British aristocrat and had painted portraits of the English ruling class successfully for over ten years before coming to the colony. His derivative and restrained colonial version of something like David's imperial manner of flattering Napoleon suited the Canadian compradors of the British empire in North America perfectly.

Sir John Beverley Robinson, for one, was so pleased with the large official portrait Berthon did of him that he

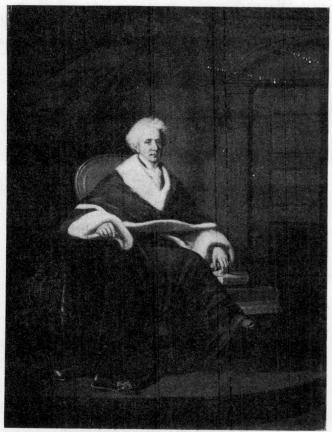

Fig. 84: George Theodore Berthon (1806-92), *Sir John Beverley Robinson,* oil, 24" x 18", National Gallery of Canada

Very few of the portraits of the bourgeoisie are this interesting; Berthon and subsequent official portrait painters, like Hamel in Canada East, soon settled down into the steady production of routine canvases. Where a revolutionary victory might have inspired a whole generation of portraits of the leaders and heroes of a new nation, the confirmation of the Family Compact in its place and the gradual introduction of some of the reforms Mackenzie and the others had fought for, after the Act of Union in 1841, encouraged a safe, conservative approach by portrait painters who knew how to keep the imperial standard of judgment in mind.

Some of the portraits of the petit-bourgeoisie are more exciting. Perhaps the most appealing is the picture of *Dr Margaret Cuthbertson Smith* (Fig. 85), who is said to have been Canada's first woman doctor. She and her husband Robert were painted in Kingston in 1842 by an otherwise unknown artist named *William Hale.* He was probably one of the many itinerant portrait painters who continued to travel from town to town seeking commissions like this one until the middle of the century.

For his portrait of this very advanced woman, Hale chose a character study that suggests an inquisitive and thoughtful nature. Her finger to her lips, this early leader in the struggle to change women's position in the colony pauses in thought as she reads a letter; adorned with her Cuthbertson family tartan, she has put a ring on almost every finger to have her portrait painted in her finery. This may have been at the suggestion of Hale, who obviously enjoyed the challenge that this variety of colour

ordered a smaller version for himself (Fig. 84). It shows us Sir John (brother of the Peter Robinson who had 'befriended' Howard) in his robes as Chief Justice, in which position he had sentenced many of the Patriots and refused to relent to either the petitions of the people or the pleas of the heroes' families when Lount and Mathews were hanged. Robinson sits removed from us on a raised dais, almost a throne, surrounded by the trappings of office, a heavy courtroom door and some studio drapery wrapped around a thick circular column that is supposed to symbolize the strength and stability of the judge's bench.

Berthon's portrait is in every way fitting. The figure of the sitter is almost swallowed up by his robes and furnishings—it's clear that he would be nothing without them. His left hand riffles through the pages of a law book, while his right rests on a table draped with the royal standard, both symbols of oppression with which he hopes to justify his crimes against the Canadian people. He fancies himself a little Napoleon, and in his face we can see his scorn for the people. What a difference from Mackenzie's forthright gaze! Looking haughtily off to our right, his legs crossed and his foot raised high, Robinson expresses his disdain for all except his imperial masters. Ironically, Berthon's portrait conveys precisely that isolation from the people which is one of the chief characteristics and greatest weaknesses of the comprador class.

Fig. 85: William Hale, *Dr Margaret Cuthbertson Smith,* 1842 oil, 30" x 26", Winnipeg Art Gallery

A Nation of Canadians 93

and texture in both costume and jewellery afforded him.

Judging from his limited ability at modelling, Hale was probably self-taught, but the sophisticated pose and conception of this portrait suggest that he was familiar with Renaissance portraits, or at least engravings after them. He may have been a well-educated British settler who turned to painting likenesses for a living after his attempts at farming failed; Susannah Moodie's *Roughing It in the Bush* and other accounts of the time tell many similar stories of the hard life of pioneer farming in eastern Ontario.

A few years later photographed portraits began to appear. By the 1850s they had started to replace paintings. In the following decade *cartes d'identité,* little portrait photographs mounted on cardboard, were being widely used as calling cards and personal mementoes. Many people who might have commissioned paintings now settled for photographs; painted portraits were soon limited to the upper ranks of the bourgeoisie, and then mostly for offical purposes such as a board room or government chambers. Canadian portrait painting here died a quiet, dignified death.

The conservative effect of the defeat of the revolution was even more telling for the painting of people in the landscape. *A View of King Street, Toronto* was painted in the early 1840s, but it is probably just a continuation of earlier views of the city done before 1837 by the architect-artist *Thomas Young,* to whom it is attributed. For the most part the confidence in the people as belonging to a new nation, and therefore the self-confidence for the artist to document our own people in our own land with a strong sense of purpose, was set back for at least a generation.

THE ART OF PAUL KANE

We can see this most clearly in the work of Paul Kane. Born in Ireland, he had been brought to Toronto as a child about 1820, and tried to make his living in the mid-1830s in Cobourg and Toronto with a combination of sign painting, furniture decoration and the few portrait commissions available. He followed two travelling American painter friends to Detroit, and then worked his way south, painting the captain's portrait for a ride on a Mississippi steamboat down to Mobile, Alabama, where he carefully saved the money he could make from his portraits to pay for a trip to Europe.

By the time he had toured Italy, visited Paris and arrived in London, Kane was obviously a young man looking for his direction in life. The remarkable thing is that he found it in the imperial centre, London, when he heard a lecture by the American artist, *George Catlin,* and saw Catlin's already renowned pictures of the native people of the American west. Kane recalled the natives he had seen in Toronto, and resolved to do the same thing with Canada's native people as his subject matter, especially in the northwest, before their culture too was engulfed by imperialism along with their land. (This was a favourite theme of Catlin's.) After two more years of portraits back in Mobile to repay the loan he had had to take to pay for his return passage,

Fig. 86: Paul Kane (1810-71), *Ojibway Chief Mani-tow-wah-bay,* 1845, oil on paper, 11 3/4" x 8 7/8", Glenbow—Alberta Institute

Kane came back to Toronto and began to prepare for his journey north and west.

Had this ambitious and talented young painter been able to return to a newly independent nation at this time (1845), he might very well have been attracted by the subject matter of that nation itself—its heroes, its leaders, its recent revolution and its struggles to survive and grow. As it was, with the revolution of the previous decade defeated, he was virtually unable even to *see* any Canadians other than the native peoples as subject matter for the major canvases he intended to paint.

His approach to the subject matter he did see is also instructive. In the more than 500 sketches he painted during his famous 2-1/2-year journey by the most difficult and devious routes all the way to Vancouver Island and back, he was primarily anxious to document the scene or figure before him. He often had to paint hurriedly, and in some cases to record the features of a most reluctant and suspicious sitter. *Mani-tow-wah-bay,* for instance (Fig 86), an Ojibway chief painted during Kane's preparatory trip to the Georgian Bay and Lake Michigan areas, would only consent to pose after Kane had convincingly lied to him that his portrait would be sent as a kind of ambassador for his people to Queen Victoria.

This attitude of kindly condescension can be seen throughout the book that Kane eventually published on his travels, *Wanderings of an Artist among the Indians of North America*. But the underlying fact that his basic approach to the native peoples was not to document them but to use them as exotic subject matter for his artistic purposes is most evident in the canvases he worked up from his sketches after his return to Toronto.

Blackfoot Chief and Subordinates (Fig. 87) is one of the twelve paintings commissioned by the colonial legislature after Kane's triumphant return exhibition of some 240 of his sketches at the Toronto City Hall. As with the painting of the Micmacs, we can appreciate its documentary value. It records a tribal council at which Blackfoot Chief Big Snake and other Blackfoot leaders gathered. Kane had sketched all of them on the spot.

But the painting is not really a documentation. In his studio canvas Kane has assembled his subjects like fashion models to be presented as exotic curiosities before his repeated romantic convention of a blustering stormy sky. Little more than clothes horses, they are not far removed from the racist 'cigar store Indians' carved in wood that were used to advertise tobacco shops.

In *Assiniboine Hunting Buffalo* (Fig. 88), Kane goes even farther. Using sketches of a buffalo hunt that he observed in Alberta near the foot of the Rockies, Kane has here placed his figures into a composition directly derived

Fig. 87: Paul Kane, *Blackfoot Chief and Subordinates*, 1851-6, oil, 25" x 30", National Gallery of Canada

from an 1815 print by an Italian artist named *Bartolomeo Pinelli*. The print, which Kane had picked up in Rome, shows two Italian youths chasing a bull. Kane has simply substituted his two Assiniboine hunters and a buffalo in

Fig. 88: Paul Kane, *Assiniboine Hunting Buffalo*, 1851-6 oil, 18 1/2" x 29 3/4", National Gallery of Canada

Fig. 89: Paul Kane, *Brigade of Boats,* 1850's
oil, 18" x 29", Royal Ontario Museum

exactly the same composition, replacing one exotic subject with another.

Further, the horses on which he had placed his riders were certainly not seen on the prairies. These Arabian steeds have also been derived from European painting, not only from Pinelli but probably also from the French romanticist painters *Théodore Géricault* and *Eugène Delacroix*, whose pictures Kane had almost certainly admired in Paris.

While Géricault was the more celebrated painter of such noble mounts, Delacroix had been the foremost artist to 'discover' exotic subject matter in the areas of North Africa and the Arab world that were then coming under French imperial control, following on the French conquest of Algeria in 1830. As Delacroix had relished such French-colonial subjects as his *Algerian Women* (painted in an Algiers brothel), so Kane similarly exploits the exotic appeal of the native peoples of the west. *Wanderings of an Artist* was well reviewed in Paris and London by sympathetic critics who lamented the imminent "disappearance" of these "forgotten peoples." One of them gave the native cultures only two generations at most to survive.

The reason for this difference between his documentary sketches and the exotic and exploitative use he made of them after his return to Toronto is easy to see when we consider the patrons Kane found it necessary to paint for.

To make his trip possible in the first place he had had to obtain the patronage of Sir George Simpson, head of the Hudson's Bay Company, who allowed him free transportation in the Company's canoes and free board and lodging at the Company's posts and forts. Upon returning Kane tried to get government backing to publish his book, but finally had to be satisfied with a 500 pound commission for twelve paintings and a two-hour eulogy of his efforts in the legislature. His greatest ambition was to paint a 100-canvas cycle from his sketches, and for that project he eventually found a buyer (at $20,000) in 'the Honourable' George Allan, a wealthy MP who hung them in his Toronto mansion.

Thus Kane was obliged to turn what he himself thought should be a government-subsidized undertaking (including a projected public gallery for the 100-painting cycle and an edition of popular prints) into a series of commissions for private buyers who were also the caretakers of the colony for its British rulers, and therefore decidedly pro-imperialist in outlook. Small wonder then, given Kane's own condescending attitude to his native subjects and the stylistic influences on him from his European tour, that he should cater to his patrons' taste for the exotic and at the same time seek to present his worked-up canvases as part of the most advanced European painting tradition he knew of.

Fig. 90: William G.R. Hind (1833-89), *Indian or Metis at Work on Red River Cart*, 1862
oil on board, 9 1/4" x 12", Toronto Public Library

These comprador patrons shared the imperialists' viewpoint: they did not want to see native people living in their own country but 'exotic creatures' in a 'picturesque' setting that they, the bourgeois agents of British capital, could exploit and profit from as they wished.

So even when Kane turns to the industries of the northwest for his subject matter, as in his *Brigade of Boats* (Fig. 89), he has to represent them in a European manner. His subject here is the fur-trading fleet returning to the post at Le Pas, Manitoba on the Saskatchewan River; but the landscape is treated as a romantic European marine painting, with the tossing waves in the foreground dramatically lit from the billowing sky behind, and the picturesque tree tossed by the wind to the right. The boats themselves with their sails bellied out make a grand impression, but the atmosphere lent by the passionate highlights and shadows is taken from earlier Italian painters like *Salvatore Rosa* whose work must have impressed Kane in Italy. In all Kane's canvases his colonial subject matter is subordinated to the imported style through which he interprets his subject.

THE DEPICTION OF WORKING PEOPLE

We can appreciate how much this concern for the exotic and the picturesque affected Kane's vision if we contrast his paintings with those of *William G.R. Hind*, another artist who sketched as he travelled throughout Canada. Before coming to this country in 1852, this British-born painter had been trained in the manner of an English group of artists called the Pre-Raphaelite Brotherhood. Some of these painters thought of themselves as harking back to the values of mediaeval Italian painting 'before Raphael'. Others were more scientific, and were even interested in depicting industrial labour. They all painted in a vividly coloured, painstakingly detailed manner. Hind was of the more scientific group, and favoured subjects from everyday life, especially from the life of the working people whom he encountered in his travels. He made faithful depiction of that subject matter his first concern in his art.

When Hind followed Kane's footsteps west by joining

Fig. 91: William G.R. Hind, *Lumbering,* early 1860's, oil on board, Toronto Public Library

were rolling westward. These huge-wheeled carts were a unique invention of the Métis people, perfectly adapted to the muddy prairie trails.

This very believable worker, in plain white shirt and black pants, looks at his portrait painter with a guarded glare; nine years later he was probably one of the Métis whom Louis Riel was to call on to defend their Manitoba homeland from the chauvinist aggression of Sir John A. MacDonald's comprador Ottawa government. Hind sets down his sitter's expression along with every other detail as accurately as he can, being careful to note the jackplane on the workbench, and exactly how the four sections of the rim of the finished wheel on the left dovetail together in zig-zag joints. Hind's interest is that of the scientist, as he documents with equal accuracy the worker, his production process, and the landscape in which he is fully at home. This is vividly realistic painting.

Either on this same trip in northwest Ontario, or on the way to Labrador with his brother's exploring and surveying expedition a few years earlier, Hind painted three pictures that similarly document the lumbering process, still today the leading industry in the country. One painting shows the tools of the trade with a felled tree; another depicts workers about to haul the log away. The third (Fig. 91) is a rather awkward depiction of a lumberman in the act of chopping down a tree, just at the moment when the axe is swung furthest away from the trunk. The figure is slightly stiff, and the picture lacks the sense of life and labour, but certainly Hind must be credited with having

the Overlanders' expedition to the Cariboo gold fields of British Columbia in 1862, he too paused at Fort Garry; but the Métis or native subject he chose to record there (Fig. 90) was not a chief dressed up in his regalia for some ceremony, but a wheelwright who has paused for a smoke while working on one of the massive wheels for the Red River carts in which the pioneers and prospecters, including Hind,

Fig. 92: William G.R. Hind, *Chinese Gold Washers on the Fraser River, B.C.,* 1862, watercolour, 5 1/2" x 9", McCord Museum, Montreal

Fig. 93: William G.R. Hind, *Mining in British Columbia*, about 1862-3 oil on board, 8″ x 12″, Toronto Public Library

advanced the tradition of social documentation to the specific subject matter of Canada's resource industry workers in paintings like these.

When Hind arrived in the gold fields, it was the Chinese-Canadian workmen patiently washing the last traces of gold from the Fraser River between Yale and Hope, B.C. that caught his attention (Fig. 92). These determined immigrant workers, who had moved north from California, had stayed behind to sluice out the gold dust remaining in sandbars that others had considered 'panned out' five years earlier, while moving on to search for higher-yielding streams. Again, Hind represents these workers engrossed in their job, toiling patiently in the western landscape, without any hint that they should be considered as exotic subjects for a picturesque view.

In another picture of *Mining in British Columbia* (Fig. 93), Hind was equally attracted by the rugged landscape. Rich in colouring in the woods to the left and in the reflections in the stream, with each stone in the foreground painted with typical Pre-Raphaelite precision, this little painting depicts the gold sluices with two men at work on them. The two workers (by the nearer sluice) are seen as an integral part of the landscape, as are their constructions and

the house on the hillside behind. The splendour of the landscape even anticipates the colour and verve with which *Tom Thomson* and the Group of Seven were to paint the Ontario northland, especially in their views of workers on the log jams and dams.

While Kane's paintings had been widely heralded, and even attracted a conscious follower in the person of *Frederick Verner*, who first tried to study with Kane and then set out to paint buffalo and native figures in the west from much the same exotic and picturesque viewpoint, the realistic and virtually scientific achievements of Hind remained relatively little known. His only significant patron was his brother, Henry Youle Hind, who once complained of the poor placing William's paintings had been given in a Toronto exhibition, and used his sketches to illustrate the official report of their Labrador explorations.

Hind himself spent a year or two in Victoria, enjoying a few local commissions and painting at least one tavern sign to earn his keep, then finally returned to the east where he got a job on the railroads in the Maritimes. There he filled sketchbooks with scenes of the docks and mines for a few years, but appears to have exhibited almost nothing. He retired at last to the town of Sussex, New Brunswick, where

Fig. 94: Caroline Walker (active 1859-80), *Gatling Gold Mine, Marmora, Ontario,* 1872
watercolour, Baldwin Room, Toronto Public Library

he died in 1888.

Obviously there was a big market among the comprador patrons for Kane's and Verner's kind of painting, but very little for Hind's. In his last years Hind probably did not even think of himself as an artist. Even today, while the name of Paul Kane is taught in many of our schools, Hind's would hardly be recognized.

Yet it was Hind, not Kane, who extended the documentary approach to the Canadian figure that artists like Rindisbacher had begun, and most particularly directs our attention to the working people and their actual production processes in this land. Hind's little pictures are a major step forward toward a people's art. But the bourgeois patrons of his day were not interested, so he ceased to function as an exhibiting artist.

Other painters were also interested in these subjects, although they too received little encouragement from the patron classes. We have to find out more about them. *Caroline Walker,* for instance, was an art teacher at Bishop Strachan School in Toronto in the late 1870s, and advertised her services as a portrait painter. She appears to have been a watercolour artist of competence, but it is her choice of subject matter, in line with this tradition of documentary realism, that is significant. In 1865 she exhibited pictures of oil wells in operation at Bothwell, Ontario, and in 1872 she sketched a large watercolour scene of the *Gatling Gold Mine* at Marmora, Ontario (Fig. 94).

The view includes a few houses and the road through the woods to the right, but the artist's main interest is drawn to the process of open-face mining in the Ontario bush. She

shows us the boss on a horse, perhaps discussing production with a foreman, and the workers hard at the pick-and-shovel operation of the mine. She also enjoyed the colour and texture of the surrounding woods.

"Mrs. Walker," as she signed herself, may have intended to exhibit this picture, like her oil well paintings, in the Upper Canada Provincial Exhibition; if so, she must have expected an interested public. Marmora had been known as a mining centre at least since the days of Mackenzie, who had praised it as a Canadian source of iron in his newspaper.

So-called 'primitive' painters also continued to produce documentary realist works. In 1876, an Acadian prisoner in the Saint John, New Brunswick city jail may have earned his release with a spirited painting of the jail building that he wittily entitled *Hôtel de Rankine* (Fig. 95), after its warden, John Rankine.

This anonymous artist subtly asserts the building's function, by recording each rectilinear stone block, window pane and railing picket. His calibrated recession in space interlocks neatly with his meticulous attention to frontal detail. He is careful to catch the exact tone of beige or grey in each addition to the main building, and enlivens his picture with the green of the window shades and doors on the right, and the red of the chimneys and coloured glass panes around the centre door. A large red ensign floats in a blue sky full of white cumulus clouds that are painted with a remarkable sense of space and atmosphere. A man in a four-wheel carriage with an animated horse, two figures at the left who may be Rankine and one of his policemen, and the matron at the dark doorway revealed only by her white

Fig. 95: Unknown Acadian, *Hôtel de Rankine*, 1876
oil, 15 3/4" x 21 1/2", The New Brunswick Museum, Saint John

apron and a touch of paint for her face and hand, all add to the appeal of this delightful canvas. It was to remain a realistic document far longer than the artist knew: constructed in 1836, this stone block building is still the Saint John jail!

Acadian culture had been practically exterminated by the British army in the 1700s. In the late 1800s the Acadians of eastern New Brunswick were still re-establishing their farms, villages and towns. Only recently, with the founding of an Acadian Museum at the *Université de Moncton*, have we begun to rediscover what remains of this important part of our cultural heritage. This canvas suggests that there may have been a documentary tradition of artisan's painting, perhaps not unlike the Québécois votive painters' art of the everyday lives of the people.

So we are able to recognize a strain of *documentary realism* that keeps re-asserting itself in early Canadian painting despite the comprador patrons' insistence on having things look European. *It is the practice of recording social reality as the artist finds it, with the artist preferring the discipline of his observed subject matter to any stylistic concern.* This documentary tradition provided us with the first visual records of our nation in day-to-day life.

But we can also see why painting of the Canadian figure in the landscape was not more extensive. The British imperialist and Canadian comprador patrons wanted to see the land as picturesque, not as a country in which a nation of people lived and worked. They rewarded artists like Kane for representing the native people as exotic curiosities in this picturesque land, but since scenes of English-speaking Canadian colonials could not be construed as exotic or picturesque, they virtually refused to acknowledge the people's social documentary painting as art. There was no place for the Canadian in their picturesque Canada.

3. Imperialism and the Art Schools in Paris

By the year 1877 *Robert Harris* of Charlottetown, P.E.I. had acquired considerable facility as a painter. His decision on an artist's career had been confirmed ten years before by a tour of the galleries in England. He had then saved his money from his surveying work to study painting in Boston, and for three months (all he could afford) in London, England. He had even maintained a studio for a year in Boston.

Yet Harris knew that his training would not be complete until he had studied for at least a season in one of the *ateliers* (studios) of the leading artists of the French academy in Paris. So in 1877 Harris joined thousands of others from all over the world, there for the same reason.

Crowded into miserable lodgings and eating the cheapest food, this 'international set' of impoverished art students counted themselves lucky if they managed to receive one or two grudging comments a year from one of the remote French masters. They worked hard to acquire the rigidly exacting French academic drawing and under-painting technique: the method was endless repetition of studies, first of plaster casts and then from a live model.

Once they were reasonably proficient, they tried desperately to get one of their paintings selected by the jurors to be hung in the annual Paris exhibition called the *Salon*, named for the room in which it was originally held. Inclusion in the Salon could launch a career, prominent inclusion could make one. The jurors were drawn from the same group of French academic masters as the remote instructors.

Why were Paris exhibitions so important? The mere acquaintance with a leading French painter an invaluable asset? Why, in particular, did Canadian and Québécois artists flock to Paris in such numbers?

By the 1870s, capitalists in the imperial countries had begun the process of monopolization in all the major industries. The huge monopolies and cartels fixed prices and manipulated trade. They developed large pools of excess capital which they then exported because a higher rate of profit was obtainable in the colonies.

In Canada, British capitalists began by investing their excess capital in railways and the industries that followed the rails. By 1914 they had invested over $2 billion. Canadian compradors were now given new opportunities to act as agents in finding profitable fields of investment—by selling out. They could get a piece of the action by investing Canadian capital as well, much of it stolen from the public purse.

By the turn of the century, greater profits were being made in the imperial centres from the export of capital than from the export of commodities. Under imperialism, the highest and final stage of capitalism, the ruling class is no longer primarily the industrial bourgeoisie but the finance capitalists, or imperialists. Whoever controls the banks controls the flow of finance capital, and by directing investment controls the colonial nations. Political power changed hands with economic power.

There was a mad rush for colonies. Europe, the United States, and Japan now divided the whole world into spheres of control. When claims conflicted, they went to war.

We have already seen how paintings have been used for propaganda purposes. Art now came to be used on a much wider scale. Because its effect is not limited by language, and yet it can carry a highly specific ideological message, painting has been of great value to the imperialists, especially after new reproduction techniques made the painters' images available to more and more people.

The nature of the art market also changed. Although paintings under the capitalist system had long been commodities for purchase and resale, they now began to have investment value. Speculating in the art treasures of the centuries could be profitable—like speculating in stocks and bonds. It became necessary to extend even greater control over the content and market value of works of art. Just as capital and industry had been centralized to ensure control, so was the international market for art.

Paris was the inevitable location for this world art centre. Although France was only the No. 2 imperialist power (after England), its kings and aristocracy had developed the most effective system of state control of the arts and sciences in Europe: the Academy. Although French revolutionary artists like David had tried to destroy the Academy, the bourgeoisie under Napoleon tightened their control. Napoleon had also plundered Egypt, Spain, Austria and Italy of some of their most valuable artistic treasures and brought them to Paris, making it a formidable international storehouse of art.

Of all European countries, France was the most torn by revolutions. 1789, 1830 and 1848 revolutions had been reflected in French culture by whole generations of artists through succeeding styles of neo-classicism, romanticism and realism respectively. The ideological and stylistic controversies of the century were most sharply contested in Paris.

Coming from a colony, anxious to learn to please their comprador patrons, Canadian and Québécois artists were apt to fall into the iron grip of the Academy. Yet artists who had any feeling for the oppressed at home were also bound to be attracted to some extent by those French painters who opposed the Academy and took the working people as their subject matter.

This conflict between the desire to become a successful academic artist and to paint the truth of our colonial experience is evident in the career of Robert Harris.

Harris returned to Toronto in 1879, where his Paris credentials immediately began to earn him commissions. In the following year he was elected vice-president of the Ontario Society of Artists and appointed a charter member of the new Royal Canadian Academy. Two years later, he had made enough money to pay for a return visit to Europe.

In 1883 Harris set up his studio in Montreal, where he received a $4,000 commission from the Canadian government that was to establish his reputation. *The Fathers of Confederation* (Fig. 96) was originally intended to commemorate the Charlottetown conference of 1864, but the

Fig. 96: Robert Harris (1849-1919), *The Fathers of Confederation,* 1883-4
Destroyed by fire in 1916. from a photograph in the Public Archives of Canada

commission was switched to the Quebec Conference of later that year because it included twelve more 'Fathers.' The painting itself was destroyed in the fire that burned the Parliament buildings in 1916, but the charcoal drawing for it, apparently the same size as the canvas, is almost twelve feet long and still hangs in the Parliament buildings.

Judging from the photograph that remains to us, Harris's picture was a mammoth exercise in academic painting. He carefully collected details about the appearance of each of the 'Fathers', used photographs and sent out questionnaires to friends and relatives if the subject was no longer living. He did his best to dignify them by posing them against the light of the conference room windows. But it is a dull, uninspired collection of bourgeois faces.

The painting was commissioned to hang, suitably enough, in the Railway Committee Room of the House of Commons. At this time, the Government was desperate to complete the Canadian Pacific through to B.C., a condition that the west coast businessmen had set for their entry into Confederation. Sir John A. MacDonald, Prime Minister and head of the Railway Committee, figures prominently in the picture. It was later revealed that many of his government's members of Parliament were at this time accepting bribes for supporting bills to grant millions of dollars and enormous land privileges to the railway promoters.

The painting was delivered in the spring of 1884. In years to come, ignoring Harris's attempt to retain control of the copyright, the government actively encouraged its widespread reproduction in newspapers, magazines, school textbooks and even on railway dining car menus!

Harris had set out to paint what he called "a valuable historical document." He did better than he knew. The painting truthfully reflects the formation of Canada as a single unified *colony* by these drab businessmen. While Confederation was a step forward in keeping Canada out of

the clutches of a rising U.S. empire, these sell-outs had banded together to figure out how to make more profits for their British masters and themselves. They required a stable, centralized country to administer their investments, especially in railway building, so they merged the provinces just as they might have merged their firms in one vast joint-stock company. As George Brown, one of the 'Fathers,' declared just a few years before Confederation, "If Canada acquires this territory (the west) it will rise in a few years from a position of a small and weak province to be the greatest colony any country has ever possessed."

The Fathers of Confederation is the most successful propaganda picture for the comprador bourgeoisie in the history of Canadian painting. It promotes the lie that Canada achieved independence by peaceful transition. Canada was not an independent country in 1867, nor is it today. The real mothers and fathers of our independence are the working people who have struggled to build our land, and are still fighting for its liberation. In Harris's time as today, these are the people whose portraits should be painted.

But Harris admired the working people of his own day. He expressed his respect for them in his famous *Meeting of the School Trustees* (Fig. 97), first exhibited in the Royal Canadian Academy show in the spring of 1886 with the title "Meeting of Trustees of a Back Settlement School—The teacher, talking them over."

This painting, one of the first purchases of the National Gallery of Canada, has been a popular favourite with Canadians from the day it was first displayed. Its strength lies in the fact that it is based on the actual living experience of the people. Harris had visited an uncle at Long Creek on Prince Edward Island the previous fall, and talked with a teacher there named Kate Henderson, who told him how she had to "talk over" the four farmers who

Fig. 97: Robert Harris, *A Meeting of the School Trustees,* 1886
oil, 39 1/4" x 48 1/2", National Gallery of Canada

were her school trustees.

Back in his studio in Montreal, Harris had his wife Bessie pose as the teacher, imagined four sceptical Island farmers and reconstructed the setting from his own childhood schoolroom memories. The reflected light from the window on the left outlines the teacher's head in dramatic profile. The inkwells, slates and desks nostalgically recall our earliest school days.

This scene has endured as a symbol of Canadians' determination to establish and develop a culture here. Whether "Kate Henderson" is arguing for more investment of the community's resources in education or for some reform in the schools we cannot be certain—some have suggested that she may be demanding a raise! But she stands for those tens of thousands of teachers, most of them women, who have brought literacy to rural settlements and have struggled to improve their schools under difficult conditions.

PAINTINGS OF FARMERS

Another artist who painted colonial life was *George Reid*, whose *Mortgaging the Homestead* (Fig. 98) was exhibited at both the Royal Canadian Academy and the Ontario Society of Artists exhibitions in 1890. Reid had studied under Harris in Toronto and with the American realist painter *Thomas Eakins* in Philadelphia. He had then spent the mandatory 'finishing year' in the Paris academies, and had

returned to Toronto just one year before painting this canvas. But it is his boyhood origins on a farm near Wingham, Ontario that he drew on to conceive this moving scene: a homestead farm is being mortaged to pay debts.

How often Reid must have heard of such an event in the lives of the southwest Ontario farm families around him as he grew up! It is the turning point of defeat for the family's independence, as we can see from the utter dejection of the older generation on the right. The pride of the pioneer farmer in his self-sufficiency crumbles as the mortgage agent brusquely points to the dotted line that the head of the household is reluctantly signing. In the foreground a young daughter looks up from her play uncomprehendingly, but the wife and mother cradles her baby and gravely contemplates the future. In a sequel but less successful painting, Reid went on to paint *Foreclosure of the Mortgage,* with the father of the family on his death-bed and a bank manager come to announce the grim news.

Reid's paintings record the economic reality of Canadian rural life: farmers driven off their land by imperialist-controlled banks and trust companies. Because Canadians have recognised the authenticity of this painting in our history, *Mortgaging the Homestead* has been popular Yet artists like Reid could only identify the plight of the farmers and elicit sympathy for them, never showing the actual fight against the implement monopolies and the banks that was developing, especially in the west, in the

Fig. 98: George Reid (1860-1947), *Mortgaging the Homestead*, 1890
oil, 50 1/2" x 83 1/2", National Gallery of Canada

1880s. This concern with plight rather than fight is at the very basis of academic genre painting as it was then being promoted in Paris.

Sentimental paintings that showed the people ever poor and defeated were among the hits of the annual Salon. The imperialist bourgeoisie appreciated large-scale canvases that illustrated, either from literature or from life, those virtues which kept the people in their place. In another painting, Reid showed this whole farm family on their knees in prayer. For propaganda purposes, nothing could beat faith, hope and charity. Let the farmers and workers see themselves as objects of pity. Never show the workers' strikes. Never show them at work where they have the power to control the means of production.

It was the revolutionary French artist, *Gustave Courbet,* who broke the rules and first portrayed working people as heroic figures. His *Stonebreakers* of 1849 shows two peasants doing forced labour on the country roads. This painting was rejected by the Salon because the bourgeoisie was outraged that an artist would paint working figures larger-than-life-size. Such honour should be reserved for the aristocracy, or a businessman, at least! The peasants in Ornans, Courbet's home town, took the opposite view. One is recorded as saying, "This painting should hang in the church, in place of the altarpiece."

Courbet proclaimed himself a realist and a socialist. Rejecting all idealization in art, he held that only realism was truly democratic and that the worker and the peasant were the noblest subjects for the artist. This was *social realism,* an advance over documentary realism. For it not only recorded the life of the people, but also their heroism.

Courbet followed his art into action. When the Paris Communards took and held the city for several months in 1871, he was among them. After the fall of the Commune he was jailed, and then forced into exile where he died.

During his lifetime, Courbet's works were refused by the official Salons. In 1855 and again twelve years later he boldly mounted one-man exhibitions (the first in world history) to get his pictures seen by the public. By the time Canadian artists were gathering in Paris, his landscapes and some of his other paintings might be seen, but for the most part his socialist art was known only by reputation. Canadians who were interested in the painting of working people were more likely to be influenced by another French artist, *Jean-François Millet.*

Millet was a fatalist, who saw toiling peasants as a symbol of man's lot, born to labour on this earth. He 'sympathized' with them from the viewpoint of the manor, as eternally attached to the land.

This pessimistic view played into the hands of the bourgeoisie of Europe who, following the example of the aristocracy, used the peasants as a reserve force against the revolutionary working class. Marx had pointed out (and the fall of the Paris Commune had confirmed) that the workers could not win without an alliance with the peasants. Paintings that glorified the backwardness of the peasants helped the bourgeoisie to divide workers from this vital support, especially some of Millet's pictures that were widely reproduced.

One artist who was most impressed by Millet's pictures was the son of a small-town mayor from the eastern townships of Québec, *Wyatt Eaton.* Eaton even went to live in the same village as the French artist, in the rustic Barbizon area of France.

Fig. 99: Wyatt Eaton (1849-96), *The Harvest Field,* 1884 oil, 35 1/2'' x 46 1/2'', Montreal Museum of Fine Arts

The Harvest Field (Fig. 99), painted in 1884 after Eaton's return, illustrates Millet's fatalism about 'the peasant's lot.' The women rests from her labours at the harvest, but her serious face is deep in shadow, as she turns away from the warm sun. The child in her lap must grow up to take his place beside her husband, who bends to his toil behind her.

This painting has the gravity of treating a farm family seriously as the subject for a major work. But only as eternal sufferers, one generation replacing another, forever bending their backs. In fact, the family appears as the most exploitable natural resource, capable of infinitely replacing its labour power. R.B. Angus, the notorious Bank of Montreal and CPR millionaire racketeer, was well pleased with it, and presented it to the Art Association of Montreal (now the Montreal Museum of Fine Arts) in 1889. Eaton subsequently made his fortune by painting society portraits in Montréal and New York!

But while farmers were being painted in this way, the new industrial working class was hardly depicted at all. The only Canadian painter who went to Paris and then painted workers was *Blair Bruce.* His father had been a worker in the Hamilton Iron Foundry, and the artist may have been recalling scenes he had witnessed as a boy when he painted *The Smiths* (Fig. 100), a large canvas showing a group of workers prying up an iron wheel mold from a primitive smelter. His Hamilton background may account for his interest in the subject, and the heroic role in which he casts the workers.

But even this much reflection of the Canadian working class is highly questionable, because Bruce had not returned to Canada except for a single visit since he had first gone to Paris thirteen years before. *The Smiths* are almost certainly. workers on Gotland Island, Sweden, where the Hamilton-born artist regularly spent his summers with his Swedish heiress wife. When he did bring her back to Canada with him for a visit again in 1895, they went to a reserve to paint

the 'colourful' native people! *The Smiths* was first exhibited in Stockholm and Paris in 1907, a year after Bruce's death, and acquired two years later by the National Gallery.

Bruce's residence in Europe was a coming trend. *Paul Peel,* a talented young artist from London, Ontario, had also gone to Paris in 1881, and except for a few visits home remained there. He was the hit of the 1890 Salon with his painting of two nude children warming themselves at a fireplace. Entitled *After the Bath,* this grossly sentimental picture was bid on by the actress Sarah Bernhardt, but finally purchased at an even higher price by the Hungarian government for its state museum. It eventually ended up, suitably enough, in the Oshawa collection of one of Canada's richest compradors, R.S. McLaughlin of General Motors (Canada) Ltd.

Peel was evidently appealing to the international clientele that was now to be found at the Salons. His fast-rising career was cut short two years later by his sudden death from tuberculosis. Still, he had pointed the way: if you wanted to be an artist you had to go to Paris, and if you wanted to be really successful, you had to stay there.

THE ART OF IMPERIALISM AND THE PAINTING OF OUR LANDSCAPE

This was the Paris that *Maurice Cullen* and *James Wilson Morrice,* born within a year of each other, came to from Montreal in 1888 and 1890 respectively.

Cullen and Morrice lived through the remarkable period in which imperialism completely changed the world, and the face of art. In varying degrees, both participated in that supposed transformation of the basic values of painting in which artists heard for the first time the notion that the subject matter of a work of art is insignificant. *Formalism* is the pursuit of form in painting (compositional balance, colour, contour, texture, tone and so on) for its own sake.

Although it did not appear so at the time, the evolution of formalism can now be recognized as the development of the pictorial art of the age of imperialism. Just as capitalism had given rise to the portrait, the landscape and genre, so imperialism demanded an art that reflected its particular values and needs.

Fig. 100: Blair Bruce (1859-1906), *The Smiths,* 1894 oil, 49'' x 77'', National Gallery of Canada

The new patrons did not have the same preferences as the previous ruling-class buyers. Although they could not take over the market right away, their ideas began to be reflected in the cultural superstructure at the same time as they were able to assert real power in the world. In countries like France and England, that had exploited mercantile colonies for centuries, the old capitalist class continued to dominate patronage for a longer period of time. But in the nations newer to imperialism it was easier: while Paris remained the world art centre, the market for many of the new experiments in art was to be found in the United States, Germany and Russia.

Since imperialism is simply the final stage of capitalism, not a new social system, there could be no question of fundamentally new subjects for painting as there had been with capitalism itself. New subjects arise only when a new class force is taking power; imperialism still meant control by the bourgeoisie, only now this control took in the entire world.

Being the last phase of capitalism, imperialism is essentially a social and political system in a state of decay. *Decadence* in the arts generally appears as a tendency to produce elaborate forms weak in content, as we saw in the rococo extravagances of the French aristocracy and the Québec seigneurs of the late 1700s. A world-wide system of decadence required an international art, empty of everything but form itself. The idea of art for its own sake, first advanced by the romanticists, became a way of looking at all aspects of painting and the world.

This fit the imperialists' conception of the world precisely. Global corporations were being built, with systems of finance controlled from the imperial centre. People all over the earth were considered as present or prospective subjects for oppression. Imperialism, by its very nature, had to be able to reach everywhere, irrespective of local conditions, culture, language, history or national identity.

Moreover, formalism made it easier to train artists, especially those from the colonies. If a painter is convinced that subject matter is of no importance, he is unlikely to get the idea of putting his art at the service of his people by depicting subjects that matter to them. He will believe that he can create art of major significance solely in terms of form, by acquiring the style currently fashionable in the imperial centre and producing work in these terms the equal of the artists there. His paintings can then all the more easily be judged according to the imperial standard and measured for gallery sales and auctions by standard rates of exchange for the international art market. A concentration on form rather than content leads the painter to a stylized art of appearance, not to the depiction of reality.

These developments made the problem of painting the Canadian landscape independent of an imported style more acute than ever. The influence of Paris and international formalism was much more intense and pervasive than previous systems had been. Yet at the same time, the problem was more pressing: the crisis among the world's imperial powers was sharpening into the First World War, the British regime in Canada was about to end and the class struggle here and around the world was soon to reach new heights.

The Canadian landscape, then, was what confronted Cullen and Morrice. But only Cullen can be said to have consciously faced it. Although they met in Europe, became friends and painted together on both sides of the Atlantic, their markedly different backgrounds and their divergence in class outlook were decisive in what each accomplished and in their influence on others.

Maurice Cullen, born at St. John's, Newfoundland, was brought to Montreal as a child. He went to work at the age of 14 in a British-import dry-goods store and worked there for four years, a clerk at $4.00 a week. When he left the store to study sculpture, one of his few patrons was his former boss who commissioned a portrait bust for $40. The death of Cullen's mother in 1888 left him a legacy of $2,000 which he managed to stretch over a five-year stay in France by withdrawing it at the rate of $30 a month!

James Wilson Morrice, on the other hand, was the son of a wealthy Montreal comprador family; his father had made his money in the textile trade and may well have sold his imported goods through the store Cullen worked in. Morrice satisfied his father by completing all the requirements for a legal career at the University of Toronto and Osgoode Hall Law School. In return his father subsidized his travels and painting studies indefinitely. Morrice never practised law, and until his parents' death in 1914 received $3,000 a year from them. He also had the backing of a Montreal dealer, William Scott, as well as the richest of the Montreal collectors, railway millionaire Sir William Van Horne, who bought one of the young artist's pictures before Morrice set out for Europe.

In Paris, both painters soon found that the academy had nothing much to offer. Cullen switched from sculpture to painting, but by the time he graduated after three years at the *Ecole des Beaux-Arts* (School of Fine Arts), he had come to the conclusion that the most valuable lessons in painting were not to be learned from the academic masters, nor in a studio at all, so he went on an open-air sketching trip around France. Morrice stayed less than one season in one of the ateliers, quitting in disgust when he was hit over the head with a French loaf by a fellow student who was making fun of his premature baldness.

The academy had indeed lost much of its power and influence. Its attachment to the literature and history of ancient empires as a source of themes along with its encouragement of sentimental story-telling pictures for the bourgeoisie had long since earned it the disdain of most of the forward-looking artists of France. Courbet's 1855 one-man show had successfully defied its authority. Eight years later, the outcry against the academic jurors' decisions was so great that Napoleon III had been obliged to order a *Salon des Refusés,* an exhibition of those who had been rejected by the official salon.

It is worth noting, however, that Courbet was excluded from this show as well. He had entered a painting that showed a group of drunken priests staggering down a road on their way home from a conference, a canvas that was eventually bought by a devout Catholic who promptly

destroyed it.

The artists who were admitted to the Salon des Refusés were called "painters of modern life," but their version of modern life was much less critical than Courbet's. Their landscapes and pictures of people in the parks and outdoor cafes were far less disturbing to the ruling class: the scandals they raised about subject matter centred on suggestive nudes, not on pictures of hard-working peasants or drunken priests.

The painters who had prepared the way for this reform in French painting—as opposed to the revolution in subject matter Courbet had proposed—were the group who had gathered around Millet in the Barbizon region. They painted everyday scenes of the rural landscape and insisted on the value of recording nuances of colour, light and atmosphere *en plein air* (out of doors) directly, instead of following the academic practice of working from posed models in the studio. When Morrice left the atelier he went to study with a follower of this group, *Henri Harpignies,* who agreed to criticize his work once a week.

By the time of the Salon des Refusés, another group of artists had already gone further. These were the *impressionists,* so-called because painters like *Claude Monet* were said to be trying to catch an 'impression' of a subject under different atmospheric conditions. At first, impressionism meant a genuine advance in painting because like Courbet's realism it was more than a mere change in style. With both, the underlying impulse was scientific rather than stylistic. Just as Courbet brought pictorial art up-to-date with the real subjects of modern life, Monet and others applied the new knowledge of optics, colour theory and the camera (then coming into general use) to bring art into the same world as industrial technology. The very term 'catch an impression' was first coined by early photographers.

The impressionists came to concentrate systematically on the properties of light and the effect of light on colour. They began to analyse colours as we see them in nature and to paint them by combining their pure constituents—for example, an overall green hue might be rendered in dabs of yellow and bright blue—anticipating the way colour photos are printed today. This made their landscapes extraordinarily life-like beside the turgid academics and even the pastorales of the Barbizon painters.

These were the artists Cullen was following on his outdoor painting trip around France. First he toured the villages of Brittany where *Paul Gauguin* had painted impressionist landscapes; then he went on to the village of Moret, which the impressionist painter *Alfred Sisley* was making famous. Finally he arrived at Giverny, where Monet himself was studying the effects of light at different times of the day.

Meanwhile Morrice had met *James Abbott McNeill Whistler.* This well-known artist was not one of the impressionists, but his interest in establishing an over-all tone by using large areas of a few closely-keyed hues in his paintings allied him to them. Like some of them, he had been influenced by the broad, flat areas of colour he had discovered in Japanese woodblock prints.

American-born, Whistler had been one of the first to feel the attraction of Paris as a world art centre. By the time Morrice met him he had formed a wide circle of English-speaking artist and writer friends who lived in London or Paris but were constantly travelling around Europe to their favourite painting places. These were locations with lots of 'atmosphere', such as Venice or the beaches along the north coast of France; they were also, by no accident, the favourite holiday resorts of the bourgeoisie. Morrice immediately joined their circle.

Whistler had first come to Paris in 1855. The Salon des Refusés was held in 1863, and the first impressionist group exhibition in 1874. Yet none of the Canadian or Québécois painters in Paris were decisively affected by these new ideas until after 1890! This is not because our painters were conservative or timid: it is the almost inevitable lot of the colonial artist.

We have already encountered this cultural time-lag among earlier painters. De Beaucourt had learned rococo manners in France in the 1780s, just at the time when David was establishing neo-classicism; Plamondon had studied neo-classicism in Paris in the 1820s, when Delacroix was exhibiting his major romanticist canvases; Hamel and Kane in turn had been affected by romanticism in the 1840s, at the very time Courbet was fighting for realism. So it is not surprising that it took a generation and more for impressionism to attract Canadian artists.

It was obviously different for an independent nation like the United States, by this time well on its way to becoming a world imperialist power of its own. American artists like Whistler and *Mary Cassatt* were not colonials; they came from what was then a lesser imperial centre to a greater. Accordingly, they could conceive of artists not just striving to meet an imperial standard but being able to change or set their own standards. So they were able to recognize and join with the French impressionists much earlier.

When impressionism did attract Cullen, he was most successful at it. In 1894 he exhibited no less than four paintings in the Salon (which had long since begun to accept impressionist work), and in the following year his Salon picture was purchased by the French government for one of its museums. He had the rare distinction, especially for a colonial, of being elected an Associate of the *Société Nationale des Beaux-Arts* (National Society of Fine Arts) in the company of several leading painters of the day.

In 1895 Cullen also met *Fritz Thaulow,* a Norwegian artist known for his pictures of snow. By this time he had been away from home for over six years. Perhaps partly inspired by Thaulow's pictures, Cullen decided to return to Montreal to paint snow.

François Thiebault-Sisson, art critic for the influential Paris newspaper *Le Temps,* wrote to Cullen imploring him not to go:

"At the point where you have arrived it would be disastrous to stay away from Paris for too long a period. You need to live here for several years yet, to work in the midst of the artistic movement until you are fully master of yourself and sure of success here. I will do all I can to help you sell some of your pictures from time to time."

Fig. 101: Maurice Cullen (1866-1934), *Logging in Winter, Beaupré,* 1896 oil, 25 1/4" x 33 1/2", Art Gallery of Hamilton

This letter shows us the role of the critic as well as how the market was now functioning. Only success in the imperial centre counted: to make sure of that, the artist had to remain there, at least during those crucial years when he was establishing his reputation. To be "master of yourself" you had to stay "in the midst of the artistic movement;" that is, you had to produce a sufficient body of work that met the imperial standard. Part of the critic's job was to spot promising newcomers from anywhere in the world, and make sure they stayed long enough to lose any identification with their homeland. On occasion, he could even arrange a few sales.

Cullen must have known what the letter meant. But like Homer Watson, who had made a similar decision in London five years before, he chose to renounce this open invitation to international success, and return home. He was to visit Europe again in 1896-97 and from 1900-1902, and to benefit from the brilliance of light he discovered in Venice

and North Africa; but he had resolved that the definitive subject matter of his painting was to be his own country.

Logging in Winter, Beaupré (Fig. 101) is a good example of Cullen's use of impressionism in the first year after his return. The subject is remarkable: again like Watson, Cullen attempts to leap directly to the depiction of the working figure in the landscape. A lumberman applies the switch to an ox dragging a sleighload of logs up a hill and around a bend in the road in mid-winter.

More significant; however, is Cullen's concentration on the effects of bright sunlight and shadow on deep snow. On the steep slope across the middle ground and in the sunny patches in the foreground Cullen has piled up his whitest pigment into a thick layer of paint, a technique usually called by its Italian name *impasto.* Where the snow lies in shadow, he has tinted it blue, reflecting the sky. The boughs and leaves of the trees, from the foreground on the right to the horizon at far left, are also painted with full

appreciation of the rich variety of texture and colour that the patterns of sunshine and shade bring out.

Cullen was attacked by Montreal critics of his day for his new coloration, but in fact he was advancing only a very modest application of impressionism. His subject is the kind of crisp clear winter's day that the impressionists themselves would not have known in France. In his use of blues in the shadows, he simplifies impressionist theories of light. "Snow borrows the colours of the sky and sun," he wrote, "it is blue, it is mauve, it is grey, even black, but never entirely white." In one painting he used as many as twenty tones for snow.

Cullen had taken a great step forward: he had begun to paint the landscape as he saw it out of doors with something of the scientific spirit of impressionism. This was an important example that many other Canadian artists were to follow. It was to lead finally to the solution of the problem of Canadian landscape painting and the development of a national landscape school.

Yet Cullen himself could not entirely escape the negative effects of his years in Paris. By the time he discovered impressionism in the 1890s it had become just another style. This is bound to happen to any innovation that takes place in an imperial centre. Courbet's realism had been neutralized into the Barbizon school, and impressionism was no exception. The preoccupation with light and colour to the exclusion of everything else, the very attractiveness, the charm and lively surfaces of impressionist paintings soon degenerated into a decorative, formalist interpretation and made them among the first works of art to be eagerly sought after by imperialist collectors.

For Cullen, the same impressionism that helped open his eyes to the possibilities of outdoor painting and the Canadian landscape left him unequal to his ambition in the end. It favoured an emotionally restrained, diffused treatment, a picture of reality dissolving into light. This was considerably at odds with conditions in Canada, where colour usually retains its vividness and clarity over great distances, and where a definite passion for realistically depicting the subject, especially in the foreground, was needed in order to overcome the persistence of the picturesque. Cullen was seldom able to convincingly resolve this conflict, which often appears in his work as a discord or unevenness between foreground and background.

When he turns to paint Dominion Square in Montreal (Fig. 102), for instance, his dappled brushstroke is directly impressionist. His dissolution of the forms of the building and trees in the distance is similar to Monet's studies of a cathedral façade seen at different times of dusk and dawn. But the sharply delineated horses and sleighs in Cullen's foreground are as if from another picture. Monet would have been content with only the snow, trees and buildings, as a study of forms perceived under winter conditions. Cullen seems to want more from the painting, with the anecdotal addition of the horses and sleighs; but his impressionism remains as a screen through which we make out his subject matter, the square in heavy snow.

The contradiction in Cullen is clear: his patriotism had led him to find his subject matter here, but his colonial-

Fig. 102: Maurice Cullen, *Dominion Square, Montreal,* oil 32 1/2" x 40 1/4", Beaverbrook Art Gallery, Fredericton, N.B.

mindedness allows him to interpret that subject only in terms of the formalist style he had learned in the imperial centre. This contradiction usually appears as a compromise that weakens even the best of his paintings. His regard for his subject matter never allows him to make a purely formal study out of what he is painting, as he might very well have done if he had stayed in France. On the other hand, his colonial reverence for the imperial style is so great that he always treats his subjects primarily as material for an exercise in that style. Cullen's paintings provide an excellent example of the fact that to raise form over content is inevitably to raise colonial mentality over patriotism.

Certainly there was no such contradiction in the paintings of Morrice. That son of the comprador textile importer used his family's money to remain an expatriate, returning to Montreal only to make sure of his allowance each winter. He became such an habitué of all the European haunts of English-speaking artists and writers that he served as the model for characters in four novels about the period, most notably the alcoholic poet "Cronshaw" in Somerset Maugham's book *Of Human Bondage.*

Whistler had originally been the leader of this circle, and for many years Morrice's painting showed his influence. As late as about 1905 we find Morrice painting *Dieppe, The Beach, Grey Effect* (Fig. 103), the very title of which recalls such Whistler pictures as *Harmony in Blue and Silver: Trouville,* painted at another beach resort. Morrice's division of the picture into three broad planes of closely related colour to give the over-all effect of a single tone (in this case grey) is entirely in the spirit of Whistler.

The picture as a whole is a carefully balanced composition. A beached boat at the far left provides a wedge against which a holidaying family is clustered; this group sets off the long horizontals of the rest of the painting. Clouds, waves and pebbles on the beach appear as decorative elements, each in its separate band of colour; the darkened line of the horizon contrasts with the lithe, bright curl of

the surf. The shapes of the clouds reflect similar vague forms in the waves, and both complement the soft granular texture of the beach.

The main lesson Morrice had learned from Whistler was that these formal or 'aesthetic' properties were supposed to be all that mattered in a painting. The fact that this picture represents a family on a beach was scarcely to be considered. The important thing was the formal use he could make of them. People, boats, clouds and waves are all to be arranged like so many counters in a game, as elements in a composition. In contrast with Cullen's subjects, they are allowed no significance in themselves.

It makes little difference, therefore, where Morrice finds his subject. During one of his visits home about 1909 he did the sketch for his well-known canvas *The Ferry, Quebec* (Fig. 104). Although it shows signs of Morrice's development since the Dieppe painting, it is not fundamentally different. Once again Morrice has arranged his subject in broad, flat zones of colour, and has related these four areas

Fig. 103: James Wilson Morrice (1865-1924), *Dieppe, The Beach, Grey Effect,* about 1905, oil, 23 1/4'' x 31 1/2'', National Gallery of Canada

Fig. 104: James Wilson Morrice, *The Ferry, Québec,* 1909 oil, 24'' x 32'', National Gallery of Canada

by artfully distributing buildings, the ferry, horses and sleighs and a few sketchily indicated figures around his composition.

The cold blue of the St. Lawrence River establishes the dominant tone, laced by the long white rolls of the waves. The blue is balanced by the larger white expanses of snow above and to the right on the far shore, and below and to the left on the Levis dock in the foreground. The sky is purple-grey. Flecked only with a few brushstrokes hinting at snow, it subdues the brightness of the river and the warm notes of colour on the dock.

The diagonally slanted house on the left and the converging line of the shed's roof below our viewpoint lead our eyes to the ferry and the city of Québec in the distance. The ferry's smokestack provides a single vertical in the centre of the composition, linking the river to the far shore. Its smoke curls on up to the sky with a few spiralling strokes of Morrice's brush.

About four years earlier Cullen had painted the same

subject (Fig. 105). For Cullen the scene is all smoke, fog, clouds, melting ice and reflections of the lights of Quebec City in the river. This is just the way Monet might have painted it, except that he would probably have omitted the buildings in the foreground which conflict with the atmospheric effects.

The contrast between the two paintings is instructive. Morrice's picture has greater formal unity, even if it means presenting the ferry as a flat white blob in the river to keep the plane and tone of that section of the painting; for Morrice the whole scene is simply a motif to be formally organized. Cullen's version gives us more of a sense of what the view from Levis actually looked and felt like. Even though he is heavily affected by his impressionist style, Cullen is obviously much more concerned about recognizably depicting his subject matter.

The difference in their class outlooks could not be clearer. Cullen, a petit-bourgeois, is full of contradictions, but a man of the people. Although he can only see the land

Fig. 105: Maurice Cullen, *Winter Evening, Québec,* 1905 oil, 29 1/2'' x 39 1/4'', National Gallery

Fig. 106: James Wilson Morrice, *Landscape, Tangier*, 1911-14, oil, 25" x 32", National Gallery

in terms of French impressionism, he still wants to record its specific qualities. Morrice, the visiting son of the comprador, is only interested in his native terrain insofar as it can provide him with an appealing set of variables to compose. "I have not the slightest desire to improve the taste of the Canadian public" he wrote to a friend about this time.

Morrice's painting also shows how styles in Paris were changing. Living in Montreal, Cullen continued his applications of impressionism. Morrice, however, could follow the further stylistic developments that are now generally called *post-impressionist.*

Although varied in their particular directions, post-impressionist artists had in common an interest in taking the concentration on the formal aspects of painting still further. *Paul Cézanne,* who had earlier been one of the impressionists, had gone on to hypothesize that all of nature could be analyzed into the elements of formal geometry, cones, cylinders and spheres. Gauguin, one of the impressionists who had influenced **Cullen,** had also gone further to explore the possibilities of pure colour, not modulated to achieve a quiet tonal effect, but expressively combined in strong contrasts. By 1905 *Henri Matisse* and a few others were taking this violent juxtaposition of colour so far that they earned the nickname *Fauves,* a French word meaning 'wild beasts'.

Morrice shows some very modest (colonial) signs of the influence of these artists on him in his view of the Quebec ferry. His colour is livelier than it was in the Dieppe painting, and he uses the tip of his brush freely to outline the shapes of the ferry, the roof of the shed and the city, and to summarily indicate the smoke and the figures on the dock. The colour is still much milder than in any of the Fauve paintings, but the brushwork on the horses and figures is very much in the manner of one of Matisse's close friends and followers *Albert Marquet.*

Back in Paris, Morrice decided to arrange an encounter between himself and Matisse. They had met briefly in 1908

or 1909, but Morrice wanted to associate himself more closely with the French master. He followed Matisse to North Africa, then largely under French imperial control, and managed to end up painting side-by-side with him from adjacent windows in a Tangier hotel. The hotel, suitably enough, was called the *Hôtel de France.*

Delacroix had first combined the romanticists' love of colour with the exotic appeal of Algiers shortly after the French conquered Algeria in 1830. Gauguin had further associated exotic subject matter with strong coloration, visiting various French island colonies and finally going to live in one, Tahiti. Matisse was now continuing this tradition.

In Morrice's *Landscape, Tangier* (Fig. 106) the influence of Matisse is just as pronounced as Whistler's formerly was. The colour is now high-key, the light is hot. The forms of the landscape and the figures are painted in passages of vivid colour. The building on the horizon is painted as a solid cube; the wall reflecting the sun is rendered by a single brushstroke.

Over the whole canvas the pigment has actually been applied more thinly, so that the underpainting is allowed to show through in places to increase translucency, especially in the deep greens of the hills. Morrice has even used the pointed end of his brush-handle to scratch in relief.

The perspective of the hills and roads is only barely retained. The two-storey building on the left is brought forward, the walled town in the middle pushed back, and the buildings in the background appear much larger than they could have been from that distance. These distortions are for purely formal purposes: the artist aims to achieve unity not by perspective but by the interplay of strong colours and intense light.

Yet none of these distortions are as strong as Matisse himself would have made them. He would have grasped the scene entirely as an arrangement of colour, paying even less attention to the spatial depth and treating it almost as a single plane. Morrice's version is more cautious. His is the painting of a follower.

Morrice's picture, exhibited at an annual survey of imperialist art, the 1914 Carnegie International show in Pittsburgh, also exploits the exotic aspects of his subject. A 'picturesque' minaret asserts a slender pillar of colour into the hillside behind. The three Arabs in the foreground are nothing more nor less than exotic motifs, grouped together to give compositional and chromatic unity to the whole picture. We are certainly not supposed to consider them as the fighters against imperialism they really were, having attacked the French at Casablanca and the Spanish in the desert only a few years before.

Here again, Matisse would have favoured a sprightlier minaret, and would certainly have made more decorative use of the 'colourful' costumes of the Arab people. Morrice, as a colonial artist painting in another empire's colony, has a more detached sense of the exotic. He always keeps it at a reserved distance, never relishing it as Matisse does.

By this time, all subjects had become equally exotic for Morrice, and all people were viewed at an equivalent

distance. From Paris to Brittany, the Netherlands, Wales, Venice, Provence and North Africa, returning each winter to Montreal for his stipend, he had become a professional itinerant. As Matisse described him, he was "always over hill and dale, a little like a migrating bird but without any fixed landing place."

After the death of his parents in 1914, Morrice stopped coming to Montreal: no more cheques to pick up! The First World War interrupted his other travels and broke up his circle of friends. He moved to London for a while to escape the Paris blackouts, and in the years that followed none of the old places or people were the same. He tried his hand at war art, but produced one of the worst paintings of his career; the air of a detached observer that pervades all his work was hardly relevant. New styles and new artists' circles dominated Paris after the war, and he gradually grew more and more frenetic in his travels, pausing only briefly to sketch before moving on again.

Unable to find enough suitable 'atmosphere' in postwar Europe, he journeyed increasingly to more 'exotic' places, especially the colonial West Indies. *Landscape, Trinidad* (Fig. 107) is typical of the last few canvases he painted, in which he was able to unite briefly the various influences on his career. It combines the strong coloration of his African paintings with a richer tonal effect than his Dieppe or Québec views.

The formal unity Morrice attains in this painting is considerable. A bold green headland surges down to a deep blue Caribbean bay, separated from it only by the brown beach at the shore. Across the foreground stretches warm sand, about equal in area on the canvas to the creamy-grey sky above.

In the white lip of the surf stands a bather indicated in black, legs apart, looking out to sea. Through the waves another is wading towards the shore. Thus both formal movements to left and right in the picture (the bay to the left, the headland to the right) are exemplified in these two people's positions. Along the height of the peninsula are two other details that similarly reflect the over-all composition, the massive tree in the middle and the lone one seen in profile pointing down further along the slope.

But it is a purely formal unity. Morrice knew or cared nothing about the lives of the Trinidadian people. He painted there simply as a sophisticated tourist, used the natives as exotic subject matter, and moved on. In 1924, he died of the accumulated effects of alcoholism in a hotel room in Tunis.

He had been the perfect colonial artist. He had gone to the imperial centre, stayed there, acquired the painting style and even the degenerate life-style he found there, and severed all connection with his colonial origins—except for exhibiting and selling paintings in Montreal through his dealer! His comprador bourgeois outlook from the beginning enabled him to do this. Morrice had accepted the international career Cullen had turned down.

In Paris, his reward was a 14-work retrospective at the fall Salon in the year he died, and a further retrospective exhibition three years later in France's official *Jeu de Paume* galleries. He is referred to by the French as a minor

Fig. 107: James Wilson Morrice, *Landscape, Trinidad*, 1921, oil, 26″ x 32″, National Gallery

post-impressionist, one of a number of artists of the period who painted in a similar manner.

Our own art gallery and museum officials, critics and art historians, however, have shown their colonial mentality by refusing to leave it at that. Morrice has been variously praised at the very least as "our best-known artist abroad," but more often as "our only artist of assured international reputation." For years he was our only artist with both a biography and a complete catalogue of his works published. Repeatedly our government has sent exhibitions of his paintings abroad, especially to France. In 1958 the National Gallery of Canada included a retrospective exhibition of his works as part of its first entry in the Venice *Biennale* (Biennial), although only living or recently deceased artists are ordinarily included in that international exhibition. In 1968 yet another retrospective went to Britain and France.

This campaign to convince Canadians and the rest of the world of the merits of this painter who turned his back on his own people is usually supported with a quotation from Matisse, who once called Morrice *"le peintre à l'oeil gentil,"* the painter with a fine eye. This is cited as proof positive of Morrice's top 'international' quality. In reality, it is nothing more than a condescending pat on the head for a loyal follower whose painting at its best never approaches the fluency and assurance of the master. It proves that being accepted in this way as a talented follower is about all the colonial painter can expect if he follows Morrice's path and makes the style of the imperial centre his first concern.

Cullen's success was very different. In 1910 he had married a widow with five children, and for many years, as he said, "the wolf was never more than one step from the door." By 1922, however, the Group of Seven had established a new patronage for Canadian landscape art, and even Montreal was affected by it. In that year Cullen received $10,000 from his dealer as his share in picture sales, and over the next dozen years until his death in 1934 he netted a total of $175,000. When a New York gallery

Fig. 108: Maurice Cullen, *Brook in Winter,* about 1927, oil, 24" x 32", McMichael Canadian Collection, Kleinburg, Ontario

offered to buy all his pictures from an exhibition, Cullen was patriotic and confident enough to ignore the offer.

Cullen used his hard-won financial security to build a studio cottage at Chambly, southeast of Montreal. Winter or summer, he liked to sketch out-of-doors, but especially when the snow was deep, around Chambly or in the Laurentians. Then he would come back to his studio and paint up canvases like *Brook in Winter* (Fig. 108), a typical late work.

Concentrating on the landscape alone, Cullen keeps the vaguer, more negative effects of impressionism in the far background. The winter landscape for which he left Paris has at last become truly primary for him, and although he falls short of the original landscape style that the Group of Seven had achieved by this time, he does make us see the vibrant beauty of this country. He paints the vivid contrast of rocks and snow, sunlight and shadow, the foliage of the fir trees and the bare white birch saplings, the edge of ice and the rush of the deep, cold stream in the foreground.

The fact that Cullen was not able to realize this degree of unity in his earlier paintings of people in the landscape reflects the primacy of form over content, or colonial-mindedness over patriotism, that afflicted his career. Cullen's paintings are the first signs of a bourgeois viewpoint that is not comprador but nationalist in its outlook. In his time, however, this national bourgeoisie was still very weak.

As a class, it still thought of itself primarily as building a great colony within the empire, just as Cullen thought of himself primarily as an impressionist artist. Taken together, the predominance of form over content in much of Cullen's painting and the exclusive emphasis on form in Morrice's work, indicate the enormous strength of imperialism at this time, particularly in Montreal.

As part of their campaign to impress Canadians with the importance of their favourite Morrice, our colonial-minded critics and art historians have laid great stress on the supposed influence that Morrice's formalist art must have had on the Group of Seven. The facts are different. When *Arthur Lismer* first arrived here in 1911, it was a Maurice Cullen exhibition in Montreal that inspired him with the possibilities of painting Canada. And *A.Y. Jackson,* who was living in Montreal at that time, has confirmed that "he (Cullen) influenced us more than Morrice did."

Faced with the demands of a Paris-centred art world, Canada's artists refused to follow Morrice by becoming derivative imitators of the latest French fashions. Instead, they struck out on a new path. Cullen's patriotic decision to return to Canada was not lost on the Group of Seven; nor were his attempts to find the colour, light and texture of paint that suited this land. Writing as the Group spokesman, Jackson gave the final judgment on Cullen: "To us he was a hero."

4. The Group of Seven:
A National Landscape Art

"It was boasted in Montreal that more Dutch art was sold there than in any other city on this continent. Dutch pictures became a symbol of social position and wealth. It was also whispered that they were a sound investment. They collected them like cigarette cards. You had to complete your set. One would say to another, 'Oh, I see you have not a De Bock yet.' 'No—have you your Blommers?' The houses bulged with cows, old women peeling potatoes, and windmills. . . . If you were poor and had only half a million, there were Dutchmen to cater to your humbler circumstances. Art in Canada meant a cow or a windmill. They were grey, mild, inoffensive things, and when surrounded by heavy gold frames, covered with plate glass and a spotlight placed over them, they looked expensive."

So wrote *A.Y. Jackson* in 1925, recalling the rich Montreal patron class of the last years before World War I. As the global crisis of imperialism heightened the conflicts between the world powers, these English-speaking compradors grew more conservative than ever in the art they selected.

For centuries artists had been applying a clear varnish to their paintings to protect their pigments from dirt and discolouration. After about 75 years, however, this varnish itself starts to discolour, and gradually gives the whole painting a dull yellowish tint.

Nowadays this varnish is usually removed by cleaning and a fresh coat applied, so that we can see the original colours of the painting. At this time, however, most of the museums of Europe were full of paintings covered with this yellowed varnish. Assuming that this tint was part of the artist's intention, gallery-goers called it 'Rembrandt glow', after their favourite Dutch artist, and decided that it was one of the attributes of truly great painting. They looked for contemporary artists whose work had the same dull tint, and in the Dutch painters who were then working around the Netherlands capital at The Hague, they found it.

This Hague School of painters had developed their art from the ideas of the Barbizon group of French artists. They too went to the farmyards and fields (cows and windmills), and tried to catch the atmosphere of the passing moment, the twilight of Millet's pessimism.

The irony is that by the 1920s the resale value of Hague School paintings was already negligible. The Montreal Museum of Fine Arts today has one of the largest collections outside the Netherlands of this decidedly minor school, most of the pictures having been given or bequeathed to the museum by the families of collectors who preferred 'immortality' to embarrassment at the auction block.

What did these Anglo-Montrealers think of Canadian art? "It's bad enough to have to live in this country," one rich old woman told Jackson, "without having pictures of it in your home."

Through the 1890s and into the early years of this century, these patrons had supported painters like Homer Watson, whose pictures of Waterloo Country farmland they could associate with Barbizon and Hague School subjects. But by 1907 even Watson's sales had fallen off so badly that he became one of the founding members of the Canadian Art Club, an association of artists formed with the avowed purpose of stemming the inflow of Dutch imports and promoting Canadian art.

By this time the need for a "distinctively Canadian" art based on the land was being consciously discussed. As early as 1894 W.A. Sherwood had tried to define "A National Spirit in Art" in the *Canadian Magazine*. In 1912 the critic Newton MacTavish praised Cullen as our "Painter of the Snow" in the same publication, and urged Canadian artists to achieve a "style that will be, if not Canadian, at least distinctive."

Yet it was not the Canadian Art Club that was to meet the challenge. "We must show that our things are so much better than most of it," Watson wrote; other members, like Morrice, saw the whole problem simply as a lack of high-quality Canadian work combined with a "deficiency of taste" among colonial patrons.

The eight invited other artists to submit work to their exhibitions only if the newcomers' art met their standard of international 'quality.' In their eyes the Club's highest achievement was its successful 1911 exhibition in England! Not surprisingly, it folded four years later.

THE NATIONAL BOURGEOISIE

Landscape historically is a bourgeois art form. To achieve a national art of the Canadian landscape, therefore, the support of a *national bourgeoisie* was needed.

The national bourgeoisie are the middle-sized capitalists in a colonial country such as Canada. They have a certain regard for the national interest and the land, since their capital and profits are realized principally within the nation. As a class it is extremely unreliable because its members both want to drive out the imperialists (so as to increase profits) and want to exploit the people (so as to increase profits). Its class interests are clearly not served by imperialist domination of the country, and at certain stages of the struggle for liberation the national bourgeoisie or parts of it can be a useful ally for the people.

The establishment of even a small national bourgeoisie in a heavily-dominated colony like Canada was not easy. For thirty years following Confederation it was made even harder by the fact that, except for a few brief periods, the new Dominion had failed to live up to its bourgeois founders' hopes for greater profits. Not until the turn of the century was there a definite upturn in the economy. Then at last the prairies began to be settled in some depth, and industries were established to supply the new immigrant market. These were mostly in Ontario, which already had the industrial labour force, the developed sources of power, and the centres of capital administration. With their

new-found wealth, Ontario compradors were now able to finance the discovery and development of the mineral resources of north-eastern Ontario and the Abitibi region of Quebec.

Of course this western settlement, northern exploration and central Canadian industrialization primarily benefited the British and the Americans. But inevitably some national-bourgeois enterprises also got a start, in fields like the manufacture of farm implements. The headquarters of this Ontario-centred small new class was definitely going to be Toronto, rather than Montreal. Their interests in art similarly centred on Ontario, and especially on the newly discovered northland.

An art that reflects the national bourgeoisie will be both bourgeois and national in character, which is precisely what a national landscape art is. The fact that this art depicted primarily a certain region of northern Ontario is not in itself a limitation: the French are known for the Barbizon school, the U.S. for the Hudson River School, and so on. A particular region may very well be selected by the artists of a national landscape school as their subject, depending on the interests of the patron class. The national character of this painting of our northland lies in its break with the imperial traditions about Canada, not in accounting for the entire range of the country. In patronizing an art of the northland, the national bourgeoisie provided the decisive backing necessary to help achieve one major step forward in the struggle for an art of the Canadian people. For the first time we were to see our country in terms that reflected a national outlook on it!

In the late 1800s, a number of national-bourgeois enterprises got started in a field of direct relevance to the artist: the printing and publishing of illustrations. Until about 1880 periodical and book illustrations had been printed from engravings cut into wood, based on an artist's original sketch; Lucius O'Brien had hired engravers for this laborious and time-consuming technique for *Picturesque Canada* in 1882. By that date, however, wood-engraving had already begun to give way to line-engraving, a process in which photographs of line drawings could be transferred chemically to metal plates.

The first publisher in Canada to make extensive use of the new technique was *John W. Bengough,* a well-known cartoonist who signed himself "Grip" after the cynical raven in Charles Dickens' novel *Barnaby Rudge.* The *Canadian Illustrated News* was already flourishing in the 1870s, but in 1873 Bengough, a Liberal or "Grit", brought out his own satirical newspaper and called it by his pen-name *Grip.* It was a great success. By the 1880s he was using photo-engraving to reproduce his line drawings, and Canadians were enjoying such cartoons as *Goods Prohibited, But Evils Admitted* (Fig. 109), in which Bengough contrasts Conservative Prime Minister Sir John A. Macdonald's tariff policies with his willingness to allow "Yankee Political Notions" into the country. The avaricious, high-hatted Uncle Sam was already a familiar image, having appeared for the first time as early as the War of 1812-14.

After *Grip* ceased publication, Grip Ltd. continued as an engraving firm. It was one of many such companies; by

GOODS PROHIBITED, BUT *EVILS* ADMITTED.

Fig. 109: John W. Bengough, *Goods Prohibited, But Evils Admitted,* printed in *Grip,* 1880's, Public Archives of Canada

1892 the industry produced the first issue of its own trade magazine, *Canadian Printer and Publisher.* Three years later the Ontario government made the 300 Mechanics' Institute libraries in the province into public institutions supported by government funds. People were demanding more books and magazines, and the printing, publishing and illustrating firms stood to profit.

Students at the art school founded by the Ontario Society of Artists began to study line drawing with an eye toward possible employment. In 1886 they founded a sketch club. Six years later as the Toronto Art Students League they published their first calendar, illustrated with their own sketches. The themes chosen for each year's pictures included "Canadian Waterways" and "Canadian Village Life."

In 1898, with many of their members graduated, they changed their name to the Toronto Art League and continued to produce the calendars. *The New North* (Fig. 110), a block print by *David Thomson* from the 1904 calendar, is typical of the patriotic consciousness of Canada as "the Northland" that was growing during these years.

David Thomson, who was no relation to *Tom Thomson* but had an influence on him, was one of the first to begin sketching trips to the Laurentian Shield country north of Toronto. It is significant that this early example of the Northland theme depicts woodsmen sawing logs beside a pile of lumber. The forest industry was still of primary importance in Canada, and the artists from the beginning

recognized the workers they met there as a vital part of "the new North."

Since these calendars hung on the walls of most people in the Toronto area who were interested in the arts, such themes were highly influential. The driving force behind them, especially after his return to this country in 1899, was *Charles W. Jefferys,* an artist who was to continue making a significant contribution to Canadian culture for over half a century.

Born in England in 1869, Jefferys had been brought first to the U.S. and then to Canada as a child. He had served as an apprentice lithographer on Toronto newspapers and worked for seven years in the 1890s as an illustrator for the *New York Herald.* Employment in the U.S. only heightened his sense of Canadian patriotism. It was a decade of U.S. expansionist aggression that culminated in the Spanish-American War and the U.S. occupation of Cuba and the Phillipines. These were the days when William Randolph Hearst's *New York Journal* and other American newspapers were using front-page cartoons and stories every day to whip up chauvinism and jingoism among the American people to extend the U.S. empire, and when Mark Twain established an Anti-Imperialist League to oppose them.

Three years after Jefferys' return, while continuing the Art League calendars, he also helped to bring out *The Moon,* a satirical magazine that was a successor to *Grip.* One of his own cartoons for it, *Auctioneer Johnny Canuck* (Fig. 111), shows how consciously anti-imperialist his patriotism was. "Canadian Trade" is being auctioned off by the Canadian government, with Prime Minister Laurier recording bids. Front and centre sits a fat John Bull (this is still the British regime), but next to and just behind him Uncle Sam sits back, speculatively fingering his long white beard. At the door a few other competitors are unlikely even to be noticed by the auctioneer. Jefferys was sharply aware that U.S. imperialism was already a close second in Canada to British rule.

Jefferys was also an enthusiastic advocate of sketching trips to get the artist out to see and record our country. "It is inevitable that a country with such marked physical characteristics as Canada possesses should impress itself forcefully upon our artists," he observed. In 1907 he made his first trip to the newly-formed provinces of Saskatchewan and Alberta, where he discovered the clear light, long horizontal lines and subtle atmospheric effects of the prairies. Paintings like *Prairie Trail* (Fig. 112) were produced in Jefferys' studio from sketches he made on these trips, a practice that the Group of Seven painters were to follow. It includes a sign of the old west, the rider on horseback, as well as of the new settlement, the line of poles reaching off to the horizon. Jefferys' ambition to record the excitement and vastness of the prairie is greater than his ability on this large canvas, but his concern to paint topical Canadian themes was influential.

Jefferys' interest in Canadian subject matter was certainly approved by one of his painting instructors, George Reid. Even before *Mortgaging the Homestead,* during his own training in Philadelphia and Paris, Reid had always painted Canadian subjects. Now that he was teaching at the Central

Fig. 110: David Thomson, *The New North,* 1903, block print, 7" x 8 1/2", Toronto Art League Calendar, Library of the Art Gallery of Ontario

Fig. 111: Charles W. Jefferys (1869-1952), *Auctioneer Johnny Canuck,* 1903, from *The Moon*

Fig. 112: C.W. Jefferys, *A Prairie Trail,* 1912, oil, 35 3/4" x 50 3/4", Art Gallery of Ontario

The Group of Seven: A National Landscape Art 117

Ontario School of Art and Design, he encouraged his students to do the same.

In 1896 Reid became president of the Ontario Society of Artists. Two years earlier the Society had changed its constitution, eliminating the requirement that the president had to be a bourgeois patron, so that now it could begin to serve the interest of artists more independently. Under Reid's presidency in 1898 the Society featured a European genre painting as its main attraction at the Toronto Industrial Exhibition (now the Canadian National Exhibition), and limited its showings to Canadian artists only. In 1900 the Society also initiated the plan that was to lead to the founding of the Art Gallery of Toronto (now Ontario).

Another of the Society's progressive undertakings during Reid's six-year presidency was to stimulate patronage for the applied arts, not only in published illustrations but in other fields of design as well. This was an extremely important goal that had been advanced most notably by the British socialist artist *William Morris.* "I do not want art for a few, any more than education for a few, or freedom for a few," Morris had declared. He understood that only a socialist revolution could really put art at the service of the masses in England, but while working with the Marxist Social Democratic Federation toward that end, he continued to develop many ways of making art more available to people through the design of fabrics, furnishings and especially books. The international arts and crafts movement that grew out of his activities had as its purpose "to turn our artists into craftsmen and our craftsmen into artists." It was one important way for the painter to refuse to remain exclusively a producer of luxury commodities for wealthy picture buyers, and to put his talents at least partially at the service of the people.

Under Reid's direction the Ontario Society of Artists attempted to apply some of these ideas in Toronto. A Toronto Guild of Civic Art was formed, comprising artists, architects and interested citizens, with the purpose of "stimulating and guarding municipal art." 'Guild' was the medieval term for an artisans' organization that Morris had revived in his Art Workers' Guild. "Guarding" or preserving aesthetically valuable and historic structures had been one of Morris's aims from the first.

In 1896 the Toronto Guild and a new Society of Mural Decorators tried to get painted murals included in the Toronto City Hall then being built. Reid himself donated a mural in the City Hall entrance, hoping to stimulate further interest. Reid repainted it thirty years later, but we can still see that his 1899 subject matter linked pioneer settlement very closely with land values, depicting a party of surveyors preparing to drive a claim stake in the forest while a puzzled native looks on from behind a tree. Reid's inscription on the mural reminded Canadians to honour the memory of our pioneer ancestors. Since the mural was seen by thousands every year, especially by contemporary Toronto artists and art students, it acted as a powerful stimulus to the painting of such patriotic subjects.

The national bourgeoisie was by no means strong enough to patronize murals on a wide scale. Nevertheless Reid continued to promote the idea of an applied arts industry.

In 1900 the Ontario Society of Artists, still under his presidency, opened Canada's first Applied Arts Exhibition, in which firms like Grip Ltd. displayed their employees' work. This exhibition led to another in 1904, at which the Arts and Crafts Society of Canada was officially formed. Morris's British association, founded in 1887, had been called the Arts and Crafts Exhibition Society. The Canadian group exhibited again in 1905, and continued thereafter as the Canadian Society of Applied Arts.

It is a mark of Canada's continuing colonial condition that these and other attempts to develop a national applied arts industry were largely in vain. Many of the crafts in which artists might have worked in Canada—ceramics, for example—were flooded with imports from the imperial centre. Others, like textile and furniture factories, were owned by imperialists or compradors who duplicated patterns from the imperial centres rather than originating their own. The small locally-owned glassware houses were being bought up completely at this time, and were losing their distinctive designs. Canadian crafts had a fine tradition, but they could not compete against imperialist industry.

Only in printing and publishing, where illustrations had to be prepared for the local market, could the national bourgeoisie gain a slight foothold. Their patronage of the arts was not at first in the purchase of works of art, but in offering jobs to artists. With the salaries they received, painters could go sketching on weekends and holidays, and work in their own studios on long winter nights.

But firms like Grip Ltd. were more than just a source of wages. They were really a non-academic training school where artists apprenticed and then went to work as salaried employees, more like industrial workers than artists in Canada have ever been, before or since. It is significant that our first independent school of artists was trained in a commercial art studio. Painters learned their skills in a very practical discipline, as a means of representing significant subject matter; the whole orientation of a professional illustrator was exactly the opposite of the art-for-art's-sake formalism that by now dominated the art of the imperial centres.

These firms also maintained a healthy independence of mind toward the use of imported formalist styles. They had to compete with the products of the imperialists and their colonial branch plants, so it was necessary to study and adapt the best technical and stylistic ideas generated in the imperial centres. Employees were expected to keep up with the latest British and U.S. publications, especially the illustrated magazines. But at the same time the Canadian companies wanted to offer something distinctive to their Canadian customers, so they featured Canadian subject matter in the advertising and other commercial illustration work they did, and tried to develop their own styles to depict it. In this way the national-bourgeois outlook was incorporated into the day-to-day working experience of the painter. Tom Thomson and the others were to apply the same principles to painting the landscape.

ARTISTS AND PATRONS GATHER

Already in the 1890s some of our leading younger artists

Fig. 113: William Cruikshank (1849-1922), *Breaking a Road,* 1894
oil, 35" x 68", National Gallery of Canada

were beginning to find work in this industry. Like C.W. Jefferys, *A.Y. Jackson* got his start as a lithography apprentice, going to work in Montreal in 1894 at the age of 12. In Toronto, *J.E.H. MacDonald* started to work at Grip Ltd. in the same year, having already completed four years of his apprenticeship.

Born in England of Canadian parents, MacDonald had come to live in Hamilton, Ontario with his family when he was 14 years old, and first studied art in the night classes given at the Hamilton Art School. At Grip he became an expert illustrator. In 1900 some of his catalogue covers showing the influence of William Morris's designs were included in the Grip display at the Ontario Society of Artists' Applied Arts Exhibition, and he sent a sample book design to a well-known follower of William Morris in the U.S. In the same year Albert H. Robson, a former member of the Toronto Art Students' League, took over as manager of Grip and began to encourage his designers to take sketching trips and paint the Canadian landscape in their spare time.

MacDonald joined four other Canadians working for one of the leading British design studios in England late in 1903, but when he returned to Canada three and a half years later he had no trouble getting his old job back. About the same time Robson hired another designer who specialized in hand lettering and mechanical shading techniques: *Tom Thomson.*

Like Homer Watson and George Reid, Thomson had his roots among the patriotic farmers of southwest Ontario. He had been born at Claremont, Ontario in 1877, but was brought up on a farm at Leith, near Owen Sound. He had gone to work first as a machinist's apprentice in an Owen Sound foundry, but quit after only eight months because he didn't like the foreman. He later remarked that he regretted not having stayed to get his papers.

Thomson's formal education ended with three years at a business school in Chatham, where he had his first lessons in lettering. In 1901 he went to Seattle, where one of his

brothers was a partner in a business college; after a few months practising penmanship there, he landed his first permanent job with an engraving firm. When he returned to Toronto in 1905, Thomson was an accomplished illustrator.

At Grip, Thomson was encouraged to develop his talents in painting by Robson, MacDonald and others after hours. Mostly self-taught, he took some lessons with the technically proficient *William Cruikshank.* Since Thomson was to be almost exclusively a landscape painter, it is interesting to note that he chose Cruikshank as his teacher: this Scottish-born artist was best known for his 1894 canvas *Breaking a Road* (Fig. 113), which had been exhibited repeatedly in Toronto and the U.S. by the time Thomson went to study with him. It is an impressive treatment of the heroic labours of the pioneer settlers, situated in a northern winter landscape.

In 1909, *Frederick H. Brigden,* another former member of the Toronto Art Students League and a sketching companion of C.W. Jefferys, entered *A Muskoka Highway* in the Ontario Society of Artists exhibition. Brigden was a bit uncertain in his grasp of atmosphere, distance and light conditions, but he again confirmed the excitement of snow-covered logging trails and the vistas over rolling northern wooded hillsides as subjects for a Canadian painter.

Brigden worked for his family's engraving house, a rival to Grip. In the fall of 1910 he went to England to find experienced designers to match the team Robson had assembled at Grip. An employee at Grip, who came from the industrial city of Sheffield, advised Brigden to look up an old friend of his still working in his home town, a talented illustrator named *Arthur Lismer.*

In many ways Lismer was perfectly suited for this new Toronto art world. Born in Sheffield in 1885, he had studied painting at nights in the local art school while serving his apprenticeship in an engraving firm. He had worked as a newspaper cartoonist and had also been secretary of a workers' sketch club. He had returned from a

year and a half's study in Antwerp (where he had gone because there was no tuition fee), and had been working in Sheffield as a free-lance illustrator for three years when Brigden persuaded him to emigrate.

Shortly after Lismer arrived, he too joined the staff at Grip. There, in addition to Thomson, MacDonald and others, he found a young Canadian painter named *Frank Johnston*, who had recently returned from commercial art work in New York. Lismer also soon met a new apprentice, *Franklin Carmichael*, who had left his father's carriage shop in Orillia and come down to Toronto to get his start as an artist.

The sketching trips and common working experience of this growing group of painters had already led to a series of associations. Around the turn of the century there had been the Mahlstick Club, a sketching group named after the short stick used as a rest for the painting hand; it had been followed by the Graphic Arts Club, a more social organization of people working in the illustrating and publishing trade. Lismer was now introduced to the Arts and Letters Club, which had the unique characteristic of bringing together artists and patrons. Robson and Jefferys were among the members; in fact, almost every man concerned with the arts in Toronto could be encountered in the Club's popular dining hall. (Not women concerned with the arts, though; the Club excluded women — and still does!)

Here was a meeting-place where the rising national-bourgeois consciousness of Canadian art and Canada's land could be expressed. In 1911 MacDonald had his first one-man show there, a collection of sketches he had made in High Park and in the area just north of Toronto. The power of one of his small canvases of that year painted along the Humber River (Fig. 114) comes from his direct use of the colour and texture of his pigment to depict the dense forest, the rough shapes along the shoreline, the cold water and the bright spring sunlight. The paint handling is not unlike that of Courbet when that realist artist painted landscapes. Significantly, the subject is a log drive, with lumbermen using their long picks to break up the jams: again, the workers in the lumber industry are an integral part of the scene.

MacDonald's show was a great success. Only one year earlier a British critic had castigated a Canadian exhibition in London arranged by the Royal Canadian Academy, complaining that "the more immutable essence of each scene is crushed out by a foreign-begotten technique." Now C.W. Jefferys, writing in the Arts and Letters Club magazine *The Lamps*, was able to recognize MacDonald's achievement in these sketches as pointing to the resolution of the Canadian landscape challenge. MacDonald, applying the lessons he had learned in style and technique just as he would have in the engraving studio, had made the depiction of the specific atmosphere and qualities of his Canadian landscape subject matter his chief concern. It is to Jefferys' great credit, and a reflection of his always perceptive patriotism, that he observed of this first exhibition:

"Mr MacDonald's art is native—as native as the rocks, or the snow, or pine trees, or the lumber drives that are so largely his themes. In themselves, of course, Canadian themes do not make art, Canadian or other, but neither do Canadian themes expressed through European formulas or through European temperaments . . . so deep and compelling has been the native inspiration that

Fig. 114: James E.H. MacDonald (1873-1932), *By the River, Early Spring*, 1911, oil, 20" x 28", Art Gallery of Hamilton

it has to a very great extent found through him a method of expression in paint as native and original as itself."

It is by no means accidental that this real beginning of our national landscape art was accomplished in the same year that Laurier's trade policy of reciprocity (meaning mutual low tariffs) with the United States was so crushingly defeated at the polls. "We must decide whether a spirit of Canadianism or of Continentalism is to prevail on the northern half of this continent," proclaimed Robert Borden in his final election appeal. Five days later he entered Ottawa in triumph, with flag-waving crowds lining the streets to welcome him. Canadians had resolutely rejected any form of economic union with the United States.

As a federal government institution, the National Gallery of Canada showed the effects of this patriotic victory. In a colony like Canada, there are very few capitalists rich enough to form their own collections and give or bequeath them to an institution like the Gallery; as a result the National Gallery has always had to be much more dependent on public support than British or U.S. galleries have. The Gallery had begun its Canadian collection with donations from the artists, who were required to give one of their works in order to become members of the Royal Canadian Academy. Beyond this forced subsidy the Gallery depended on annual appropriations, which had been sporadically voted to it by Parliament up to this time.

Although this government control allows the bourgeoisie to use the Gallery as their private playground at the people's expense, it is at least a collective response to a social need, a typical solution for a colony. Now that the national bourgeoisie was getting somewhat stronger, this public institution was bound to grow more national in character.

In 1910 the Gallery's first full-time curator, Eric Brown, had been brought over from England. Despite his imperial background, Brown soon recognized the strength of the patriotic sentiments then sweeping the country. In 1911, the year of the election, he had offered to buy *A Dutch Peasant*, a painting done in the course of a prolonged study tour of Europe by the Toronto artist *Bill Beatty*. He was a former house painter and fireman who had started painting as a hobby but had been encouraged to take it more seriously by his teacher George Reid. Beatty had returned to Canada two years before, and had joined in the discovery of the northland so enthusiastically that he was one of the first to sketch in Algonquin Park. A few weeks after Borden's victory, Beatty patriotically wrote to Brown, "I am a Canadian, and I would much rather be represented by a Canadian picture." Brown shrewdly agreed to exchange the Dutch painting for one of Beatty's Algonquin canvases, *The Evening Cloud of the Northland.*

Beatty's 1910 painting was not nearly as independent of European style as MacDonald's sketches were. Its sombre colouring, indeterminate foreground and preoccupation with subtle atmospheric effects in the sky all showed the influence of the Barbizon painters and their Hague School followers who had impressed Beatty during his three years in France, Holland, Spain, Italy and England. Nevertheless the conception of the painting and its explicit title directed attention to the unique qualities of our northern landscape. Beatty's choice of subject and his approach affected Tom Thomson deeply and within a year or two, Thomson also would be sketching in the Park.

Meanwhile the national-bourgeois manufacturers of the country were rejoicing in their triumph. Although Borden continued business as usual with the British, his election on a nationalist platform allowed them to take a much more active role in the country. Among them were firms such as Massey-Harris, an agricultural implement company founded by the Harris family in Brantford, which had developed a light binder in the 1880s and had merged with the Hart Massey factory in Toronto in 1891. The founder's grandson, an artist named *Lawren Harris*, was a charter member of the Arts and Letters Club. Like Jefferys, he recognized at once the national character of MacDonald's paintings, and sought him out to congratulate him on his show.

It was Harris who brought this vigorous national-bourgeois outlook directly into the group of artists that was now forming. It was Harris's enterprise that got them exhibiting together, attracted patrons, installed them in the specially-built Studio Building that he helped to finance, and encouraged them to see themselves as part of a national movement. Unlike the others, Harris had been able to afford both a university education and an extended period of formal study in Europe. From the beginning he saw their aspirations and accomplishments in a broad philosophical context.

Harris began by introducing MacDonald to a Dr James M. MacCallum who also admired his sketches. This eye specialist and professor of medicine lived in Toronto, but he had been brought up in Collingwood and had learned to love the islands and waters of Georgian Bay while accompanying his father, a minister, on his rounds. In 1898 Dr MacCallum had been one of the first guests at a camp opened up at Go Home Bay by the Madawaska Club, an association of University of Toronto professors. When the Club purchased a large block of Crown Land in the Georgian Bay district for its members, he had been one of the first to build a cottage there. He now enthusiastically invited MacDonald and Harris to visit him.

This was the beginning of a new phase of patronage. The artists had come about as far as they could, working full-time and painting at nights and on weekends. Now they needed sales, exhibitions and full-time work on the possibilities they were opening up in their paintings. Harris and Dr MacCallum together provided the initial encouragement and the money.

First they persuaded MacDonald to give up his job at Grip. He and Harris went sketching together, and Harris made sure that they were well represented with saleable paintings at the Ontario Society of Artists exhibition in 1912. The reviews were excellent, and Dr MacCallum made good on his invitation, providing a houseboat for the MacDonald family to live in while the artist sketched around Split Rock Channel and Go Home Bay.

Fig. 115: J.E.H. MacDonald, *Tracks and Traffic*, 1912
oil, 28" x 40", Art Gallery of Ontario

If we examine the sales records of the Society exhibition, we can see that the patronage that was becoming available was patriotic, but definitely bourgeois in outlook. MacDonald's largest painting in the show was *Tracks and Traffic* (Fig. 115), which was to be the only canvas in his entire career with an industrial setting. Painted at the edge of the rail yards near the foot of Toronto's Bathurst Street, it shows gas storage tanks in the distance and two workers near the right edge of the painting on the snow-smeared sidewalk. In many ways it includes all the best elements of MacDonald's painting: a powerful but sensitive handling of atmosphere, a measured recession into large spatial areas placed approximately parallel to the picture plane, and rich painting of texture ranging from the foreground snowdrifts through the piles of lumber to the billows of smoke and steam. Although that district of Toronto has now been altered in almost all details, there are few industrial workers anywhere in Canada who would not find it familiar.

Although this painting was most favourably mentioned in the exhibition's reviews, it was a winter landscape with skiers that the Ontario government bought from the show. *Tracks and Traffic* was not sold for 25 years, until five years after Macdonald was dead! The new patronage was not for industrial scenes that workers would recognize. In fact, the government purchase had been arranged by the President of the Bank of Commerce, Sir Edmund Walker.

Walker is a curious contradiction among bourgeois Canadian patrons. He had joined the Bank of Commerce in 1868, just one year after its founding and Confederation. The dominant position of the finance capital that banks administer, and its control by the imperialists, is crucial to their whole economic system. As a banker of the new Dominion, Walker was bound to be a dedicated comprador, "an Imperialist" as he proclaimed himself during World War I.

Yet he was also very much caught up in the prosperity that finally bloomed after the turn of the century. He directed the rapid growth of the Bank of Commerce in the west, where many branches were quickly set up. He also got involved in financing exploration and development in the near north, as well as Ontario industrialization. So to some extent he was concerned with the rising national bourgeoisie. But Walker, like so many colonial capitalists, was still convinced that it was the British Empire that was to benefit from the new prosperity.

In 1896 Walker had written a history of Canadian banking. He repeatedly defended the Canadian banking system against those who wanted to alter it to a U.S. model. In 1911, although a Liberal, he opposed Laurier's reciprocity sell-out to the U.S. Uneasy about the growing power of the U.S., Walker wanted a prosperous Canada, but mostly for the sake of the British Empire!

Walker had first discovered art in England, and his own small collection included the inevitable Dutch marks of a comprador's taste. But even as President of what was then becoming the country's largest bank, he was not wealthy enough to amass a huge collection himself; so he used the people's money in the many educational and cultural institutions he enthusiastically supported. In this public patronage, especially as the most active trustee of the National Gallery, he always supported Canadian culture as opposed to foreign imports.

It's not surprising that Walker did not buy *Tracks and Traffic*. But his preference for the skiing scene shows how closely his idea of Canada was tied specifically to the land north of Toronto that was already being used for recreation

and holidays. Walker himself enjoyed hunting and fishing trips to Muskoka, and greatly valued the cottage he had built on Lake Simcoe. In the next dozen years he was to be instrumental in numerous Ontario government and National Gallery purchases and exhibitions, consistently favouring scenes of the unoccupied north.

By inviting MacDonald and the others to his cottage, Dr MacCallum was reinforcing that preference. He and the professors in the Madawaska Club joined others like Walker in encouraging an art of the land where they took their vacations and spent as many weekends as possible. It was this landscape, not the countryside where most Canadians actually lived and worked, that was to be the subject for our national landscape art. It led to a romantic identification of the Canadian spirit with "the true north strong and free." There were strengths to this identification. But it was also an escape from the harsh realities of the struggle for production.

Wanting such an escape in art is not surprising. Although the national bourgeoisie was now more prosperous, it was still firmly under the control of the British empire. In the heavily industrialized U.S., a Group of Eight artists had founded a school of urban subjects that earned them the nickname "The Ashcan School". But in colonial Canada, the subject matter of our national landscape art was to be vistas of the northland, mostly without people in sight. Only in these cottage plots and islands could the new patrons feel any confidence that the land could in any sense be theirs.

It was Harris who had introduced MacDonald to the city as a subject for serious painting. He sketched the gas works alongside MacDonald, and was already becoming known for his views of streets and house fronts. But the Harris painting that Walker as trustee arranged for the National Gallery to buy from the same 1912 exhibition was another large scene of the north. *The Drive* (Fig. 116), again shows the attraction that forest workers had for these painters, once more depicting lumberjacks on the spring log drive. The real content of the painting, however, both for Harris and his patrons, is the panorama of the northland itself, with the pattern of light and shadow cast by the sun breaking through the clouds on the snow, logs and forest to animate the whole canvas.

The effect of Harris's patronage over-all was to encourage this kind of landscape painting. In January, 1913 he and MacDonald took the train to Buffalo to see a large exhibition of Scandinavian paintings, and both artists came back with a heightened sense of the significance of what they were doing. Wrote MacDonald:

"It seemed an art of the soil and woods and waters and rocks and sky, and the interiors of simple houses, not exactly a peasant art, but certainly one with its foundations broadly planted on the good red earth. It was not at all Parisian or fashionable. These artists seemed to be a lot of men not trying to express themselves so much as trying to express something that took hold of themselves. The painters began with nature rather than with art. They could be understood and enjoyed without

Fig. 116: Lawren S. Harris (1885-1970), *The Drive*, 1912 oil, 35 1/2" x 53 3/4", National Gallery

metaphysics, or the frosty condescensions of super critics on volumes or dimensions and other art paraphernalia."

In fact, the Scandinavian paintings were heavily influenced by the same flat patterning and sinuous decorative lines that MacDonald was familiar with in his design studio. This style was called *art nouveau* in French, *Jugendstil* in German; both words had been used originally in Europe in the 1890s, when this approach to design had really been a 'new art' or a 'youth style.' Especially from his reading of the British art magazines, MacDonald could not have helped recognizing its influence on the Scandinavians.

But the question of style was secondary. What mattered was that these Scandinavian painters had the same attitude to their subject matter as MacDonald and the other Canadians were developing. Both groups of artists had rejected the imperialists' doctrine (as learned so well by Morrice) that subject matter was insignificant. MacDonald had even identified this ideology of artists "expressing themselves" through art-for-art's-sake formalism ("volumes and dimension" and so on) as the metaphysical nonsense that it is!

As artists of independent countries, these Scandinavian painters had achieved a degree of freedom from the imperial centres. The similarities in landscape and climate further allowed them to exert a direct progressive influence on our artists. Just as the Norwegian painter Fritz Thaulow in 1895 had encouraged Cullen to return to Canada to paint the snow, so this whole school of Scandinavian artists now strengthened MacDonald and Harris in their resolve to make the subject matter of the northern Canadian landscape the primary concern of their painting.

Harris next arranged a show at the Toronto Reference Library, where people of all classes could come, but where the petit-bourgeois especially (professors and professionals in particular) could be counted on to buy. He made sure that all the pictures in the exhibition were sketches or small canvases, low enough in price and modest enough in size to appeal to such customers. There was no admission charge, an unusually democratic feature for those days, and the catalogue cost only 10 cents. In it the visitor could read:

The Group of Seven: A National Landscape Art 123

Fig. 117: Alexander Young Jackson (1882-1974), *The Edge of the Maple Wood*, 1910
oil, 22 1/2" x 26", National Gallery of Canada

"We knew that there were many people who would like to buy pictures for their homes if they knew what to buy, if they could see pictures which were suitable for home use, such as one could live with and enjoy, and especially if it were possible to see the productions of Canadian Artists whose work is a part of our national life."

This *First Exhibition of Little Pictures by Canadian Artists* was a great success. As one Toronto reviewer observed, it was not a "social orgy" like most exhibitions, but "a business exhibition pure and simple". He noted that the general public was able to take an interest for the first time. And without the huge genre paintings around to intimidate the lower-income buyers, sales of the small pictures were excellent.

Now a building was needed. Harris could always afford a good studio, but most of the painters had to work in less than ideal conditions, and a meeting place was absolutely essential if the group was to stay together for any length of time. With Harris's and Dr MacCallum's money behind it, the Studio Building of Canadian Art was completed early in 1914. A three-storey structure in Toronto's Rosedale ravine, it consisted of six big, well-lighted studios. Rents were to be low ($22 a month) and payments could always be deferred until the next exhibition.

Harris and the doctor, meanwhile, took steps to ensure they had gathered all the leading young artists whom they knew to be dedicated to painting the Canadian landscape. Lismer had gone back to England in the summer of 1912 to get married; while there he had persuaded an old friend to join him in Canada. *Frederick H. Varley* had been struggling to make a living for himself and his family in Sheffield as an illustrator. He was four years older than Lismer and also a graduate of the free-tuition Antwerp academy. Varley soon found work in the photo-engraving industry, and after Dr MacCallum issued an invitation he and Lismer went north to discover the attractions of Go Home Bay.

Harris had meanwhile "saved the life" of A.Y. Jackson, as Jackson himself later put it, by buying *The Edge of the Maple Wood* (Fig. 117), a 1910 canvas that Jackson had exhibited in the 1911 Ontario Society of Artists show. Jackson had left for his third trip to Europe shortly after the exhibition, but the painting had impressed all the members of the growing group in Toronto who saw it, and Harris persisted until he finally reached Jackson a few months after his return.

In the same month that the Little Pictures were selling to a new class of collectors in Toronto, Jackson and another Canadian artist had been suffering through a two-man exhibition in Montreal that got good reviews but sold nothing. Jackson was so discouraged by the complete

lack of interest in his non-Dutch paintings that he was seriously considering going to New York to find a job in commercial art when Harris's purchase changed his prospects.

Tom Thomson maintained that *The Edge of the Maple Wood* was the first painting in which he could see the possibilities of the Canadian landscape. In fact, it had been painted just after Jackson's return from his second tour of Europe, and shows the effects of the impressionist painting he had been doing there. It is a study of bright spring sunlight and shadow, with traces of snow still on the ground, painted near Sweetsburg, Quebec.

Yet Thomson was right. Jackson's handling of paint resembles MacDonald's at approximately the same time (Fig. 114). Instead of trying to "express themselves" or work out the implications of a style, both artists had used all their stylistic and technical resources to depict the rugged shapes, clear light and brilliant colour of our country. As Jackson later wrote:

"It was good country to paint, with its snake fences and weathered barns, the pasture fields that had never been under the plough, the boulders too big to remove, the ground all bumps and hollows. It was here, while the sap pails were still on the trees, that I painted Edge of the Maple Wood . . . "

Contrast this painting with Cullen's *Logging in Winter, Beaupré* (Fig. 101). What strikes us about *The Edge of the Maple Wood* by comparison is its materialistic sense of the earth. Jackson emphasizes the foreground, and we get a vivid impact of the half-frozen, dug-up ground. Beyond it stretches a continuous recession of space that is not dissolved or dazzled by light, but is revealed to us by the shadows across the land. Even though Cullen's painting may have higher definition of detail, it remains an impressionist rendering of a Canadian subject in terms of light, without a strong foreground and without this sense of the earth. But Jackson's and MacDonald's paintings are fundamentally realistic in character, even when they use impressionism or other stylistic methods.

Jackson had noted the kinship of his work with one of MacDonald's sketches exhibited in Montreal in 1911, and the two painters had begun an intermittent correspondence. When Harris purchased *The Edge of the Maple Wood*, Jackson decided to go to Toronto instead of New York, to meet this sympathetic band of artists. Harris was out of town when Jackson passed through, but followed him to Berlin, Ontario (now Kitchener), where Jackson was visiting some relatives. Harris tried to convince the Montrealer to join the growing group in Toronto, but at this point Jackson would only agree to think it over while he took a summer holiday on Georgian Bay. Obviously concerned, Harris then wrote to Dr. MacCallum and urged him to find this gifted painter and talk to him if he could.

Dr. MacCallum did better than that. He finally located Jackson at the end of the summer, patching up an old shack to use as a studio. The doctor offered the artist his own cottage, and also talked him into staying in Toronto that winter. When Jackson spoke of going to New York, the doctor replied, "If all you young fellows go off to the States, art in Canada is never going to get anywhere." With that, he solved Jackson's patronage problem by offering him space in Lawren Harris's studio until the new Studio Building was ready, and by guaranteeing Jackson's expenses for a year.

That winter Jackson astounded all the other members of the group by painting a large canvas that he originally called *The Northland*, although it has since become known as *Terre Sauvage* (Wild Country) (Fig. 118). *The Edge of the Maple Wood* had used impressionist light and shadow to achieve its realistic character. This major painting startled with its juxtapositions of strong colour and bold, black outlining of forms, effects that Jackson had picked up from the post-impressionist paintings he had seen on his last visit to Europe. These stylistic devices were the means, but what excited the other artists was that a monumental presentation of the real grandeur of our northern landscape was the aim.

Fig. 118: A.Y. Jackson, *Terre Sauvage* (originally *The Northland*), 1913, oil, 50" x 60", National Gallery of Canada

THE ACHIEVEMENT OF TOM THOMSON

The artist who was most profoundly impressed by the big painting was Tom Thomson. He had first visited Algonquin Park, following Beatty's example, a year before. He had also taken his first long canoe trip down the Mississauga River in 1912, and had lived all the summer of 1913 in the Park, so he was an excellent judge of the painting's verisimilitude. He and Jackson became close friends as Thomson kept coming back to the studio to watch the picture develop.

Thomson had discovered the need for these stronger colours in his own work. In his first year of sketching in the north he had taken Beatty's approach, keeping to the darker tones, a distant view and a low horizon enabling him to concentrate on atmospheric effects in the clouds. Even so, his fellow painters recognized that, in Lismer's words,

Fig. 119: Tom Thomson (1877-1917), *Drowned Land*, 1912, oil on canvas board, 6 7/8" x 9 13/16", Art Gallery of Ontario

"here was a new artist and a new idea about the North Country." Sketches of 1912 like *Drowned Land* (Fig. 119) went much further than Beatty or anyone else had in capturing what Grip art director Robson praised as "an intimate feeling of the country."

What is impressive about *Drowned Land* is its realism. Thomson has not yet learned to paint northern colour. But even though the sky is kept neutral grey, a believable light infuses the picture. The reflections of the trees are arresting in their clarity. The space between the flooded areas of land and the tree trunks is recorded with accuracy as the artist guides his brush directly by what he sees.

So excited were his friends by these sketches that they urged Thomson to paint up a canvas for the spring 1913 Ontario Society of Artists show. The result, *A Northern Lake* (Fig. 120), goes even further in realism. Like Mac-Donald in his sketches of 1911, and like Courbet in his landscapes, Thomson has applied paint thickly in bold, rough strokes that convey the solid shapes of the boulders and the mass of the clouds. He has even followed Courbet's example by using a palette knife rather than a brush to render the texture and forms of the rocks. His eye for the exact temperature and resultant hue of the water at different depths is also impressive, as is the way he catches the light on the distant shore in one long flash of brilliant green.

In this picture Thomson invents what was to become a standard composition for these northern painters. The rocky foreground pitches down steeply to the lake, but from it arise trees that form a vertical screen uniting the horizontal layers of the rocks, the waves, the far shore and the sky. Here the trees still stand to either side, like a picturesque arbour framing the typical romantic landscape; but soon Thomson and the others were to move them to the centre of the canvas and to break completely with the conventions of the picturesque.

A Northern Lake was a phenomenal success. Not only was it praised in a newspaper review as "remarkable for its fidelity to the northern shore," but to Thomson's great surprise it was bought for $250 by the Ontario government. The purchase had been arranged by the ubiquitous Sir Edmund Walker. Thomson was delighted to get the money, because it meant that he could take a full summer off from his job and go sketching again in Algonquin Park. When he

Fig. 120: Tom Thomson, *A Northern Lake*, 1913, oil, 27 1/2" x 40", Art Gallery of Ontario

returned to Toronto in the fall, Dr MacCallum finally persuaded him to accept the same financial backing as Jackson, and to become a full-time artist. In January of 1914 Thomson left the illustrating trade for good, and moved in to share Jackson's quarters in the new Studio Building.

The two artists exchanged influences. Thomson was apparently so successful in communicating his enthusiasm for the northern landscape that by the end of February Jackson was already up in frozen and snow-covered Algonquin Park. Before Jackson left, however, he introduced Thomson to some of the stylistic traits of impressionism and post-impressionism that he had learned in Europe. He showed Thomson how to get rich chromatic effects by painting what Jackson called "clean-cut dots" of colour, the expressive little touches that the Fauve artists had developed from the broken brush strokes of the impressionists. This was just the technique Thomson needed to record the brilliance of colour he observed in the north.

At first Thomson's canvases of that winter showed the usual colonial artist's problems with a style imported from the imperial centre. He painted several laboured applications of impressionism, scenes of moonlight reflected on the waters. It was only after he returned to Algonquin Park and to Georgian Bay in the following spring and summer that he could begin to put Jackson's lessons to better use, as his desire to record the splendour of his subject matter again took over his sketching.

A 1914 panel like *The Lily Pond* (Fig. 121) for instance, depicts a subject that the French impressionist Monet had painted many times. But Thomson's treatment of it is exactly opposite to Monet's. He uses the bright touches of colour that he had learned from Jackson, not to dissolve the forms of the lily pads floating on the water but to assert them most vigorously. His concern is that of the realist, to make his landscape believable as solid form in objective space. Thomson's lily pond is no formalist shimmer of irridescence: his pads gleam, but they are firmly located on a definite body of water receding in space.

A sketch of two years later, *Autumn Birches* (Plate VI), shows how far Thomson was able to take this new technique. The panel is charged with oil pigments brushed on in bold strokes that register directly the glorious fall colours that Thomson sees before him. He allows the wood to show through around the edges of many of his strokes. The excitement of colour is a direct transcription of the autumn woods. Each vivid brushstroke notes down another element distinct in space. "When I will take these sketches down to Toronto, the experts will all scoff at them, but those were the colours that I saw," he once commented to a friend.

So emphatically do the colours leap from Thomson's late panels that some critics and art historians have even compared them to the high-keyed non-representational paintings that were being developed in Germany only a few years earlier by the avant-garde Russian artist *Wassily Kandinsky*. But Kandinsky's abstract art was merely a further stage of formalism: he used such strong colours first to distort his subject matter for expressive purposes, and then as notes of colour 'for their own sake.' Thomson's

Fig. 121: Tom Thomson, *The Lily Pond,* 1914, oil on panel, 8 1/2" x 10 1/2", National Gallery

vivid coloration, on the contrary, is not at all a distortion, and is certainly not intended for its own sake.

Like other members of the group, Thomson carried a specially-designed portable sketching box into the woods. From the local sawmill he ordered panels cut to fit the inside of this box, and he would prop them up against the lid when he found his subject to paint. Working as a forest ranger or a fishing guide during the summer, he concentrated on the moments of change in the northland, during the spring and fall. On one occasion he is said to have set out to paint the changes in the woods day by day over a two-month period.

It was on panels like *Autumn Birches* that Thomson at last solved the struggle for the Canadian landscape. "The variety of Colours in the Woods shew the true Nature of the Country," Thomas Davies had written in 1762. Now, a little more than 150 years later, a Canadian artist was painting those colours and expressing that true nature without the intervening viewpoint of a European style.

This was the beginning of our national landscape art. A way had been found to express the rugged beauty of Canada's land. For the first time a Canadian artist, supported and encouraged by patrons with a nationalist outlook, was documenting Canada on our own geographic and climatic terms, with full regard for the brilliance of colour, boldness of form and depth of space perceivable in our clear light. It was not just a matter of riotous autumn colours: sunsets, cloudscapes, moonlight and the Northern Lights, waterfalls, rapids and dams, and the melting of ice and snow are among Thomson's favourite subjects. He is especially interested in the moods of nature at night and in early morning.

One particularly moving sketch, *Moose at Night* (Plate VII), shows a bull and cow moose emerging from a lake, probably as observed from Thomson's canoe, where he would often spend the night to avoid the black flies. The massive forms of the two animals are seen from the back.

The hillside behind them and the dark water are so richly painted in purples and greens as to suggest the influence of Varley, the colourist among his friends whom Thomson most admired. Underlying the hill and lake, around the forms of the trees and in the sky near the top of the painting, the surface of the panel has again been allowed to show through, reproducing most eloquently the luminous qualities of reflected moonlight. But our attention is most powerfully drawn by the series of dark forms seen in silhouette against the horizon line, from the antlered head in the centre, to the weatherbeaten shrubs to its left, finally to the proud stand of trees in the distance towards which the bull moose gazes.

Clearly the next step was to develop these on-the-spot sketches into a series of major paintings that would really constitute the basis of a national landscape art of the north. That was the ambition Thomson had recognized in Jackson's big painting in 1913. In the winters that remained to him before his sudden death at the age of 40 in 1917, Thomson set out to fulfil this ambition.

Lismer had already sketched stormy days on Georgian Bay, with the whitecaps on the water. In his last winter of painting, Thomson took one of his own sketches of this subject (Fig. 122) and gave the theme its first epic statement, *The West Wind* (Fig. 123).

If we compare the sketch with the finished painting, signs of the *art nouveau* graphic arts style that Thomson had learned as an illustrator are evident in the canvas. His use of the trees as a screen through which the rest of the scene is viewed, his outlining of the trunks, the long curving tendrils of the tree forms and the somewhat flat, decorative treatment of the foreground all show the effects of this training. Sketching outdoors Thomson was relatively free of this style, but in his studio during the winters he found it much harder to resist. The same stylistic properties are even more apparent in another famous Thomson painting, *The Jack Pine*, and clearly dominate the well-known canvas *Northern River*.

In *The West Wind*, however, these imported design elements are kept in check. Thomson concentrates on conveying the enormous power of the northland, and retains the dynamic movement of the wind and waves from the sketch. *The Jack Pine* stands as a personification of this power; *Northern River* is more serene, but the entire surface of *The West Wind* is swept by the energy and strength of the north.

This sense of movement is heightened in the canvas by a subtle opposition between the mood of the sky and the rest of the painting. In the sketch, and across the face of the water on the canvas, the colours and motion suggest an approaching fall storm: but in the clouds of the canvas, a sunnier day and a less pronounced movement hint at fairer weather. It has even been suggested that Thomson may have used the spring sky outside his studio window when he was completing the canvas, in place of the original fall scene. Thomson is said to have been not completely satisfied with the painting when he went north again in the spring of 1917.

The picture he left behind, however, has become a

Fig. 122: Tom Thomson, *The West Wind* (sketch), 1916 oil on panel, 8 3/8" x 10 1/2", Art Gallery of Ontario

national emblem. Its theme is the staunch resistance of the trees to the unremitting harsh winds. Lismer has called it "the spirit of Canada made manifest in a picture."

There is a truth to this image. The tree in the wind is a symbol of the tenacious grasp on the land and on life that our nation has maintained. Like the tree, Canadians have had to fight to survive. Nothing comes easily in this country. In our basic struggle for production with nature, Canadian farmers and workers have had to overcome great hardship. And in the struggle to build our nation under the dominance of a succession of the world's leading imperialist powers, we have similarly had to dig in and hold on, to become and remain who we are.

Yet this is clearly a national-bourgeois symbol for our nation. To a class that is always being tempted to sell out, it represents the ideal of steadfastness. But a storm-tossed tree is never able to right itself, let alone claim any more land than the marginal territory it clings to. This is not the symbol of the working people fighting for liberation, but of a class that identifies strongly with the land and hopes to hold on to what it has. As an image of heroic endurance, therefore, *The West Wind* reflects both the aspirations and the limitations of the national bourgeoisie itself.

The West Wind and several other canvases were left behind in the spring of 1917 when Thomson again went north to Algonquin Park for another season of sketching and working as a part-time guide. On July 7 he wrote to Dr MacCallum for the last time, and about noon of the next day set out on a routine fishing trip. The following afternoon his canoe was seen floating upside down. Eight days later his corpse was recovered from the lake. His head was bruised as if from a blow, his limbs entangled in fishing line.

No one really knows how or why Thomson died, although many explanations have been suggested, including murder. It is unlikely that it was accidental: Thomson was a strong swimmer and skilled in a canoe. The hasty inquest and the mysterious removal of the body to its supposed

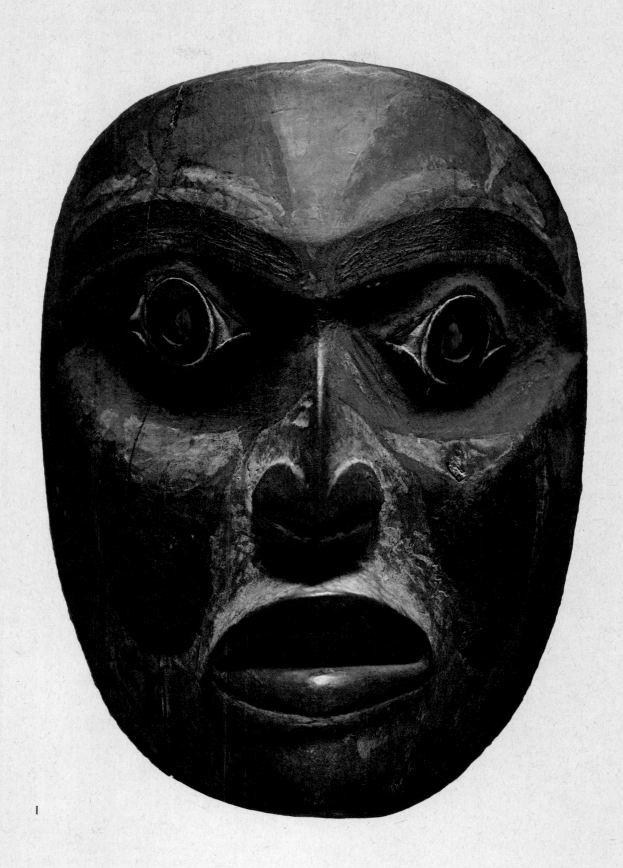

I

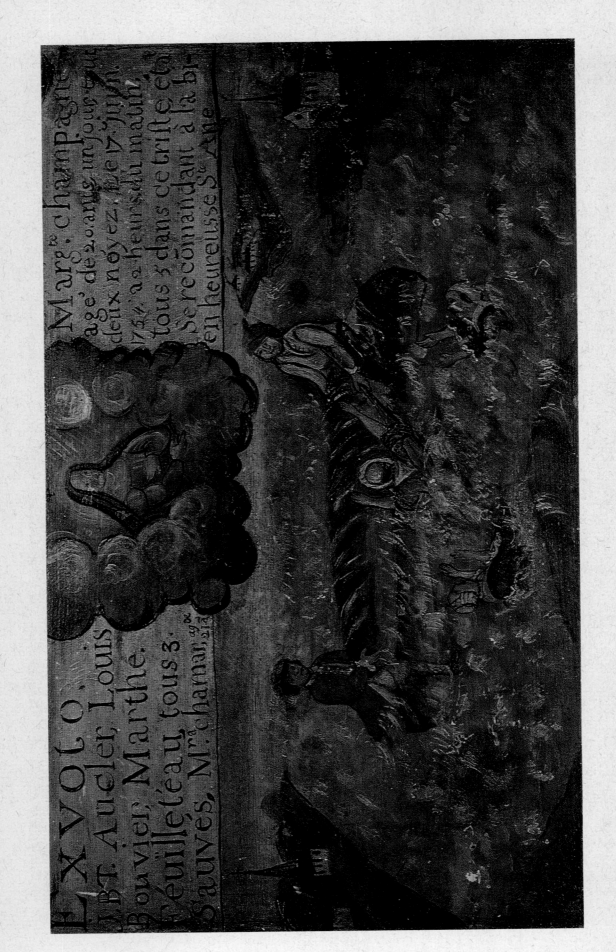

IV

V

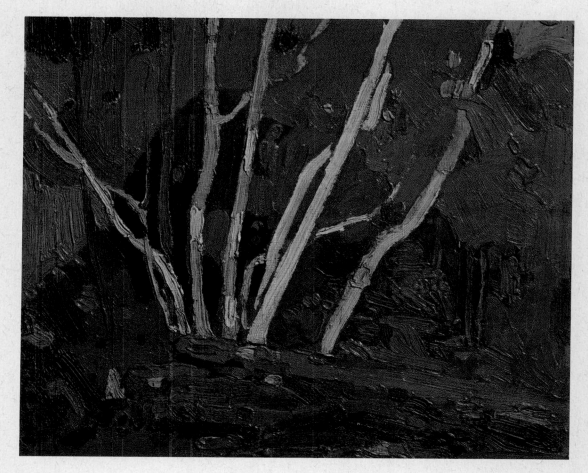

VI

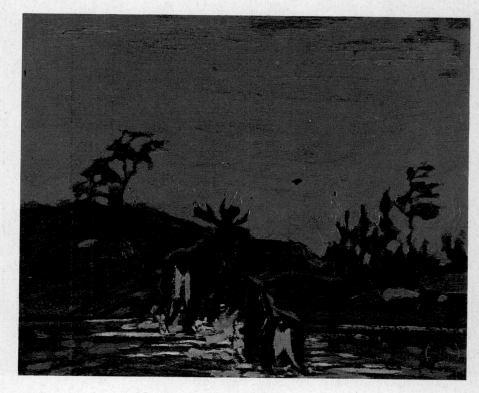

VII

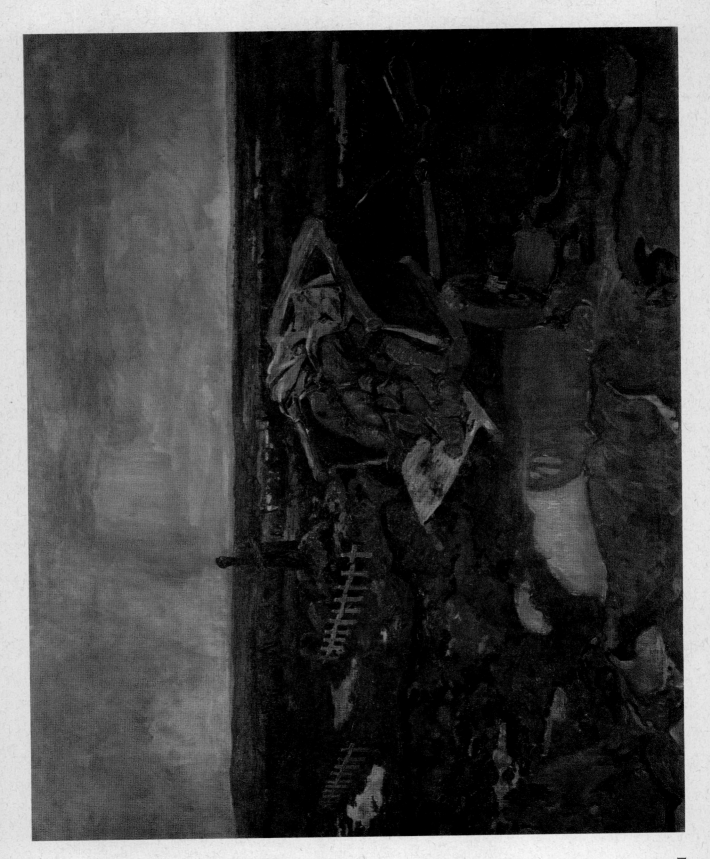

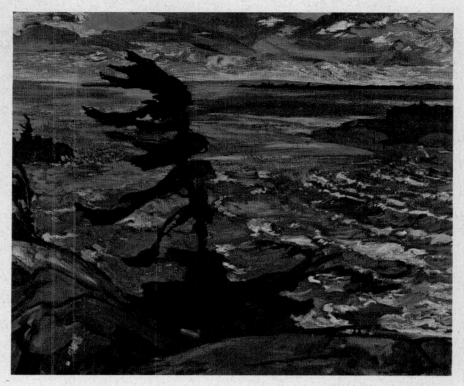

IX

X

XII

XIII

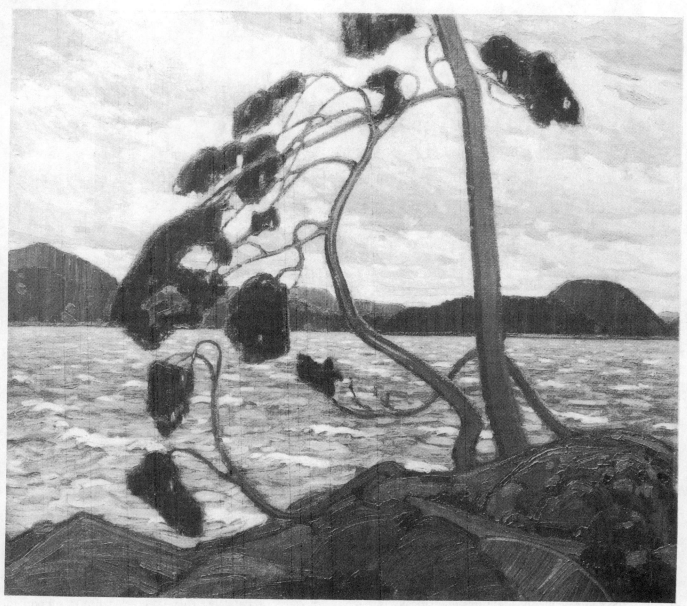

Fig. 123: Tom Thomson, *The West Wind,* 1917
oil, 47 1/2'' x 54 1/8'', Art Gallery of Ontario

though unconfirmed gravesite in the family plot at Leith convey the impression of a cover-up. Suspicions mount when it is learned that the doctor who performed the inquest had lunch at the house of the prime suspect just before concluding that the cause of the death was "accidental drowning."

The suspect is a U.S. citizen of German extraction, one Martin Bletcher Jr., who quarreled with Thomson and threatened him at another guide's party the night before Thomson disappeared. The United States had finally joined the First World War in the spring of that year, but Bletcher was known to have been previously openly pro-German; Thomson was opposed to the war, but he was also a patriotic Canadian.

What would Thomson have painted if he had lived?

Despite the enthusiasm of a number of pro-formalist critics, it is virtually certain that he was *not* headed for abstraction in the manner of a Kandinsky. As we have seen, he was essentially a realist throughout his brief painting career, and it was his ability to make his subject matter so convincing that had always given his work its authority, even among his fellow painters of the north.

There is an interesting possibility, however, suggested in the last canvases. *The Jack Pine* and *The West Wind* appear to have been the culmination of their theme; but a new direction can be observed in *The Pointers*, and especially in an unfinished picture called *The Drive* (Fig. 124). In both of these paintings for the first time on canvas Thomson's subject is working people in the northland.

The Drive is a powerful treatment of the annual spring

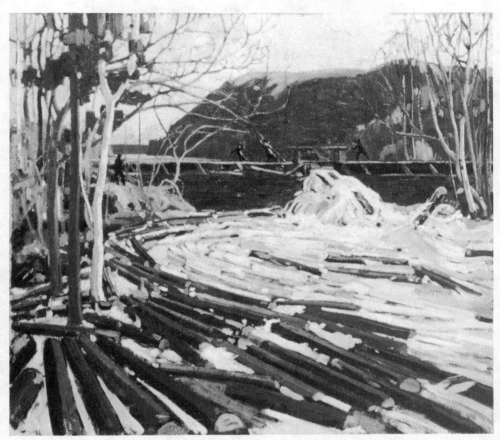

Fig. 124: Tom Thomson, *The Drive*, 1916-17
oil, 47 1/4″ x 54 1/8″, University of Guelph

lumber drive, with the logs being put through a chute. We have already seen that MacDonald and Harris were early attracted to this subject, and Thomson was probably also familiar with an interpretation by Lismer. Thomson's version is dynamic, as the workers are ranged along the dam in the middle distance, their long picks shunting the timber through the chute, while the logs surge dramatically toward us in the bright spring sunlight and melting ice. The *art nouveau* influence is restrained to a few sinuous boughs in the upper left, but without the flat patterning effect; in fact, the painting is unusual for Thomson's inventive use of a continuous advance in space, the logs following the current to the lower right corner. The way they break off the foreground edge of the painting shows that Thomson was ready to associate striking new compositional ideas with this more complex and challenging subject matter. Thomson's death deprived us of an artist who not only had achieved our national landscape art, but might very well have been able to lead the way toward the next great goal, the painting of the working people in our land!

THE FIRST WORLD WAR YEARS

The subject of Thomson's and Bletcher's argument was World War I. Since the fall of 1914, when Thomson, Varley, Lismer and Jackson had painted together in Algonquin Park, the war had disrupted their progress and plans.

The crisis of global imperialism had finally led to the first great inter-imperialist conflict, and Canada was enlisted to defend the British Empire.

The artists, like many other Canadians, were generally reluctant to fight in such a cause. Thomson's family later claimed that he had tried to volunteer but was turned down because of flat feet. There is no evidence to support this, however, and we do know that Thomson wrote to Dr. MacCallum that he was very disturbed to think of Jackson being in "the machine."

In April and May of 1915, the Canadian Corps heroically held the line in the Ypres salient, but sustained devastating casualties from the Germans' first poison gas attacks. Jackson was one of many who felt it his patriotic duty to answer the call for replacements, and in June of 1915 he became Private A.Y. Jackson. A year later he and his regiment advanced to France, where he was wounded at the battle of Maple Copse. Harris also signed up, and served as a gunnery instructor in Canada until suffering a breakdown after hearing of his brother's death in combat.

On the home front, the most immediate effect of the war for these artists was a sudden falling-off of work in the lithography studios, and the complete disappearance of free-lance design commissions. Franklin Carmichael had abandoned his studies in Antwerp (where Lismer and Varley had advised him to go) because of the war, but when

he returned he found so little work that he had to go back to his father's carriage business in Bolton. Lismer similarly had very little income, so when the Victoria School of Art and Design in Halifax offered him the job of principal, he gladly accepted and moved there for three years.

A second "Little Pictures" show earlier in 1914 had been successful, but the war made continuation of the series inadvisable. There was now very little money available among petit-bourgeois patrons for the purchase of works of art. Instead, the Royal Canadian Academy organized a travelling exhibition of *Pictures and Sculpture Given by Canadian Artists in Aid of the Patriotic Fund.* MacDonald designed the catalogue and poster, and paintings of the northland were loyally praised in newspaper reviews wherever the show toured, in all the major cities of Ontario, Québec, the Maritimes and in Winnipeg.

This change in exhibiting organizations and the national scope of the show are significant. The imperialists in each belligerent country and the compradors in their colonies had issued their respective calls to arms under the banner of patriotism. Faced with widespread opposition to the war, not only in Québec but also among Canadian workers and farmers, they aimed to transform the patriotism of the Canadian people into a chauvinistic defence of "our mother country."

This meant that the imperialists and compradors had to make a deal with the national bourgeoisie. This small and relatively weak class was now called upon for the first time to play a significant historical role.

Needless to say, the national-bourgeois stood to gain. The year 1915 saw a record wheat harvest in the west, most of which was shipped to the soldiers, while in southern Ontario industrial activity was multiplied many times over, with munitions plants and other factories rapidly being built. The national-bourgeois shared in the bloody wealth. But in addition, by supporting the imperialist war as a patriotic one, they were able to assume a much more central position in Canadian life. Still without real ownership or control, they could take on the appearance of a much more powerful class by enlisting patriotism in the service of its opposite, pro-imperialist chauvinism.

So comprador cultural institutions like the Royal Canadian Academy suddenly found themselves organizing popular exhibitions in cooperation with those upstart patriotic painters of the Canadian north who represented the national-bourgeois outlook. The amount of money actually raised for the war effort by this "Patriotic Fund" exhibition was trifling. Its real purpose was to put on a show of unity among Canadian artists, and to encourage patriotic Canadians to associate their support of our artists with support for the war.

The artists, in need of patronage, quickly became dependent on this new alliance. The main channel for it, however, was not the Royal Canadian Academy but that other British-style federal institution, the National Gallery.

By 1913, working closely with his chief trustee Sir Edmund Walker, the Gallery's curator Eric Brown had managed to get himself appointed director, and had also secured a headquarters for the institution in a wing of Ottawa's Victoria Museum building, now the National Museum of Man. Walker soon emerged as the key figure in the new alliance of interests. He was already familiar to the artists as a consistent patron: in addition to Thomson's *A Northern Lake*, he had arranged for the Ontario government to buy paintings by Lismer and MacDonald, and possibly at Harris's urging he had also recommended a MacDonald to Brown.

In the latter part of 1913 Jackson wrote to Brown, insisting that the Gallery should actively support the national landscape school; Brown vaguely agreed. Not satisfied, Jackson and Harris the next year wrote letters to that effect to the editors of the leading newspapers. Walker came hurrying down to the Studio Building to confer with the artists, and later met with Dr MacCallum several times. The result was the Gallery's purchase, in 1914 alone, of pictures by Harris, Jackson, Thomson, Lismer and Mac-Donald.

By 1920 the Gallery had acquired 18 major works by these artists, as well as 27 pictures by Thomson. The painters certainly needed it: MacDonald had to give up his house and move his family to cheaper living accommodations by the third year of the war. But the Gallery needed it too. Wartime budgets allowed the institution very little money and after Parliament burned in 1916 the exhibition rooms were taken over to provide space for the homeless MPs. Brown and Walker had to work harder than ever to establish the Gallery as a national centre.

Walker showed his awareness of the mutual interests served by these purchases when he wrote to Brown in 1916, recommending another MacDonald acquisition with the reminder that "Mr MacDonald is, as you know, one of the most promising of our artists and one who has the right kind of feeling regarding our position as Trustees for the Nation." The alliance between the comprador federal art institution and the painters of our northern landscape had been established.

MacDonald was especially eager to accept this patronage because he had just been ridiculed for his painting *The Tangled Garden* (Fig. 125), exhibited in the 1916 Ontario Society of Artists show. Those critics who were apologists for the academic artists had attacked the painters of the north for the first time in 1913, caricaturing them as the "Hot Mush" school, so named for their thick pigments and strong colours. Now, however, MacDonald was singled out as the most extreme, and was accused by Hector Charlesworth, the conservative *Saturday Night* reviewer, of "throwing his paint pots in the face of the public."

This was a famous charge that the British critic John Ruskin had levelled at Whistler for one of his formalist canvases forty years before. Charlesworth was beginning a long tradition of misinterpretation of these painters as formalist artists. MacDonald quite correctly replied that he and the other painters "expect Canadian critics to know the distinctive character of their own country and to approve, at least, any effort made by an artist to communicate his own knowledge of that character."

For *The Tangled Garden*, in fact, MacDonald had gone no further than his own backyard in Thornhill, near

Fig. 125: J.E.H. MacDonald, *The Tangled Garden,* 1916
oil on board, 48″ x 60″, National Gallery

Toronto. He had examined the vivid flowers and plants in
the clear autumn sunlight with great care, and made several
sketches and preparatory studies. To do justice to the
vitality of his subject matter, he decided to paint it close-up
and almost life-size.

By bringing the flowers close to the surface and filling
the background with the wall of his shed, MacDonald
achieves his characteristic over-all decorative effect, show-
ing the lingering influence of his design experience. His use
of the sunflowers as a screen through which the rest of the
garden is viewed, with their long drooping stems among the
lush undergrowth, is a specific *art nouveau* trait. The theme
is also partly based on the similar subjects and treatment
seen several years before in tapestries by the Scandinavian
artists. But above all *The Tangled Garden* is a realistic
depiction of a Canadian backyard, in all its vigour.

It was far too realistic for Charlesworth. "In the first
place the size of the canvas is much too large for the
relative importance of the subject," he wrote, "and the
crudity of the colours rather than the delicate tracery of all
vegetation seems to have appealed to the painter." A garden
picture ought to be smaller, more sedate and 'refined' in
hue. Something picturesque? Or a quiet tonal study by
Morrice?

MacDonald didn't ape these European manners, so
Charlesworth could see *The Tangled Garden* only in terms
of yet another European manner — formalism. Subsequent
critics have unanimously ridiculed Charlesworth, but only
to *praise* MacDonald and the others for this alleged formal-
ism. Charlesworth and his opponents have one thing in
common: they all measure Canadian art by the imperial
standard.

The Tangled Garden remained unsold until seven years
after the artist's death in 1932. MacDonald was upset by
the attack, which came at a time when he could hardly
afford to appear as an unsaleable rebel. "The artist is not
paid to exhibit his picture," he commented, "it is his stock

in trade and certainly should not be flippantly lowered in
the estimation of his public." His continuing bleak pros-
pects and the death of Thomson weighed heavily on him,
and in 1917, just after erecting a memorial cairn to
Thomson in Algonquin Park, he collapsed from nervous
exhaustion.

THE CANADIAN WAR MEMORIALS

Meanwhile in England the Canadian-born multi-millionaire
Sir Max Aitken (soon to be Lord Beaverbrook) was com-
missioning almost exclusively British artists to paint pic-
tures of Canadian soldiers for the official Canadian War
Records! Aitken had left his own country to reap enormous
profits in England, and now he was showing what a loyal
British subject he was.

The Royal Canadian Academy, acting in its newfound
role as spokesman for our artists' national interests, com-
plained that Canadian painters should be given at least a
few of the commissions. Since we were good enough to die
for the Empire (60,000 killed), we ought to be good
enough to paint our own soldiers! From a population of
only 11 million, Canada had 628,000 in uniform, 425,000
overseas, and had sustained 225,000 casualties by the end
of the war. An equivalent per capita participation by the
United States would have meant five million soldiers! Yet it
was not until June of 1917 that the Canadian Corps finally
got a Canadian commander.

Sir Edmund Walker agreed with the Academy, and
Beaverbrook was obliged to begin employing some Cana-
dian portrait painters. Only after he had been introduced to
Private A.Y. Jackson (who had also been given portrait
commissions) did he take the further step of having Cana-
dians paint landscapes to record the camps and training
grounds as well as the fields of battle, wherever Canadian
soldiers were posted.

So the Canadian War Memorials project came about. Sir
Edmund Walker also insisted that it should include pictures
of the home front, and took over administration of this
section himself. Jackson, Varley, Beatty, Cullen and Mor-
rice were among those who painted in England and France,
while Homer Watson, George Reid, C.W. Jefferys, Lismer
and Frank Johnston were all awarded commissions in
Canada. Over 850 works were produced in all, and are now
in the Canadian War Museum in Ottawa.

The artists followed orders as to location and general
subject matter, but specific topics and treatment were
largely up to them. Reid sketched scenes of the new
munitions factories that by 1917 were producing almost a
third of all the shells fired by the British Empire's armies on
the western front. Lismer did some large canvases of
wartime shipping in Halifax. Jefferys painted Polish regi-
ments in training at Niagara-on-the-Lake.

Johnston took advantage of the commissions to sketch
what must be among the first Canadian views ever painted
from an aircraft. Although Canada had contributed about
24,000 men to the empire's flying corps, with over 8,000
Canadians making up more than a quarter of all the officers
in the British air force and including some Canadian aces

Fig. 126: Francis H. (Franz) Johnston (1888-1949),
Beamsville, 1918-19, oil, 72" x 54",
Canadian War Museum

like the famed Billy Bishop, it was only towards the end of
the war that we began training our own Royal Canadian Air
Force. Johnston began sketching part-time at the flying
schools while still working as a commercial artist, and then
enthusiastically quit his job to accept a full-time com-
mission.

Beamsville (Fig. 126) is one of the large canvases he
worked up from his sketches. It shows us an aerial view of
the south shore of Lake Ontario over that Niagara Peninsula
town (now part of Lincoln), with the clouds parting to
reveal a small squadron of Canadian training planes on
manoeuvres. Johnston is careful to show us the shadow of a
cloud on the wing of a plane below, and also to vary the
colour of the lake according to the depths of the water and
the submerged sandbars. He is especially attracted by the
patchwork of fields, creeks and roads stretching below.
Although the subject is quite different from the scenes of
the north that these artists had been painting, the idea of
the commanding panorama, seen from a high hillside if not
from the air, was to be important to them in conveying the
grandeur of Canada. Johnston, who took time off from
painting this canvas to go sketching in Algoma with Harris
and MacDonald, must have been excited about sharing his
discoveries with them.

In Europe, Jackson and Varley were the two members of
this group of painters to witness actual fighting. Jackson
had been invalided back to England, where he managed to
see the controversial exhibition of war art called *Void,* by

the British painter *Paul Nash* in London in 1917. This show
was so realistic that Jackson said he instinctively ducked
when he first looked at one of Nash's canvases. It exposed
to the British public for the first time the horrors of trench
warfare.

When Jackson went back to the front as a war artist, he
was strongly influenced by Nash's paintings. Without the
stimulus of his Canadian landscape subject matter, he was
much more apt to defer to European styles. *A Copse,
Evening* (Fig. 127) follows Nash in concentrating on the
hellish landscape created by the endless succession of
shell-holes filled with filthy water, the debris embedded in
the heaps of slime, the grotesquely blasted tree trunks that
were once "a copse," and the eerie searchlights on the
horizon. Yet we can still see the painter of *Terre Sauvage*
(Fig. 118), making a powerful dramatic statement from the
stark outline of the trees.

The column of soldiers we can scarcely make out moving
up to the line through these hillocks of sludge are part of
what had become the storm troops of the western front.
Ever since their victories on the River Somme in 1916, the
Canadian Corps had been sent in where ruthless, sustained
attacks were needed in desperate circumstances. "Whenever
the Germans found the Canadian Corps coming into the
line they prepared for the worst," the British Prime Minis-
ter Lloyd George later wrote. Jackson was with these
near-invincible soldiers at the time of their most spectacular
victory, the taking of Vimy Ridge. They then went on to
set the world's armies an incredible example of heroic
persistence in the capture of Passchendaele.

Varley joined the Corps for six weeks in the last few
months of the war, during "Canada's Hundred Days," their
victorious but bloody advance from August 4 to November
11, 1918. Often under fire, he accompanied the hard-
fought campaign that led to the capture of Cambrai. "I tell
you, Arthur," he wrote back to Lismer, "your wildest
nightmares pale before reality."

Back in England, painting just after the Armistice,

Fig. 127: A.Y. Jackson, *A Copse, Evening,* 1918, oil, 34"
x 44", Canadian War Memorials Collection,
Canadian War Museum, Ottawa

The Group of Seven: A National Landscape Art 133

Varley reproduced no heroics on canvas. Instead, daring to paint the first large compositions of his career, he used the imperialists' War Records commission to make a passionate and profound statement against their war.

For What? (Colour Plate VIII) is one of the great works of art to come out of World War I. It shows a Canadian burial team preparing graves on an immense war-ravaged plain. Another stretcher load of mangled corpses has been dragged to the field in a heavy iron cart, its wheels rutted in the mud. While two soldiers go on digging, half hidden by the grave, a third pauses on the pile of muck. Silhouetted by the yellowish horizon of an overcast sky that promises more rain, his face in anonymous shadow, the soldier contemplates his comrades' bodies. Not a tree breaks the uninterrupted expanse of shell-pocked ground that has been fought over many times. Only the grimy pools in the shell-holes reflect the sickly sky, as the warm red and brown colours of the earth mingle with a dank mould green. The two rows of crosses imply many more.

We do not need to know the title of the painting to understand the question it asks. Painted as the imperialists were arranging the terms of the armistice to their own advantage, this canvas takes the point of view of the soldiers who did the fighting and dying in the mud for four years. It mourns the dead, but also demands reason for the slaughter. *For What?* was a question many Canadian veterans were to ask as they came back to a Canada of exploitation, repression and unemployment.

CANADA AND THE 1917 REVOLUTION

Varley's painting reflected the fundamental questions that many people all over the world were now demanding answers for, questions about the international system of oppression that had led to such a war. In 1916 the Russian revolutionary leader Lenin had put these questions, together with their answers, in their most profound and pertinent form in *Imperialism: the Highest Stage of Capitalism.* Here he advanced Marxist science to an understanding of this new stage, pointing out how it differed from earlier stages of capitalism, how it had been the cause of world war and "is the eve of the social revolution of the proletariat." In 1917 that revolution, supported by the Russian peasantry as well, established the first stronghold of socialism in the world. Out of the crisis of imperialism had come the birth of its opposite.

The revolution had an electrifying effect on progressive Canadians, and especially on the Canadian working class. Now at last the oppressed all over the world could see a clear road ahead, with the establishment of the first workers' state. Millions of Canadians joined those everywhere who were cheering the infant Soviet Union on its way. The Russians had shown that it could be done!

Among the first Canadians directly involved with the revolution were the Canadian Corps veterans who were scheduled to go to Russia late in 1918, to support the reactionary White forces that were trying to put down the revolution. The imperialists hoped that the shock troops of the western front might make short work of the revolution-

aries. Many veterans were held in England for this purpose, while others like Jackson's regiment were transferred to Halifax but kept in readiness for the Russian expedition.

By the middle of January, 1919, Jackson was already writing to the other artists in Toronto that the Russian trip was most unlikely. One artillery outfit had gone to Murmansk, and 4,000 Canadians were sent to Vladivostock, where they joined 8,000 U.S. troops and 70,000 Japanese, but did no fighting. Back in England and in Canada, the Canadian Corps had won still another victory; they rioted to show that they refused to go, and definitely would not fight in alliance with the reactionaries against the revolution. Canadians at home also demonstrated their resistance to sending this force to Russia.

By the spring of 1919 the Russian proletarian revolution was an inspiration to a far larger section of the population. On May 15, 24,000 workers in Winnipeg closed the factories, the railway yards, and all construction and transportation. Within two days 35,000 workers out of a total population of 200,000 men, women and children were on strike, shutting down all communications, power sources, retail food and public services. The city was controlled by the workers, led by their Central Strike Committee, whose *Strike Bulletin* was the only newspaper being printed.

This Winnipeg General Strike was actually nation-wide. In Vancouver 60,000 walked out in sympathy, workers across the prairies shut down mines and railways, the Cape Breton miners went out, and despite the opposition of the U.S.-controlled unions, 15,000 joined them in Toronto. The demands were a living wage, the 8-hour working day, and most important, the governments' recognition of the workers' right to collective bargaining. Crucial to the strikers was their alliance with the 10,000 veterans in Winnipeg who repeatedly marched on the civic and provincial government to support the workers' demands.

On June 21 a special force of 2,000 strikebreakers and Royal Canadian Mounted Police on horseback charged a peaceful parade that included women and children led by these veterans, fired 120 bullets into the crowd and killed two strikers. With the open collusion of U.S. union leaders who feared the rank-and-file militancy of the strike, and with police-state control imposed on every major street corner in Winnipeg, the strike was put down.

The ruling class had been terrified. Prime Minister Meighen called it "Bolshevism," and Toronto manufacturers agreed that it was a "rebellion against capital." It was certainly the most heroic hour of the Canadian proletariat up to that time, and showed its steadily increasing power. But there was clearly no possibility for the workers to seize political power at this stage: not only did they not have a political organization of their own that was capable of leading such a move, but our country was still not even independent!

Even so, the ruling class had to proceed carefully. The Liberal party, the political representative of U.S. interests, in 1919 turned to its new leader Mackenzie King, who had brought his experience and connections as John D. Rockefeller's labour relations manager back to Canada. Laurier's

Fig. 128: J.E.H. MacDonald, *Leaves in the Brook (Sketch)*, 1919,
oil on panel, 8 1/2'' x 10 1/2'', McMichael Canadian Collection, Kleinburg

policy of outright economic union with the U.S. would be attempted by King, but in stages. In the beginning, to get elected, he had to steal a good many of the National Progressive Party's programmes.

Then during his first terms of office, from 1921 to 1926, he had to maintain what he could of the old wartime deal with the national bourgeoisie. But meanwhile he was encouraging U.S. investment in general, and making Canada more profitable for the Rockefellers in particular. The days of the British regime were numbered.

It was during this period of transition in Canada, with British imperialism drastically weakened, U.S. control not yet firmly instituted, and the small national bourgeoisie temporarily advantaged, that our national landscape art was finally established.

THE ESTABLISHMENT OF A
NATIONAL LANDSCAPE SCHOOL

In the spring of 1918 Lawren Harris and Dr MacCallum set out in search of a new northern landscape. After crossing Manitoulin Island, they found what they were looking for in Algoma, the district north of Sault Ste Marie. In the fall they were back with MacDonald and Johnston, sketching the glorious autumn colours of that magnificent region. Harris had chartered a caboose, and arranged with the Algoma Central Railway to have their car shunted onto sidings and moved from place to place as they required. The trip was a great success; in 1919 they returned, with

Jackson taking Dr. MacCallum's place, and on subsequent trips they brought Lismer along as well.

Leaves in the Brook (Fig. 128), painted by MacDonald on the group's second 'boxcar trip', is one of the finest of the thousands of sketches in our national landscape tradition. The pigment rushes forward and down the little panel with the stream, and the touches of brilliant yellow and red pick out the fallen leaves. We can sense the varying depths, temperature and motion of the water, as it ranges from a deep dark glow to grey-white froth in the current. The forms of the rocks are brushed in with solid strokes of warm tones that also lend structure to the picture as a whole, with the biggest stones additionally outlined in black. The tangle of brushstrokes never clogs, even on the thickly painted far bank. The rich colour and rapid movement are conveyed to us with all the freshness of the original autumn scene.

"I always think of Algoma as MacDonald's country," Jackson later wrote. "He was awed and thrilled by the landscape of Algoma and he got the feel of it in his painting." In his earlier sketches and canvases based on his Algoma trips MacDonald preferred these intimate, close-up and even closed-in views of nature, where his entire picture surface is suffused with the colour and texture before him. By the second and especially the third year he tended to prefer the panorama, the grand view in which he could evoke the majesty around him.

The Solemn Land (Plate X) is undoubtedly the

greatest of his large canvases on this noble theme. Based on sketches made during the 1919 trip and on a photograph taken a year later, it reveals a dramatic vista of the Montreal River valley in Algoma. Below us the land slopes steeply off to the left. Near the centre at the bottom edge of the canvas is a red-leafed tree, a vivid note of colour. Behind it, the dark stands of fir trees lead our eyes away upriver.

Beyond the hulking shoreline forms, where more flashes of red are glimpsed among the brown-green and black foliage, a stupendous rocky promontory plunges down to the water, its cliffs and its crown of orange and yellow treetops partly glowing in the strong afternoon sun, partly steeped in the shadows cast by the heavy cumulus clouds overhead. On the right side a series of peninsulas fall dark brown and black into the shining river. In the distance the lower hills gleam, but the higher ranges stand boldly purple against the bright sky.

All the prominent forms, including the clouds, are painted with a strong outline. The effect is one of great deliberateness, as each shape is given its full weight. We sense how solidly rooted we are on yet another clifftop. This feeling of being part of the solemnity of the landscape, of actually standing and observing this great land, reinforces the drama and power of MacDonald's scene.

With paintings like *The Solemn Land,* our artists of the northern landscape brought our national painting tradition to full realization. Conscious of their historical role, matured by their wartime experiences, sensitive to both the wealth of detail and the massive grandeur of our country, they had achieved an art of the landscape that was equal to the challenge of Canada. They had fulfilled the promise of Thomson's *The West Wind.*

The first group of three painters who returned from Algoma in the fall of 1918 (Harris, Johnston and Mac-Donald) were so excited about their discoveries and their accomplishment that they wanted to exhibit their sketches and paintings at once. Sir Edmund Walker was again on hand, this time as a board member of the Art Gallery of Toronto (now the Art Gallery of Ontario), and he quickly arranged for a three-man show in its new exhibition rooms for May, 1919.

So in the very month that the General Strike was raging across Canada, our leading painters were exhibiting their scenes of Algoma. It is significant that the high point of the working-class struggle to date came at the same time as the attainment of a national landscape art. The lack of unity between the two is equally apparent.

By the spring of 1920 these artists were ready to take their next great step. Instead of trying to repeat an exhibition restricted to the Algoma themes, they decided to exhibit as a group, consciously putting forward their pro-gramme of a national art. Lismer, MacDonald, Johnston, Varley and Carmichael gathered at Harris's studio; Jackson was out of town, but they knew they could count on him, so they called themselves *The Group of Seven.* Their first exhibition opened at the Art Gallery of Toronto in May, 1920, and was followed by a second and third exhibition in the same month of the next two years.

The catalogues for these exhibitions all contain a brief statement of purpose. A quotation from the 1921 edition shows how conscious these artists were of their national mission, and what it had to do with the Canadian land-scape:

"A word as to Canada. These pictures have all been executed in Canada during the past year. They express Canadian experience, and appeal to that experience in the onlooker. These are still pioneer days for artists and after the fashion of pioneers we believe wholeheartedly in the land. Some day we think that the land will return the compliment and believe in the artist, not as a nuisance or a luxury but as a real civilising factor in the national life."

One of the outstanding paintings in this 1921 exhibition was *A September Gale, Georgian Bay* (Fig. 129) by Arthur Lismer. Here Lismer finally brings to its culmination an epic theme that had recurred in his work since his first visit to Dr MacCallum's cottage eight years earlier, when he had been caught in a sudden storm. In September, 1920 he and Varley were sketching together in the same area when a similar gale blew up, and both artists caught the excitement of the fierce winds and lashed-up waters on their panels.

An earlier attempt by Lismer at painting a tree in a Georgian Bay storm had possibly suggested the subject matter of *The West Wind* to Thomson. Now in turn, Lismer was certainly familiar with Thomson's canvas by the time he painted *September Gale.* In his panel sketch he had caught the rush of the waves, the eddy of the little bay below, and the sharp thrust of the rocks in the foreground. In a further small canvas study he expressed the storm's motion in the massive cloud forms, solving the problem of the sky that Thomson had encountered, and then followed Thomson's example by extending the trunk of his tree beyond the top framing edge of his picture.

In Lismer's finished canvas as in *The West Wind,* the trunk of the tree stands in heroic resistance to the furious force of the gale winds that drive everything else, including its gnarled boughs, off toward the left. The reeds and the small blowing bush in the foreground accentuate this movement, while the rocks from which we look steeply down and the island across the inlet provide the solid foundation for this profound, elemental drama.

Lismer's version achieves its great power through a masterful organization of line, composition and mass. Varley's *Stormy Weather, Georgian Bay* (Plate IX), achieves much the same statement through a passionate use of colour and light.

Again our viewpoint is steeply down; again a tree stands up to the buffeting of a wind that is churning up the waters of the inlet below and scattering clouds across the sky. But in Varley's rendition, also exhibited in the 1921 show, the forms are conveyed to us not by the strong outlines of a Lismer or MacDonald, but by the most rhapsodic mingling of colour, exquisitely responsive to the light as it qualifies and modulates each surface of every wave, boulder and bough. The sun, just beginning to set, lights the clouds from beneath, casts the distant peninsula and islands in darkness, and allows Varley a full range of his favourite light purples

Fig. 129: Arthur Lismer (1885-1969), *A September Gale, Georgian Bay,* 1921
oil, 48" x 64", National Gallery of Canada

and greens. Unlike Thomson and Lismer, Varley keeps the top of his resistant tree in his picture, and draws our attention out to the expanse of the Bay. The top of the tree breaks the distant horizon brushed in with long sweeping strokes of the lightest green and a thin line of blue land. Here is the sensitive, emotional painter of *For What?*, now revealing the grandeur of Canada's northland.

September Gale is the title J.B. McLeish used for his biography of Lismer. Certainly we could take the title *Stormy Weather* to describe Varley's life and career. But the titles are significant of even more than the life stories of the individuals who gave them to their paintings. *The West Wind, September Gale* and *Stormy Weather, Georgian Bay* embody the notion that the conflict observed in a September storm can mirror the struggles of mankind, and that the northern Canadian landscape in particular reflects the heroic efforts of the Canadian people. The image is still the national-bourgeois one of a tree that endures and resists rather than one of a people who fight back. But for artists and a public who had recently been given an unforgettable demonstration of courageous tenacity at Passchendaele, the

identification of this stark drama of the land with the essential character of Canadians was irresistible. The Canadian Corps had strengthened our confidence in our abilities to fight as a nation; here were paintings to express that heightened spirit of struggle.

"The Dutch patriots are getting scared," Jackson wrote in a 1919 letter. They were scared enough to make some effort to take over the new art. Since the national bourgeoisie had compromised itself in its wartime deal, an unequal bargain from which as a class it was never to escape, the compradors were now in a good position to take charge.

We have seen how dependent MacDonald had become by 1916 on Sir Edmund Walker and National Gallery purchases. In the postwar period, even before Walker had arranged the Group's Algoma showing at the Art Gallery of Toronto, he and Eric Brown took steps to ensure that the National Gallery became the chief exhibitor as well as purchaser of the major Group paintings.

In this new phase of its patronage, the National Gallery revealed its comprador character more clearly. During the

first five post-war years, while the Group was just establishing itself in Toronto, the Gallery sent no less than three travelling exhibitions to the United States!

The purpose of these exhibitions was made clear when the academic critic Hector Charlesworth again attacked the Group, calling the Gallery "a national reproach" for its patronage of these artists. No less a personage than Sir Edmund Walker replied to Charlesworth's comments that "It is rather a weakness in the force of his criticism of the Canadian modernists that it should be at such complete variance with the opinions of critics of world-wide reputation who have seen them." The main aim of the Gallery's efforts was to associate the group with international "modernism", by which both Walker and Charlesworth meant formalism, and specifically to submit the Group to the judgment of "critics of world-wide reputation", namely those of the imperial centres.

To Walker and Brown in 1924 this still meant primarily the British. In the dying moments of the British regime in Canada, the imperialists in London had decided to stage a "British Empire Exhibition" at Wembley to recall the old days of the "Colonial and Indian Exhibitions." Brown seized the opportunity to turn it into a British triumph for the Group. The Royal Canadian Academy protested loudly, having reverted to its pre-war role of representing those artists who still thought they could serve the Empire best by imitating out-of-date European styles; after 1924 the Academy stopped exhibiting at the Gallery, and did not show there again until 1961.

The Gallery showed the real purpose of its "international" programme by reprinting and distributing widely the British critics' favourable reviews of the exhibition. "The English notices of our pictures at Wembley have established the newer painters in a secure place," The Canadian Forum obediently concluded. The clincher came when London's Tate Gallery bought one of Jackson's works in the show. In 1925 the exhibition was repeated and Brown did it all again, once more reprinting the British reviews: if he could have continued, he might have produced an "annual review" of imperial art criticism for the colony!

But the Group's achievement of a national landscape art remained indelibly and uniquely Canadian, however these comprador agents tried to use it. The artists themselves were concerned to get their works seen by Canadians: in the two years during which their first three major exhibitions were being seen in Toronto, they organized over 40 smaller shows for other Canadian towns and cities. In 1922 they got the National Gallery's backing for a year-long touring exhibition that started in Vancouver, where it caused quite a sensation, and ended in Fort William (now Thunder Bay).

Encouragement from the patriotic petit-bourgeoisie now grew stronger than ever. In February of 1917 (just as the first stage of the revolution was breaking out in Russia), a group of students and professors at the University of Toronto had founded a magazine called The Rebel, and in 1920 they had broadened their base among professionals and intellectuals to bring out the first issue of The Canadian Forum. Barker Fairley, writing regularly for both publications, became the Group's most perceptive critic.

At about the same time Bess Housser, a friend of Lawren Harris, began to run features on the Group regularly in Canadian Bookman. And in 1926 her husband Fred, who was financial editor for the Toronto Star, brought out his book, A Canadian Art Movement: the Story of the Group of Seven. Still an invaluable source of information, Housser's book was by far the best work of art criticism that had ever been written in Canada: it made clear the character of our national landscape art, and underlined the patriotic nature of the Group's achievement. Over the years it has continued to tell Canadians the Group's story in bookstores and public libraries across the country.

Housser's book came out in the first year that U.S. investment in Canada exceeded British; one regime was ending, another was about to begin. The national bourgeoisie had been effectively cut off from any possible chance at getting control of the country. Their viewpoint, however, had been eloquently expressed in art.

In 1919, in a list of quotations from the artists, the Belleville Intelligence printed their simple and profound statement, that "the great purpose of landscape art is to make us at home in our own country."

IV Painting in the age of U.S. imperialism

In the depression year of 1920, coal miners on Cape Breton Island in Nova Scotia were making $21.42 per week. The British-owned Nova Scotia Steel and Coal Company decided that its profits required that those wages be cut by 37 per cent.

In 1921, while the British Empire Exhibitions were being planned in London, steel workers employed by the British Empire Steel Company in Sydney, Nova Scotia were getting about $15.94 per week, with 60 per cent of them making less than 35¢ an hour.

When the coal miners and steel workers struck or slowed down production to protest wage cuts or demand higher wages, they were met with police and imported militia armed with machine guns. As one Member of Parliament described the reception given to a column of unarmed strikers, "A line was drawn and a machine gun was set up before Bridgeport Catholic Church, and the men were ordered not to pass the line on peril of being fired upon."

Yet by 1923 the workers' determined militant actions had forced even Prime Minister Mackenzie-King to admit that "There is need for revision of the statute affecting the calling out of militia in aid of the civil power." The statute was revised, but that didn't stop company police from firing on strikers and killing one miner in the street two years later.

Leader of the 8,000 coal miners in these heroic struggles was J.B. McLachlan, chief officer of District 26 of the United Mine Workers of America (UMWA). McLachlan had so much popular support as a leader that when he was imprisoned at Dorchester Penitentiary in New Brunswick on a two-year sentence for conducting an 'illegal' strike, he had to be let out after only four months because of the massive demonstrations and on-the-job actions in protest.

Among the workers' enemies was John L. Lewis, the so-called 'international' president of what was really a U.S.-run union. Lewis joined the courts and the companies in

calling the 1923 and 1925 strikes against the use of militia "illegal" and "a violation of existing agreements." He revoked the district's charter, deposed McLachlan and the other elected leaders, and got his appointed agent to obtain police protection to take over the offices and funds of the district. In Ottawa, the president of the already U.S.-dominated Trades and Labour Congress chimed in that "The miners will do well to remain loyal to their international union."

The miners did not take his advice. Instead, they called a mass meeting in Glace Bay and denounced the UMWA for having "lined up with provincial and federal governments and the British Empire Steel Corporation." The era of U.S. imperialism had begun: even where U.S. corporations had not yet taken over from the British, U.S.-run unions were ready to collaborate in the oppression of Canadian workers.

The events in Glace Bay reflected the whole new world situation. The capitalist system had collapsed in one-sixth of the globe. The imperialist centres were now more dependent than ever on their colonies, and their increased exploitation of colonial labour and resources would only lead to a sharpening of the conflicts within each colony. The new Soviet Union was able to offer a socialist base of support. And the working class in imperial centres like England could now unite their own struggles (such as the British workers' General Strike of 1926) with the growing campaigns for independence in the colonies. The whole nature of these national liberation struggles had now changed: instead of just seeking independence for the capitalists in the colonies to exploit their own people, they could now ally with socialist revolutionary forces, and prepare the way for a socialist transformation of their societies.

In Canada, the situation was qualified by one major factor: while imperialism in general had been weakened by the war, U.S. imperialism had grown stronger. Britain had

Fig. 130: Lawren Harris, *Miners' Houses, Glace Bay,* 1921
oil, 43″ x 51″, Art Gallery of Ontario

really been defeated, not by Germany but by the U.S., which had stayed out of the war until its last year and had capitalized on the British government's need for cash to pay for munitions and supplies. Now Britain was in debt to the U.S., and was far too weak to hold onto all her colonies in the fiercely competitive imperialist world. The U.S. was in an excellent position to take over, and nowhere more so than in Canada.

At about this time, in the late winter or early spring of 1921, Lawren Harris came to Cape Breton on a sketching trip. As early as 1910, Harris had begun painting street scenes and houses in Hamilton, Grimsby, Unionville and Barrie. In Toronto he had favoured houses in 'the Ward,' a district occupied at this time mostly by working-class Jewish immigrant families. But his paintings of these subjects had been essentially decorative studies of the colour, texture and forms of the houses.

Miners' Houses, Glace Bay (Fig. 130) is different. It is anything but decorative, as the stark series of tall, slanting buildings is further emphasized by the massive rocky outcrop in the foreground, and by the strange light that falls on the roofs, walls, fences and boulders from the break in the clouds in the upper left of the picture. The sky is blue-black: the rust-orange glow of reflection and an almost phosphorescent green glimmer are the only other hues in the scene.

The expressive lighting, breaking dramatically from the

sky as if into a mine shaft, together with this choice of colours and the way the rocks reach down into the earth below our view all create a feeling of the coal mines. The houses themselves are not so much unlike pithead sheds. They fit a description by a minister visiting in the region of Pit No. 11 in 1923:

"At the back of the house stood rows of dilapidated latrines, each family having to pay $1 to have them cleaned up. No double windows or storm windows in many of the houses, and the whole place had a squalid appearance."

At the same time, both in their individual vigour and in the strength they derive from their massing in rows, the houses seem to personify the miners themselves. The darkened windows above and below in each house, with the curtains slightly parted on some, suggest the sleeping power within. The whole composition, realized in terms of light and darkness, is a particularly rugged version of the triangular volume that Harris often uses, with the jagged picket fence across the foreground forming part of its base, and the rooftop reaching furthest into the sky at its apex. Interlocking with this rough triangle is the pronounced diagonal recession of the rocks and houses, ranged like men in ranks to the horizon line.

Harris has evidently been moved by his experience of the miners' world to a statement of great expressive power. In mood and meaning, this painting might even be compared

to Joseph Legaré's paintings of the St. Roch fire or the landslide at Cap-aux-Diamants (Figs. 48, 49). Although Harris is not out to document a specific event, he does use similar painterly means to convey the hardships of the people.

That Harris was affected by the sufferings of the miners and their families is confirmed by a block print that he made at this time, called simply *Glace Bay* (Fig. 131). It represents an almost identical group of houses, but with a mother and her two children taking over the foreground, while a miner toils up the road on the right, on his way to the mineworks on the horizon at left. The woman staring desperately out at us, her daughter also looking full face out in the lower left corner, the way the paper is used for the light of the sky and the light from the windows, and the single figure walking away on a sharply receding path all reflect the influence of the Norwegian expressionist artist *Edvard Munch*, and remind us that Harris had studied in Berlin, where Munch's work was well-known. But these are not simply expressionist distortions of reality, exaggerated to prove a point: they depict the real conditions on Cape Breton as described by J.S. Woodsworth only two years later, "children crying from hunger, three loaves of bread for a family of seven." Many of the miners by this time were getting only six or seven days of work a month at the reduced rates.

Fig. 131: Lawren Harris, *Glace Bay,* 1921, block print, Artist's estate

In Halifax on this same trip Harris painted the homes of another group of oppressed people, the large minority of black Canadians in that city. *Black Court, Halifax* (Fig. 132) shows one corner of the two-storey frame blocks in which these people lived in extreme poverty. Again the

Fig. 132: Lawren Harris, *Black Court, Halifax,* 1921, oil, 38" x 44", National Gallery of Canada

colour is restrained: the grey of the unpainted tenements predominates, mingling with the mud and slush between the buildings. At the windows hang the acid-green blinds then commercially available, and the door that stands open to show two figures in the dark interior is painted the same colour.

The black children playing on the steps appear constricted by the sombre rectilinear shapes of the wooden structures around them. The sky behind the buildings echoes this severity in its overhanging clouds, and even the water glimpsed between the houses has a greenish hue. An unpainted board fence on the right closes off the court, and completes the picture of a people hemmed in by poverty.

Obviously Harris's paintings of social subjects have the same limitations as Legaré's, in that they depict the plight of the poor but do not show the ongoing fight of the blacks or the miners to change their conditions and defeat their oppressors. Harris, like Legaré, remains a sympathetic bourgeois deploring the suffering of the masses, not a man committed to their struggle for justice.

Harris went almost directly from his experiences in Halifax and Cape Breton to the lonely country on the north shore of Lake Superior, which he first visited with Jackson. For the next five years it was the barren rocks, the enormous lake and the great clouds in the vast sky of that region that attracted him, not the problems of the workers or minority groups.

North Shore, Lake Superior (Fig. 133), painted at the end of this five-year period, sums up Harris' encounter with this commanding landscape. The huge stump that stands exposed on the shoreline had been discovered by Jackson and Harris a few miles north of the Lake, but Harris has here transposed it, silhouetting its wind-worn shape before the infinite horizon line and the great rolling layers of clouds. We can recognize the broad-based triangular composition, and the light breaking from the upper left corner, both effects explored earlier in *Miners' Houses, Glace Bay.* Linking horizontal areas of sky, clouds, lake, rock and

Fig. 133: Lawren Harris, *North Shore, Lake Superior,* 1926, oil, 40" x 50", National Gallery

foreground vertically, the grey stump is also distinctly related to the trees in *The West Wind, September Gale* and *Stormy Weather, Georgian Bay.*

But what a difference in Harris's version! Instead of the realistic force for change that is the wind, we have the cold, clear illumination of Harris' 'transcendental' light that bursts as if from the heavens. In place of the scudding clouds and churned-up bay, Harris paints clouds that appear almost solid and permanently shaped, and one long low wave that heaves silently on the still water. The stump, rather than being an image of heroic endurance like the trees battling the winds around them, is a derelict victim of some lightning storm of the distant past, cracked open and worn smooth by many seasons. It does not resist: it simply reflects the sky's light.

Harris's universe is static, without change. He had fled from the challenge of the working-class subjects he had found on the east coast, to an idealistic world in which he can order all the elements in terms of light and composition. As Sydney Key pointed out in his introduction to Harris's 1948 retrospective exhibition, Harris had realized "a more substantial pictorial structure" in his Maritime paintings, in order to express the outrage he felt at these scenes of extreme poverty; but he then rejected "the disturbed humanitarianism of the eastern pictures, in favour of detached, firm statements of law and order."

The only way that Harris could have gone forward from the Halifax and Cape Breton scenes of dire poverty was to identify with and depict the workers' struggle to change those conditions. But he remained a bourgeois, and kept the national-bourgeois outlook towards painting the landscape. What had been a great step forward in 1911, and was still progressive at the time of Tom Thomson's death in 1917, was no longer enough. In this new period, following the First World War and the world's first successful socialist revolution, it was essential to link up struggle for an independent Canada with the cause of the working class. Harris and the other members of the Group who refused to make this advance could only go backwards.

So Jackson took to wandering all over the country, applying the same approach to the landscape wherever he went, until it became a trite formula. Johnston, who left the Group after its first exhibition, degenerated to producing decorative landscapes for department store salerooms. MacDonald tried unsuccessfully to render the Rocky Mountains in the Group's style, and gradually spent more and more of his time in teaching. Lismer also became a teacher, and was instrumental both in spreading knowledge of our national landscape art through his coast-to-coast lecture tours, and in introducing a new appreciation of children's art; but his painting was never again to equal *September Gale.*

Even while continuing his Lake Superior series, beginning in 1924, Harris had moved on to the Rockies, simplifying their boulders, snow, ice and peaks into his compositions with light. A 1930 trip to the Arctic with Jackson made such simplification even easier, painting icebergs.

Then in 1934 the artist who had been such a driving force in the creation of our national landscape art left the

country to take up a university position in the United States. Just before leaving he published an essay on "Theosophy in Art;" he was more and more drawn to this idealist theory of transcendence of all the troubles of this world. For four years he painted in a studio at Dartmouth College in New Hampshire, then spent two years in the even more rarified atmosphere of Santa Fe, New Mexico, where he joined the so-called "Transcendental Group" of painters. In 1939 he exhibited at the New York World's Fair as an American painter!

Harris had come a long way from the realities of Glace Bay. By the time he returned to Canada to live in Vancouver in 1940, he was painting works like *Composition No. 1* (Fig. 134). Here again we can see the triangular composition, the even gradation of light, and an interest in patterns of reflection that Harris had shown much earlier in some of his Algoma and mountain paintings. We may even recognize the abstraction of an iceberg or a mountain peak. But essentially these canvases are meant to be approached in formalist terms: we are asked to appreciate this embodiment of spirit in terms of colours, planes and their arrangement.

In style and in conception *Composition No. 1* shows the influence of the metaphysical theories of abstraction advanced by Kandinsky. Since the late 1920s Harris had been the only Canadian member of the *Société Anonyme* ("Anonymous Society"), an international association to promote abstract art formed by the wealthy New York collector Katherine Dreier. She, herself, wrote books on the metaphysical notions of abstract art, and used her millions to buy paintings by Kandinsky, Mondrian and other non-representational artists. Harris was strongly influenced by this rich patron's theories. They had taken him far from his beginnings.

By bringing our national landscape art to its height in their major paintings of the early 1920s, the Group of Seven had begun what can be called *new-democratic culture* in Canada. No-one would have used that term at the time, because it wasn't until 20 years later that the leader of China's national liberation struggle, Mao Tse-Tung, was able to analyze scientifically the conditions for a people's culture in this period after the world's first socialist revolution and the end of the first imperialist world war. In an essay *On New Democracy*, written in 1940 for a new magazine called *Chinese Culture*, Mao gave the most incisive description to date of this concept. He used the term "new-democratic" to refer to national liberation struggles after 1917, to distinguish them from the old bourgeois-democratic independence campaigns of the era before these major changes in the world's balance of forces. For the new-democratic art of a colonial people engaged in a struggle for independence in our own time, Mao proposed three criteria:

- that it is *national*. It upholds the dignity and independence of the nation, and opposes domination from the imperial centre.
- that it is *scientific*. It stands for seeking truth from facts, depicting the realities of struggle and change; in painting, this means realism. New-democratic culture is opposed

Fig. 134: Lawren Harris, *Composition No. 1*, 1940 oil, 61 1/2" square, Vancouver Art Gallery

to idealism, metaphysics and mysticism.

- that it is *democratic*. It serves the working people, the vast majority of the population, and will gradually become understood and supported by them. This is not the art of one class only, but of all those classes in the colony united in fighting imperialism, led by the working class. Neither does it ignore the art of other countries, nor deny the people's cultural heritage, but learns from them.

If we judge the Group of Seven by these criteria, we can see that their major works of the early 1920s were *national* because they depicted our country's landscape for the first time with a content and style born of our own struggles and awareness. The group learned from European painting and from the art of the past, but were not dominated by them; in their choice of subject matter and in their treatment of it, they were independent and national in character.

Pictures like *September Gale* and *Stormy Weather, Georgian Bay* are also *scientific,* reflecting the heroic endurance of our people by realistically depicting the struggles in nature. Based on an experience of our land that most Canadians share, they are the beginning of a *democratic* culture. Originally encouraged by patrons with a national-bourgeois outlook, they have been enthusiastically taken up by patriotic Canadians of all classes.

Harris's paintings of Halifax and Cape Breton pointed the way toward the next stage of this new-democratic culture, one that would incorporate realistic depiction of the social struggles of the masses. But if we evaluate his subsequent paintings according to these three criteria, we can see that he first became unscientific, representing a static rather than a changing world; his art then ceased to be national in character, as he stopped painting Canadian land-

scape and moved to the U.S.A.; finally, his late paintings became totally unscientific as he attempted to convey metaphysical notions of spirit through formalist means. The result of these fundamental changes was that Harris's art became the opposite of democratic: it is art for an elite.

Harris's evolution toward abstraction was typical of what was to happen to many Canadian and Québécois painters in the age of U.S. imperialism. Against this trend, painters of a people's art had to fight.

1. Repression and Revolt in Québec

Conditions for a new-democratic culture in Québec were discouraging. Through the entire period from the mid-1800s to the 1930s, the Church remained the dominant patron. Canayen artists struggled through a profoundly reactionary period of colonial oppression.

CULTURAL NATIONALISM AND THE CULT OF THE HABITANT

In the year 1870, on his twelfth birthday, *Horatio Walker* of Listowel, Ontario first came to Québec with his father, a

Fig. 135: Horatio Walker (1858-1938), *Oxen Drinking*, 1899, oil, 47 1/2" x 35 1/2", National Gallery

lumber dealer who shipped timber to England through Wolfe's Cove. Walker was evidently delighted with his birthday visit, because ten years later he was back for a leisurely sketching trip, walking all the way from L'Epiphanie, near Montreal, up the St. Lawrence River valley to Quebec City.

Walker then returned to New York, where he had been living. His paintings of habitants at work soon began to bring good prices in the galleries and auction rooms there. By 1883 he was able to buy a house and estate on the Ile d'Orléans, downriver from Quebec City. Alternating at first between summers there and winters in his New York studio, he eventually found it possible to live there year-round, and became known among people as *"le grand seigneur de Ste Pétronille."*

Walker's *Oxen Drinking* (Fig. 135) was sold to the National Gallery of Canada in 1911 for $10,000. But it is typical of the works with which he appealed to conservative American bourgeois collectors. These were the same U.S. investors who were beginning to set up a two-tiered system of oppression for Québec. Just as the Ontarian Walker was painting pictures of Canayens for them, so Toronto-based capitalists were to act as their agents in Québec.

Walker's canvases reminded their New York buyers of the meek long-suffering peasants of Millet. Walker would never have dreamed of painting the farmers of his native southwest Ontario in this way; it was only the Canayen farmers whose markets were constantly being flooded by English-speaking grain merchants, forcing them to remain at this low level of farming. The yoked oxen and the antiquated well in this picture provide just the right setting for Walker's 'Jean-Baptiste,' leaning on his staff.

Walker's habitant, unlike Krieghoff's, is almost always a solitary worker. Gone is the ebullient community of the Jolifou Inn. The lone peasant is surrounded by sanctimonius trappings (heavenly light in the sky, church steeple in the distance) that are supposed to ennoble his life of toil. Krieghoff's levity is also missing. This is a much more decadent stage of the exotic, which cannot venture even a humorous representation of Québec society.

National consciousness remained high among the Canayens. In 1885 there were huge rallies all over the province to condemn Ottawa's hanging of the heroic Métis leader, Louis Riel, and two years later Honoré Mercier, calling himself "Riel's brother in spirit," led his new *Parti National* to power with an overwhelming victory. Only five years later Mercier and his cabinet had disgraced themselves by taking a $100,000 bribe for awarding a railroad construction contract; but in 1898 the new upsurge of nationalism continued with widespread support for Henri Bourassa (son of the cultural-nationalist painter Napoléon Bourassa) in opposition to the sending of troops to fight for the British empire against the rebellious Boers in South Africa. The Conservatives bought off Bourassa by getting him to join them against the provincial Liberals in 1908. But the English-speaking compradors had to depend more and more on the Church to control the people.

Since the defeat of the 1837-39 revolution the Church had been preaching "Back to the Land!" as the solution to Québec's problems. With the good farm land occupied, and

little industry developing, tens of thousands of Québécois were forced to flee to jobs in the textile and paper mills of New England. The bishops encouraged large families, only to see most of their tithe-paying congregation disappear south of the border! "Back to the land" meant that the Canayens should wear themselves out trying to make productive farms out of the stony northern bushland, or the Gaspé. Then the fat bishops and priests could invest profits from the new parishes in the wilderness in the U.S. and British-owned companies that controlled Québec!

As early as 1864 the Catholic censors had approved for publication in serial form in the French-language periodical press a novel by Antoine Gérin-Lajoie entitled *Jean Rivard, Economiste* ("Jean Rivard, Settler"). Ten years later it was reprinted in book form, the forerunner of *Maria Chapdelaine*. In 1887 the Mercier government tried to put the book into practice by offering 100 acres of free rocky bush country to all parents of 12 or more children!

By the turn of the century, when cartoonist *Henri Julien* was illustrating French-language books, this colonization programme had merged with that reactionary cultural nationalism (a nationalism that in fact renounces all claim to political power) which the Church had long espoused. Here is Bishop Paquet on "the vocation of the French race in North America:"

"We are not only a civilized race, we are the pioneers of civilization; we are not only a religious people, we are the messengers of the very idea of religion; we are not only submissive sons of the Church, we are, or ought to be, numbered among its zealots, its defenders and its apostles. Our mission is less to manipulate capital than to exchange ideas; it consists less in fighting the fire of factories than in maintaining and making shine far and wide the luminous fire of religion and thought."

To keep this "mission" going the Church had to keep the people as ignorant as possible: the Bishops made sure that only one in five Canayens learned how to read and write, and that those few were almost entirely the sons (and very few of the daughters) of the small French-speaking bourgeoisie and the larger petit-bourgeois class. For those who insisted on a higher education, the Church provided its classical colleges and Laval University, concentrating almost exclusively on humanities and language courses, suitably censored. Students were encouraged above all to become priests or nuns, or else to prepare themselves for careers in law or the civil service. Science and mathematics were unsuitable for pioneers of French culture!

For those who were interested in the history of their nation, the Church revived all its worst aspects. In the area of Deux-Montagnes north of Montreal, where a strong Patriote organization had flourished, a teaching priest named *Father Guindon* painted visions of the strange creatures mentioned in the legends and superstitions of the region, very much in the manner of *Hieronymous Bosch*, the late mediaeval Flemish artist.

So it is not surprising that Henri Julien should become best-known for his *Chasse-Galérie* picture, illustrating the climax of an old Québec folk tale in which a company of

Fig. 136: Henri Julien (1852-1908), *Canot d'écorce qui vole* (often called the *Chasse-Galérie),* pen and ink, 12″ x 18 3/4″, Musée du Québec

coureurs de bois trade their souls to the devil in return for a flying canoe to take them to the city for a night. In a pen-and-ink rendition (Fig. 136), Julien sketches a view of the Montreal of his day, and shows the flying canoe manned by the woodmen's ghosts about to beach on Mount Royal. In costume, expression and physical appearance, all the figures are just as stereotyped as Julien could make them.

Backward-looking patronage continued well into the U.S. regime. In 1933 the same 'Jean-Baptiste' figure Walker had painted 50 years before was still to be seen ploughing a furrow with ox and horse in his newly-cleared rock-strewn field when *Clarence Gagnon* did 54 small-format pictures to illustrate a new edition of *Maria Chapdelaine*, the well-known novel of Québec farm life first published in 1914.

Gagnon's illustrations and the novel itself have been popular because they represent the real struggles of the Canayen people to make these stony fields productive. Many accepted the challenge of the colonization programme rather than move to the U.S. or work for the big Anglo-American lumber or paper companies; they preferred the independence of farming, even under such difficult conditions, to the gross exploitation of wage slavery in the factories of the cities.

As examples of a national culture, however, Gagnon's illustrations and the novel itself are a sham. The book had been written not by a Canayen but by a French journalist, Louis Hémon. As for Gagnon, he spent most of his creative years living in Paris, and did the illustrations in his Paris studio. He paid regular visits to the village of Baie-Saint-Paul on the north shore of the St Lawrence, and then returned to his European home to paint. He even sketched snowy mountain tops in Switzerland and Norway, then added them to some of his canvases as fake Laurentians! Since Québec's "mission" was French culture, Gagnon saw no contradiction in this. His paintings mark the extreme low point of cultural nationalism and its cult of the habitant.

Fig. 137: Marc-Aurèle de Foy Suzor-Côté (1869-1937),
Le Camp sur la Colline, 1909, oil, 23 x 28 3/4'',
National Gallery of Canada

Fig. 138: Adrien Hébert (1890-1967), *In Montreal Harbour
(S.S. Montcalm),* 1925, oil, 46 1/2'' x 68 1/2''
Mrs. H. Fauteux-Massé, Montreal

THE LANDSCAPE OF QUEBEC

When *Marc-Aurèle de Foy Suzor-Côté* returned home to stay in 1908 after many years of studying impressionism in Paris, there could be little Canayen patronage for his landscapes. His 1909 painting, *Le Camp sur la Colline* (Settlement on the Hillside, Fig. 137) is closely comparable to the first pictures of deep snow painted by Maurice Cullen after his return from France 13 years earlier. Like Cullen, whom he knew well, Suzor-Côté contrasts the cool blue of the shadows with the crisp, frosty dazzle of winter light.

The pattern of shade falling across the foreground and the rough texture all over its surface is also comparable to A.Y. Jackson's 1910 canvas, *The Edge of the Maple Wood* (Fig. 117). It may have influenced Jackson, although that young Montreal artist was probably in Europe when Suzor-Côté's painting was first shown at the Royal Canadian Academy exhibition of 1909.

Le Camp sur la Colline is a strong indication that there was every possibility for the development of a national landscape art in Québec, had there been the patronage to encourage it. But the Church made sure that the small national-bourgeois class was dreaming only of its "mission," and looked on the northland as a place for farmers. Suzor-Côté's canvas was purchased by the National Gallery, and went to Ottawa.

We get a little closer to the realities of life in Québec in the paintings of *Adrien Hébert* and *Marc-Aurèle Fortin.* Hébert insisted that scenes around the port of Montreal were just as 'national' as the proverbial ploughman. *In Montreal Harbour (S.S. Montcalm)* (Fig. 138) is one of his best, based on the many sketches he made there in the early

1920s and '30s. Unlike much of Hébert's art, it puts workers in the foreground: a gang of longshoremen tug on a line to swing a barge into position in the crowded harbour. Dominating the picture to the left is the *S.S. Montcalm,* partly of interest to Hébert for the historic connotations of its name.

With the smoke billowing from the stacks of the ships and the tangle of vigorous man-made shapes in the harbour, Hébert succeeds in integrating the leaning and pulling motion of the six longshoremen with the tremendous force of the boats all around them. He shows how the power of the working class is an indispensable part of the industrial process. But there is no suggestion of any contradiction between the interests of the workers and those who own and control the shipping. In most of Hébert's harbour pictures, in fact, the workers appear only incidentally, as minor notes in an industrial landscape dominated by modern technology, if they appear at all. His subject is really the vitality of the harbour itself, not the workers who keep it all moving.

Fortin's *Landscape, Hochelaga* (Fig. 139) similarly shows the rapid industrialization that was sweeping over Montreal in the later 1920s. Church steeples still dominate the skyline, but hydro-electric towers and lines cut across it. The railway takes up the middle ground. Fortin is careful to include another by-product of this capitalist industrialization, the workers' homes and backyards in the foreground, and the tenements on the far side of the tracks.

Hébert and Fortin were both members of a writers' and artists' group called *L'Arche* (The Arch), formed from the growing number of Montreal intellectuals and professionals,

mostly around the *Université de Montréal.* By the 1920s this circle had replaced an earlier writers' club, the *Ecole littéraire de Montréal* (The Literary School of Montreal). Their ideas were expressed in *La Revue Populaire* (Popular Review), a monthly periodical which Hébert often illustrated.

In Fortin's work, nostalgia for the tree-lined streets soon took over. He was the son of a judge in the small town of Ste Rose, on the north shore of Montreal Island, and had to fight his conservative family's wishes in order to become an artist at all. He went to France only in 1935, when he was drawn more to the light and colour of the south of France and northern Italy, than to the attractions of Paris. After his return he began to paint high-keyed but static views of trees and houses in small-town Québec, renouncing industrial subjects and arresting all signs of movement in his canvases. By the late 1930s these paintings had degenerated into trite illustrations of his comfortable small-town theme.

Hébert was the son of a successful sculptor, who had been Cullen's first teacher. This artistic family lived partly in Paris, partly in Montreal. In the 1930s, as the struggles of oppressed Québécois workers sharpened into a series of violent strikes, Hébert turned away to paint street scenes, with shoppers mingling in front of well-known Montreal stores. His colour had never been strong, and in these later works the compositional strength of his industrial subjects is also absent.

THE CULTURE OF REPRESSION

The Church had lost its capacity to generate any original art. From 1890 to 1892, five young painters were sent to Paris and Rome to study religious art, and were given commissions when they returned. But the combination of their training as copyists and their endless repetition of religious subject matter could only lead to derivative murals that lacked even the pretence of inspiration. Copies of Italian Old Masters and imitations of contemporary French religious painters covered the walls of Québec churches.

Ozias Leduc learned to paint in this stultifying environment. Born in the village of St Hilaire east of Montreal, he was the son of a carpenter. He began as a teen-age assistant to *Luigi Cappello,* an Italian immigrant artist and *Adolphe Rho,* a Canayen mural painter, in the parish churches of rural and small-town Québec. By the mid-1880s he had become a church decorator in his own right, and built a studio at St Hilaire to which he retired to paint canvases between commissions.

Leduc was totally dependent on the Church for his livelihood. The Archbishop's Palace at Sherbrooke and the ceiling of the Baptistery in Notre Dame Cathedral in Montreal were among his commissions. He did try to revitalize church art; yet most of his large, pretentious and rather insipid church decorations are exactly opposite in spirit to the small, intense studies he painted at home in St Hilaire without any hope of a market. He exhibited these canvases in the annual Spring show of the Art Association of Montreal (now the Montreal Museum of Fine Arts), and in a few other exhibitions, but sold virtually nothing.

Fig. 139: Marc-Aurèle Fortin (1888-1970), *Landscape, Hochelaga,* 1929, watercolour, 19 3/4" x 28", National Gallery of Canada

Le Repas du Colon (Plate III), painted in 1893 and shown only once in Leduc's lifetime at the Spring Show of that year, is typical of these almost secret paintings. Catalogued as *Nature Morte, Etude à la Lumière d'une chandelle* (Still Life with Candlelight), it is a patient, painstaking examination of the varying intensity of the candle's glow, ranging from the flame and its aurora to its reflection on every surface and texture in the painting. The composition is serenely balanced: the candle provides the axis, with its vertical line as well as its amber light source, and the tip of melting wax is at the centre of the picture. The edge of the table provides a horizontal limit to the plane in the foreground, and the larger volumes of jug and bowl on either side are complemented by secondary shapes that also reflect the candle's light, but from a slightly greater distance. The tablespoon resting on a diagonal links the two halves of the painting, simply but effectively.

Leduc called this picture "The Settler's Meal." Candle, bowl and spoon, jug and glass are the plain tableware of the habitants, especially those who had gone out to the bush as settlers. Leduc was a founding member of his region's historical society, and wrote a local history. He knew the significance of such settlers' lives, past and present.

Leduc paints this subject with realism, not the stereotyped figures of Julien's or Gagnon's illustrations. His little painting conveys the frugality but also the homely beauty of the habitant's life. The vessels and utensils have the supple grace of objects designed and produced by Canayen artisans. The warmth and illumination of the candle create an intimate domestic scene, and imply that it is nightfall before the hard-working habitant can sit down to his meal.

In other works of this kind, Leduc painted apples on a plate, onions on the table, or a jug with two eggs. Occasionally he varied his subject matter, including a magnifying glass, his own sketchbox, books and letters, and the model of a head marked for studies in phrenology (fortune-telling from bumps on the skull). But for these subjects his light is drier and his colour has less fervour. He sometimes verges

Fig. 140: Ozias Leduc (1864-1955), *L'Enfant au pain,* ("Boy with a piece of bread")
begun 1892, completed 1899, oil, 20" x 22", National Gallery of Canada

on tricks in composition and texture that encourage us to confuse the picture with the real thing, showing that he may have been familiar with the American still life tradition called *trompe l'oeil* (fool-the-eye) painting. In such canvases we miss the depth and rich contrast of the homelier still lifes.

When Leduc includes figures in his paintings, the arrested quality in his work is even more apparent. In *L'Enfant au Pain* ("Boy with a Piece of Bread," Fig. 140), completed over seven painstaking years between 1892 and 1899, he poses a St Hilaire boy perched on a chair, playing a harmonica, with an emptied bowl and a crust of bread on the table before him. Notice again the homely simplicity of the life Leduc paints: the table and chair are spare and plain, the bowl and soupspoon probably of Québec manufacture, and the clothes the boy wears proclaim his class character as among the working people. He has no shoes, and his rough plaid shirt is out at the elbow, splitting at the shoulder. His lunch has been as simple and as satisfying as the music he is making on his mouth organ.

But surely no boy ever sat so still! His body is shaped to form the left half of an oval that is rounded out by his hat, and the form of his bowl and crust opposite. This oval is perfectly proportioned inside the rectangle of the picture, and is buttressed on either side by the vertical and hori-

zontal shapes of the table and chair. The edge of the table bisects the oval, balanced by the boy's waistline and the chair slat on the other side of the picture, but leaving its centre free for the diagonal thrust of the boy's cocked left leg, an angle that is reinforced by the tilt of the spoon.

The curl of the boy's cuff and the curve of his suspender strap are opposed by his hatband and brim, but all these ellipses are given their perfect geometric expression in the rim of the bowl. Just to the right of the boy's head is the greatest intensity of light on the wall behind him, but this luminosity is balanced by the bright spot of reflected light on the inside rim of the bowl in the generally darker right half of the picture. By all these careful balances, Leduc manages to give his subject a classic air of eternity, as if the boy were fixed forever in this position.

This is the Québécois tradition, but in a subdued, discreet fashion. Leduc's means are light, a rich coloration of amber, russet and browns, and sensuous textures and forms arranged in a straightforward but effective manner. The social significance of his subject matter is restricted to the tranquillity of a village boy relaxing after his meal, but the drama Leduc can find and express in the everyday lives of the people of St Hilaire is all the more convincing within his limitations.

The Québécois tradition had begun with the votive

painters' depictions of people overcoming danger, and had been brought to its high point in the social document paintings of Legaré. But in the long years after the defeat of the revolution, the Church had served its British masters well by undermining any such confidence of the people in their power. Leduc's rendition is accordingly cautious: the Church's stifling hand is evident in the small scale, the subdued tones, the utter stillness and the quasi-spiritual atmosphere that suffuses the otherwise earthy materiality of paintings like *Le Repas de Colon*. This is the art of colonial repression.

It is instructive that Leduc had achieved this much by living and working in close contact with the people. *Le Repas du Colon, L'Enfant au Pain* and Leduc's other paintings of this period show that he was influenced by the many copies of Renaissance and other Old Master compositions that he had seen in the churches; he may also have been familiar with engraving after the still life canvases of the French painter of the 1700s, *Jean-Baptiste-Siméon Chardin,* or the studies of candlelight by the master of the previous century, *Georges de la Tour.* But like Legaré long before, and like Thomson in the Canadian tradition, Leduc learned how to be an artist without journeying to the imperial centres.

He did go to Paris once, in 1897, just after having painted his most remarkable still-lifes. He seems to have found there only what he needed to confirm the direction he had already taken. From *Henri-Eugène-Augustin Le Sidaner,* a follower of impressionism, he learned how to break and cross-hatch his brushstrokes even more finely to render the nuances of light. He also inspected the latest fashions in French church art.

Back home, Leduc gradually became more interested in painting the landscape of Québec. For the best part of two years, 1914-15, while Thomson and the future Group of Seven artists were exploring Algonquin Park, Leduc was patiently painting and repainting in his St Hilaire studio the picture he called *Pommes Vertes* (Green Apples, Fig. 141).

The way the boughs hang as a screen in this picture may remind us of Thomson's *Northern River.* Leduc, like Thomson, had been strongly affected by *art nouveau* notions, although he had discovered them primarily in church decoration.

The spirit of Leduc's landscape, however, is radically different from anything Thomson or the others were producing. While the latter were concerned to evolve a new Canadian landscape art, Leduc is here attempting to extend his recovery of the Québécois tradition of painting to the landscape. The dramatic expression in terms of light, the passionate coloration and the evocative organization of forms in space distinguish the Québécois tradition at its best.

What is missing is a sense of change. The apples cluster before an infinitely sensitive sky, embodying light as their leaves gather the shadows. The tree on the horizon stands starkly outlined where the light dims. The whole is a profound statement of contrasts in light and darkness, foreground and distance, suspension and weight, the solid, round forms of the apples and the crisp, jagged shapes of the leaves. All is still.

But things were moving in Québec. Opposition to the June, 1917 Conscription Act was country-wide, but it was centred in Québec where the Canayens steadfastly refused to fight for the British empire. Tens of thousands gathered repeatedly all over the province, four were killed in Quebec City, shouts of "*Vive la Révolution!*" recalled the recent

Fig. 141: Ozias Leduc, *Pommes vertes* ("Green Apples"), 1914-15
oil, 24 1/2" x 36 1/2", National Gallery of Canada

Fig. 142: Ozias Leduc, *L'heure mauve,* 1921, oil, 36 1/2"
x 30 1/2", Montreal Museum of Fine Arts

events in Russia as well as 1837, and even the Quebec Assembly was obliged to debate a motion for secession from Confederation over the issue. At one point the people armed themselves with the few guns they could find, and fired on police. Some 19,500 Canayens were eventually forced into uniform, but almost as many, 18,827, remained on the Wanted Lists at the end of the war.

A few attempts were made by artists and critics to reach a new patronage. In 1916 Leduc had his first one-man show at a Montreal library, and two years later he designed the cover for the first issue of *Le Nigog,* a new monthly journal of art and literary criticism. But the exhibition, one of a series in which Hébert also showed, was organized by a vicar; the magazine, Quebec's first of its kind, failed after only 12 months.

Leduc's long years of painting for the Church, with almost no other patrons, gradually took their effect. He became more and more withdrawn, and no longer had any living contact with the working people. *L'Heure Mauve* (Fig. 142), painted in 1921, expresses this withdrawal clearly. Again we can see *art nouveau* influence in the organic patterns made by the drooping roots and branches; and the painting in form is derived from the Québécois tradition, with its emotional treatment of light falling on a snow bank at the moment of dusk, the "mauve hour" of the title. The dark forms of the dead leaves and vines set up strong patterns of contrast.

But the scene is almost claustrophobically still. The

closed-in viewpoint, the time of day, the absence of strong colour and the subject of dead leaves and branches in heavy snow all contribute to a picture in which nothing is likely to change, except the failing light. Leduc had gone outdoors, but he remains a painter of still life. The culture of repression, this half-smothered Québécois tradition, has become the art of a landscape occupied only by a dying glow.

At just about the time Leduc was painting *L'Heure Mauve,* he met a teen-ager named *Paul-Emile Borduas,* who became his assistant. A native of St Hilaire, also the son of a carpenter and ironworker, Borduas identified strongly with his teacher. "I was already acquainted with his painting because of the little church at St Hilaire which he had so extensively decorated," Borduas later wrote, "I am convinced that all my subsequent liking for pictures stemmed from my admiration of those."

Borduas worked with Leduc on church murals in Sherbrooke, Halifax and Montreal, while studying at the *Ecole des Beaux Arts* (School of Fine Arts) in Montreal. He also got to know Leduc's canvases. The aging master gave him one he had painted when he was a young man, a vivid little study of light falling on three apples, all in yellows and browns. The Québécois tradition was changing hands.

THE CULTURE OF RATTRAPAGE

In 1936 *Alfred Pellan* decided to come home to apply for a teaching job at his old school. Born in 1906, just one year after Borduas, Pellan was the son of a railroad engineer and had grown up in Limoulou, a proletarian district of Quebec City. He had entered the Ecole des Beaux Arts there at the age of 14, and had made his first sale to the National Gallery, a view of snow-laden rooftops, when he was only 16. In 1926 he had won a provincial government scholarship to go to Paris, and now, ten years later, he was back to apply for a job.

Pellan's account of his application gives us a good idea of the vast distance that had developed by this time between Québec's conservative, church-dominated colonial schools, and the standards of the imperial centres:

"As I had left all my canvases in Paris, I was asked to do several paintings so that the quality of my art could be judged. I accordingly set to work in Québec and produced several compositions. The examining board, however, didn't like them . . . I made my way back to Paris carrying with me the work I had done in Québec . . . Shortly after my arrival, I received a visit at my studio from Monsieur Huysman, then Minister of Fine Arts, and Monsieur Rey, at that time curator of the Fontainebleau Museum. They bought two canvases, one for the Musée du Jeu de Paume, Paris (now in the Musée National d'Art Moderne) and the other for the Grenoble Museum. One of these acquisitions was precisely one of the canvases I had painted in Québec to show the examining board there!"

La Bouche Rieuse (Fig. 143), painted by Pellan in 1935, is the kind of picture the examining board turned down. It represents a disembodied "laughing mouth" as the title suggests, along with fragments of the rest of the face, a

quizzical bird, and so on. Most of the canvas is occupied by decorative circles, squares and triangles of bright colour that can be associated with various combinations.

This loose, decorative geometry reflects a late stage of an approach to painting called *cubism,* a style that had been developed by Picasso and other artists before World War I. When the examining board asked Pellan for his preferences in painting, he named Picasso, Matisse and other School of Paris artists. "The reply was that with such ideas I could never be accepted," Pellan recalls.

These ideas had initially been based on an attempt to find a new way of interpreting the world in painting. Just as modern science was formulating new systems of physics and mathematics at this time, so a group of leading artists had set out in the period 1908-12 to analyze what they took to be the underlying geometric structure of reality. Cézanne had held that the whole world could be analyzed into cones, spheres and cylinders, and the cubists now began to translate this structure into the plane geometry of the picture surface. Given their name because of the many-faceted little 'cubes' into which they tended to divide their subjects, the cubists were imbued with a scientific spirit that made their works widely influential.

For a few years after the revolution of 1917, a group of Russian artists called *constructivists* tried to apply cubist notions to artistic and practical problems in the Soviet Union. Although they had some effect in architecture and textile design, their ideas mainly bore fruit in theatre and especially in their influence on Russian film-makers. Wherever representation of the class struggle was primary, as in the revolutionary Russian films of the 1920s, analysis into structural units and synthesis into a greater whole was useful. But when the artists tried to develop these ideas for their own sake in non-representational paintings and sculpture, they grew further and further away from the people. They began to spin theories about the autonomy of colour, line and plane from any meaning. Wassily Kandinsky, who had returned to Russia in 1914 and served several years as a cultural commissar, took the lead in developing this kind of abstraction. This was clearly not art for the people: Kandinsky left the Soviet Union for good in 1921.

Among imperialist countries, the older and more established could afford to remain more conservative. But the younger, more dynamic imperial centres, such as Germany, Japan and the United States, were very interested in new ideas that could be useful in the design of their buildings and products. In 1919 a German design school called the *Bauhaus* began to put this notion of geometric analysis together with the attention to the crafts and industrial design that Dutch and German followers of William Morris had pioneered. The Chicago skyscraper architect Louis Sullivan had already declared that "form follows function." Now the Bauhaus teachers and students began to work out this idea systematically, with a scientific analysis of form, function and materials used in industrial production. The question they left unanswered was: functional for whom?

Kandinsky joined the Bauhaus in 1922, and many leading artists and future industrial designers either taught or studied there. Many considered themselves either socialists

Fig. 143: Alfred Pellan (born 1906), *La bouche rieuse* ("Laughing Mouth"), 1935, oil, 21 1/2" x 18", National Gallery of Canada

or Communists, and some tried to work closely with labour unions as well as companies on design commissions. The Nazis hounded the school as a Communist cell, and closed it immediately after seizing power in 1933. Thereupon a "new Bauhaus" was opened in the U.S., the Chicago Institute of Design.

The U.S. had first been introduced to cubism and other modern paintings in an exhibition held in the New York Armory in 1913. The Armory Show was ridiculed by the press, but the ruling class was not laughing. They recognized that this new painting had its roots in the art of post-impressionists like Cézanne, which they were already patronizing.

Like the impressionists, the cubists had not extended their analysis to the contradictions within society. They refused to take sides with the people as Courbet had done. So their achievements could only degenerate. De-emphasizing or even eliminating subject matter prepared the way for an art that could be highly developed formally, but lacked definite content. Their whole system of design ideas could be fitted to technological function anywhere, regardless of the social needs or national character of the people. They evolved the art of the era of modern imperialism.

In the boom years for the U.S. following the First World War, the ruling class in New York led the way in acknowledging this art as their own. The Depression hardly slowed them down: in fact, while many investors and small companies collapsed, the imperialists made still greater profits. In the very season of the 1929 Stock Market Crash the Rockefeller family joined with a few others to open their

own Museum of Modern Art in New York. The first show, fittingly, was an exhibition of post-impressionist paintings. The 'Modern' quickly became a propaganda centre for formalist art and design. Its series of travelling shows and publications, as well as its major exhibitions in New York, affected styles in art, architecture and product design, "I learned about politics at the Modern," Nelson Rockefeller later observed.

By this time, cubism in Paris had degenerated into just another style. Already in the years 1912-16 its originators had gone over to using its geometric constituents (squares, triangles, circles) to compose or 'synthesize' pictures with only a general, thematic reference to any subject matter. These abstract geometric units, along with pieces of newspaper, oilcloth and other manufactured materials, were used much more 'for their own sake,' for the shape or texture they would give to the picture, than for the subjects they purported to represent.

After the First World War the French utopian-socialist artist *Fernand Léger* went on trying to adapt the forms of cubism to working-class subjects, but most of the cubist followers simply began using the geometric conventions to make decorative semi-abstract paintings like *La Bouche Rieuse*. Pellan was awarded first prize in a mural competition in 1937, and became a well-known member of this "School of Paris."

The art schools of Québec were certainly being consistent in rejecting this 'modern art.' They were administered by the Québec government under the watchful eye of the Church. In 1936, with the reactionary *Union Nationale* government of Maurice Duplessis just elected, both of these bodies opposed any ideas that might weaken their grip on the people. The Church was still propagating its "Back to the Land" ideology, all the more so because of the Depression, and Duplessis saw any ideas that might challenge his rule as "Communist-inspired." In 1937 he got his infamous Padlock Law passed, permitting police to enter and search any premises without a warrant, and to put a padlock on anyone's door to stop their suspected "anti-government" activities. This was used to stop publication of a Communist newspaper, *Clarté* (Light), while Québec fascist groups were allowed to distribute their propaganda freely. Pellan's 'laughing mouth' was not exactly what Duplessis' art schools were looking for!

In opposing modern art, as on so many other points, Duplessis was fundamentally in agreement with the Nazis. In 1937 Hitler's *Reich* officially sponsored an exhibition of "Degenerate Art," in which much abstract and expressionist art was ridiculed and destroyed (although a good deal was quietly sold by the Nazis at high prices to imperialist patrons through Swiss dealers). Rockefeller and his friends in the bourgeois democracies could afford to propagate the liberalism of formalist self-expression, but from 1919, when there was a failed Communist revolution, until 1933, Germany was perpetually teetering between revolution and counter-revolution. The Nazis had instituted their New Order to save German imperialism: the culture of a liberal bourgeois democracy had to go.

There is no question that many of the artists the Nazis condemned were sympathetic to the cause of the people. In the same year of 1937, Picasso himself painted *Guernica*, a mural for the loyalist Spanish government pavilion at the Paris world's fair. Nazi planes, flying in support of Franco's fascist takeover of Spain, had bombed Guernica, the cultural capital of the heroically resisting Basque people. Picasso answered the atrocity with a monumental mural that graphically expressed the anguish and outrage felt all over the world.

Yet even *Guernica* shows the limitations of this commitment. It is a highly individualistic act of protest. Its distortions have to be explained to any viewer, and its precise meaning has been the subject of endless scholarly debate. One thing is clear: it expresses the terrible plight of the Spanish people, not their bitter fight against the fascist takeover.

This kind of protest is acceptable to the imperialists. Even though he had blocked arms shipments to the Spanish Loyalists and prevented any effective oil embargo against the fascists, Rockefeller was delighted to take *Guernica* for his Museum of Modern Art when Picasso decided to ship it away from France to keep it out of the hands of the Nazis. It is still one of the chief attractions at the 'Modern,' where it provides a fine left-liberal front.

Picasso was not the only School of Paris artist to view the approach of Hitler's army with concern for his personal safety. In the spring of 1940, many of the painters and others prominently connected with this kind of art decided to flee. Those who eventually crossed the Atlantic mostly gathered in New York: some, like Léger, visited Montreal during the war years. Père Couturier, a French priest who favoured modern art, came to live in Québec, and soon became a missionary for the new culture.

Pellan came home as part of this exodus, and immediately held a huge retrospective exhibition of 161 works, displayed in both Quebec City and Montreal. It had a startling effect on both artists and collectors. One reviewer praised him as a "European painter . . . born in Québec!" Another revealed his colonial mentality by assuring his readers that "although a Canadian, Pellan takes a place among those in the world who hold in their hands a portion of human genius." Pellan himself soon went off cynically to paint a few representational pictures of rural Charlevoix County, to 'educate' more backward patrons. But his exhibition had firmly established in the minds of Québécois intellectuals the idea of *rattrapage,* the vain hope of liberating Québec culture by "catching up" with Paris.

THE CULTURE OF REVOLT

The painter who was most profoundly affected by Pellan's exhibition was Paul-Emile Borduas. He had spent two years in France, and had even met Père Couturier there, but had worked at church decoration in the provinces to support himself for most of his stay, and returned to Québec in 1930 without showing any particular French influence on his approach to painting.

Living in Montreal through the 1930s, Borduas had

begun to associate with Université de Montréal professors who told him something of contemporary French art. In 1937 he had been impressed by a Morrice retrospective at the local museum. Then he met *John Lyman,* an English-speaking artist and critic who had lived in Paris for many years, and was a devoted follower of both Matisse and Morrice.

Lyman had tried to introduce his own post-impressionist art to Montreal as early as 1913, with a one-man show that was howled down by the local press. In 1927 another Lyman exhibition was better received, and four years later the independently wealthy artist moved back to Montreal to stay. For two years he ran an art school called The Atelier. Its prospectus claimed that:

"The essential qualities of a work of art lie in the relationships of form to form, and of colour to colour. From these the eye, and especially the trained eye, derives its pleasure and all artistic emotion... In its teaching the Atelier considers it necessary to emphasize the study of form, while at the same time allowing the student every other liberty."

When the school failed, Lyman became art critic for the English-speaking compradors' magazine, *The Montrealer.* Well informed on the latest developments in Paris, he was able to supply Borduas with the current French-language publications on modern art. The former church decorator, now working as an art teacher, was especially interested in the writings of André Breton on *surrealism.*

This style of literature and art attempted to 'go beyond' realism to the subconscious. Artists either strongly distort-ed reality, as in the well-known picture of drooping 'limp watches' by the Spaniard *Salvador Dali,* or else rejected representational painting entirely and tried to register their subconscious directly on canvas with abstract colours, lines and shapes. The leader of this wing of the movement was the writer, Breton, who defined the surrealists' goal in a 1924 manifesto as "the true process of thought...free from the exercise of reason, and every aesthetic or moral preoccupa-tion."

"Surrealism is the systematization of confusion," Dali declared. Its aim was to confuse people, not to enlighten. The intellectual progress of mankind is the story of moving from unconscious to conscious awareness, from ignorance to knowledge, from metaphysics to science. Claiming to issue from the subconscious, this art placed itself outside the bounds of human reason. Faced with the contradictions of life under imperialism, it offered a step backward to irrationality, fantasy and complete self-indulgence.

It is not hard to see what social class surrealism serves. Such a culture can only aid the imperialists, whose interests lie in keeping people as ignorant of reality, as deluded and as isolated from each other as they can. The most widely publicized exhibitions at Rockefeller's Museum of Modern Art have been those devoted to surrealism and related styles.

But the political meaning of surrealism is even more significant. By promoting such unfettered individualism in a period of bourgeois decadence the surrealists were actually preparing the way for the imposition of total control by the enemies of all freedom, the fascists. It is the fascists who are truly "free from the exercise of reason, and every aesthetic or moral preoccupation." The Nazis proved it many times over.

Yet surrealism was proclaimed in manifestoes that were headlined "revolutionary." In 1925 Breton even tried to attach the whole surrealist movement to the French Com-munist Party. The Party rejected him, but the dangerous and misleading association of surrealist painters and poets with the so-called 'radical left' has continued down to the present day.

In 1938, the very year that Borduas discovered Breton, the French writer made a pilgrimage to Mexico to visit the renegade who had tried to betray the Russian revolution, Leon Trotsky. There Breton co-authored a manifesto with Trotsky that was published in a U.S. 'left' magazine, the *Partisan Review.* The manifesto appeared over the signa-tures of Breton and the Mexican artist *Diego Rivera,* a former Communist who was temporarily attracted to Trot-sky.

Trotsky's collaboration with surrealism is completely in character. Trotskyism is an ideology that claims to support a socialist revolution, but really doesn't; it panders to people (mostly in the petit-bourgeoisie) who want a social revolution but are not willing to make the necessary changes in themselves to carry out or defend that revolu-tion. Trotskyism stands most opposed to the selflessness that is essential to any people engaged in a revolutionary struggle, and caters to the individualism that is especially strong among the petit-bourgeoisie. In practice, therefore, Trotskyism is counter-revolutionary.

Time and again Trotskyites have been proven to be working in the pay of the police, the imperialists and even fascist governments, against genuine revolutionaries. At the time Breton visited him, Trotsky was living on big cheques from *Life* magazine, payment for denouncing his former comrades in its pages. In 1939 Trotsky even offered to appear before the Dies Committee of the U.S. House of Representatives, forerunner of the infamous House UnAmer-ican Activities Committee, to testify against American 'subversives' known to him; he only withdrew his offer when he saw from the public response (including a protest march of 20,000 in Mexico City) that he would lose all credibility as a 'revolutionary' if he went through with it. A few years later, at the height of the Second World War, when the Nazis were at the gates of Moscow and Leningrad, the Trotskyites were actually putting out leaflets calling on the Russian people to rise up and overthrow Stalin! Hitler could hardly have done better.

Borduas may or may not have been aware of Breton's collaboration with Trotsky. But his own attraction to sur-realism was particularly dangerous in view of his growing influence. Since 1937 he had been teaching at Montreal's *Ecole du Meuble,* a design school, and he was now be-ginning to attract many enthusiastic students and followers. In 1939 he joined Lyman in founding *a Société D'Art Contemporain* (Contemporary Art Society), an exhibiting organization that brought together painters and a rapidly developing group of new patrons. These young collectors

Fig. 144: Paul-Emile Borduas (1905-60), *Nature morte* ("Still Life"), 1941, oil, 12 3/4" x 15", Montreal Museum of Fine Arts

Fig. 145: Paul-Emile Borduas, *Printemps* ("Springtime"), 1942, gouache on paper, 17 1/4" x 23 1/4", Montreal Museum of Fine Arts

were mostly French-speaking doctors, lawyers and professors at the Université de Montréal, with a few national-bourgeois elements like Maurice Corbeil, owner of a shoe factory.

The people of Québec at this time were joining in the world war against fascism. In the fall of 1939 Duplessis had called a snap election, declaring himself opposed to participation in the war. The Québécois turned him out of office, and elected the Liberal leader Adélard Godbout by an overwhelming majority. By January, 1941, over 50,000 Québécois had already volunteered to fight.

Yet just when the anti-imperialist struggle in Québec was most broadly united with the world-wide resistance to fascism, and a more popular basis for patronage was at last developing, Borduas, the artist who was to lead the forces of revolt against the Church, was turning ever more inward. How useful this ideology of self-expression is to the ruling class!

Two paintings of this period show the direction of Borduas' development. A still life of 1941 (Fig. 144) is fundamentally a continuation and intensification of the studies of Borduas' old teacher, Ozias Leduc. At least formally, it remains in the Québécois tradition of Leduc's little picture of three apples. Borduas' apples have a luminous solidity in common with Leduc's, and his painting emphasizes strong contrasts of darkness and light, vibrant colour, and the lush, sensuous shapes of the fruit. The artist was already familiar with the votives from his church-painting days, and in addition had spent the summers of 1938 and 1939 making surveys of Québec art and historical monuments for the provincial government. He undoubtedly knew at least some of the paintings of Legaré.

But instead of Leduc's balanced composition and even distribution of light over a static whole, Borduas arranges his picture much more dynamically He makes our eyes move through the forms of the fruit and the rumpled cloth above, in a clockwise, swirling, almost spiral movement. He

uses the end of his brush to scratch in the lines of the leaves in a graphically striking manner. This is the culture of revolt, not repression.

In a painting of just one year later entitled *Printemps* (Springtime, Fig. 145), Borduas is already painting wholly formalist work in which the relations of colour, light, line and mass are meant to be seen 'for their own sake.' The formal remnants of the Québécois tradition remain, but Borduas' painting is essentially now part of the international style of surrealism. We can pick out organic shapes in *Printemps*, illustrative of its 'springtime' theme. This little painting in *gouache* (a pigment like poster paint) is an example of what is called *biomorphic abstraction*, in which the non-representational shapes vaguely resemble animal or vegetable life. This was a favourite manner of the surrealists, and was most fully explored by the Spanish surrealist painter, *Joan Mirò*, whose work Borduas had probably seen in reproduction by this time.

In 1942 Borduas sold 37 out of 45 works from an exhibition he called "Surrealist Paintings" to his growing new group of patrons. But such sales just encouraged the patrons' sense of being an avant-garde elite, leading the way to rattrapage with pre-war Paris. Borduas' next show, without the Parisian title, didn't sell nearly as well.

Almost everything in this new Montreal art world was tending in the same direction. The first exhibition of the Contemporary Art Society was a selection of "privately-owned foreign paintings." In 1941 French priest Père Couturier organized a most successful exhibition of Québécois artists called *Les Indépendants,* in imitation of a well-known modern art show in Paris with that title. France had fallen, but Québec would continue her culture!

The limitations of this programme of rattrapage are evident in a mural that Pellan painted for Maurice Corbeil's shoe factory in 1945 (Fig. 146). It shows the continuing dominance of Picasso over Pellan's art, particularly in the witty combinations of forms around the hands and feet. Especially after having been affected by surrealism in the 1920s, Picasso enjoyed turning one thing into another with

a single cursive line. Pellan apes his master's example here as best he can, but being a colonial follower he loses his grasp on a central image, so that his surface becomes a great jumble of shapes lacking any definite focus.

The influence of Fernand Léger's intertwined masses of figures can also be seen here. In other Pellan paintings it is sometimes Miró or Kandinsky who presides, but it is never Pellan. To this day he remains an eclectic borrower of styles, not an originator of content.

Pellan called his mural *La Magie de la Chaussure* ("Shoe Magic"). But the workers in Corbeil's factory know that there is no 'magic' in the making of shoes. In modern industry shoes are the product of socially organized labour, the hard work of men and women who toil all their lives at the lasts and stitching machines to make the profits with which men like Corbeil can buy paintings. Pellan uses his Picassoesque jumble to try to confuse people and mystify this completely rational process of exploitation.

The 'magic' of capitalist production is the way in which profit is wrung from objects like these boots, heels and soles that are of use to us all. Pellan's mural glorifies *commodities*, what shoes and all other products of our labour become when they enter into the market and start earning profits for the owners of their means of production, while their actual producers can hardly afford to purchase them. Far from "undermining bourgeois consciousness," as it had promised to do, surrealism serves the bourgeois' fetishistic fascination with commodities. It has in fact been a most effective style for advertising and store window design.

So Pellan's art of rattrapage with modern France was just as oppressive as the long-standing mission of the Church to crusade for French civilization. Pellan offered only an updated colonial mentality for an industrial age. In the mid-1940s, as this became more evident, especially to the younger painters, leadership in the Montreal artistic community passed to Borduas.

In 1943 the industrious Père Couturier opened an exhibition of 23 Québécois painters under the age of 30 called *Les Sagittaires,* 15 of whom had been Borduas' students. A year later, the Montreal critic Robert Elie gave Borduas' approach to art still more currency by publishing a highly subjective and idealist book about him. By 1946 six of the former Sagittaires were ready for a group show with Borduas himself; in 1947 they held a second exhibition, and for the first time were called *Les Automatistes*.

"Pure psychic automatism" was one way Breton had characterized surrealism. The automatistes now took this term to refer to their own kind of "automatic painting," a way of getting at the underlying consciousness of the artist by working as much as possible without premeditation. Spontaneity, directness and passion were the values the automatistes prized in their art.

The large painting that dominated the Sherbrooke Street apartment in which the 1947 exhibition took place was Borduas' *Sous le vent de l'île* ("Wind over the Island," Fig. 147). It consists of a cluster of what are called *taches* (touches or dabs) of intense colour, suspended as if floating far above a background of long, sweeping brushstrokes that

Fig. 146: Alfred Pellan, *La magie de la chaussure* ("Shoe Magic"), 1945, mural in oil, 84" x 37 1/2", for the shoe factory of Maurice Corbeil, Outremont, Québec

suggest an island seen from the air. The landscape, however, is in what Borduas called "the world within."

In technique, this is Borduas' first prominent use of the palette-knife. This tool, ordinarily employed to mix or scrape paints, has here been used to apply the pigment directly, in the taches of colour. This palette-knife handling of paint was eventually to take over the whole of his canvas surfaces. Here, however, it remains in contradiction to the broad horizontal brushstrokes of the background.

Another conflict apparent here is between the surrealist tendency to self-expression at any cost, and the ordering principle of a more classical approach to painting. This can be seen in the contrast between the vague, loosely defined background, and the much more precise and comparatively disciplined arrangements of the taches in a series of more or less vertical ranks.

Three years before, Borduas had seen his first example of the art of *Piet Mondrian,* the Dutch artist whose flat, geometric organization of colour and line was the final reduction of all formalism to a unified system. Borduas had been very much impressed, but was unable to reconcile such classic simplicities with his own expressive use of texture and colour. This is his first attempt to impose this formal order on his expression, and it sets up a tension that was to continue throughout the rest of his work.

At the basis of these conflicts in technique and form is the fundamental contradiction in what Borduas wants to do with his art. On the one hand, he has become part of the international elite of 'the art world,' committed to self-expression in his art. In the very month that he was painting this canvas, he felt sure enough of his own direction that he rejected an invitation from Breton to participate in the next French surrealist exhibition. A few months later, Borduas sent four works to an exhibition of his own group, called *Automatisme,* that two of his followers had arranged in Paris. On the imperialists' art scene he was beginning to be noticed, and on his own terms.

Yet at the same time *Sous le vent de l'île* is also a continuation of the Québécois tradition. It is a passionate statement in brilliant colour and flickering light. With an over-all brownish tone established in the background between passages of aquamarine to either side, and with the bright greens, reds, browns, blacks and whites flashing across the foreground, it is a formal equivalent to the votive painting of the overturned canoe. Because he had developed his art to this point from Leduc's teaching and from his own experiments, rather than learning to paint School of Paris canvases as Pellan had done, Borduas had managed to keep this close to the Québécois tradition.

The conflict between Pellan's line of continued rattrapage with Paris, and Borduas' development of a Québécois version of automatic paintings built to a climax as their common revolt against the authorities heightened. In 1945 Pellan had scored a great victory for the modernists at the Montreal Ecole des Beaux Arts, where he was then teaching, by forcing the resignation of the reactionary principal. A year later, the Church struck back, with the publication of a pamphlet called *Art et Bolshévisme,* identifying all

Fig. 147: Paul-Emile Borduas, *Sous le vent de l'île* ("Wind over the Island"), 1947, oil, 45" x 58", National Gallery of Canada

modern art as a Communist plot. At the same time, despite Borduas' achievements as an artist and teacher, the authorities at the Ecole du Meuble cut his teaching duties by two-thirds.

Within the Contemporary Art Society, Borduas' more independent direction was gradually gaining dominance over Pellan's Parisian adherents, as Borduas' many younger followers formed up a youth section of the Society. In 1948 Pellan constituted the artists of his persuasion into a loose grouping called *Prisme d'Yeux* (Prism of Eyes), which lasted only about a year and a half. When Borduas was elected President of the Contemporary Art Society by his youthful majority, Pellan and the Prisme d'Yeux artists withdrew. Lyman refused to support him, so Borduas had no choice but to resign as well, and the Society was abruptly dissolved.

Meanwhile Duplessis had long since been re-elected, and the forces of reaction in Québec were coming down harder than ever. Borduas would soon have to decide whether to commit himself to the battle wholeheartedly, or to drift off into complete isolation from the people. His culture of revolt had left him ill-prepared for this decision.

COMPLETE WITHDRAWAL

"To hell with the incense-burners and holy-wine-sippers! They extort a thousand times over anything they have ever conferred. Reaching over their heads we are able to touch the ardour of human fraternity to which Christianity has become a closed door. The reign of this hydra of fear is ended."

So Borduas launched his decisive assault on the power of the Church in Québec. In August of 1948, exasperated by the continuing official resistance to his teaching at the Ecole du Meuble, and encouraged by his growing support among the intellectual elite, Borduas published his *Refus Global*, a broadside attack on the repression of Québec society. Eight men and seven women who considered themselves part of the automatiste movement, added their signatures to the manifesto. It was published as a small mimeographed book, with other essays and illustrations by the signers.

Refus Global has been translated as "Total Refusal," but "Complete Rejection" might be more accurate. It correctly identified the Church as the primary agent of Québec repression, but instead of showing how the bishops acted in the interests of the imperialists who really controlled the colony, it went on to generalize about "the crimes of society" and its "conventional patterns." Borduas called for a complete rejection of these conventions. "Refusal to obey, to be made use of for such ends," he proclaimed. "The shame of submission without hope gives place to pride in a liberty which is within one's power to conquer if one struggles hard enough." Québécois, he insisted, must assume "complete responsibility for tomorrow."

This was a brave statement. It exposed the reactionary role of the bishops and their agents in government-run educational institutions. Borduas stated publicly that the priests taught a "false evaluation of the main events of history, when complete ignorance thereof proved impracticable."

The problem with the manifesto was its identification of "society" as the enemy. The automatistes did not see the broad masses of the people as an ally, but as part of the opposition ranged against them. Borduas' rallying cry, despite its rhetoric, remained elitist in character:

"Let those who are fired by the spirit of adventure join with us. In a foreseeable period of time we envisage mankind, freed from his useless chains, realizing in an uncharted, necessarily spontaneous order, in resplendent anarchy, the abundance of his individual gifts. Meanwhile, without rest or pause, in community of feeling with all those who are thirsty for a better life, without fear of long delays, with encouragement or against persecution, we shall follow joyfully our violent fight for liberation."

But at this very time, among those "thirsty for a better life," Québécois workers were leading the way. They knew that their chains were far from "useless" to their exploiters, and that the oppressed need organization, not "resplendent anarchy," to win. In the summer of 1946, 6,000 of them at Dominion Textile, producers of two-thirds of Canada's cotton goods, won their fight for union recognition and the 40-hour week, in a struggle that has been called "an historic advance, a break with slavery."

But Borduas, long since separated from his own proletarian origins, took no interest in uniting with the workers. More concerned with his 'freedom of self-expression' than with the freedom of workers to organize, and afraid of what he would have called the "social conventions" of a union or political party, he printed only 400 copies of his *Refus Global*, and made no effort to distribute it beyond the narrow circles of his art-world elite. In Paris, André Breton commented that "Reading the manifesto convinced me that the way of seeing and understanding the world in the most evolved milieu in Canada is the same as here;" but in Quebec, this "most evolved milieu" made little contact with the one class that was scoring real victories against the oppressors.

Thus when the infuriated Clergy retaliated, Borduas could only retreat. Within a month of publication of the manifesto, he was fired from his teaching post at the Ecole du Meuble. One Jesuit called him insane. His students and followers gathered signatures on a petition of protest, but Borduas' dismissal was confirmed by none other than Jean-Paul Sauvé, Duplessis' Minister of Social Welfare.

Rather than stay in Montreal and build support to continue the struggle, Borduas withdrew to his native village of St Hilaire. Within a month he had written to Rockefeller's Museum of Modern Art, unsuccessfully trying to arrange for an exhibition, and applied to another well-known imperialist foundation, again in vain, for a Guggenheim Fellowship to study in the United States. Borduas had made his choice: unwilling to join his people in their fight against oppression, he preferred to leave them in order to seek favours from the imperialists.

Meanwhile the *Refus Global*, in frayed copies passed

from hand to hand, or partially reprinted in newspaper accounts, was having a profound effect on Québécois students, teachers, writers and a few professionals. The same petit-bourgeois class among whom Borduas had found his patronage was strongly moved by his words that revealed the realities of clerical oppression. Phoney liberals like Gérard Pelletier (now in Ottawa) attacked the manifesto because it made no reference to sin or God; but some of those who were to lead what is called 'the Quiet Revolution' in the early 1960s have declared that they were stirred to action by Borduas' manifesto. A few went out to the mining town of Asbestos to support the strikers in the great anti-imperialist struggle of 1949.

This Asbestos strike was to prove Borduas' case against the Church in a particularly flagrant way. The chief company involved was the huge U.S.-owned Johns-Manville. After Duplessis had sent in 150 provincial police armed with tear gas and machine guns, and had ordered 180 workers and other citizens who supported the strike to be arrested and savagely beaten, Archbishop Charbonneau of Montreal was moved to speak out on the workers' side. "When there is a conspiracy to crush the working class it is the duty of the Church to intervene," he declared. "We want social peace but we don't want the crushing of the working class."

The U.S. owners of Johns-Manville did want the crushing of the working class. They got Duplessis to send his Labour Minister direct to Rome with their orders, and in a matter of months, former Archbishop Charbonneau found himself in a retreat in far-way British Columbia, where he was kept until his death a few years later. The Church went back to its usual comprador role of trying to persuade the workers to accept the U.S. company's terms.

The Asbestos strike had "exploded social structures," as one historian later commented. U.S. corporations, the Québec government and the Church had lined up solidly on the one side, while on the other were the workers and the great mass of the Québécois people who had kept truckloads of supplies rolling into Asbestos for over three months. The union was Québécois, not U.S.-controlled, and Québécois workers had rallied as never before. Many intellectuals had also spoken out, and even the bourgeois newspapers had been forced to admit some justice in the workers' cause.

Here indeed was a struggle for a complete change in society. It was not however, directed against society in general as Refus Global had been, but quite concretely against the U.S. imperialist corporations that were so obviously the controlling power behind both of Borduas' enemies, the Québec government and the Church.

It is to Borduas' great credit that he joined in this struggle by leading the automatistes in a demonstration against police violence at Asbestos. But his concern did not show in his art. In 1949 he was busy writing and publishing a new work, Projections Libérantes, an autobiographical statement of his evolution toward personal 'liberation' in his art and teaching methods.

"Self-interested activity remains bound to its initiator," he had written in Refus Global, "it is still-born." His own words proved to be all too true: after the great success of his manifesto, his self-centred "Projections of Liberation" were hardly noticed. Immediately after their failure, Borduas fell seriously ill with stomach ulcers. He remained a sick man for the rest of his life, and published no more manifestoes.

THE ABSTRACT ART OF U.S. IMPERIALISM

"I have spent a glorious and unique summer," Borduas wrote in September of 1953. "40 new paintings. It is more than I did in five years in Canada."

The five lean years were those following August of 1948, the month of Refus Global. Unable to get a teaching job, Borduas had been forced to live off the sale of his work alone. His wife had left him to support their three children, and he had finally been obliged to sell the house he had built in St Hilaire.

Now he had left Québec, its conflicts and his unresolved. He had painted all summer on Cape Cod at Provincetown, Massachusetts, and was ready to move on to New York. He was never to live in his homeland again.

The world art centre was now much closer. Not only was the U.S. the world's dominant imperialist power in the years immediately following World War II. Not only had the American Eagle immeasurably strengthened its grasp on Canada through continental defence production agreements during the war. But New York had also taken over from Paris as the imperial centre of the art world.

Fig. 148: Paul-Emile Borduas, *Le retour d'anciens signes emprisonnés* (The Return of old imprisoned Signs"), 1953, oil, 31 3/4" x 42", National Gallery of Canada

After the fall of France in 1940, most of the emigré artists had paused briefly in London, then under bombardment, and hurried on to New York. The U.S. painters, like the Montrealers, were strongly affected by the Europeans' arrival, and began to develop quickly in their own work along similar lines to that of Borduas.

When the war ended, there was much phrase-making by Parisian cultural bureaucrats about the "glory" of France; but the glory, the power, and the money had all moved. By the late 1940s, painters in Paris were already imitating the latest styles from New York.

Le retour d'anciens signes emprisonnés (literally, "The Return of Old Imprisoned Signs," Fig. 148) is a typical example of the work with which Borduas first established his reputation in New York. It may even have been painted on Cape Cod. In any case, it shows all the signs of the great spurt of creativity Borduas felt on first escaping from Québec.

This is the art of a man in flight. The taches that made up the foreground of *Sous le vent de l'île* have now taken over the whole surface of the canvas. The painting has become nothing but a 'field' for the direct application of paint, primarily by the palette knife. What is left of the Québécois tradition—the contrast of light, the rich colour and texture, the sensuous forms—is nothing but the particular nuance that Borduas gives to what New Yorkers could recognize as *abstract expressionism.*

This was the art that New York painters had evolved from their contacts with the cubist and surrealist artists from Paris. Like the automatistes, artists like *Arshile Gorky* and *Jackson Pollock* had concentrated on what they called the 'gesture' of the brushstroke or other means of painting as an act of self-expression. But while this concentration had led Borduas to the use of a palette knife loaded with pigment, Pollock had taken it all the way to dripping paint directly from the can onto his canvases stretched on the floor.

But there is a difference when you are expressing yourself in New York! While the Montreal artists had found a few patrons among those petit-bourgeois and French-speaking capitalists who thought they could somehow liberate Québec by 'catching up' with France, the New York painters were exhibiting and selling their works in the world's largest imperial centre, just at the time when the U.S. was emerging as the leading imperialist power.

At first these New York artists had to fight to get their painting accepted. Some had been painters of social reality during the 1930s, and worked closely with Communist organizations, so that for many years their art was attacked by reactionaries inside the U.S. as 'subversive' and 'un-American.' But they had been drawn to the art of self-expression by the same Trotskyite-surrealist logic of Breton and others who had influenced Borduas, and by the same process found themselves producing art that was highly acceptable to a growing group of imperialist patrons, led by and centred in Rockefeller's Museum of Modern Art.

The art market that was set up to handle the new painting was supposed to look like this:

How the New York Art Market is Supposed to Work

According to this myth, *the artist* is a free soul who creates paintings purely out of his imagination; *the dealer,* a dedicated lover of the arts, discovers these paintings in the artist's studio and decides to give them an exhibition in his gallery; *the critic,* a disinterested observer with a fine eye for 'quality,' reviews the exhibition in his art magazine or newspaper column; *the collector,* equally devoted to aesthetic values, reads the review and visits the exhibition to add this new artist's paintings to his collection; finally, *the curators and art historians* contribute their knowledge of the past and ability to analyze the profound meaning of the artist's work, and decide to include him in a major group show that associates him with similar artists past and present; or they grant him the highest reward, a one-man retrospective exhibition that shows how every little pencil mark he ever made on a piece of paper is all a part of his magnificent and mysterious life's work, thereby ranking him among all the geniuses of history!

As for *the people,* they are unfortunately "unable to appreciate the finer things of life." But they will benefit from the "stimulating" effects of this art on the design of the objects they use. Anyway, art is good for them, in some vague, idealistic way. It's part of their "civilization." So it's OK to spend their money on it.

The Imperialists

(Rockefellers, Guggenheims, Mellons, Hirschhorn, etc.)
On the boards of the key museums and galleries.

The Compradors

(Zacks, Bronfmans etc.)
On the boards of the colonial galleries.

The Curators, the Professors

U.S. citizens, pro-U.S. formalists.

The Editors, Publishers, Critics

The Dealers

The Artist

Work
of
Art

The People

Now let's look at how the system actually works:

Imperialists on the Boards of the Key Museums: These are the Rockefellers, Carnegies, Mellons and others whose money in some cases originally set up these museums, for which they received big tax advantages. Some of them remain on the boards to direct long-range policy, or are represented by their wives or agents.

Few in number, these imperialists are enormous in the control they exercise through a few trend-setting institutions. Their exhibitions and purchases are followed by the provincial U.S. public galleries and museums as well as in the colonies.

One of these imperialists, Joseph H. Hirshhorn of New York, made his money from various illegal and barely legal speculations with the wealth produced by Canadian miners, especially in the uranium fields at Elliott Lake. Our galleries

dearly hoped to receive his international sculpture collection, valued at over $50-million, but Hirshhorn decided to give it to the U.S.-government instead.

The Compradors: These are the capitalists in the colony who get rich from the continued sell-out of our country to the imperialists. Among their many interlocking directorships they sit on the boards of institutions like the Montreal Museum of Fine Arts (Samuel Bronfman) or the Art Gallery of Ontario (Ayala Zacks). They also give a little of their profits to keep control of these institutions, and often form collections which they eventually donate or bequeath, although they don't get the huge tax write-offs that the imperialists do for this 'philanthropy.'

These compradors make the major decisions on long-range policy as to how our money is to be spent in these supposedly public institutions. They take their standards

directly from the imperial centres, especially New York. They visit the galleries and museums there regularly, and anxiously scan the 'international' art magazines, mostly U.S., to spot the latest trends.

Curators, Professors, Critics, Editors: Between the comprador patrons and the dealers who actually sell the paintings lies the middle-man's world of the museum, the art magazine and the university art department. Many of the petit-bourgeois who teach, direct or work for these institutions are patriotic Canadians and Québécois; but the compradors make sure that the key positions in the larger institutions are held by their faithful servants. The director of the Montreal Museum of Fine Arts, David Carter, and the Chief Curator of the Art Gallery of Ontario, Richard Wattenmaker, are just two examples of U.S. citizens at prominent posts. The art history departments of our English-speaking universities and the art departments of our colleges and universities are among the most heavily dominated by U.S. and British professors. Even the editor of *artscanada,* the "national art magazine", is an American!

Of course many of the Canadians and Québécois in leading positions are also convinced that all good modern and contemporary art comes from New York. The curators and directors have to please their patrons, hoping to 'earn' their gifts and bequests. A few like Brydon Smith, Curator of Contemporary Art at the National Gallery of Canada, take up the comprador viewpoint enthusiastically, and buy and exhibit almost exclusively American art.

Particularly influential in a colony are the government cultural bureaucrats. Since most of the wealth we produce is drained out of the country, there isn't much private patronage. Canada Council grants and other government projects become the predominant source of the artist's income. Many of the bureaucrats who direct these grant programmes follow the compradors: to qualify for a grant the artist must at least show signs of being able to meet the U.S. standard of approval.

All of these sell-outs follow the U.S. art magazines like a gospel. These trade publications—*Art News* was the chief one in Borduas' time, *artforum* today—are the principal means of communication between the imperial centre and the colonies. Their publishers are mostly smaller capitalists who make sure that their over-all outlook conforms to the imperialists' interests; they hire and fire the editors who in turn guarantee that the critics discuss the art that is advertised in their pages. In Canada, the Eaton family dominates the board of *artscanada* magazine; but our colonial art mags use far more of the people's money, and depend heavily on the Canada Council and other grants to keep publishing. Despite this public funding, *artscanada* has refused to pay artists for reproductions of their work on the magazine's cover!

The Dealers: pay for the ads in the magazines, but depend on the comprador collectors and the cultural bureaucrats who are their chief customers. A highly unstable group, dealers range from the smallest petit-bourgois entrepreneurs to big international cartels, such as the London-New York Marlborough chain with its Toronto-Montreal branch plant,

the Marlborough-Godard Gallery. Each dealer tends to specialize in art for one particular interest in the market, and business goes up or down according to the fortunes of that school or style of painting.

The Artist: works in a studio to produce the paintings from which everyone else in the system profits. Only rarely does he or she get anything like the financial rewards that go to the dealers, publishers, art investors, and eventually the big auction firms like Sotheby's who collect after the artist is dead.

Artists in this system are forced to be completely dependent on their dealers, who generally charge at least 40 per cent commission on sales, and may also bill the artist for all expenses (rent, advertising, promotion costs) pertaining to his exhibitions. The artist is supposed to work away for years on a shoestring, hoping he will be one of the few painters who 'make it,' rather than one of the tens of thousands who don't. Some keep adjusting their styles to fit the latest fashions, as set by the museums and the magazines.

The People: as our diagram shows, are completely cut off from any access to control of the system, even though public tax money is used to operate most of it in the colony. The people are certainly affected by the system, though. The upside-down pyramid is also a spearhead: even for those of us who never go into a gallery or museum, U.S. imperialist culture functions as propaganda, reaching us through advertising, design, movies, fashion, the whole architectural and visual surround of our cities.

But the pyramid-spearhead is top-heavy. It tips easily. Every time there's a shift of weight at the top, the whole system shakes: the imperialists change their propaganda requirements slightly, the compradors take up the cry, their curators arrange new exhibitions, the art magazines take a new tack, and sales in the galleries shift dramatically from one type of art to another. Auction bids on historical works are one direct way the imperialists have of showing their new interests. As the earthquake works through the system, dealers are wiped out, and successful artists must either change their way of painting or lose their favoured position. Old careers are ruined, new ones suddenly made.

The top-heavy structure of the system allows the few imperialists at the top to control the many artists at the bottom. But it also means that the whole thing is highly unstable. When the artists at the bottom get together in organizations, they can topple the upside-down pyramid, if the organizations are supported by the people. Our diagram shows workers and artists with a battering ram.

In Borduas' time this U.S. imperialist system of art control was just beginning to work efficiently. We can see how it functions in practice by looking at his 'success' in it.

In 1954 he had his first one-man show in New York. His first dealer, the Passedoit Gallery, primed the art-market pump by presenting one of his paintings to Rockefeller's Museum of Modern Art in time for inclusion in the Museum's 25th anniversary show. The Museum obligingly bought a second painting for its collection the next time

Fig. 149: Paul-Emile Borduas, *L'étoile noire* ("Black
Star"), 1957, oil, 63 3/4" x 51 1/4", Montreal
Museum of Fine Arts

Borduas showed at Passedoit, in the spring of 1955. The Carnegie Institute in Pittsburgh also bought a painting, and borrowed another for a forthcoming international exhibition. In addition to the reviews in the art magazines, *Vogue* featured Borduas as one of three artists in an article on Canada.

By the summer of 1955, Borduas was too successful to remain with Passedoit. The bigger and more internationally-connected Martha Jackson Gallery took him over, guaranteeing to buy a certain proportion of his work. They got the Dominion Gallery in Montreal to agree to buy a smaller portion.

"Therefore I will arrive in Paris with sufficient security to give the best of myself," Borduas wrote. Despite his positive reception in Manhatten, he was still committed to the old French-language imperial centre, on which colonial artists had been dependent for so long. He persuaded three of his old Montreal patrons to buy a total of 18 more paintings to provide him with the fare, and crossed the Atlantic. Although his absence made it impossible for the Martha Jackson Gallery to arrange the personal meetings with trend-setting collectors that were so important, the Gallery nevertheless bought his past six month's work in 1956. "It is by far my most important sale," Borduas commented.

It is obvious that Borduas' "security" was completely dependent on the New York art market. Once the first round of museums had made their purchases, and with younger artists still in New York constantly competing for sales, it became harder for him to make a living. By 1955 he was writing that "economic need is great."

L'Etoile Noire (Fig. 149) is representative of Borduas' painting during this period. Compared to his "Ancient Imprisoned Signs," it is bigger, simpler, more geometrically organized and suggests a larger space. All of these changes are due to Borduas' experience in the 'international' art world.

The most obvious influence is that of *Franz Kline*, the New York abstract expressionist who painted mostly in black and white, with large sweeps of a housepainter's brush. Borduas had seen several Kline exhibitions in New York, and in paintings like *L'Etoile Noire* similarly employs large black and brown shapes against white.

The influence of Mondrian's geometric abstraction is less immediately apparent, but more important as an underlying factor. Mondrian died in New York in 1944, and Borduas had seen his works there and in Paris. What was only a tendency to vertical-horizontal disposition of foreground and background in *Sous le vent de l'île,* and reappears as the horizontal edges of the vertical palette-knife strokes in *Le retour d'anciens signes emprisonnés,* has in this picture become the geometric organizing principle of the whole composition. The passage of Borduas' palette knife has left the white paint arranged in more or less vertical rows, against which the roughly rectangular black and brown shapes are balanced.

There is still some landscape reference in *L'Etoile Noire,* with its "black star" floating high above a vaguely suggested

horizon. This horizon does not limit or contain the forms, as the brushstrokes in the background of *Sous le vent de l'île* did; on the contrary, these black and brown shapes are placed in a wholly idealized space and light.

In his headlong flight from reality, Borduas at this time was taking extended high-speed drives down the highways of France, sometimes as far as Spain, Italy and Greece. There he found light and buildings that stimulated him to these stark contrasts, and to other canvases in which a few smears of colour provide the only incident on the white.

But the real source of his idealized space was not in Europe: it is a space that is found in most of the large abstract expressionist canvases of the New York painters, usually on a much larger scale. Borduas had acquired the feel of it there, and was using his experience in the Mediterranean to recharge his particular version.

Critics have made up all sorts of metaphysical and existentialist terms for this sense of space, but in fact it is just an abstract reflection of the 'unbounded' space claimed by U.S. imperialism. Like U.S. corporations, it disregards the specific character of any one place, and arrogantly asserts universality. It is really the space of Strategic Air Command, the bomber armada that the U.S. Air Force was building up at this time.

Of course Borduas' example is that of a colonial. He does not grasp this space with the confident sweep of a Pollock or a Kline; instead, he qualifies it with signs of tension all over his canvas. In *L'Etoile Noire* the dark masses are contrasted with the whites around them; the texture rises from the flat swipe of the palette knife to the welt-like edges that act as lines in the painting; and the slight traces of brown on white reinforce a sense of strain.

Like the other abstract expressionists, Borduas was keenly aware of the anxieties and contradictions of his time. The contrasting elements in his late paintings can even be seen as a struggle between the forces of light and darkness, although no specific symbolism is intended.

The trouble is that the struggle is wholly self-centred and internalized. Like the U.S. abstract expressionists, Borduas insists on making it a strictly personal statement. He refuses even to imply its social roots, which he knew so well.

The formal unity that he imposes on these conflicting abstract elements is a determined attempt to bring some sort of order into the raging contradictions he had experienced in his life. But since he had not resolved these contradictions, he could only make more and more rarified abstract statements of them, gradually eliminating colour and painting almost entirely in terms of light. Leduc's late work is similar. *L'Heure Mauve* and *L'Etoile Noire* are not that far apart.

Reality was different. Borduas complained of loneliness, homesickness, and planned to write on the problems of art in Canada. "From now on," he confided in a letter, "Paris is a city without hope." Early in 1960 it was "Life is becoming hard." Within a month he was dead of a heart attack.

After his death, the Guggenheim Foundation gave him an award for *L'Etoile Noire*. In the posthumous citation, addressed to his widow in St Hillaire, it declared:

"This certificate is in recognition of the pre-eminence of your late husband's painting, L'Etoile Noire, *which was selected by the distinguished National Committee as the best painting to be executed in your country in 1960."*

The award from this well-known U.S. foundation was fitting: "the distinguished National (U.S.) Committee" apparently didn't know that the painting they were honouring had been painted in France in 1957.

CORPORATION PAINTING

Jean-Paul Riopelle, Borduas' most prominent follower, did not participate in the second automatiste exhibition in Montreal in 1947, because by then he was already living permanently in Paris. There he remained, getting very high prices for his paintings. With the change of fashion in abstraction that set in during the 1960s his sales have fallen off somewhat, but he remains an extremely successful colonial painter.

In a Riopelle painting like *La Roue II* (Fig. 150), the artists loads his knife with one or more bright colours, then applies them with a flick of the wrist. The result is a shimmer of multiple facets of colour and light all over the surface. Here the formal properties of the Québécois tradition are reduced to the tinsel of surface decoration.

Riopelle has varied his style from time to time, now squirting the paint directly from the tube, now reverting to the conventional brush. Other painters of this first generation developed alternative techniques, such as the very broad swipes of paint by *Marcelle Ferron*. This kind of 'trademark' was all that the personal expression of these artists finally amounted to. The artist achieved a certain effect by one or another exaggerated technique, and then produced a whole body of work in that way. The result was that the artists came to be identified by the 'look' of their paintings, exactly like standard brand names. The individuals or corporations who were collecting their paintings had to have 'a Ferron,' or a 'Riopelle,' which meant any painting that had the brand-name look of these artists about it. A painter like Riopelle, who needed to sell several works to the same collectors over a long period of time was well advised to change his style every few years, so that it became necessary for the collectors to have a Riopelle of each period. Still, the artist (and his dealer!) had to be careful to keep the same over-all look, so as not to devalue his earlier paintings and make the collectors lose confidence in their re-sale value.

By the early 1950s, the utter decadence of these painters was already becoming apparent. A small group of Montreal art students, led by the critic Rodolphe de Repentigny, began to reject the endless series of textural excesses, each gushing out its creator's supposed sensitivity. In 1954 one of these young artists, *Guido Molinari*, even refused to have his work included in an exhibition of such paintings chosen by Borduas on one of his return visits to Montreal. These students were much more impressed by the logic of Mondrian's geometric abstractions, and began to paint with colour and plane geometry alone.

Fig. 150: Jean-Paul Riopelle (born 1923), *La roue II*, oil, 78 1/2'' square, National Gallery of Canada

Mondrian had called his art *plasticisme*, meaning that it was produced with the 'pure' or essential two-dimensional values that had always given paintings their 'plasticity,' the illusion of three-dimensional depth. Just as the Bauhaus had applied formal and functional analysis to the design of objects, so Mondrian claimed to be taking to its ultimate conclusion the analysis of painting that Cézanne had begun. If painting could be reduced to a few essential formal elements, why not keep it pure? Why not paint with the plastic elements of the craft alone?

Following Mondrian, the Montrealers referred to themselves as *plasticiens*. In 1955 four of them exhibited together and issued a manifesto, explaining:

> *"The significance of the work of the plasticiens lies with the purifying of the plastic elements and of their order; their destiny lies uniquely in the revelation of perfect forms in a perfect order... The plasticiens are completely indifferent, at least consciously so, to any possible meaning in their paintings."*

This was to oppose any metaphysical speculation about the 'meaning' of their abstract art, by this time the standard jargon of the art magazines. But the plasticiens also revealed the emptiness of their own approach to painting. No more devastating critique than their own words would be possible.

Molinari was not included in this original plasticiens' exhibition, but in the years to come he and his friend *Claude Tousignant*, calling themselves *néo-plasticiens*, took these ideas to their logical limit. By 1956 Molinari was already painting canvases like *Angle Noir* (Fig. 151). It consists simply of the "black angle" of the title, with a black rectangle equal to one arm of the angle running down to the bottom edge of the canvas, and another, longer rectangle in the upper right corner of the painting. There is no other colour, no variation in texture, and no reference to even an imaginary space. This is formalist painting at its extreme.

Angle Noir was painted one year before *L'Etoile Noire*. Although Riopelle was well-known as Borduas' main follower, and was repeating his palette-knife technique *ad nauseam*, it was really Molinari who took the formal aspects of Borduas' painting on to their next stage. By deleting what could be called the 'abstract struggle' from Borduas'

work, he was able to place undivided emphasis on the question of formal unity of the canvas. So he distributes black rectangles at a distance from each other, but balances them off; the vertical and horizontal passages of white around them are similarly balanced across the painting. The black-white contrast of Borduas' late paintings is made absolute and rigorously logical in Molinari's early work.

Tousignant at this time was painting in an all-over flat monotone, or with just two colours in equal halves. For some of these works he was using automobile paint to give a smooth, hard, shiny finish. Like Molinari, he was aiming at an absolute in his art, the painting of "pure sensation" as he later called it.

When both artists first exhibited these works in 1956, they found neither buyers nor much appreciation, even from the other plasticien painters. No-one had been prepared to go quite this far with their formalist ideas. In 1955 Molinari had opened a gallery called *L'Actuelle* (The Present) to show his art, but he had to close just two years later. He joined in the *Association des Artistes Non-Figuratifs de Montréal* that was formed in 1956, although most of the paintings exhibited and sold through this Montreal Non-Figurative Artists' Association were automatiste or abstract expressionist in character.

But Québec was changing. In 1959 Duplessis died, and a year later a new generation of compradors came to power under Liberal leader Jean Lesage. The bookstore that had distributed *Refus Global* and first exhibited the plasticiens was called the *Librairie Tranquille* (Quiet Bookstore); now these new-style sell-outs, many of whom had been influenced by the *Refus Global*, proclaimed their regime a *"Révolution Tranquille."*

All through the 1950s demands had been growing for a more scientific education than the Church was willing to provide. Québec workers had continued their hard-fought strikes, adding demands for adequate pensions and hospital care to their contracts. Now Lesage's Liberals partially met these demands, introducing hospital insurance and a government-administered pension fund as well as setting up Québec's first secular Ministry of Education in 1960. The long rule of the Church over Québec schools was at last coming to an end.

The purpose of these reforms was the opposite of revolutionary. They were long over-due if Québec was to take its place both as a producer and consumer in the new-style U.S. empire. A better-educated working class was essential for an age of computers and electronics, and the minimum security of pension and health insurance schemes was necessary if people were to be persuaded to join in the free-spending "American Way of Life." This was genuine rattrapage, catching up not with Paris but with most of the rest of colonial Canada.

It was in this Quiet-Revolutionary age that Molinari and Tousignant found their patronage. In 1962 Tousignant saw the paintings of *Barnett Newman* in New York. The U.S. painter's huge areas of flat colour with only a few narrow stripes reminded Tousignant of his monochrome and two-colour paintings of 1956. Newman was just beginning to be recognized as the pioneer of a new 'cool' style of abstraction,

Fig. 151: Guido Molinari (born 1933), *Angle noir* ("Black Angle"), 1956, oil, 60" x 72", National Gallery of Canada

one that replaced the wild gestures of the abstract expressionists with massive expanses of uninterrupted colour. These paintings were even larger than the abstract expressionists' had been, and filled the great space they created with simple colour combinations. This was the bland new art of U.S. imperialism, in this era when Québec was catching up with the rest of the empire.

Molinari had been working through a series of colour-stripe paintings since 1959. By 1963 he began producing canvases that were as absolute in their use of colour as *Angle Noir* had been in black and white. Each painting consisted simply of a sequence of vertical stripes of equal width, with the colours repeated in the order chosen for that work. *Bi-Sériel Orange-Vert* (Orange-Green Bi-Serial, Fig. 152) is a typical 1967 example.

Fig. 152: Guido Molinari, *Bi-sériel orange-vert* ("Orange-Green Bi-Serial"), 1967, acrylic, 80" x 143", National Gallery of Canada

As everyone says when they first see these paintings, they look exactly like a striped awning. Molinari explained what he is aiming at in them in a 1969 interview in Toronto:

> "My only purpose as an artist is to obliterate the distinction between figure and ground. Why? Well, to me the figure-ground relationship represents a duality. This duality is symbolic of the anthropomorphic view of man that sees him at the centre of the universe and opposed to his environment. I hold that there is a unity between man and his surroundings."

There are two identical sequences of six foot-wide stripes of colour in *Bi-Sériel Orange-Vert*. Ordinarily we would expect that one colour beside another would produce a receding and advancing effect, with one colour seeming to be the "figure," another the "ground," and so on across the canvas. In fact, Molinari's colours remain absolutely equal in value, or else interchange equally one with another, so that this distinction is indeed "obliterated."

Why does Molinari consider this an important achievement? Like the cubists and the impressionists before him, he starts from an analytic basis. If painting is essentially colour, and if its representational function was always merely incidental, then the only logical and consistent path for the artist is to eliminate the last vestige of representation, the way one colour appears to be a figure before another. In this way he can achieve a new "unity" between viewer and painting.

Tousignant's *Accélérateur Chromatique* (Chromatic Accelerator, Fig. 153) is another example. After seeing Newman's paintings in New York, Tousignant had begun to paint broad bands of colour that were segments of circles on rectangular canvases. By 1964 these paintings had begun to look like targets, and in the following year the artist took the next logical step by making the canvases themselves circular.

In *Accélérateur Chromatique* the narrow bands of intense colour seem to race around one another. Like Molinari's stripes, they take up equivalent positions in spatial depth, or else compensate for one another's varying depth with equal values of brightness. They do not blend, but bounce. The result is that this whole huge circle seems to reverberate almost hypnotically in space, fulfilling Tousignant's goal of an art of "pure sensation."

The vivid hues of these paintings are due to the use of *acrylics,* a chemical-based pigment that replaced oil paints in the studios of many artists in the 1960s. This new paint dries fairly rapidly, and so facilitates the use of masking tape. To produce his narrow concentric circles, Tousignant had to cut out long elliptical strips of tape, lay them along lines he had drawn lightly with a simple 'string' compass, and paint along the edge of the tape. Then he removed the tape, laid down a fresh band over the fast-drying acrylic, and was ready for his next circle.

In this technique the acrylic gathers slightly against the tape to produce a characteristic 'hard edge,' for which this kind of painting has been called *hard-edge abstraction.* Artists who paint broader areas of colour often use a paint roller to get an even finish, while others follow the automobile body-shop painters by using a spray gun over their shapes marked off by tape.

The shiny industrial look of these paintings is not accidental. Like a Detroit automobile or a slick corporation symbol, they have a reassuring surface gleam about them. This is an art of total appearance. It tries to deny the reality of contradictions and struggle by setting up a false "unity between man and his surroundings."

In fact, the struggle between people and our environment has been one major source of human progress. But Molinari would have us "transcend" this and all other struggles in an experience of sheer colour. Like so much U.S. imperialist culture, this art aims to overwhelm us with a glut of "pure sensation."

In 1965 Rockefeller's Museum of Modern Art suddenly decided to give a big promotion to the many artists in all parts of the empire who had been producing such "sensations." With a full fanfare of publicity, the Museum produced an exhibition of what *Time* magazine called *op art*. This show trivialized even the formalist ideas of hard-edge abstraction into a preoccupation with the optical sensations excited in the viewer's retina by visual tricks like Tousignant's concentric circles. It established a new low in decadence for American painting. But then 1965 was also the year many people were beginning to see clearly how the heroic Vietnamese were defeating the mighty U.S. military machine. With all that offshore oil to worry about, Rockefeller and *Time* had good reason to try to dazzle and confuse people.

The short-lived fashion for this kind of painting led to a brief spate of New York exhibitions and sales, a bit of museum attention and the inevitable articles in art and fashion magazines for these Montreal painters. Tousignant even moved to New York temporarily, as did *Marcel Barbeau*, a former automatiste who had taken up the op fashion.

Yet these painters never really 'made it,' as Borduas did. A Washington, D.C. painter named *Gene Davis* had already cornered the market on vertical stripes before Molinari become known in New York, even though Molinari had begun painting them earlier than Davis. Several other artists were doing targets, and had better access to the market than Tousignant. These Québec *colour painters,* as they are sometimes called, had to depend on comprador patronage in Canada.

Most of Molinari's sales have been made not to Québécois, but to collectors in Toronto and English-speaking cultural bureaucrats stationed in Ottawa. His chief customers have been museums and the few branch-plant offices of imperialist corporations that try to maintain a 'good corporate citizen' front by collecting the colony's art.

A flagrant example of such corporate collecting is the Rothmans cigarette company. In addition to maintaining their own gallery at Stratford, Ontario, where they cater to the Shakespeare festival audiences each summer, Rothmans has spent large sums of money to buy and circulate whole exhibitions internationally. Rothmans also runs an "Art in the Factory" programme, principally in its Netherlands

plants.

Of course Rothmans includes works by Riopelle, Molinari and Tousignant in this collection. They put before their Dutch factory workers and before the world an image of art as pure form, a dazzling brilliance of colour and style that is intended to make us forget that art has any national character, or indeed any meaning at all. Hanging their collection in their factory is a kind of visual profit-sharing, a public-relations scheme to give workers a 'share' in the culture only the imperialists can afford.

Rothmans needs this kind of propaganda badly because its international headquarters is actually not in Amsterdam but in Johannesburg, South Africa. Lots of Riopelle glitter and Tousignant flash are needed to distract people all over the world from the fact that Rothmans supports and profits from the South African government's vicious repression of blacks. The money that pays for so many lush catalogues, cocktails at gallery openings and so much high-priced art comes out of the sweat of South African workers, toiling under virtual slave-labour conditions.

Allied with this kind of corporation patronage is that of the federal government. The Canadian government is proud and happy to subsidize art that looks so much like the U.S. product, yet has its own 'Québécois' flavour. The National Gallery and the External Affairs department have both been active not just in buying paintings but in mounting national and international exhibitions, such as Tousignant's 1973 National Gallery retrospective, or Molinari's showing at the 1968 Venice *Biennale.*

This Biennale, which Molinari considers his greatest triumph to date, is a particularly instructive example as to how serving pro-imperialist patrons pushes a colonial artist toward reactionary politics. From the early 1950s, as the western European capitalist countries regained some measure of independence and then became strong enough to oppose U.S. interests in a few cases, this biennial exhibition in Venice developed as the great international art-market trade fair in Europe. Dealers, collectors, curators, publishers, critics and even artists from all over Europe, the U.S., Latin America and Japan gathered there every two years to set the latest prices for their wares. Exhibiting in Venice at all was enough to include your name in the international art stakes; winning a major prize there multiplied an artist's prices astronomically. Dealers combined political pressure, personal favours and bribes on behalf of their entries, with the leading New York galleries usually pitted against whatever European power was vieing for cultural supremacy that year.

In 1968 the Biennale was due to open just as the workers and students of France rocked their government with the May uprising. Acting in solidarity, Italian students and artists attacked the Biennale as a symbol of the corruption and decadence of imperialism, and called on the artists of all countries to boycott it. Some official delegations, such as Sweden's, closed their doors; many other artists, including the original representatives of the U.S., withdrew their paintings, forcing organizers to find last-minute replacements. The French pavilion itself was closed. Molinari and the Québécois sculptor, *Ulysse Comtois,*

Fig. 153: Claude Tousignant (born 1932), *Accélérateur chromatique* ("Colour Accelerator"), 1967, acrylic, 96" in diameter, National Gallery

who was exhibiting with him, refused to cooperate with the international boycott. The tiny Canada pavilion, its walls hung with stripes, remained dishonourably open. "To close the exhibition" Molinari doubletalked, "would have been to play into the hands of the bourgeoisie." His justification for this claim shows his colonial character: "as an artist who has to live off grants," he claimed, "I can't say that the bourgeoisie patronizes my art."

This does point to a real problem. The interest of corporations like Rothmans in collections of colonial art is limited. Even among the cigarette companies that are hard-pressed for good publicity, head offices prefer to buy the art of the imperial centre and ship it to the colony. Most of the compradors want to collect original U.S. art, not Québécois or Canadian versions of the same abstract motifs. And most of the people, despite the constant propaganda in favour of this kind of painting, couldn't care less.

So the colonial artist is forced to depend on grants. A few come from imperialist cultural foundations, mostly the Canadian government. Molinari had worked for two years to produce his exhibition for Venice, painting on a grant from the Guggenheim Foundation. As a colonial artist given his chance to succeed, he was not about to deny himself the opportunity simply because the workers and students of France were rising against their oppression. "After all" he concluded, "you don't work for two years to close an exhibition!"

The boycott was a success. The Venice exhibition was widely exposed as the racket it is, and it has never been as powerful since. But the directors of the Biennale showed that they appreciated Molinari's loyalty in 1968 for precisely what it was worth. They awarded him a minor prize.

THE CHALLENGE FOR QUEBECOIS ARTISTS TODAY

In 1966 the people of Québec decided to call an end to the Quiet Non-Revolution. A new-look Union Nationale government then continued the U.S. sell-out. Since April, 1970 Robert Bourassa's Liberal regime has stepped it up even more, all the way to James Bay.

The FLQ crisis of October, 1970 brought the contradictions in Québec society into the open. The people's answer to the governments' continued betrayal has ranged from the 15,000 who turned out to demand a *"McGill français"* in 1969, to the General Strike of 1972, in which workers took over whole towns for days. The movement for national liberation is so strong that a new Parti Québécois has appeared to take advantage of it. PQ leader René Levesque is a former Quiet Revolutionary, and one of the generation affected by *Refus Global*. His party promises independence but maintains the closest possible links with Rockefeller and company, offering Washington and New York a direct route for exploitation through Quebec City instead of the diversion via Toronto and Ottawa.

Artists and art students have certainly been part of the people's resistance to the sell-out. As well as participating directly in the demonstrations, they have produced posters and designed publications for the unions and working-class community groups. They have also formed their own organization, the *Société des Artistes Professionels du Québec* (SAPQ, the Society of Professional Artists of Québec), which has met with Québécois union leaders to try to work out ways of co-operating. In 1966 Québec artists responded generously to an exhibition in support of the Vietnamese people. *Serge Lemoyne* has displayed works like his 'monument to U.S. imperialism' (all bandages and blood-stains); and various artists have tried to introduce popular subject matter such as hockey in their paintings and prints.

But there has been a real crisis of patronage in Québec. Especially after the kidnapping of the British diplomat James Cross and the execution of Bourassa's Labour Minister Pierre Laporte in 1970, many of the Anglo-Saxophones (as Léandre Bergeron calls them) and their French-speaking bourgeois pals lost the 'confidence' they need in a colony in order to make long-term investments like art. As a result, some of the galleries in Montreal closed, and many curtailed their activities.

The museums offer little help. The *Musée d'Art Contemporain* and the *Musée du Québec,* both provincially supported, have miniscule budgets for purchases. The Montreal Museum of Fine Arts, still under U.S. director David Carter, has had so much trouble getting money from its worried Westmount supporters that it has actually been forced into the arms of the Québec government. Going right along with the long-standing French-centred cultural nationalism of that government, Carter has recently imported French-speaking middle-management cultural bureaucrats from Europe! Artists and others have been demanding that the Museum be taken over and run by and for the Québécois.

In the almost complete absence of patrons for their work, Québec artists have become more dependent than

Fig. 154: Jean-Paul Lemieux (born 1904), *L'orpheline,* ("The Orphan"), 1957, oil, 24" x 18", National Gallery of Canada

ever on provincial and especially federal government support, especially through the grants system. It is not unusual to find artists who seldom exhibit and virtually never sell their work, perpetually applying for yet another grant to produce more work. This makes the problem of advancing to a new-democratic culture in Québec extremely difficult.

The challenge for Québécois painters today is to renew the Québécois tradition, not just in style but in substance, by painting the working people of Québec. This is not just a matter of painting figures in the landscape, as *Jean-Paul Lemieux* has done. His paintings like *L'Orpheline*, ("The Orphan," Fig. 154) focus strictly on the plight of the Québécois, never on their ability to unite together to fight and win. The figures always stand staring meekly, their arms at their sides, engulfed in the immense landscape of Québec, often with a town marked by a church steeple on the horizon. As one critic has said, "They are conscious of the emptiness which surrounds them and they are powerless to act."

This is an art that tells us that people are alone, futile, orphaned in the world. It has been patronized by the same corporations and government institutions that buy Riopelle or Molinari, but it has also been popular among private bourgeois and petit-bourgeois collectors, and has been widely reproduced. As propaganda, its message clearly is that the situation is hopeless, so that the best we can do is

Fig. 155: Arthur Villeneuve (born 1910), *L'industrie de la pulpe à Chicoutimi* ("The Pulp Mill at Chicoutimi"), 1967, oil, Montreal Museum of Fine Arts

feel sorry for these repressed souls. It is entirely in character that Lemieux began his serious painting in the early 1940s with pseudo-primitive depictions of the clergy, and that he has taught in the conservative art schools (the same ones that opposed Pellan and Borduas) continuously from 1934 until his retirement in 1965. From the dark days of Duplessis to the unjust society of Bourassa-Trudeau, Lemieux has depicted only the mute victims of oppression.

A more positive example has been set by *Arthur Villeneuve,* the Chicoutimi painter who started drawing only after some 36 years of living and working around his home town, first as a paper mill and lumber camp employee and then as a barber. Villeneuve has painted the doors and walls inside his house as well as hundreds of canvases, and in 1959 opened his own home in Chicoutimi as a museum. In Montreal he first exhibited in a friend's barber shop, but has since moved on to commercial galleries there and in Toronto. In 1971 his work was the object of an enormous retrospective at the Montreal Museum of Fine Arts, an exhibition entitled "Chronicle of Quebec."

Unlike Lemieux, Villeneuve has a proletarian outlook. He seldom paints victims, more often representing people in some kind of struggle. Like the votive painters of New France, he documents people overcoming difficulties, as in one painting where he shows how he and his wife were saved from drowning by the quick action of his son. Having left school after Grade 3, and without any formal training in art, he paints what he sees in the straightforward manner of direct transcription that links up his art with the whole body of what is called 'primitive painting.' His painting goes back to the very beginnings of the Québécoic tradition, as we can see at once by comparing his work to the votive of the injured Saguenay woodsman, Dorval, (Fig. 18).

L'industrie de la pulpe à Chicoutimi ("The Pulp Mill at Chicoutimi," Fig. 155) is typical of Villeneuve's many views of the mill where he once worked. They all show the topography of the Saguenay River valley, and the buildings and processes of the mill. Workers as such occur for the most part only incidentally, like the man who appears to be carrying a lunch pail to the right of the building here. People are much more likely to be seen as faces embedded in the rocky hillocks, like the one at left centre in this example.

Villeneuve's art is both national and democratic. It upholds the dignity of his nation, and not only springs from the people but to some extent has been taken up by them. Until the early 1960s his patronage was mostly local, ranging from family and friends to prominent businessmen of the district. He is also relatively scientific in works like the Pulp Mill picture, to the extent that his imagination is rooted in a realistic depiction of the world he knows so well. In other paintings, which include dreams, nightmares and fantasies, he is less objective. His art shows the limitations of his background, too: he never achieves any conscious depiction of the working people as heroic, and in some of his work he gives way to the superstitions of the past. But on the whole Villeneuve's painting is clearly one step toward new-democratic Québécois culture today.

Most Québec artists have a formal training and cannot revert to the primitiveness of Villeneuve. Nor do many of them share his familiarity with the small-town scenes he has known all his life. But most come from among the working

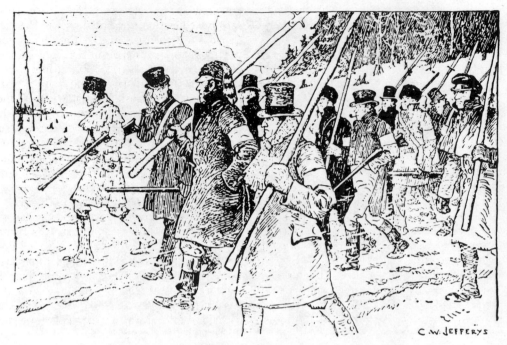

Fig. 156: Charles W. Jefferys (1869-1952), *Rebels Marching Down Yonge Street,* ink, Public Archives of Canada

people, and could make their struggles and victories the subject of new art.

The fundamental problem that must be solved is that of patronage, and artists cannot do it alone. Reaching the masses of the people with paintings, learning from them and developing a new Québécois people's art can only be solved with the spirited participation of artists and their organizations in the anti-imperialist struggle. The way ahead lies through organization.

2. Canadian Painting: the Struggle to Paint our People

The struggle to paint our people to the present day consists of two phases. In the first, from the latter years of the Group of Seven to the end of the Second World War, many artists continued landscape painting, while a more advanced group struggled to find patronage for paintings of the working class. After 1945, U.S. imperialism led many painters to American-style abstraction, but a new group of artists has once again taken up the painting of people. During both periods artists have worked to establish strong patriotic national organizations, through which they can better serve the people with their art.

C.W. Jefferys was the artist who most fully and consciously grasped the need to advance to the next stage of new-democratic culture, the painting of Canada's people. Since 1912 Jefferys had been teaching drawing in the architecture department of the University of Toronto. In addition to painting murals with Canadian historical themes for public buildings and hotels, he continued his work as an illustrator. In the 1920s and '30s he gradually came to concentrate more and more on carefully researching and

then sketching events in Canadian history. Especially after his retirement from teaching in 1937 he was able to devote full time to the crowning achievement of his long career, the publication between 1942 and 1950 of his three-volume *Picture Gallery of Canadian History,* the most authentic and comprehensive depiction of our history ever compiled.

Rebels Marching Down Yonge Street (Fig. 156) is one of the most famous of his over 1,000 historical paintings and drawings. It is a stirring sketch—rifles at the ready and the determined but apprehensive expressions on the faces of the men giving us a sense of the drama of the moment, as the Patriots of 1837 advance on Toronto. The pikestaffs made by the Patriots of Lloydtown, Ontario break the top of the picture at angles that drive our eyes forward and left, with the march. We can practically hear the crunch of the boots in the snow.

Jefferys by this time was past master at the art of line drawing to suggest the varying texture of the Patriots' caps and coats. He is careful to show us the mixed class origins of the Patriot column, made up of farmers, workers like the heroic blacksmith Samuel Lount, and petit-bourgeois like Mackenzie. Nor does he miss narrative touches, like the man with his glove shielding his ear, or another with his pipe clenched tight in his teeth. He has researched all aspects of the sketch, not only details of costume but also the topography of the route, the weather and the time of day.

Jefferys' art is a striking example of new-democratic culture. It is national, being based on events in our history, and upholding the dignity and independence of our nation; scientific, being thoroughly researched and realistically depicted; and democratic, having been taken up enthusiastically by the Canadian people. It describes not just the

plight of our colony, but our ongoing fight for liberation.

Most Canadians are familiar with these drawings from the pages of our schoolbooks. In 1952, one year after Jefferys' death, the entire collection of his original sketches and paintings was purchased by Rockefeller's Imperial Oil (Esso) Canada Ltd. The multi-billion-dollar U.S. imperialist giant payed only $14,250, $11 to $15 per drawing, for this collection that is of priceless value to Canadians. For that price Imperialist Esso got to deface our history texts and other reproductions of Jefferys' work with its name as owner of the originals.

Jefferys' will required that the purchaser agree to make the drawings available to Canadians for "educational or cultural purposes." In 1971 NC Press, the publishers of this book, set out to use some of the drawings to illustrate the English-language edition of Léandre Bergeron's *The History of Québec: A Patriote's Handbook*. The compradors who administer Rockefeller's profit-taking in Canada, led by Canadian chairman W.O. Twaits, complained that the book had "a particular political or social philosophy" and therefore was not of "educational of cultural" value! They refused NC Press use of the originals.

In response, patriotic individuals and organizations led by the Canadian Liberation Movement demonstrated at 13 Imperial Oil offices across Canada. Over 75 prominent professors, politicians, publishers, union leaders, authors and artists signed an open letter to Twaits, demanding that the drawings be released to NC Press, and that the whole Jefferys collection be handed over to the Public Archives of Canada for the use of the Canadian people. The letter pointed out that Bergeron's book had already sold over 60,000 copies in French alone (now over 250,000 in all versions in both languages), and that its "particular political philosophy," obviously a popular one, is the philosophy of anti-imperialism, directly opposed to U.S. Imperialist Esso.

Faced with the widespread popular support for this campaign, Esso was forced to capitulate. NC Press used the illustrations. Nine months later it was quietly announced that Imperial Oil (Canada) Ltd. had presented the Jefferys collection to the Public Archives of Canada, where they are now available to all Canadians on request.

This victory proves that the people can win, even against huge U.S. corporations like Esso. It is also a fitting tribute to the life and work of a great Canadian. For over 50 years, beginning with his Art League calendars and patriotic cartoons, (Fig. 111), continuing through his enthusiastic support for the beginnings of the Group of Seven, his own paintings of the Canadian west (Fig. 112), and his decades of dedicated work as an illustrator and muralist on Canadian historical themes, Jefferys made a memorable contribution to our people's art. Throughout this whole period in which painters have struggled to establish the Canadian people as their subject matter, his achievement stands as an example and a challenge.

Fig. 157: Franklin Carmichael (1890-1945), *A Northern Silver Mine,* 1930 oil, 40" x 48", McMichael Canadian Collection, Kleinburg

Figure and Landscape: The Struggle to Paint our People to 1945

In 1903, during the laying of the Temiskaming and Northern Ontario Railway track, right-of-way workers at Cobalt, Ontario found silver. At Porcupine and Kirkland Lake within the next decade, gold miners successfully developed a new technology for extracting ore from the hard rock of our north. During the First World War nickel was needed, so the huge deposits at Sudbury began to bring enormous profits to the imperialist investors who got control of them. From 1923 to 1929 speculation in mining stocks ran wild, and many a capitalist like stockbroker Sam Zacks (later to become a leading art collector) made and lost several fortunes in the mines of northern Ontario.

A Northern Silver Mine (Fig. 157), painted in 1930 by *Franklin Carmichael*, the youngest member of the original Group of Seven, shows that the example set by Lawren Harris on his trip to the Maritimes in 1921 was not entirely without effect. Like Harris on Cape Breton (Fig. 130), Carmichael paints the tall, narrow structures of the mine and the houses of the miners in a dramatic light. His panoramic viewpoint, the radiance of the clouds and the rhythmic folds of shadow and highlight in the rocks and hills open up a commanding vista that accords with the rugged forms of the land and the power of the mining operation itself. He also gives a sense of the isolation of life in these mining villages.

Yet there is a distance that is more than just physical between the artist and his subject. The miners themselves are not seen; their houses and places of work are incorporated into the landscape just as if they were boulders or trees. The steeply falling foreground and the vertical thrust of the minehead with the bay behind it make up a conventional Group of Seven format: the headframe takes the place of some great tree. Carmichael shows us the populated northland, but only by assimilating the structures of man to those of nature.

This tendency to interpret towns and villages according to the Group of Seven landscape style was passed on by Carmichael to his friend *A.J. Casson*, who became a member of the Group in 1926. It was clearly not an attempt to advance to painting the Canadian people, but merely an inclusion of buildings in the existing national landscape style. Employed in this way, the Group's typical composition soon became an empty formula for the repetition of landscape subjects.

Even artists whose style had developed independently of the Group of Seven joined in this trend. The Winnipeg painter *Lionel Lemoine FitzGerald* had been stimulated by Frank Johnston's landscapes after Johnston left the Group and became principal of the Winnipeg School of Art in 1921. But FitzGerald achieved his dry, meditative style largely on his own, with just one season of study at the Art Students' League in New York.

Nevertheless *Doc Snider's House* (Fig. 158), one of three paintings FitzGerald sent to the final Group of Seven exhibition in 1931, shows this same still-life approach to

the city. Of course there are winter days in Winnipeg after a snowfall when the light is this clear, the air that still. FitzGerald had built a little shack on runners, and even installed a stove in it, so that he could stand the bitter cold to paint scenes like this view of the dentist's home next to his own on Lyle Street in the St James district of Winnipeg. He worked two winters on the canvas, painting every weekend and all through Christmas vacations from his teaching duties.

But FitzGerald's world, even when he paints with a more expressionist brush, is always this still, silent, arrested. We may sense that life continues under the layers of snow, as suggested by the delicately painted surface and the subtle nuances of colour in the snowbanks and tree trunks. But only in a rare watercolour self-portrait and a few drawings of nudes does FitzGerald disrupt his clearly defined spaces with signs of conflict, and then it is always internalized and suppressed. Although the light in his pictures is much brighter and his colour far fresher, FitzGerald's art of repressed self-expression is not unlike the late work of Ozias Leduc.

Doc Snider's House was one of the most talked-about works in the 1931 exhibition, and led to FitzGerald's being invited to join the Group of Seven a year later, just before its dissolution. At about this same time, in the little village of Palgrave northwest of Toronto, *David Milne* gave the unoccupied landscape theme its ultimate expression in *The Empty House* (Fig. 159).

Like Tom Thomson, Milne had grown up on a farm near Owen Sound. But he had gone to New York as early as 1904, at the age of 22, and had stayed in the U.S. until 1928, with two years out for service as a war artist and a winter's stay in Ottawa and Montreal, in 1923-4. In New York Milne had been caught up with the formalist avant-garde, and in 1913 participated in the Armory Show, the exhibition that introduced Fauve and Cubist painting to the U.S. He was our first artist to be trained in the new imperial centre, New York, rather than Paris, and is the current favourite of our colonial-minded art historians, who rank him along with Morrice as an artist who 'makes it' according to the imperial standard.

Milne's style is a rarified version of the technique of the colour-loaded Fauve brushstroke that he had learned in New York from U.S. Fauve followers like *Maurice Prendergast* (who was actually born in Newfoundland, but brought to Boston as a child). Milne referred to his own works as "compressions," in which he selected the salient details of the scene, and then "compressed" them onto his canvas with a few touches of his brush.

We can see this theory at work in *The Empty House*. The walls of the farmhouse and barn are a light purple-grey, but the shadows under the eaves are deepest purple, their limits marked by an even stronger black line than the forms of the buildings. The bright sunlight on the snow is stroked in starkest white onto the roofs and over the ground, with a far paler white more loosely brushed into the sky. The whole picture is held together by its dun-coloured ground, which Milne allows to show through in many places to give a light, airy effect.

Milne composes with what he called "open and shut spaces." The house is massed against the spaciousness of the sky, as the lesser volume of the barn is set into the rolling fields. The partial recession of the porch is balanced by the dark rectangular void of the open barn door. We sense the emptiness of the buildings, the distance between things, the utter stillness.

Milne has the reserve, the indifference toward his subjects, that Morrice did. Whether he paints flowers in a vase, reflections on a pool, or a wooded hillside, his main concern is not subject matter but form. All objects, balanced against one another, have the same value. There is no struggle, no ultimate contradiction in Milne; like Morrice and Lawren Harris, he paints a static world. People appear only as decorative elements, if at all; their figures are "compressed," like everything else, into formal motifs.

The Empty House is a painting of refined sensibility, but it indicates that landscape painting in Canada after the Group of Seven could not go beyond this point, the restrained application of formalist principles. The national bourgeoisie was no longer in the ascendant. The force of the landscape as subject matter was gone.

Only on the far west coast was one woman able to fill her landscape paintings with the charge of being lived in. This was *Emily Carr*, who made the next great contribution to our people's art.

THE ACHIEVEMENT OF EMILY CARR

"Dare to struggle! Dare to win!" This motto of Mao Tse-tung would have appealed to Emily Carr. All through her life she waged an audacious struggle against oppression, and finally conquered.

Emily Carr was born in Victoria in 1871, daughter of a prosperous merchant. Brought up by her eldest sister after her parents' death, she had to fight against her family's resistance when she set out, at the age of 16, to study art in San Francisco, the nearest art school she knew of.

The training she found there was a distant echo of the Paris academy of around 1890, a derivative version of the same arid discipline that Cullen and Morrice were both rejecting at this time in France. But since she very much wanted to paint, and could hardly be expected to perceive the shortcomings of such academic training, she worked hard at it, acquired certain basic skills, and returned to Victoria after four or five years to teach art to children in a studio that she fixed up in the loft of a barn behind her house.

So much dedicated study was a bit unusual for a 'lady', who wasn't supposed to take her art too seriously. On the other hand, Emily Carr didn't take her religion nearly as seriously as her older sisters and other bourgeois Victorians of the Beacon Hill district thought she should. In 1898 she accompanied a missionary to Ucluelet, a native village on the west coast of Vancouver Island that was a mission station. She made fun of the missionaries, but was immediately at home among the native people. Even on this first visit, she was sketching boats and houses.

By this time, the limitations of her San Francisco art

Fig. 158: Lionel Lemoine FitzGerald (1890-1956), *Doc Snider's House*, 1931, oil, 29 1/2" x 33 1/2", National Gallery of Canada

education were becoming obvious to her. She wanted to paint outdoors, where her academic studio training was of little use. Following the advice of most Victorians of her family's class, she went to England. There she had to have a toe amputated, and a combination of overwork and British boarding-house diet landed her in a sanatorium for a year and a half with pernicious anaemia. Nevertheless, she managed to pick up the techniques of outdoor English landscape painting, which were at least a little more fluent than her previous training.

Back home, she wasted a disastrous month trying to get the Vancouver Ladies' Art Society to take their painting seriously, then settled for teaching art to children for a

Fig. 159: David Milne (1882-1953), *The Empty House*, 1930-32, oil, 20" x 24", National Gallery

Fig. 160: Emily Carr (1871-1945), *Kwakiutl House,* 1912
oil on card, 23 1/2″ x 35 3/4″, Vancouver Art Gallery

living. The friends she made during this Vancouver period were not the bourgeois 'ladies' of the town, but the native women of the North Vancouver Reserve. She visited native villages farther up the coast, and on a steamer trip to Alaska about 1907 discovered that she had developed a strong feeling for painting native subjects.

"By the time I reached home my mind was made up," she later wrote, "I was going to picture totem poles in their own village settings, as complete a collection of them as I could."

But she was still dissatisfied. Her British landscape techniques were appropriate for picturing the polite woods of Cornwall and Hertfordshire, or a Victoria garden party, but she couldn't get the power and drama she needed for totem poles. So in 1910, at the age of 39, she went to Paris to study the art of painting for a third time.

On this trip, despite another bout of anaemia that caused her to spend the winter in Sweden, she found what she was looking for. From spring to fall of 1911 she painted in Breton and French villages, studying the Fauve technique of dabs and broken brushstrokes of vivid colour to achieve an expressive effect. Her teachers were a British painter named *Phelan (Harry) Gibb*, and a New Zealand woman, *Frances Hodgkins*. An Emily Carr painting was accepted in the fall 1911 Paris Salon.

Kwakiutl House (Fig. 160), painted in 1912 during the visit she made to coastal villages the year after her return, shows how she applied this bolder method of representation to documenting the native culture. She does not use the broken brush stroke as she had in France, but she does put far stronger colours in close juxtaposition, and employs dark outlines to show the shapes that have been carved and painted on this magnificent housefront. Details of the

houseposts that tell the history of the clan living in the house can be seen clearly; but the drama and vigorous carving of the figures can also be appreciated, especially in the two-headed *sisiutl* or sea-serpent figure across the top. The powerful expression of the large human face in the centre is vividly depicted, and the architectural construction of the house is also shown in the patterns made by the planks. The shacks to either side are presented with the same realism. She seldom painted the older native people because of their belief that their spirit would be trapped in her likeness of them at death, but she does add the children playing by the prow of the great canoe as an integral part of this living culture.

This 1912 series of paintings constitutes an invaluable document of the native peoples' life on the Pacific coast, especially the Kwakiutl, while these people were still continuing their original traditions. Her approach to the natives was very different from that of Paul Kane. While Kane had documented native customs in his sketches, only to paint them up into exotic European-style canvases, Emily Carr remains faithful to the documentary assignment. For her the native people are not exotic subjects to be used to ornament a style; on the contrary, she puts her style at their service, using it to reveal the majesty of their art.

We can also see the difference between her use of Fauve technique, and that of colonial-minded artists like Morrice or Milne. While they served the imperialists by devoting their lives to perfecting this style, making subject matter insignificant, Emily Carr learned the style only because she needed it to paint her subjects effectively. Like Tom Thomson, she made subject matter her first concern, and was interested in style only as a means of bringing out the

essential character of her subjects. Again we observe that subject, not style, must be primary if the artist in the colony is to create art of any value to the people.

Before her 1912 trip she had exhibited her paintings from France, which were greeted with keen interest by the city's tiny art elite, who welcomed them as examples of the Parisian art world they had heard so much about. A year later, when she showed her paintings of the native culture, she was attacked and ridiculed. These paintings were far less experimental in technique than the French ones: it was their subject matter that offended the Vancouver bourgeoisie. In the lumber and fishing industries, and in the steady flow of cheap native labour to the towns and cities, they were profiting from the oppression and near-extermination of this culture; they didn't want to see paintings that showed its continued vitality, dignity and power. Not only were there no sales from the show, but parents who had been sending their children to Emily Carr's art classes began to withdraw them; any woman who associated so closely with natives was no fit teacher for the sons and daughters of the bourgeoisie! With her social status as a polite lady art teacher lost forever, and her only means of revenue cut off, Emily Carr was forced to go home to Victoria.

How was she to live? At the age of 42 she had become a social outcast. In desperation she became a rooming house landlady, hoping this would provide her with enough time and money to paint. Bravely, she rigged her living room furniture onto pulleys, so that it could be raised to the ceiling to clear space for a makeshift studio.

But as 14 years went by, she found less and less time for painting. Her rooming house duties tired her out, and still didn't bring in enough income. Shunned by most of her former friends, she drew on her lifelong affection for animals, and raised hundreds of sheep dogs for sale. Since she was an artist who had been identified with the oppressed natives, she also became a tourists' version of a native artist: she modelled pots (which the west coast natives didn't) and wove carpets, decorating them with the native motifs she knew so well. Beacon Hill residents were offended when they saw her wheeling her pet monkey around in a baby carriage; but her laundryman and the worker who delivered her coal had a great affection for her, as we can tell by reading her diary and the stories she later wrote.

These 14 lost years in the painting career of one of our greatest artists stand as a symbol for the millions of years of creative work by women lost forever due to their perennial oppression under social systems of slavery, feudalism and capitalism. As Lenin observed:

"In most cases housework is the most unproductive, the most savage and the most arduous work a woman can do. It is exceptionally petty and does not include anything that would in any way promote the development of the woman."

In the first year after the revolution in Russia, the new Soviet Union passed sweeping laws for the emancipation of women, and called numerous conferences to make sure that these laws were implemented. Canadian women, with brilliant leaders like Nellie McClung of Winnipeg, were fighting for similar emancipation at this time, but victories in this colony had to be wrung one by one from the imperialist ruling class. Emily Carr's art remained interrupted by housework.

Help came from the native people. Other visitors to their villages, like the world-famous Québécois anthropologist Marius Barbeau, admired their culture and wanted to document it. The trouble was that many of these scholars worked for museums, in the U.S. and Europe as well as the few from Canadian institutions, and they were constantly offering to pay the hard-pressed natives for the best examples of their art. This may have helped to preserve the painted wood carvings, which quickly deteriorated in the heavy rains of the Pacific coast, but it also meant that the natives were being deprived of the best examples of their work.

With the economic basis for their culture ripped away by the cannery owners, lumber companies and missionaries, even the Kwakiutl recognized that their arts were likely to die with the last of that generation of carvers. These were also the years when the RCMP was raiding illegal potlatches and confiscating hundreds of objects for the museums in Toronto and Ottawa.

The native people could ill afford to lose the few precious examples left to them. So they remembered this friendly woman who had shown her respect for their culture by recording it in her paintings, leaving their villages as she found them. "*Klee Wyck*", they called her, "the laughing one." Although often uncommunicative with the U.S. and European anthropologists, they told the Québécois Barbeau about her.

In 1915 Barbeau visited this eccentric landlady in Victoria, and bought two of her 1912 paintings, which he subsequently used to illustrate his publications on the native arts. In 1921 he brought her paintings to the attention of Eric Brown, the director of the National Gallery. But Brown was busy at that time with the Group of Seven. It was another six years before he got around to organizing an exhibition of native west coast art, and decided to include 26 of Emily Carr's 1912 paintings in the show. Fifteen years after she had painted them, her documentary pictures were at last to be seen in the context of the native arts that had given her inspiration. Their content had made them important.

Brown found that this isolated onetime artist was completely unaware of the accomplishments of Tom Thomson and the Group of Seven, so he suggested she read Fred Housser's recently published book on the "National Art Movement." He also arranged for a railway pass so that she could come east for her exhibition, and made sure that she met members of the Group of Seven while in Toronto.

This 1927 exhibition and her encounter with the Group of Seven, especially Lawren Harris, formed a decisive turning point in Emily Carr's career. Inspired anew by the example of their national landscape art, and by the sight of her own paintings in the company of powerful examples of native art, she returned to the west coast determined to go back to the native villages and paint again. But this time she

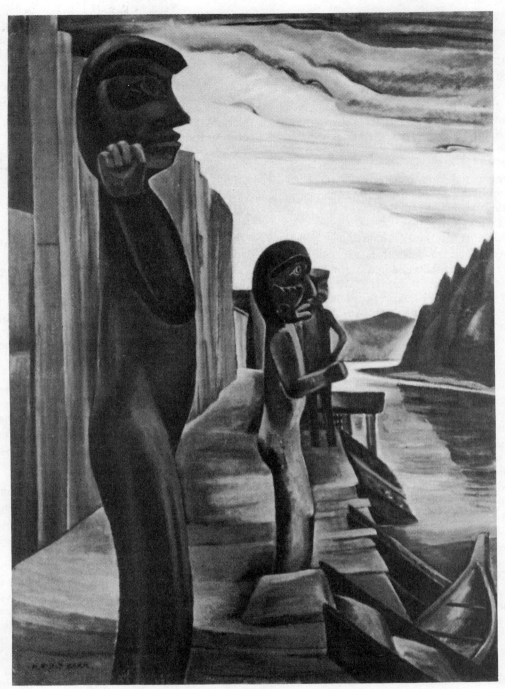

Fig. 161: Emily Carr, *Blunden Harbour,* 1928-30
oil, 51'' x 37'', National Gallery of Canada

had an even deeper commitment, a far richer understanding of what she was doing. After looking at the paintings that A.Y. Jackson had made from his 1926 trip to the Skeena River villages of northern B.C., she commented:

"I felt a little as if beaten at my own game. His Indian pictures have something mine lack—rhythm, poetry. Mine are so downright. But perhaps his haven't quite the love in them of the people and the country that mine have. How could they? He is not a Westerner and I took no liberties. I worked for history and cold fact. Next time I paint Indians I'm going off on a tangent tear. There is something bigger than fact: the underlying spirit, all it stands for, the mood, the vastness, the wildness, the Western breath of go-to-the-devil-if-you-don't-like-it, the eternal big spaceness of it. Oh the West! I'm of it and I love it."

This is an enthusiastic description of the difference between *documentary realism* and *social realism.* Emily Carr's 1912 paintings were an extension of the documentary realist tradition in Canadian art, reaching all the way

back to the painting of the Micmac native people that is attributed to Elizabeth Ladds (Colour Plate IV), and the early sketches of prairie settlers by Peter Rindisbacher. Now, building on the achievement of the Group of Seven painters, Emily Carr was ready to go forward to "something bigger than fact." She saw this as flowing from her "love . . . of the people and the country . . ." The "underlying spirit" that she wanted to express on canvas came to her not just from the land, but from the people who live on it.

Blunden Harbour (Fig. 161) is one of the major works she was able to achieve with this new insight. It is a moving depiction of the dock of a Kwakiutl village. Three life-size carved and painted human figures stand on the wharf, two looking out across the inlet, one at the end staring straight toward us, hands on hips. The grandeur and dignity of these massive statues are enhanced by their simplified setting of posts and planks, the ladders to the sea, and the trees on the mountain shore opposite, as well as by the decisive modelling of the monumental sculptures themselves. A rich, expressive light breaks behind the mountain to the right, fills the sky with its brilliance, sets up dynamic rhythms of shadow along the edges of the clouds, highlights the shapes of the carvings, illumines the reflection of the mountain in the inlet, and even spills into the canoe in the lower right corner. This is a masterful drama staged with completely assured control of the power of light and darkness to reveal the artist's meaning.

That meaning is clear. These austere figures, full of dignity, show us the strength of the native peoples, their ability to fight back. They stand as guardians on the dock, an identification of this village and a warning to unfriendly visitors. The rage of the native people at the destruction of their proud civilization can be sensed in the raised fist closest to us, and in the determined expression on the three carved faces. Especially in the powerful head in the foreground, dark against the sky with the lines of the clouds crackling away from it as if to manifest its strength, Emily Carr has used the dramatic sculptural shapes of the Kwakiutl to show the might of the native people.

Yet we also see that these figures are only wood. Effective guardians in the past, they cannot prevent the oppression of the native people by their present enemies; so majestic here, they can easily be stolen away, paid for by only a tiny fraction of their real worth. The rapidly changing light, the very stillness and the great sense of space around these figures are all charged with the threat to the civilization they represent. The painting strikes at the heart of the struggle going on in Blunden Harbour, but proclaims that the strength of the native people is primary.

Blunden Harbour has been called an *expressionist* painting, because it uses strong contrasts of light and vigorously modelled shapes to a dominant expressive purpose. It shows the influence of Lawren Harris, and of a U.S. expressionist painter, *Mark Tobey*, whom Emily Carr invited over to Victoria from Seattle to give lessons in her studio for a three-week period in 1928.

But *Blunden Harbour* is not a distortion of reality, as so many expressionist paintings are. Its painter has employed Tobey's lessons in interlocking form only because they help her to reveal the meaning she senses in her subject matter. And although the awesome stillness of Harris's Lake Superior paintings has obviously impressed her, so has the feeling for social reality that she must have sensed in his Cape Breton and Halifax paintings of a few years before. *Blunden Harbour* is essentially social realist in character.

In 1930 she exhibited with the Group of Seven, and also in Victoria and Seattle. The following year she went east again, and renewed her acquaintance with Harris and other members of the Group. The example of their landscape art spurred her on this visit to turn her attention to the specific qualities of the west-coast landscape she knew so well. "Too bad that West of yours is so overgrown, lush— unpaintable," A.Y. Jackson had written her. When she returned, she proved him wrong.

Unable to afford canvas or even the sketching panels that the Group of Seven had used, Emily Carr hit on an expedient that served her very well. Brown butcher paper, the kind she got the meat wrapped in when she went shopping, was cheap, plentiful, and light to carry in quantity. By thinning her oil paints with gasoline, another inexpensive and readily available material, she was able to make the pigment adhere to this paper. Her new materials encouraged a looser, more sweeping motion with her brush, entirely suitable to the dynamic qualities of the western rain forest that she wanted to express.

We can see the effects of this technique in her canvases of the 1930s, such as her 1936 painting *Reforestation* (Colour Plate XII). The green and yellow strokes of the long grass surge in waves up to the darker green, black and grey-purple trees behind, their boughs brushed in with a free swipe of the brush that conveys the vitality of their verdant growth. The trees to the left in this painting in the middle distance are typical of the more solid, structured forms she favoured earlier in her landscape art. But the freer brushing of the trees in the centre and on the right are more characteristic of the expression she finally arrived at. A swirl of light leaps from the yellow highlights in the grass through the conical shapes of the trees to the deep blue-purple whirl of the sky, animating the whole picture.

In paintings like *Reforestation*, Emily Carr extended our national landscape art to the Pacific. Like Tom Thomson in Algonquin Park, Lismer and Varley in Georgian Bay and J.E.H. MacDonald in Algoma, she had found the way to express the unique characteristics of a region of Canada. But she did more than that. Even in the most isolated locations, which she reached with the aid of the trailer she had bought in 1933, she almost always makes evident the presence of people working and living in the land. In this case it is the growth of the young trees in the middle ground, sprouting up to replace those that have been cut down for human use; but even when her subject is not specifically *Reforestation*, her late paintings throb with her awareness of the process of life using up the materials of nature, and their rebirth. Like the native people, she sees the forest as a place of human habitation to be constantly replenished, not as a static backdrop to be assembled into a picture; her paintings are in every way the exact opposite to the old British tradition of the picturesque. At last our land

is fully grasped as the home of our people.

"Seventy years had maimed me, loggers had maimed the clearing," she wrote of a similar painting site near Victoria. In 1937 she suffered the first of a series of heart attacks, only one year after she had finally been able to afford to sell her rooming house. Increasingly confined to bed in later years, she responded characteristically by launching into a whole new field of struggle: she began to write. In 1941 she published *Klee Wyck*, a collection of stories recalling her life among the native people, for which she received the Governor-General's Award. *The Book of Small*, recollections of her Victoria childhood, followed, along with *The House of All Sorts*, in which she drew on her life as a landlady. She even based a small book on her stay in the British sanatorium. She was transforming every moment of her life, including her worst experiences, into a triumph of creative expression. Her own life had become a constant process of regeneration. Towards the end, unable to paint at all, she still worked relentlessly on her autobiography, *Growing Pains*, which finally appeared in 1946, a year after her death. Since then her long and detailed diary has been added to her list of publications.

The prose in which she wrote these books is simple and to the point. It makes indelibly clear that her art was based on her love for people, especially the native tribes, as well as her fondness for animals and all living things, and her

Fig. 162: Frederick H. Varley (1881-1969), *Margaret Fairley*, 1921, oil, 30 1/4" x 22 1/2", Art Gallery of Ontario

patriotic pride in being a western Canadian. Her paintings and books stand as a magnificent contribution to Canada's new-democratic culture: they are national, upholding the dignity and independence of the native people, and bearing the unmistakable stamp of the Canadian west; they are scientific, being based on objective reality and the processes of change she found in nature and society; and they are democratic. In 1932 she had tried in vain to establish a "People's Art Gallery" in Victoria. Six years later, when she finally triumphed in Vancouver with an exhibition that sold a phenomenal 11 paintings, she wrote, "What made me so pleased about it was the fact that I had been able to make their own Western places speak to them." Emily Carr makes our places "speak" for all of us.

THE DEPRESSION

Frederick H. Varley, the only member of the Group of Seven who was seriously interested in the painting of people, managed to make a living in the early 1920s as a portraitist. Among his sitters was the critic Barker Fairley, and his wife *Margaret Fairley* (Fig. 162).

Varley's portrait is a thoughtful picture of a woman who was already showing her concern for and commitment to the struggles of the oppressed. In 1921, the year this canvas was painted, the Communist Party of Canada was founded; Margaret Fairley was to become a staunch party member. Among many other activities she edited a wartime collection of Canadian writings on democracy, and assembled an important collection of the political theory of William Lyon Mackenzie, published in 1960.

This dedicated woman looks seriously off to one side, obviously taking the opportunity of the sitting to think her way through some problem. Rather than trying to regain her attention, Varley preferred to paint her as she was. In her simple, conservative dress and hair style, we can see that she was not overly concerned with appearances, on the occasion of her portrait or otherwise. Her thoughts are far from herself, engaged with reality rather than appearances.

The Canadian economy was just beginning to come out of the severe slump that had followed World War I. As a Marxist, Margaret Fairley understood that these cycles of boom and bust, with all the human misery that results, are a built-in part of the capitalist economic system. The 1920s were to be boom years again. But the Great Depression that began with the stock market crash of 1929 was a disastrous failure of imperialism that ravaged the whole world for a decade.

As a colony, Canada suffered far worse than imperialist countries like Britain or the United States. Canada was actually being sucked dry by foreign investors: in 1928, $113.9 million were paid in dividends by Canadian companies to foreign capitalists, while $164.1 million went to Canadian capitalists; but by 1932, dividends paid to foreigners had *increased* to $126.8 million, while those paid to Canadians *decreased* to $102.8 million. The imperial markets for colonial raw materials like lumber, base metals and wheat were almost non-existent, even though millions of people were hungry and in want.

Fig. 163: F.H. Varley, *Dhârâna, 1932*
oil, 34" x 40", Art Gallery of Ontario

A prolonged drought worsened the situation in the prairies. By 1932 the price of wheat in Winnipeg fell to 38 cents a bushel, its lowest ever. Railway workers were handed their fourth steep wage cut in two years. The army set up relief camps for some of the estimated 200,000 unemployed men wandering the country looking for work. Especially in Vancouver, the end of the line west, they gathered in large numbers.

In 1926 Varley had been welcomed to Vancouver by Harold Mortimer-Lamb, a B.C. mining executive and typical national-bourgeois patron of the Group of Seven. Varley took over direction of the new Vancouver School of Decorative and Applied Arts (now the Vancouver School of Art). He plunged his students simultaneously into exploration of the mountains and the study of Asian philosophy and art, while he himself painted some of the most sensual portraits and nude studies in the history of Canadian painting.

But from 1929 to 1932, real wages in B.C. fell by 40 per cent. In 1933 Varley was forced to resign when cuts in his salary amounted to 60 per cent. For two years he and fellow artist and teacher *J.W.G. (Jock) Macdonald* (no relation to J.E.H.) tried to run their own B.C. College of Art.

Yet *Dhârâna* (Fig. 163), painted at Varley's cottage in the Lynn Creek Valley above North Vancouver in 1932, shows only the rapt figure of a girl in metaphysical communion with the universe. The title refers to a Buddhist state of meditation, in which the mind is supposed to be 'free' of the body and at one with its surroundings. Hence the girl's dreamy expression, and Varley's attempt to integrate her figure with the Coast Range. The purple of her jacket and the deep green of the nearer hills recur throughout the canvas, especially in the light green and purple tones of the sky, reflected through the evening light in the girl's upturned face.

Dhârâna is the exact opposite of the portrait of *Margaret Fairley*. The Toronto Communist is genuinely 'out of herself' because she is serving other people. The Vancouver art student, on the contrary, looks up and away, avoiding confrontation with reality by sinking into reverie. Apparently contemplating nature, she is really serving herself by refusing to trouble her mind with the social problems so pressing around her, much less do anything about them. This mystical doctrine of *Dhârâna* is actually a doctrine of selfishness that depends on ignoring the real sufferings and struggles of others, whether in Asia or in Canada. Today, 40 years later, it is still a fashionable means of escape for many artists and students; but it serves only the ruling class, who are delighted to see young people and intellectuals cut off in this way from the oppressed and from workers.

Varley was fleeing from reality. After bill collectors closed the B.C. College of Art, he drifted to a teaching job in Ottawa. Loathing government bureaucrats, he moved on to Montreal, dulling his acute sensitivity with heavy drinking. At his lowest point he failed even to recognize Arthur

Fig. 164: Charles Comfort (b. 1900), *Young Canadian*, 1932
watercolour, 36″ x 42″, Hart House, University of Toronto

Lismer on the street. It was only after he moved back to Toronto in 1945 and was helped by another bourgeois patron, Charles Band of the Canadian Bank of Commerce, that Varley's life and painting began to cohere again. He had become completely dependent on the bourgeoisie.

Other artists took a more realistic attitude toward the Depression. *Charles Comfort*, who had decided to become a painter after seeing the first Group of Seven exhibition, posed his friend and fellow artist *Carl Schaefer* as a symbolic *Young Canadian* (Fig. 164). Schaefer is seen on his family farm at Hanover, in southwest Ontario, where he lived each summer from 1932 to 1939 because he couldn't afford to remain in Toronto. Schaefer had been working as a display artist at Eaton's department store in 1930 when 16 of the 18 artists on staff were laid off.

The expression on Schaefer's face sums up the determin-

ation and creative ingenuity with which most Canadians faced the appalling effects of the Depression. His hands, emphasized in the foreground, show that he is ready to take action. There is no dreaming of *Dhârâna* here, but a stubborn will to set to work (in this case at sketching), even if the worker knows in advance that there will be little or no market for his product. Schaefer resolutely turned his restrictions to advantage, and made some memorable paintings of wheatfields and farm houses around his family home that catch the spirit of the region.

Comfort himself managed to get through the Depression by joining with two other artists to set up a commercial art studio in Toronto. By imaginatively combining every possible type of commission—portraits, murals, graphic design, advertising, theatre sets and sign painting—they achieved a modest success.

Another individual solution was found by David Milne. In 1933 he had moved to a cottage on the Severn River north of Orillia to reduce his expenses. A year later, in desperation, he wrote an appeal to the millionaire Vincent Massey.

Massey was descended from the other half of the agricultural implements firm of Massey-Harris, the same company from which Lawren Harris got his money. He was reflecting national-bourgeois interests when he agreed to patronize Milne. He appeared to be supporting a continuation of the landscape tradition. But this tradition had turned into its opposite: just as the national bourgeoisie was selling out to the imperialists (the McLaughlin family having sold their auto works to General Motors in 1918, for instance), so the national-bourgeois painting of our land had become the formalist art of an empty landscape.

Massey bought *The Empty House* and presented it to the National Gallery. He also bought a large number of Milne's paintings and arranged to sell them through annual exhibitions in Toronto's Mellors Gallery, remitting any profits to Milne. The artist soon realized that this arrangement guaranteed more to the dealer Mellors, who was sure of his commission in any case, than it did to him; he might or might not realize a profit over the price Massey had already paid him. In 1938 Milne ended the arrangement, and switched to exhibiting with the Picture Loan Society, a gallery operated by Douglas Duncan, a dealer who had befriended him.

Duncan was independently wealthy from an inheritance, so he could afford to rent or 'loan' paintings to people who couldn't buy them; unfortunately, he could also afford to keep transactions at a minimum and to cater to an elite. He generously subsidized artists like Milne, brought in Fitz-Gerald's work, and gave first Toronto showings to painters like *Goodridge Roberts* of Montreal, who was applying the lessons of Cézanne to the Ottawa valley. Duncan's patronage, like Massey's, tended to concentrate on the formalist interpretation of the landscape, not the painting of people.

For most artists, the answer to the problem of patronage during the Depression lay in organization. It is no accident that Comfort's *Young Canadian* is a large-scale watercolour. The Canadian Society of Painters in Watercolour had been founded by Franklin Carmichael, A.J. Casson and Fred Brigden in 1926 to encourage work in this low-cost medium. In the 1930s this Society's annual exhibitions became important sources of revenue.

An even cheaper medium was drawing, which could also be used for book illustration, print-making and the commercial art work that provided many artists with an income. In 1933 the Canadian Society of Graphic Arts was formed on the basis of the old Graphic Arts Club of Group of Seven days.

It was soon followed by a Canadian Society of Painter-Etchers and Engravers for those who made colour prints. Several artists, including *Walter Phillips* in Winnipeg and *Leonard Hutchinson* in Hamilton, established international reputations in this medium. Both did landscapes, but Hutchinson was also well-known for his woodcuts and other prints of unemployed men in Hamilton's Gore Park,

workers in the steel mills, and pickers in the tobacco fields southwest of the city.

Even though Hutchinson was director of the Art Gallery of Hamilton, his two wood engravings *Protest* and *Woman Farm Worker* (Fig. 165) were refused for a Hamilton group exhibition. *Protest* shows a demonstration for higher wages and better working conditions at Hamilton's Dominion Foundries and Steel Company (Dofasco, which is still non-union), while *Woman Farm Worker* is one of many prints Hutchinson based on his sketching trips to the tobacco fields. Both are technically and stylistically excellent prints: they were clearly rejected simply for their heroic presentation of working people, the same reason that Courbet's life-size peasant figures had been excluded from official exhibitions in France almost a century before.

In Winnipeg Phillips was more conventional in representing workers on the job. He was part of the circle that collected around Brigden's engraving house, a branch of the Toronto firm. Employees like *Eric Bergman* there produced illustrations for department-store mail-order catalogues, and at nights or on weekends made pictures for the group exhibitions.

The largest of the exhibiting associations was the Canadian Group of Painters. Established in 1933 as an outgrowth and replacement for the Group of Seven, it began with 28 exhibitors, one-third of them women. Its stated purpose is revealing:

Fig. 165: Leonard Hutchinson, (born 1896), *Protest,* wood engraving, 10 3/4" x 8 1/2", Artist's collection, Toronto

Fig. 165a: Leonard Hutchinson, *Woman Farm Worker,* wood engraving, 10 1/8" x 8 1/4", Artist's Collection

"Its policy is to encourage and foster the growth of Art in Canada, which has a national character, not necessarily of time and place, but also expressive of its philosophy, and a wide appreciation of the right of Canadian artists to find beauty and character in all things."

The self-confident assertion of a national character in our art shows how well the Group of Seven had done its job. But the vague reference to philosophy and the refusal to take a stand in favour of democratic subject matter attests to the influence of Lawren Harris. In practice, Canadian Group of Painters exhibitions featured endless repetitions of the 'empty landscape' formula, based largely on Group of Seven conventions. Its leading members, some of whom had been active in a revived Art Students' League in the late 1920s, retreated to Toronto's Gerrard Street 'village,' where they could temporarily forget the realities of the Depression.

Artists who were more concerned with changing those realities gathered in the Progressive Arts Clubs, first established with 35 members in Toronto but soon spreading to Montreal, Vancouver and other cities. The Clubs' purpose was "to provide the basis for the development of a militant working class art and literature."

In 1930 Canadian workers had established the Workers' Unity League (WUL), a branch of the Red International of Labour Unions and a powerful new centre for the independent Canadian union movement. By 1932 the WUL repre-

sented over 40,000 workers and was leading 90 per cent of the successful strikes in the country. The Progressive Arts Clubs set up over 100 Workers' Theatre groups, not only in the big cities but especially in the small working-class towns where the WUL was strong. They wrote their own plays and recitals, based on current struggles.

In the visual arts, the Clubs' publication *Masses* pioneered "the beginnings of Marxist criticism of art" in Canada. Reviewing the 1933 Ontario Society of Artists exhibition, *Masses* attacked:

"Little rural houses on still suburban streets, rural churches on barren country hills ... Is this Canada? Is this what even bourgeois newspapers reflect? Is this industrialism, depression, bankruptcy, oppression and struggle? Or is it the mediaeval peace of a mythical Québec village?"

There was one major contradiction in all this activity. The Communist Party of Canada, whose members were providing leadership in these organizations, betrayed the basic principles of Communism: they refused to act on the evidence that Canada was already a colony of the United States. The Canadian party's leaders tailed after U.S. Communists, who at this time were advocating a theory of "American exceptionalism," according to which U.S. imperialism was an "exception" and was somehow 'progressive' because the United States was such a young, vital, dynamic, capitalist country!

Spreading their own treacherous version of colonial mentality, Canadian Party leaders dissolved the Workers' Unity League in 1935, and threw Communist organizing energies into strengthening U.S.-run unions in Canada. *Masses* was discontinued late in 1934. The Progressive Arts Clubs, instead of encouraging the Workers' Theatre groups to write our own plays, recommended American scripts. And when an Artists' Union was organized in 1936, Communist artists encouraged its affiliation to the U.S.-dominated Trades and Labour Congress.

This Artists' Union began in Toronto with 55 members, and by May 1937 represented over 250 Toronto artists and 75 per cent of the artists in Hamilton. Although Local 71 president *A.T. Vivash* insisted that the union was open to all artists, in practice it recruited only commercial artists who were concerned to stop price-cutting on their jobs. The union struck commercial art houses and department store catalogue shops, and succeeded in shutting down the commercial art industry in Toronto for some time. The worst price-cutting abuses were ended, but the strike did not result in any lasting contracts. Vivash was obliged to go into business for himself, and the union gradually lost its strength.

The failure of this union to unite commercial and 'fine artists' shows that the close working relationship between the two fields that had characterized the early days of the Group of Seven was now gone. Too many 'fine artists' disdained 'commercialism' while some of the commercial artists looked on painters as potential price-cutters who might do free-lance commercial work in their studios. The unions had called for a rental fee for paintings lent to exhibitions, but the lack of unity meant that it remained

only a demand. The division between commercial and 'fine artists' has always served the bourgeoisie, never the interests of the artists.

PAINTINGS OF THE WORKING CLASS

In the late 1920s *Edwin H. Holgate* in Montreal tried to make up for the lack of figures in the Group of Seven tradition by posing lumberjacks, a fire ranger and other workers before typical Group of Seven landscapes. Although Holgate was admitted to the Group in 1931 on the strength of these canvases, they are stiff and unconvincing works, not based on any concrete experience of the working class.

The same must be said of the paintings of women farm workers that Holgate's associates in the Beaver Hall Hill Group sometimes produced. These artists, named for the address of the studio they shared, were mostly English-speaking women whose portraits, landscapes and figure studies provided a thin cultural veneer for Anglo-Montreal society.

Artists of the Jewish working-class community in Montreal were much more closely involved with the lives of workers. *Alexandre Bercovitch*, an immigrant from Odessa, painted day-to-day life there, while in Toronto *Henry Orenstein* recorded a similar community, continuing to work full-time in the garment industry himself.

Nathan Petroff, born in Poland in 1916 and brought to Toronto at the age of 13, was one of the most promising of these artists. His 1937 watercolour *Modern Times* (Fig. 166) sums up the spirit of the decade, as a young woman searches the want ads for work. The fragment of a newspaper headline "SHELL MADRID" links fascism in Spain to unemployment as twin evils of the world imperialist system.

Many details of this picture show Petroff's grasp of the realities of life for an unemployed woman of 1937. The squashed hassock on which she sits and the upholstered chair behind her suggest a rented room. Her cast-off shoes tell us that her feet are aching from another day of making the rounds of possible employers. She is wearing her one job-seeking dress. Her hair hangs down in disarray, she holds her head in her hands and rests her elbows on her knees in a most 'unladylike' posture as she wrestles with the problems of her own life and of world politics.

Petroff had studied under Carl Schaefer and others at the Central Technical School in Toronto, but any chance he had to relate his art to the history of Canadian painting was lost in 1938 when he became one of a number of these artists who were encouraged and even subsidized by the Canadian Communist Party to study at the American Artists' School, operated by Communist artists in New York. There our budding social realists learned to see their own work as an example of *regionalism*, the painting of the people of specific areas of the U.S. with an eye to their special 'regional' characteristics. The Communist Party of Canada was doing the job of an agent of U.S. imperialsim in sending our artists to New York: for there was no way Canadians could become "American regionalists" without

Fig. 166: Nathan Petroff (b. 1916), *Modern Times,* 1937 watercolour, 22" x 14", National Gallery

taking up a completely continentalist outlook! Petroff, in fact, stayed in New York as an artist and photographer, and never returned to Canada.

Modern Times illustrates another of the limitations of much of this art: its preoccupation with the *plight* of the unemployed, instead of showing their ability to fight back. In 1935 the Relief Camp Workers' Union, organized by the Workers' Unity League, led 1500 unemployed men on the famous "On to Ottawa" trek all the way from Vancouver to Regina; there were many other heroic struggles to stop evictions, provide community centres for the children of working mothers, and so on. But the pictures and stories of the period kept presenting an image of the unemployed as helpless and defeated. The artists' own individualistic despair, rather than the proletariat's positive and collective response to hardship, is what many of these works reflect.

Workers Arise! (Fig. 167) by *Miller Brittain* is just the opposite. A Communist Party speaker, his features highlighted by the glare of an overhead lamp, holds the stage. His conviction and joy in relating his revolutionary message are unmistakable. He addresses himself to each man in the

hall, feet planted wide apart and body hunching forward to get his meaning into the hearts of his listeners, who are rapt in concentration. The open gesture of his right hand is contrasted against the illumined figure of the meeting's chairman, who cups one hand to his ear to catch every word. The blinds are drawn, and a worker in the lower right corner looks suspiciously at the artist, who is sketching in the back row.

Workers Arise! was drawn in Saint John, New Brunswick, where Brittain had been sketching since the age of 10. When he went to the Art Students' League in New York from 1930 to 1932, the social realist teachers he found there only confirmed his earlier interest in portraying the working people of his industrial port city with attention to

the dramatic contrast of light and darkness, and the rhythms set up by the position and movement of people's bodies.

"A picture ought to emerge from the midst of life and be in no sense divorced from it, and I call history to be my witness," Brittain said a few years later. "And I think artists should be rooted in their native heath, not self-consciously, but naturally. And they will be so if their life and work are one and the same."

In 1936, the year *Workers Arise!* was worked up from on-the-spot sketches, Brittain was elected to the Canadian Society of Graphic Art, and was hailed by Graham Campbell McInnes, a leading critic of the day, as "a Canadian Brueghel." The reference was to *Pieter Brueghel*

Fig. 167: Miller Brittain (1913-68), *Workers Arise!* 1936
pencil, collection of Dean John Saywell, Toronto

Fig. 168: Miller Brittain, *Longshoremen,* 1938-40
glazes on board, 20'' x 25'', National Gallery of Canada

The Elder, a Flemish painter of the 1500s well-known for his realistic depictions of peasants and other working people.

Brittain was pleased with the comparison, because he was learning to paint by studying the techniques of Brueghel and other Flemish realists. In New York he had been too poor to take the painting classes, so he had limited himself to drawing lessons, which required much cheaper materials. Back in Saint John he set out to teach himself to paint by studying a library book on the methods of the Flemish masters.

Longshoremen (Fig. 168) is typical of the paintings that resulted. Like the Flemish pictures, it is painted on a wooden panel over many layers of polished white ground, giving the figures of the workers a translucent gleam. The medium is not oils but vivid tinted glazes, as concocted by Brittain from a 'recipe' in the library book. Of course it is a very rough approximation of Flemish technique; but it suits

Brittain's concern with the drama of light and shade, and allows him to paint the working class with a heroic 'shining forth' quality.

The self-taught painter is still uncertain of his ability to organize space. His figures are too closely crowded together, even in the narrow passage he has allowed them. As in his drawings, he concentrates on gestures and movement. The longshoremen are coming off shift, several lighting up cigarettes to create that ruddy glow Brittain favours. Two men argue heatedly in the background, while the main figure in the centre of the panel strides energetically off to the left.

These Brittain paintings of the late 1930s and early '40s are always slightly awkward, but they are filled with the warmth and close-range familiarity of a man who has lived all his life among these people. Not one of them was purchased by any public gallery or museum outside the Maritimes during the artists's lifetime. Nor were they

widely exhibited. In addition to the usual ruling-class reluctance to subsidize positive representations of the working class or workers' families, there was the added factor of central Canadian *chauvinism*, which refuses to take an artist who lives in Saint John as seriously as one from Toronto or Montreal. Its effect on Brittain was to isolate him from the mainstream of Canadian art, so that many exhibitions and accounts of our art history left him out.

Like so many Maritime artists, Brittain was forced to find his own patrons within the region. In 1940 artists in the area's various art clubs, schools and university art departments came together to form the Maritime Art Association. In 1941 the Association's very successful journal *Maritime Art* reported that Brittain was just completing a mural on the theme of sports for a new gymnasium at the University of New Brunswick. It also mentioned that he was just beginning work on a mural project for the Saint John Tuberculosis Hospital.

Although many artists wanted to paint them, mural commissions were hard to get. Following on the Mexican bourgeois-democratic revolution of 1912, the Mexican government through the 1920s and '30s had subsidized a magnificent programme of murals for their new public buildings, in which leading Communist artists like *Jose Clemente Orozco, Diego Rivera* and *David Alfaro Siqueiros* had produced monumental works uniting that nation's long history of struggle with the cause of the working class today. During the Depression a Works Project Administration (WPA) in the U.S. had commissioned destitute American artists to decorate public buildings with murals and other works of art, as part of Roosevelt's "New Deal." But in colonial Canada the few mural commissions available were mainly offered by hotels like Ottawa's Chateau Laurier, or occasionally by universities; they were mostly for lounges, playgrounds of the rich, where a strictly decorative treatment was required.

The Saint John hospital project was an attempt to provide a serious mural commission for Brittain. In 1941 Dr R.J. Collins convinced the Hospital Commission to try to find the money for a mural that would cover the corridors

Fig. 169: Miller Brittain, Cartoons for projected Saint John Hospital mural, 1941-2, charcoal, crayon and chalk on brown paper, each about 110″ x 100″, The New Brunswick Museum, Saint John

leading to the operating room, and a large working area in the hospital. The theme was to be the causes and treatment of tuberculosis, the very subject to which Dr Norman Bethune had made such a great contribution before leaving Canada to help fight the fascists in Spain. Brittain responded to the challenge, and in his set of drawings for the mural (Figs. 169, 170) produced our greatest monument of social realism to come from the Depression.

These 11 drawings (called *cartoons* when they are preparations for a mural) are just over nine feet high, sketched in charcoal, crayon and chalk on long rolls of brown paper taped together to form surfaces as wide as the walls, each more than eight feet across. Like Courbet in the *Stonebreakers*, Brittain has realistically presented the working people as heroic figures, not only in his approach to them but by the sheer scale on which he conceives them. He incorporates these figures into his planned hospital location by leaving empty rectangles to allow for doorways,

and one slanting bottom edge for a staircase. In some cases he uses the doorways literally in the drawing, as where one figure perches above the corridor entrance, resting on the arch. Similarly, he incorporates the illness and its cure into our daily life.

"Poverty, poor food, unsanitary surroundings, contact with infectious foci, overwork, and mental strain," Bethune had listed as the chief environmental factors predisposing people to tuberculosis. Brittain shows the dust and dirt of unsafe working conditions on a construction site, with one worker leaning wearily on a doorjamb rectangle while others continue their labours in an excavated pit. A family group is crowded into the corner of a tenement apartment, where a boy tries to study in a cramped corner, a scene that would have been painted under an actual staircase.

"The incurable tuberculous who will fill our sanatoriums for the next five years are now walking the streets, working at desks with early curable tuberculosis," Bethune had

Fig. 169a: Miller Brittain, Cartoon for projected Saint John Hospital mural, 1941-2

Fig. 170: Miller Brittain, Cartoon for projected Saint John Hospital mural, 1941-2

written. In one of Brittain's panels children walk by a smoky billiard parlour, a boy pausing to look in, while in another a different class of people are seen at a loud party.

"There is a rich man's tuberculosis and a poor man's tuberculosis," Bethune observed. "The rich man recovers and the poor man dies."

The mural encouraged people to come into the hospital for examination and treatment. "Lack of time and money kills more cases of pulmonary disease than lack of resistance to that disease," Bethune wrote. "The poor man dies because he cannot afford to live." The mural shows a woman in a crowded waiting room wiping a boy's nose, a man registering with a nurse, and a portrait sketch of Dr Collins seen from the back taking an X-ray.

Anyone who has ever gone to a hospital or accompanied a relative or friend with a dread disease like tuberculosis can appreciate how powerful these murals would have been. A series of three cartoons would have covered an entire corridor with a view inside the operating room, where the thoracic surgery operation which Dr Bethune perfected is

seen in progress.

"All health is public, there is no such thing as private health," Bethune had written. In the cartoon for the mural that would have risen along the stairway, a man and wife in a slum scene on the right look up in hope to a group of figures at the centre, one of whom holds a plan and points to the clean, happy home of a worker's family on the left, with a boy drinking milk at the table. In another scene, intended for an end panel or perhaps the landing above, a group of workers, a teacher, a mother and baby, a young boy and others stride forward in jubilant good health.

These last panels tell us that we have to change society in order to end disease. Behind the man with the plan in the centre of the staircase mural is a construction worker with a spade, and two other men wearing hats. The Mexican Communist muralists whom Brittain admired had used similar central, gesturing figures to indicate the leaders of socialist revolution. Whether Brittain intended this much or not, he certainly shows that we need a whole new plan for society, and that the plan must be supported by the working class. Only by this means can we achieve the

Fig. 170a: Miller Brittain, Cartoon for projected Saint John Hospital mural, 1941-2

jubilation of the marching group, with the worker carrying his pick over his shoulder leading the way ahead.

This is social realist art of a high order, with an underlying socially progressive purpose affecting a powerful realistic depiction of life. Not only would it have informed the anxious and otherwise isolated patient of the social causes and steps to a cure of his disease, both inside the hospital and out; it would also have reminded the hospital staff that their job is really to serve the people, and can only be completed by sweeping changes in the social order outside the hospital doors.

Social realism is art that serves the people: it reveals the underlying contradictions in the world, lays bare the class struggle that is going on in society, and takes up the side of the working class and the oppressed. It shows the heroism of the working people, and gives confidence and courage to those engaged in the fight. It is definitely an art of fight, not plight.

All through the winter of 1941-42 Brittain worked diligently on the cartoons. Early in 1942 he demonstrated his technique on the billiard parlour scene at a convention of the Maritime Art Association in Fredericton. Could foreknowledge of the murals' intended content at provincial government level in the New Brunswick capital have something to do with what followed? Senior personnel at the hospital were suddenly changed, and Dr Collins was abruptly informed that money for the mural commission would not be available after all!

Soon after he learned of this decision, Brittain was advised of another: his long-standing application to join the Royal Canadian Air Force, previously refused because of his slight physical stature, would now be accepted.

The cartoons were deposited in the New Brunswick Museum. Their artist became a bombardier. Our major mural of the Depression was never to be painted.

ARTISTS AGAINST FASCISM

The Depression led to desperate measures in many imperialist countries. In 1931 Japan invaded Manchuria. In 1933 Hitler joined Mussolini and Salazar as rulers whose ideology was *fascism*, the ultimate and most vicious form of imperialism. In 1935 Italy invaded Ethiopia. Well before the outbreak of World War II, Canadians had begun to fight fascism.

In February of 1936 the Canadian League against War and Fascism sponsored an exhibition in Montreal by the German immigrant artist *Fritz Brandtner*. Born in Danzig, Brandtner had come to Winnipeg in 1928, where he passed on his first-hand knowledge of recent European art to L.L. FitzGerald. By the time he moved to Montreal in 1934, Brandtner had developed his own vehement version of expressionism. His exhibition showed people in gas masks, a

Fig. 171: Artists' Branch, Communist Party of Canada, Banner and four portrait sketches for rally sponsored by Friends of the Mackenzie-Papineau Battalion, Toronto 1939

symbolic reminder of World War I and a warning of another world war that was inevitable as long as fascism continued unchecked.

One of Brandtner's most enthusiastic patrons at the exhibition was Dr Norman Bethune. The brilliant surgeon was also a part-time painter, with a successful exhibition to his credit in 1935. He was attracted both by Brandtner's anti-fascist politics, and by his use of expressive symbolism in art. After the show's opening Bethune, Brandtner and another Montreal artist, *Marian Scott*, together founded a Children's Art Centre, which under Brandtner's and Marian Scott's direction continued to offer art classes to the children of workers and the unemployed in Montreal until 1950. When Montreal fascists broke into Bethune's apartment in 1936, it was his collection of children's art that they destroyed.

The Canadian League against War and Fascism was only one of the organizations in which Communists, socialists and others alert to the dangers of fascism could unite. The main cultural voice of this "popular front" was a magazine called *New Frontier*, founded early in 1936. Brandtner joined its editorial board, and reproduced some of his gas mask drawings.

After July of that year, the movement had a new battle-field to concentrate on. Aided by Hitler and Mussolini, Spanish general Francisco Franco and his fascist Falange were subjugating Spain, raising a military revolt against the elected Republican government. The Soviet Union and Mexico were the only two countries to come to the aid of

the Spanish republic. Canada and the U.S. placed embargoes against the shipment of arms to the Spanish people.

Charles Comfort was one of a distinguished group of Canadian cultural leaders who contributed to a special issue of *New Frontier*, condemning the fascists and speaking out in support of a democratic Spain. A Committee to Aid Spanish Democracy was formed. Dr Bethune joined it, and set out on his historic mission to save the lives of anti-fascist fighters all over the world.

Bethune wrote back to *New Frontier* that he was "afraid of the banality of words;" only an art that was "the legitimate and recognizable child of experience," he said, could do justice to the heroism he saw around him in Spain. He continued:

"The function of the artist is to disturb. His duty is to arouse the sleepers, to shake the complacent pillars of the world. He reminds the world of its dark ancestry, shows the world its present, and points the way to its new birth. He is at once the product and preceptor of his time. After his passage we are troubled and made unsure of our too-easily-accepted realities. He makes uneasy the static, the set and the still. In a world terrified of change, he preaches revolution—the principle of life. He is an agitator, a disturber of the peace—quick, impatient, positive, restless and disquieting. He is the creative spirit working in the soul of man."

Thus from Madrid under siege, from the midst of a life-and-death struggle against fascism, came an impassioned

statement of the role of the artist in society. Bethune matched his words with more deeds. His revolutionary blood-transfusion service now operating smoothly, he had a documentary film made, and embarked on a lecture tour of Canada and the U.S., aimed at breaking the embargoes against arms shipments. A workers' parade welcomed him to Toronto, including a contingent from the Artists' Union, bearing huge mock pencils like rifles over their shoulders.

Dr Bethune was not the only contribution Canada made to the Spanish anti-fascist cause. In addition to Canadians who fought in the British and U.S. international brigades, 1239 volunteers (five times larger than the U.S. contingent in proportion to population) insisted on forming a Canadian battalion, despite the Americans' opposition, and proudly called it The Mackenzie-Papineau Battalion. Just 100 years after the revolution of 1837, they were upholding the tradition of the patriotic and pro-democratic struggles of the Canadian and Québécois people.

Only 646 of these volunteers returned to Canada. When they did, early in 1939, 10,000 people mobbed Toronto's Union Station to welcome them. A rally sponsored by the Friends of the Mackenzie-Papineau Battalion (Fig. 171) included huge portrait sketches of four of their outstanding heroes, and a great banner proclaiming "They Died that Democracy Shall Not Perish," "In Defending Spain—They Defend Canada," and "The Spirit of 1837 Lives On."

The remarkable large portrait sketches, along with the silhouette of the marching battalion, portraits of Mackenzie and Papineau, and the symbol of the raised fist over a map of Spain and the red star, were painted by *Avrom Yanofsky* and other members of the Artists' Branch of the Communist Party. At far right is battalion commander *Major Edward Cecil Smith*, a former contributor to *Masses* who was famous for having broken up an entire fascist division's cavalry charge at Teruel with just his headquarters staff and three machine guns. Second from left is *Ivor ("Tiny") Anderson*, a Communist miner and union organizer from Vancouver who had saved many lives when the Canadian contingent's ship was blown up by an Italian submarine off Barcelona, but who died along the Ebro River. At far left is *Niilo Makela*, one of the many Finnish-speaking Canadians from northern Ontario mines and lumber camps who served in the machine-gun companies; so beloved was Makela of his comrades that news of his death in battle had to be kept from them until after the engagement was over.

These six-foot posters of 1939, now lost, are the only known paintings of our heroes of the war against fascism in Spain. Before any others could be painted, the world war they had fought to prevent had broken out.

WORLD WAR II

While Miller Brittain was earning a Distinguished Flying Cross by flying 37 missions as a bomb-aimer over Germany, *Jack Humphrey*, who was 38 when the war broke out, remained in Saint John and contributed to the war effort with paintings like his heroic portrait of *A Canadian Sailor* (Fig. 172).

Fig. 172: Jack Humphrey (1901-67), *A Canadian Sailor* early 1940s, oil on plywood, 30" x 23 7/8", Canadian War Museum

Humphrey had studied cubist and expressionist styles of painting in the U.S. and Europe, and worked out a variety of American regionalism in his paintings of Saint John streets. But he was never better than in the straightforward realism of his portraits.

Canadian workers were building corvettes to protect the convoys of ships taking men and materials across the Atlantic. Thousands of other Canadians like this young seaman were stationed in Saint John and Halifax between tours of duty in the tough little boats. In this simple but moving portrait painted on a plywood panel, Humphrey has recorded his homage to all these sailors, posing his sitter before the open sea wth just the "HMCS" portion of his hatband showing, so that we do not identify him with any particular ship but with them all. The light falls full on the youthful hero's face, as he looks up to a bright sky with the glint of life in his eyes and the assurance of battle-tested courage in his bearing. Humphrey was probably unaware of Robert Field's romantic and very British picture of our first naval hero *Lieutenant Provo William Parry Wallis* (Fig. 78) of the War of 1812-14, but his portrait of a representative able-bodied seaman is a modern, democratic, Canadian equivalent to it.

Humphrey also painted Saint John workers *Building Ships for the Merchant Navy* (Fig. 173). On this canvas he organizes the activities of seven workers, showing their inter-relation against another ship in progress behind them. Humphrey's strong sense of colour and sure grasp of spatial

Fig. 173: Jack Humphrey, *Building Ships for the Merchant Navy,* 1944
oil, 30″ x 42″, Mrs. Jack Humphrey, St. John, New Brunswick.

structure are due to his expressionist and cubist training; but his choice of subject matter is most significant here.

A healthy merchant marine is one sure sign of an independent nation. The glaring absence of a merchant fleet in this colony with its long coastlines has helped to impoverish our Atlantic ports, especially Saint John and Halifax, since the last days of the wooden ships. As a life-long Maritimer, Humphrey knew how important the construction of this merchant fleet was; as an artist with respect for other working people's accomplishments, he paints this group of riveters and welders with considerable warmth of feeling. He could hardly anticipate that our postwar government would rapidly dismantle our merchant marine, and place all our exports under U.S. foreign policy requirements. To Humphrey in 1944, the workers' achievement in rapidly building this fleet of ships must have seemed promising.

As in every war since 1812, Canadians were growing in our sense of pride as a nation in combat. Many artists wanted to paint pictures like Humphrey's, and wrote to Ottawa offering to serve as war artists.

In June of 1941, over 150 artists from across the country met at Queen's University in the first national Canadian Artists' Conference, known as the Kingston Conference. They reviewed the lessons of the Depression in the need for patronage, called for a more central position for the artist in Canadian life, took steps to expand *Maritime Art* into *Canadian Art* magazine, and constituted themselves as the nucleus of a new organization, The Federation of Canadian Artists. One of the Federation's first priorities was to press for a war art programme. Within a year over a thousand FCA members and supporters signed a petition calling for war art commissions.

The National Gallery commissioned a few painters, but the cabinet still refused. Prime-Minister Mackenzie-King, that old Rockefeller employee, was using the continental defence treaty (precursor of NORAD) to bring in a massive "American Army of Occupation," as Canadians called the U.S. Army engineers and technicians who swarmed into our northland. Mackenzie-King's sidekick, the U.S.-born C.D. Howe, was using the defence production sharing agreements to see that U.S. corporation branch plants profited most from wartime production. Both of these sell-outs intended to continue this extension of the U.S. takeover of Canada after the war, so they were anxious to avoid manifestations of patriotism similar to those that had accompanied the heroism of Canadian soldiers in World War I.

To this end, Mackenzie-King refused to demand any voice for Canada in the Allied councils of war. He went along with the scandalous presentation of Canadian soldiers as "Anglo-American forces" in reports from General Eisenhower's Supreme Allied Headquarters. And he delayed as long as possible such patriotic responses to the war as a Canadian war art project.

In December of 1941, *Paul Goranson,* a Vancouver commercial artist who had been one of Varley's outstanding students, managed to get accepted by the Air Force as an official service artist. Just as Frank Johnston in the First World War had painted views from the air over Lake Ontario at a training station near Beamsville (Fig. 126), so Goranson now recorded comparable training scenes over the same lake.

Splash Firing at Bombing and Gunnery School (Fig. 174) is a watercolour Goranson painted from sketches made in the air over Mountain View in Prince Edward County near Trenton, Ontario. Goranson is less impressed

with the panorama than Johnston was but he gives us a far more arresting, even startling, view down the spine of a Fairey Battle plane, with a rear gunner practising shooting at targets in the lake.

Mountain View was one of the 149 new airfields constructed, along with 73 old ones improved, as Canada's massive contribution to the British Commonwealth Air Training Plan. In all, 131,553 aircrew learned to fly, shoot and bomb in Canada, about 100,000 of them Canadian recruits to the RCAF. Goranson conveys a vivid sense of the excitement of this enormous training programme, which was to prove of inestimable value to the allied forces.

Like other graduates of Varley's classes, Goranson is a realist, recording every rivet on the fuselage as well as every rock on the sand below. The drama of his picture is enhanced by the diagonal tilt at which he has placed the plane, the intent concentration of the pilot in the lower right corner, and the shadow of the plane falling across the observation tower at the lower left. The painting is alive with action as the plane hurtles toward us, the gunner fires down and away, the waves roll in from the upper right corner, and a strong wind blows the flag and the windsock out to the lake. Goranson even catches the ripple of the wind in the tall grass and shrubs along the beach.

Goranson and a few others were attached to arms of the service, but not until January of 1943 did the cabinet finally give in to the popular demand for a war art pro-

gramme. When they did, there was a rush to volunteer. One of the first to go overseas was Charles Comfort, who later wrote about his experiences in his book *Artist at War*. Commissioned as a Major so that he could move freely from one headquarters to another, Comfort was sent first to England and then on to join the First Canadian Division in Italy.

Canadians had fought magnificently in the suicidal raid on the extremely well-fortified seaport of Dieppe in 1942. They were to add to the Canadian Army's proud record on D-Day, when they advanced further than any British or U.S. troops, and again in Normandy at Falaise, "the killing ground," where they dealt the Germans their most decisive defeat after Stalingrad. But the Canadian forces' most sustained fighting was in the Italian campaign, which began with a landing in Sicily in July, 1943.

Comfort joined them just as they were beginning their advance up the eastern side of the Italian peninsula, breaking the line that the Germans had intended to hold for the winter of 1943-44, and fighting their way through to the bloody, house-by-house capture of Ortona, one of the most vicious battles of the war. Then they were pulled back to the western front, where U.S. and British troops had failed to make similar advances, in order to tie up as many crack German divisions as possible in the months before the invasion of Normandy.

Comfort and *Lawren P. Harris* (son of the Group of

Fig. 174: Paul Goranson (born 1911), *Splash Firing at Bombing and Gunnery School*
1942, watercolour, 18 3/4'' x 22 3/4'', Canadian War Museum

Fig. 175: Charles Comfort, *The Hitler Line, 1944*
oil, 40″ x 48″, Canadian War Museum

Seven painter) sketched right along with them, often under fire. The Canadians advanced up the Liri River valley, smashing through all three ranks of the Adolf Hitler Line, which the Germans had thought impregnable. Comfort's *The Hitler Line* (Fig. 175) has been judged by the veterans as the painting that most accurately depicts "the way it was."

Painted in an over-all yellow-brown tone, Comfort's canvas shows the Canadian infantry in khaki with the bright red flashings on their shoulders, moving up through the Liri valley, with the dramatic mountains of southern Italy behind them, toward one of the series of fortifications that the Germans had erected to stop them. Guns at the ready, they push past a knocked-out *Panzertrum*, a fortified position with a 19-foot gun mounted on a turret, while behind them tanks advance through a horrendous artillery barrage.

In the foreground Comfort has placed at a converging diagonal the shattered limbs and trunk of a tree that have been part of the fortification. Its spreading splinters are a correlate for the explosions that are sending great billows of smoke into the sky across the field, and a symbol of the stubborn but yielding German defence. Comfort later commented that this was "the toughest battle Canadians had ever faced in any war." *The Hitler Line* is a forceful record of the courage of Canada's soldiers in the world war against fascism.

Comfort, Harris, Goranson, Brittain, Carl Schaefer, Goodridge Roberts, young *Alex Colville* and 27 others eventually served as official war artists, most of them stay-ing in uniform to complete their canvases in 1946. But one painter who had backed the idea of a War Records Collection from 1939 onward, who had helped to organize the Kingston conference, and was a founding member and executive officer of the Federation of Canadian Artists, was still unable to get a commission: he was *Frederick Taylor* of Montreal.

Born in 1906 into the wealthy home of Colonel Plunket B. Taylor in the ruling-class village of Rockcliffe in Ottawa, Frederick Taylor is the younger brother of the infamous millionaire E.P. Taylor. His family disapproved of his ambition to be an artist; he was required to graduate from McGill University in the more respectable discipline of architecture before he was allowed to study drawing and painting in England for three years in the mid-1930s.

After Taylor returned to Montreal in 1937, he was completely ostracized by his family. Not only had he become an artist, but he was an artist with obvious socialist sympathies. His close association with Communist and anti-fascist organizations was just too much for the Taylors.

Shortly after the war broke out, Frederick Taylor began writing to the National Gallery and other government offices with his own proposal for a war art project. Over a million men and women were involved in industrial production for the war, and the output of Canadian manufactured goods tripled from 1939 to 1944. Taylor wanted to go into the factories that were producing armaments and other war materials, and paint heroic portraits of workers with outstanding production records, as well as pictures of highly

Fig. 176: Frederick B. Taylor, (born 1906), *Applying the Tracks,* 1942
oil, 30″ x 33″, photograph courtesy of Agnes Etherington Art Centre

productive work teams in action. These, he suggested, could be used as posters and otherwise exhibited in factories and union halls to encourage an all-out effort to increase war production to defeat fascism.

Ottawa was not even willing to discuss the proposal. Although there had been some pictures painted of World War I industries as part of the Canadian War Memorials project, this comprador government wanted no part of paintings that would relate patriotism to the enormous productive might of the Canadian and Québécois working class.

Refused official backing, Taylor turned to his old family connections, and wheedled a pass to enter some war-production plants to sketch and paint. The Canadian Pacific Railway's Angus Shops in Montreal had been converted from locomotive to tank production. In 1942 Taylor sketched there, and produced a documentary painting of the process of *Applying the Tracks* (Fig. 176) to the cogs of a a Valentine tank. CPR officials were displeased with Taylor's painting because it showed men doing work that was supposed to be done by machines, and because it featured a tank that was said to be a 'death trap' and was shipped in great quantities to the Soviet Union, as part of the Allied capitalist countries' 'aid' to the Red Army. For precisely these reasons Taylor was drawn to this subject, and insisted on making a major painting from it.

The shapes and mass of the almost completed tank are a powerful presence in the locomotive shed. The long gun barrel glints in the mixed natural and artificial light. Behind the dark bulk of the tank, the long series of windows in the Angus shop opens up a high and wide space, and a gradually clearer light.

Off to the right stand the foreman and a superintendent, both trying to look as if they're doing something useful. But Taylor concentrates on the main productive force, the gang of workers who are pulling with all their might on the cable that draws the tracks through the cogs. By massing the shapes of their bodies around the end of the cable, he shows the team operating as a single cooperative unit. In fact, he has crowded them a bit too closely together, and doesn't really account for all of their bodies in the space available. But they function as an impressive concentration of human power, pitted against the resistance of the tank, making possible its forward movement, and bringing its latent power to life. The light falls full on the faces and limbs of the workers, contrasted with the sleek dark gleam of the tank.

Taylor was so struck by the power of this contrast and movement, and the larger meaning of this group of workers straining to complete another tank for the war effort, that he painted a larger canvas in which he concentrated on them alone. In this version (Fig. 177), the workers' tremen-

Fig. 177: Frederick Taylor, *Applying the Tracks, for Victory and After,* 1942
oil, 40'' x 32'', Canadian War Museum

dous surge of enthusiasm for the war effort comes at us directly, as the gang pulls along the diagonal of the rails in the factory floor. The figures of the workers, foreshortened by Taylor's viewpoint, make up an even more concentrated mass of muscular shapes embodying directed, intelligent human purpose. Again Taylor has crowded them a bit too closely together, and is vague about placing the rest of the bodies behind the leading figures. But the proletarian spirit and impact of the painting are undeniable.

The difference between these two versions again shows the distinction between documentary and social realism. The first painting gives us more information about the factory and the production line. But Taylor's second version brings out the heroism of the working class in the struggle for production, and in the war against fascism. Contrast the direction and expression of the leading worker's face in the two paintings: the first shows him concentrating his tremendous strength on the job of hauling the tracks through, looking down and away, with his hair falling onto his forehead slightly. In the second painting Taylor has changed this leading figure's orientation, so that he looks straight ahead, half grimacing with the strain and half smiling with confidence and pride in the ability of his work team to accomplish its great task.

Taylor was aware that the Angus Shops CPR workers were among the politically most advanced proletarians in Montreal at this time. They were at the core of the industrial union movement, which was chiefly responsible for the phenomenal increase of 100,000 members in Quebec's labour unions between 1942 and 1944. Taylor shows that these workers are also leading the way in war production, and that their solidarity and proletarian spirit are the basis for struggles to come. He added another title to his second painting: *For Victory and After*. "In it," he wrote, "I have succeeded in expressing *what* we all feel, and *how* we must go forward."

This remarkable artist was also concerned that his pictures should be seen by the people he painted them for. In all, he produced 114 drawings and 85 paintings of war production subjects from 1942 to 1945, an invaluable contribution to the realistic painting of the working people. He showed these works in factory lunch rooms, wherever management allowed him to exhibit as well as paint. He sent exhibitions to the Workers' Educational Association in Port Hope, Ontario, and to the Labour Arts Guild (successor to the Progressive Arts Club) in Vancouver. He even shipped a few paintings off to an international exhibition in Leningrad, arranged as a tribute to the people of that city for their stupendous defeat of the Nazis' 2 1/2-year siege.

Taylor's most important exhibition was the first show ever to be held in a Québec union hall. In 1944 he present-ed a survey of his war-production art in the meeting rooms of Lodge 712 of the "International" Association of Machinists (IAM). This was an aircraft workers' local, so Taylor featured paintings of aircraft production.

The workers were excited about the paintings; several commented that "It is important that these paintings should be in use." The local's executive proposed that the company buy them and hang them in the factory. When the company refused, the union raffled them off to the workers. A typical U.S.-run business union, the IAM apparently could not conceive of any more collective solution, such as the union buying them and sending them on tour to other locals.

Nevertheless, Taylor's example was important. For the first time, an artist was determined not only to paint the working class, but to exhibit and sell his art primarily to workers. Taylor wrote with obvious pleasure about the results:

"My experience in painting war industry completely explodes the widely held idea that art only concerns the privileged and the initiated. This idea, or myth, is that art is not for the people. It is false. Workers are quick to discern gold in the muck, quick to recognize that art and life are one, they are quick to learn and anxious and quick to broaden their intelligent appreciation of the said-to-be intangible which they find tangible and very good."

Taylor was especially happy with the response to *Applying the Tracks (For Victory and After)*. He liked to relate that seeing it "gave enough confidence to an inexperienced young woman to enable her to successfully complete the conduct of a meeting of workers which she was finding almost beyond her ability." Here is a painting that is definitely of *fight*, not plight.

Equally impressive are Taylor's heroic portraits of workers who had led in fulfilling wartime production goals. Intending his paintings to be used as posters, he lettered the words, "Serving on the Industrial Front" on most of them. The government refused to use them, so Taylor dispersed them through the unions and companies concerned. Some went to the workers who had sat for them. Most now have to be rediscovered.

A photograph of the IAM exhibition published in the Montreal *Standard* shows one of these portraits with the worker who posed for it. It appears to be a noble and striking canvas, depicting the dignity and strength of a textile worker who was using her many years of working experience to produce cloth for uniforms to further the cause of the world's people against fascism. Advancing together in the common struggle of the war, artist and worker here take a long step forward toward a people's art.

Abstraction and the Painting of People:
Canadian Painting Since 1945

"In no country is less consideration given to artistic matters than in Canada." So declared the Canadian Arts Council, a loose grouping of the Federation of Canadian Artists and 15 other national cultural organizations, in the *Brief Concerning the Cultural Aspects of Canadian Reconstruction* that they submitted to the House of Commons Committee on Postwar Reconstruction in 1944. The brief, supported by a delegation of artists, reviewed the problems of patronage, and called for massive government action in all areas as soon as the war was over.

In 1945 Canada had a great opportunity to fulfill the promise of our vastly increased industrial capacity. With factories, mines, shipping industry, communications and transport developed far beyond prewar expectations, we were certainly capable of building a country that could make a valuable contribution to the world.

Instead, the U.S.-born C.D. Howe, who was supposed to be in charge of postwar reconstruction, was actually supervising a policy of *deconstruction* of the Canadian economy. The reserve of U.S. dollars Canada had accumulated during the war was soon depleted, as U.S. corporation headquarters took $200-million out of our country in direct profits in 1946 alone. By 1947 a "dollar crisis" had developed, and the government announced the Abbott Plan, cutting back our imports from the U.S. temporarily, but subjugating our long-term export plans completely to the needs of the U.S. economy. As Conservative Member of Parliament Howard Green commented about the Plan:

> *"It shows an amazing subservience to the United States. One would think Canada was a subject country. No Canadian Government since Confederation has gone so far to take orders from another country."*

By 1948 Canadian-owned factories were being forced to close, but 1800 U.S.-owned branch plants were raking in profits. A year later, when the government finally got around to appointing millionaire patron Vincent Massey to convene a Royal Commission on National Development in the Arts, Letters and Sciences, the problem of U.S. control had to be added to the crisis in patronage.

The Massey Report, submitted in 1951, is a clear indication of how powerless the national bourgeoisie had become. From introduction to appendix the Report concentrates on the extent of U.S. domination of our culture. Detailed statistics on the proportion of U.S. radio programmes on Canadian stations are given, as well as the facts that the Carnegie Corporation had put over $7-million into Canadian cultural organizations from 1911 to 1950, and the Rockefeller Foundation almost $12-million from 1914 to the same date. "We must not be blind ... to the very present danger of permanent dependence," Massey warned.

The Report's chief recommendation was the creation of a government agency to fund cultural organizations. It also called for a new building for the National Gallery, and for more money and staff (then only 4!). These recommenda-

tions were implemented, beginning in 1953-54 with a series of travel grants to artists, then in 1957 with the creation of the Canada Council, initially with funding from a private bequest but soon drawing on public money for its grants. The National Gallery moved to a new and bigger location (though still only a converted office building) in 1960, and grew steadily in budget and personnel.

But this was the age of the rapidly accelerating U.S. takeover. Direct U.S. investment mounted from $4-billion in 1950 to $15-billion in 1965, largely financed by profits made from U.S.-owned operations in Canada. Even government figures admit that U.S. control of our manufacturing climbed from 39 per cent in 1948 to 46 per cent in 1963, and of our mining and smelting from 37 per cent to 52 per cent for the same dates. In 1953 Massey's own family firm was taken over by U.S. and British capital, becoming the Massey-Ferguson Corporation in 1958.

The U.S. takeover also engulfed Massey's national-bourgeois plans for our culture. Peter Dwyer, first director of the Canada Council, was British, and Alan Jarvis, a former sculptor who was appointed director of the National Gallery in 1955, had lived for many years in England. But they and their staffs and advisers were all mutually convinced that New York provided the only standard by which our artists should be judged. As Milton Acorn observes about such English 'gentlemen' in his poem *England*:

"Trained to administer colonies, they discover with surprise
There're so few colonies left the competition
Is so fierce it's like a river full of crocodiles –
　No other edible beast in sight:
So they come to Canada and other naive places
To administer the colonies of the American Empire."

Exhibitions, purchases, lecturers and publications presented one unanimous continentalist opinion; cultural bureaucrats agreed with comprador collectors, and encouraged petit-bourgeois patrons like doctors and lawyers to think and buy the same way. Instead of providing a bastion for our national culture as Massey had intended, government patronage systematically promoted our dependence on the U.S.A.

In 1952, one year after his Report came out, Massey was given the suitably hollow reward of being appointed our first Canadian (as opposed to British) Governor-General. The national bourgeoisie was reduced to the status of an irrelevant symbol of our 'independence' from the old British regime.

THREE PHASES OF U.S. ART SINCE 1945

There are three distinct phases of U.S. painting since World War II.			
Dates	**Phase**	**U.S. Presidents**	**U.S. Art**
1945-59	Expansive	Truman, Eisenhower	Abstract Expressionism or "Action Painting"
1960-63	Classic	Kennedy	Colour-Field Painting or "Post-Painterly Abstraction"
1963–?	Decadent	Johnson, Nixon	Pop Art, Op Art Conceptual Art, etc.

The art of the first 14 years may be called the *expansive* phase, paralleling a period in which, despite major setbacks in Asia and elsewhere, U.S. imperialism was generally extending and consolidating its economic, political and military control over much of the world. The art of the second phase is *classic*, reflecting a brief moment of confidence and optimism, during which it appeared that the U.S. empire had achieved a certain stability. But the art of the third phase has been openly and obviously *decadent*, as events from the U.S. defeat in Indochina to the Watergate hearings have laid bare both the international and internal contradictions of U.S. imperialism.

EXPANSIVE PHASE I, 1945-53:
THE COLD WAR, THE KOREAN WAR AND THE
FAILURE OF THE CANADIAN COMMUNIST PARTY

A newsvendor (Fig. 178), wearing a veteran's pin, hawks a Montreal *Gazette* on the street. In the crowd around him people look up as three jet bombers roar overhead. A little girl clutches her mother's skirt in fear.

One man pushes through the crowd to get a paper, another clenches his fist as he looks at the planes. A black man stares straight ahead, his features marked with bitterness. The last rays of a bright sun warm the faces of the people and the buildings, but the dark clouds are gathering fast.

Just as Frederick Taylor's *For Victory and After* expressed the optimism that many people felt in the struggle to win the world war against fascism, so his *Current Suspense* of 1951 conveys the tensions of the postwar years. Contrast the beaming confidence of the worker leading the team in *Applying the Tracks* with the anxiety-ridden face of the veteran selling the *Gazette*. The turmoil of people milling about in downtown Montreal is far from the purposive proletarian discipline that Taylor had painted in his Montreal factory scene only nine years before.

At that time, a grand alliance led by the Soviet Union and the United States was fighting fascism. Canada had friendly relations with our Soviet ally, and the United Nations was being formed, ostensibly to preserve world peace and prevent any resurgence of fascism. Just as World War I had resulted in the victory of socialism in one country, so the Second World War led to a number of countries in eastern Europe and Asia joining the socialist camp. National liberation struggles were immensely strengthened in Africa, Asia and Latin America. Vast areas of the Indian subcontinent gained their independence from a drastically weakened British empire.

But the U.S. was also enormously strengthened due to the war, and emerged as the sole imperialist power ranged against the growing forces of socialism and national liberation. In many countries U.S. neo-colonialism simply replaced British or French military rule. In 1947, desperate to shore up anti-Communist regimes in countries like Greece, Italy and France, where large Communist parties had successfully led anti-fascist resistance movements, the U.S. announced its Marshall Plan, whereby it would extend credit and thereby economic control, under the guise of foreign aid, to any governments (including fascist Spain) that would support U.S. foreign policy. The Canadian government tagged right along, subordinating our European trade to Marshall Plan policies, agreeing to continue the Permanent Joint Board of Defence under U.S. control, and in 1948-49 enthusiastically advocating and joining the military extension of the Marshall Plan, the North Atlantic Treaty Organization (NATO).

To wage its 'Cold War', the U.S. had to convince millions of people, both in the U.S. and around the world, that our former Soviet allies were now our worst enemies. Spy stories and trials became common. Especially in the U.S.-run labour unions, those all-important arms of U.S. imperialism controlling the working class, it was vital to identify, isolate and drive out Communists wherever possible.

When Taylor appealed for more union support for artists serving the working class in Communist publications like *The Canadian Tribune* and *National Affairs* in 1946, this campaign was already in high gear. It's not surprising that he had to turn to producing industrial scenes as advertisements for Algoma Steel.

These U.S. unions were hardly interested in patronizing

Fig. 178: Frederick Taylor, *Current Suspense,* 1951
oil, Dr Charles Lipton, Montreal

politically conscious artists. Taylor turned to sketching Montreal street scenes, and in 1948 held the first of a series of successful exhibitions in Montreal's Dominion Gallery. His patrons were increasingly from Westmount.

Yet U.S. imperialism was really, in Mao Tse-tung's phrase, "a paper tiger." In 1949 it suffered a momentous defeat when the Chinese Communist Party carried the national liberation struggle of the Chinese people through to victory. One quarter of the world's people was now free to begin the transition to socialism and the U.S. Navy had to throw up a blockade to protect what was left of Chiang Kai-shek's forces on Taiwan.

In 1950, when the People's Republic of Korea moved to reunify their country that had been divided by a wartime agreement, the U.S. desperately flung its army into the Korean peninsula under cover of a United Nations 'Collective Security' action. On the same excuse the comprador Canadian government committed a brigade of our professional soldiers, and Canada was at war again, but this time without the support of most Canadians.

It was at this critical moment that Taylor painted *Current Suspense*. After the U.S. had scored some initial successes and pushed up close to the Chinese border, hundreds of thousands of Chinese volunteers had rushed to

the aid of the Koreans, and threw the 'UN' forces back to the southern tip of the peninsula. A vanquished General Douglas MacArthur and other U.S. leaders were calling wildly for a retaliatory attack on China.

The threat of an atomic World War III, and the knowledge that we live under a government that might very well draw us into such a war on the side of U.S. imperialism against most of the world's people, is the basis for the anxiety in *Current Suspense*. Taylor shows how military might is now being used to control us, as the ominous British-made jets thunder overhead. These are the faces of people living in a captive state.

Still, Taylor's painting is not without hope: over the newsvendor's shoulder is the face of a worker, perhaps a railwayman wearing his distinctive cap, who looks grave but calm and determined. In 1950, 130,000 non-operating railway workers had carried out Canada's largest country-wide strike to date, before being forced back to work by the collusion of their U.S.-dominated union leaders with the government's specially drafted strike-breaking legislation. The Montreal *Gazette* had called for use of the War Measures' Act against the strikers because they were holding up materials needed in the U.S. for Korean War production. Taylor is careful to indicate the fact that a veteran from the world war against fascism is reduced to selling these papers that propagandize for the imperialists' war.

In the early 1950s Taylor was commissioned to do a few pictures of workers in the fur and leather industry by the 'International' Fur and Leather Workers' Union. The commissions may have been suggested by artist and fur worker Henry Orenstein, who had continued to work in the trade in Toronto since the late 1930s.

In Sudbury, the Mine, Mill and Smelter Workers' Union also took a step forward toward the kind of patronage Taylor had envisaged when the local commissioned Orenstein to decorate its union hall with a mural. Orenstein's painting (Fig. 179) is a realistic depiction of the slag heaps and devastated landscape around Sudbury caused by the mining operations of the International Nickel Company (INCO). It also shows the miners' families' determination to improve their polluted environment by including a woman working away in her garden in the blasted land.

But this mural and the fur workers' commissions remained isolated examples. In 1948 the United Steelworkers of America (USA) had managed to get the Mine, Mill and Smelter Workers thrown out of the 'Canadian' Congress of Labour, and in 1951 the Fur and Leather Workers were expelled too. Both unions had refused to support the Marshall Plan or the Korean War, and both had elected some leaders known to be Communists. By the mid-1950s the USA clearly had the imperialists' mandate to take control of Canada's workers in the vital mining and refining industries, and the leaders of the Canadian Mine, Mill locals had to commit all their energies and resources to fighting it.

Toronto artist *Alan Collier* began sketching in the gold mines of northern Ontario in 1951. Born in 1911, Collier

Fig. 179: Henry Orenstein, Mural, 1951-3, Sudbury Mine, Mill and Smelter Workers' Union Hall, Sudbury

Fig. 180: Alan Collier (born 1911), *Ore Car on the 2875-foot Level, Delnite Mine,* 1951, oil on board, 28 1/4" x 36", National Gallery of Canada

had worked as a miner during the Depression, and paintings like *Ore Car on the 2875-foot Level, Delnite Mine* (Fig. 180) accurately document the interior of a gold mine at Timmins.

But like Adrien Hébert in Québec in the 1920s, Collier concentrated on the powerful shapes and dramatic contrasts in texture, volume and light to be seen in his subjects. A miner is seen here, advancing along the tracks at the end of the shaft; but Collier's real interest is in the jagged frame created by the overhanging rock, the ore car casting its deep shadow to the left, and the tunnel snaking away to another pool of light in the distance. This preoccupation with composition and textural effects was entirely to the liking of Collier's patrons, who were not the unions but the mining companies. Collier's canvases, commissioned by a number of these corporations in the 1950s, were really just an underground extension of the 'empty landscape' formula, with the miners who earned huge profits for the gold speculators included only occasionally and incidentally.

The anti-Communist campaign, stirred to a new fever pitch by U.S. Senator Joe McCarthy, soon reached Canada's cultural organizations. In 1952 six musicians were fired from the Toronto Symphony Orchestra because the U.S. government had refused to allow them entry for a concert, on the grounds that they were Communists. A year later Toronto artist *William Newcombe* attacked Henry Orenstein as president of the Canadian Society of Graphic Arts, along with executive members *Avrom Yanofsky* and *Aba Bayefsky* for using political criteria rather than artistic ones in the selection of works for Society exhibitions, and for making Communist propaganda in their art.

Their response is revealing. Instead of replying "Yes, of course our art is political — all art is political," Orenstein and the others tried to duck the charges by appointing an 'impartial committee'. The committee dismissed the charges when Orenstein pointed to his work in that year's show, a

symbolic dove of peace like the one Picasso had painted a few years before, and to Bayefsky's picture of boys flying kites. Such subjects were lamentably typical of artists said to be associated with the Communist Party in those days, as was the impartial committee tactic.

Capitulation was equally evident in the Party's cultural publications. In 1952 Margaret Fairley announced in *New Frontiers*, a revival of the anti-fascist art and literary magazine of the 1930s, "We will build a consciousness of our own Canadian cultural achievements and seek to develop and enrich them." The new magazine protested the "flood of the cynical, degenerate products of U.S. commercialism," and warned that "we will lose our Canadian cultural identity if we don't fight for it." Yet Canada was not clearly identified as a U.S. colony. Full of protests and warnings, *New Frontiers* failed to offer the programme of action that people so desperately needed.

"For a Canadian people's culture in a world at peace", was the *New Frontiers* slogan. But the world was at war. Most Canadians, like most people everywhere, wanted peace; but real peace is impossible until imperialism is destroyed. By putting talk of 'peace' and 'unity' before anti-imperialist struggle, Canada's Communists were actually holding back any real progress toward peace and unity.

This betrayal of socialist principles is called *revisionism*. After 1956, revisionist leaders had taken over the Soviet Union and, under the cover of 'peaceful coexistence', had reintroduced capitalism and began to subvert revolutionary movements all over the world to their own increasingly imperialist aims. The Canadian Communist leaders applauded. With their peace doves and peace slogans they had even achieved the modest beginnings of revisionist art!

New Frontiers had far less influence than either *Masses* or the original *New Frontier* of the 1930s. By dissolving the Workers' Unity League and abandoning the fight for independent Canadian unions in 1935, the Party had cut itself off from its working-class base and prepared the way for its capitulation in the 1950s.

Fortunately, other Canadians were fighting in more principled ways. In the fall of 1952, just as General Eisenhower was announcing his "crusade" for the U.S. presidency, Ted Allan and Sidney Gordon of Toronto, two former associates of Dr Norman Bethune, brought out their biography of the great Canadian revolutionary *The Scalpel, The Sword*. It was a powerful antidote to the anti-Communist and anti-China propaganda. One Montreal reader, *Rita Briansky,* was inspired to produce one of the great paintings of heroism in our history, *Dr Norman Bethune in China* (Colour Plate XI).

Born in Poland in 1925, Rita Briansky had been brought to the northern Ontario paper-mill town of Iroquois Falls as a child. She moved to Montreal at the age of 16, and studied during the Second World War years under Alexandre Bercovitch, the leading painter of the Jewish community there. She was part of a circle around Bercovitch that included *Ernst Neumann*, who was best known for his prints of working people when he died in 1955 at the age of 48, and *Louis Muhlstock*, a painter of people from the Depression who continued to produce city scenes during

this period. Rita Briansky completed her studies first at the Montreal Ecole des Beaux Arts, then at the Art Students' League in New York, but it was from her roots among the working class of Iroquois Falls and Montreal that she responded so profoundly to the story of Bethune's life of service.

The incident she chose to illustrate is the dramatic moment in the Shansi village of Sheng Yin Kou in 1938 when Bethune successfully demonstrated blood transfusion. He had found that these brave peasants and villagers were afraid to give blood because they didn't understand transfusion. So he brought in an inert wounded soldier and lay down beside him, filling a bottle with his own blood. He showed that he was unharmed by the donation. Then, as Allan and Gordon describe it:

"With a sureness that had become a reflex action on the battlefields of Spain he inserted the needle into the soldier's forearm, taped it on securely, and stepped back, holding the bottle high.

Slowly the blood receded in the bottle. Everyone seemed to lean forward, to be pleading mutely for something to happen. Then the soldier's lips moved, he grunted, he opened his eyes, he raised his head, he looked about him uncertainly, he smiled.

A great shout rose from the crowd; a shout of joy, relief, awe and victory. . . ."

An old woman, like the ones the artist shows watching sceptically behind Bethune, came forward immediately to offer her blood. On the spot, Bethune organized the first Volunteer Blood Donor Corps in China, one of his many contributions that led Chinese troops to go into battle against the Japanese imperial army with his name on their lips.

Rita Briansky shows us the expectant scene of the villagers with a warmth of feeling in the gold-coloured sand and uniforms, and the red of the blood at the centre of the composition. The light falls full on the body of the wounded soldier, and on Bethune's face, which she painted from an old photograph (he actually grew a beard in China). For the villagers and soldiers, suitably enough, she asked friends and family to pose, and then added the rich colours of Chinese peasant costume. She has chosen a viewpoint from among the people, so that we are part of the watching and learning circle.

Dr Norman Bethune in China is an important painting in our new-democratic cultural heritage. It is national, celebrating one of our country's greatest heroes, and full of the spirit of true internationalism, based on respect for each nation's independence. It is scientific, realistically depicting Bethune's medical teaching, and showing why General Nieh Yung-Chen, his commander in China, called him "the scientist and revolutionary of the masses." And it is democratic, supporting the struggle for liberation of the Chinese peasants and workers, the same Chinese masses who were fighting the U.S. army in Korea at the time.

Like Miller Brittain's hospital mural cartoons, Rita Briansky's painting shows not just the plight of the wounded but the means by which people can fight back to

save lives. Bethune's system of blood transfusion in the field has been adopted by every modern army, and has been especially valuable to guerrilla forces like the Vietnamese.

No wonder this picture has been reproduced and widely distributed by the Chinese government! It is imbued with the spirit of struggle that many people feel after reading Bethune's life story. As Mao Tse-tung wrote in his essay *In Memory of Norman Bethune*, which is now studied by the Chinese people and many others all over the world:

"We must all learn the spirit of absolute selflessness from him. With this spirit everyone can be very useful to the people. A man's ability may be great or small, but if he has this spirit he is already noble-minded and pure, a man of moral integrity and above vulgar interests, a man who is of value to the people."

EXPANSIVE PHASE II, 1954-59:
ABSTRACT EXPRESSIONISM TAKES OVER
TORONTO

The Distant Early Warning (DEW) Line of radar stations was being erected across our northland to 'defend' the United States. U.S. profits were rolling down "Roads to Resources" paid for by Canadians. Oil and natural gas followed our ore and forest products south. Especially in Toronto, the compradors prospered. They and their intellectual servants formed the beginnings of a new patron class with a complacent belief in 'North American civilization' and the superiority of almost anything from the United States.

"Every damn tree in the country has been painted," Toronto artist *Graham Coughtry* grumbled in 1955. The 'empty landscape' tradition, which still dominated the Society exhibitions, was dead. By default, Canadian artists were being attracted to the one form of painting that would satisfy these continentalist patrons: U.S. abstraction.

Of course Canadians had painted non-representational canvases earlier. *Bertram Brooker*, a critic and painter who was a friend of Lawren Harris and a fellow admirer of Kandinsky's writings, had exhibited his abstractions as early as 1926 in Toronto and had propagandized for formalist painting in his newspaper columns and in the 1929 and 1936 editions of the *Yearbook of Canadian Art*. Lawren Harris had returned to Vancouver with his abstractions in 1940. L.L.FitzGerald, encouraged by Brooker, was making non-representational studies in Winnipeg by the early 1950s. And in Montreal the automatistes had been painting for almost a decade by this time, with Borduas' abstractions being shown in Toronto in solo and duo exhibitions from 1942 onward.

But only abstract art from New York received worldwide distribution and promotion. If colonial artists wanted to join in they would have to copy New York.

In 1947 a new teacher sympathetic to abstract expressionism began work at the Ontario College of Art in Toronto. J.W.G. (Jock) Macdonald, the Scottish-born designer and painter who had worked with Varley at the Vancouver School of Art and the B.C. College of Art during

Fig. 181: J.W.G. (Jock) Macdonald (1897-1960),
Thunder Clouds over Okanagan Lake, 1944-55
oil, 28″ x 34″, National Gallery of Canada

the 1930s, shared with Varley the conviction that art was essentially individual expression, and with Lawren Harris an admiration for Kandinsky. Just before coming to Toronto, after teaching for a year at the Provincial Institute of Technology and Art in Calgary, Macdonald had exhibited 36 abstract ink and watercolour studies in a solo show at the San Francisco Museum of Art.

But Macdonald was still pursuing his own version of the 'empty landscape,' as we can see in *Thunder Clouds over Okanagan Lake* (Fig. 181), completed in B.C. in 1945. This painting is plainly derived from a basic Group of Seven three-part composition: rocks and underbrush in the foreground, the lake reflecting light in the middle ground, and hills on the far shore as background. There is even a typical Group of Seven sapling blowing in the wind. Macdonald's modulation of tone and his romantic treatment of the mountains show Varley's continued influence; his attention to light values and cloud formations indicates the effect of Lawren Harris' late landscapes.

But the painting is enlivened by Macdonald's all-over fusing of colour and light, so that the light rolls in behind the mountain peak in the billowing clouds, shimmers across the lake to bathe the near shore, and leaps through the sky in strange flowing shapes between the storm clouds. Bold colour contrasts break across the canvas equally unpredictably. Macdonald had been strongly impressed by the paintings of Emily Carr; without approaching the profound content of her landscapes, he draws heavily on her expressive treatment of colour and light.

After his first year of teaching in Toronto, Macdonald attended the summer painting school at Provincetown, Massachusetts. It was operated by New York abstract expressionist *Hans Hofmann,* who had brought from Germany a combination of cubism and expressionism, and who taught the use of colour in space in a way closely analogous to what Macdonald would eventually adopt. In 1949 Mac-

donald returned for a second summer session. In 1954 he used an overseas travel grant (one of the results of the Massey Commission) to work in the south of France, where he was encouraged by *Jean Dubuffet,* a latter-day leader of the rapidly degenerating School of Paris.

Like Borduas, Macdonald gathered around him a group of students in whom he encouraged a similar commitment to individual self-expression in art, and whom he taught to look to Manhattan. The pupil who learned his lessons best was *William Ronald,* who had been born William Smith in Stratford, Ontario in 1926 but used his middle name for professional purposes. Even before graduation from the Ontario College of Art in 1952, Ronald had taken Macdonald's advice and gone to New York to visit the galleries and take classes from Hans Hofmann. He returned to Toronto determined to do something about the almost complete lack of patronage for abstract art.

Only in the late 1940s had the New York market begun to boom. Now Toronto had a few years' catching up to do. In 1948 the Women's Committee of the Art Gallery of Toronto (now Ontario) had started an annual sale of contemporary Canadian paintings, but this was hardly enough. In the fall of 1952 *Alexandra Luke,* an older painter who had also studied under Hofmann and had married into the General Motors sell-out family of McLaughlins in Oshawa, used her influence to get the YWCA gallery there to hold the *First Canadian Abstract Exhibition.* It toured southern Ontario galleries in smaller cities, but in Toronto was shown only at the Hart House Gallery at the University of Toronto. The one commercial gallery that would risk showing abstract art was Douglas Duncan's Picture Loan Society. But Ronald was thinking on a much bigger scale.

The designers at Simpsons department store, where Ronald had been working, were concerned in the furniture department to sell 'style' — to persuade people to buy just to 'keep up to date.' In 1953 Ronald recognized that this was the ideal setting for the new luxury commodity, abstract art. The designers themselves were 'keeping up' by reading U.S. magazines such as *Life,* which carried features on New York art. So Ronald had little difficulty persuading them to hang abstract paintings in their modern furniture displays. Advertised as *Abstracts at Home* in full-page newspaper ads, the exhibition featured paintings by Ronald, Alexandra Luke, *Kazuo Nakamura, Ray Mead, Oscar Cahèn, Tom Hodgson,* and *Jack Bush.* Ronald was hung with Danish Modern.

Although most of these exhibitors hadn't known each other before, they now realized that their best hope for patronage lay in organization. Alexandra Luke hosted a meeting in her Oshawa studio overlooking Lake Ontario. In addition to the Simpsons group, *Harold Town,* who had made his first sale of an abstract painting that year for $150, came along, as did Jock Macdonald, *Walter Yarwood,* and *Hortense Gordon* from Hamilton. *Painters Eleven* was formed that night.

Like the Group of Seven, most of these painters began with commercial art. But the nature of this business had clearly changed since the days of Grip and Brigden's: its old

national-bourgeois character was gone, and it was now firmly tied in with the ideas and values of Madison Avenue.

As advertisers, they were intensely conscious of their 'image' and were able to establish good contacts with the press and broadcasters. The Simpsons show had given them excellent publicity, but the 11 painters now agreed that they needed to upgrade their luxury commodities with the 'fine-art' prestige of a commercial gallery.

Jack Bush was the only one who had a contract to exhibit his paintings. Bush managed to convince his dealer, the otherwise conservative Roberts Gallery, to hold the first Painters Eleven exhibition in February, 1954. Although sales were few, the opening was a great success, and the first two weeks broke the gallery's attendance records. The Roberts Gallery owners were delighted. They repeated the show in 1955, and followed it with a small-pictures exhibition (since larger pictures weren't selling) in 1956.

The 1955 Painters Eleven catalogue admitted that "By now there is little harmony in the noticeable disagreement." Painters Eleven was not a unified body of friends as the Group of Seven had been. Even their name suggests that they were simply a collection of self-seeking individualists, gathered together to create a market for their art.

"There is no manifesto here for the times," their 1955 statement insisted. Following the lead of the New York artists, Painters Eleven claimed to be concerned with self-expression alone, and repudiated any association with either the patriotic statements of the Group of Seven, or the social commitment of a *Refus Global*. Of course their first exhibition in 1954 was just as much a reflection of the times as the establishment in that year of the Continental Air Defence Command, which subjected Canada's forces to direct orders from the Pentagon.

"There is no jury but time," they wrote. But in fact, 'time' as such is never a 'jury.' People make judgments about paintings in time, and their judgments reflect their class interests. For bourgeois and petit-bourgeois collectors, an important new trend had been started. In 1954 Harold Town held his first solo show; in 1955 Avrom Isaacs opened his Greenwich Gallery (now the Isaacs Gallery), featuring Ronald and four others in his first show; and in 1956 a Gallery of Contemporary Art was added to the local market.

William Ronald, whose *In Dawn the Heart* had been the hit of the 1954 show, was no longer even living in Toronto. In 1955 he moved to New York, where he was at first enormously successful. In 1956 he was awarded a Guggenheim Fellowship. By April of that year he had already interested the executive of the American Abstract Artists group enough that they invited Painters Eleven to show in their annual exhibition in New York's Riverdale Museum. The colonials were well displayed and generously reviewed. Ronald especially was featured, and a typical rich Manhattan collector, the Countess Ingeborg de Beausac, took a liking to his work. She introduced him to the dealer Samuel Kootz, and by April of 1957 Ronald was enjoying his first solo exhibition in New York. He had signed a contract to produce 18 major paintings a year for exhibi-

tion and sale with the Kootz Gallery, one of the leading commercial galleries in Manhattan at that time.

The messy but vehement canvases which established Ronald's reputation in these years were not markedly different from hundreds of paintings being produced by a whole generation of U.S. artists gathered in New York during the late 1950s. They all followed a fairly simple format: standing before a five-foot or six-foot squarish canvas, Ronald would brush in a big squarish shape in the centre, contrasting it strongly in colour, texture and light values to a more finely-brushed, brighter-hued rectangle all around. With a few darker horizontal and vertical strokes he would give it a grid-like geometric structure, the kind of composition that was praised by New York critic Harold Rosenberg as a 'scaffolding' on which the 'gestures' of the action painter could be displayed as bold brushstrokes.

These were really gestures of defiance of the oppression that people were experiencing in the latter days of the Cold War, not unlike the rock-and-roll music that was becoming popular at the same time. But like all decadent art forms, action painting stressed style and technique. It appealed to the consciences and pocketbooks of rich U.S. liberals who supported empty gesture-making, as long as it didn't threaten them.

Ronald's first exhibition opening in 1957 was a great triumph for his old teacher, Jock Macdonald. "It was everything Jock and I had talked about coming true," Ronald said. Some friends gave Macdonald the money to fly down for the event, where he met leading New York painters and the critic who was Harold Rosenberg's chief rival, Clement Greenberg. This agent for U.S. painting proposed that the Painters Eleven invite him to Toronto, to tell them how well they measured up. Even though he made more from one lecture or article than most of the Painters Eleven had earned from their sales in the entire past year, Greenberg suggested that his trip should be at their expense!

Harold Town and Walter Yarwood refused to pay the tribute money. Yarwood was soon to become a sculptor rather than a painter, but Town had his own reasons. He insisted that Ronald had disqualified himself from the group's usual sharing of expenses by moving to New York, and demanded that Ronald pay his own shipping expenses to another Painters Eleven show at the Park Gallery, the latest addition to Toronto's fast-growing art market. Ronald replied by resigning from Painters Eleven.

Town's attitude was not entirely due to patriotic zeal. He was just as committed to U.S. abstract expressionism as Ronald was, but he wanted to develop his own colonial version in Toronto. By now he was Toronto's best-known painter, thanks to his public-relations skills, and he was openly vying with Ronald for honours. In 1956 it was Town who exhibited at the Venice Biennale, and by 1957 he was already selling well enough to quit commercial art and begin working full-time at his painting and print-making.

It is entirely fitting that in 1958 Town was awarded the commission to embellish the St Lawrence Seaway with a

Fig. 182: Jock Macdonald, *All things Prevail,* 1960
oil, 42" x 48", National Gallery of Canada

huge abstract mural in the Robert H. Saunders Generating Station near Cornwall. The Seaway had been a dream of Canadians as far back as the days of William Lyon Mackenzie, and its construction is a great achievement of Canadian and Québécois workers, paid for almost entirely by our taxes. But since Canada is still a colony, this vital waterway could only be realized when it became a U.S. priority as well, principally to replace Minnesota's depleted iron resources with ore from the Ungava peninsula in the steel mills of Cleveland and Buffalo. The only reward still more suitable that Town has attained in the 1960s and '70s is his series of successful exhibitions at the Sears, Roebuck galleries in the largest provincial city in the United States — Chicago.

Town's refusal to pay Greenberg's fare, like his moving into the Group of Seven's old Studio Building, and his comparisons of his colour and texture to those of Tom Thomson, are all just the saleable cultural-nationalist poses of an artist who is really a sell-out. He is today the darling of the Art Gallery of Ontario Women's Committee and all right-thinking Rosedale matrons.

Jock Macdonald and Jack Bush stuck to New York. In 1957 Greenberg made his historic visit to Toronto, restricting himself to the artists who had paid up. Macdonald's letter to a friend in Calgary relating the visit reveals the cringing colonial to be found within this gifted artist and teacher:

"At long last I am really on the road — so says Clement Greenberg . . . he told me that my new work was a tremendous step forward, in the right direction, completely my own and would stand up with anything in New York."

This is the same line that the Parisian critic Francois Thiebault-Sisson had given to Maurice Cullen in 1895 when he urged him to stay in Paris "until you are fully master of yourself." The demanding discipline of the imperial centre's style is always presented as something "completely your own;" the critic insidiously appeals to the weakest side of the artist in the colony, his self-concern.

Cullen rejected Thiebault-Sisson's advice; Macdonald took Greenberg's very seriously. "The step forward", he explained to his friend in Calgary, "is through my being able to free myself from the canvas limitations — or what he (Greenberg) calls 'the box'."

'The box' is a typical example of the jargon of U.S. criticism. By 'the box' Greenberg meant the last vestiges of representational painting, the shallow three-dimensional illusion that even the late Cubists had retained in semi-abstract works like Pellan's *La Bouche Rieuse* (Fig. 143). Greenberg now urged artists to "kick out all six sides of the box," and thereby 'free' themselves from the 'limitations' of the canvas. To artists like Macdonald whose real limitation was their colonial mentality, this metaphysical

nonsense about transcending limitations was impressive: it was promoted by Greenberg as the ultimate conclusion of the art of individual self-expression.

Greenberg was on his way to evolving the theory of colour-field painting, the ideology of the next phase of U.S. art, the classic. The only way to 'express yourself', according to this theory, was to eliminate even an abstract reference to actual three-dimensional space, and to paint exclusively in terms of colour on canvas. Paintings were to lose their last shred of pictorial reference to the world, and to become nothing but large, portable and very expensive commodities for investment and speculation.

Like the impressionist and cubist theories of art before it, this latest advance in formalism had a superficial scientific appeal. It is literally true that paintings as commodities are nothing but colour on canvas. This new approach seemed to be more basic, more honest, and therefore promised more 'profound' self-expression.

All Things Prevail (Fig. 182), painted shortly before Macdonald's death from a heart attack in 1960, shows us how he tried to follow Greenberg's advice. Of course it is impossible for an artist to 'free himself' from the 'limitations' of his canvas, which is the material support of his painting; but he can create the *appearance* of doing so by painting abstract forms that seem to float in a space that looks as if it continues beyond the edges of the canvas. This is the same 'universal' space that Borduas was using in works like *L'Etoile Noire* (Fig. 149); it is the abstract expression of the global ambition of U.S. imperialism, the spatial claim of Strategic Air Command.

What Macdonald actually does in *All Things Prevail* is to take the formal qualities of paintings like *Thunder Clouds over Okanagan Lake* (Fig. 181), and isolate or abstract them from the landscape. Since Macdonald had originally derived these formal properties from the art of Emily Carr, Fred Varley and Lawren Harris, and since they reflect the Canadian landscape tradition so strongly, it is not surprising that Macdonald's last works have a certain authenticity. Although there is never a clear statement of struggle in nature or in life, we do sense a fuzzy, rather diffuse notion of the interplay of natural forces in Macdonald's late paintings. We have passed from the 'empty landscape' formula to an *abstract landscape* painting based on U.S. art.

This abstract notion of struggle, without any one side 'prevailing,' is the very essence of liberal continentalist idealism, the same idealism that refuses to acknowledge the colonial implications of U.S. control of our country. An inspiring teacher for many, Macdonald believed to the end that *All Things Prevail*. But in reality, as Clement Greenberg proved to him, only one side or the other prevails.

CLASSIC PHASE I:
COLOUR-FIELD PAINTING

Macdonald and Borduas died just as the upside-down pyramid of the New York art market was shifting. But William Ronald was still in Manhattan.

Overnight, the bottom fell out of Ronald's market. In 1962, he held his last Kootz Gallery show. In 1963 he tried unsuccessfully to alter his style, and even took out U.S. citizenship. But it was no use. In 1965, a victim of what amounted to a shut-down in one branch of imperialism's culture industry, Ronald came limping home to Toronto. There he has remained, primarily as a radio and TV performer, pathetically tied to his continentalist convictions and liberal pro-American sentiments: the enormous abstract mural he painted for Ottawa's National Arts Centre is entitled *Tribute to Robert F. Kennedy*!

In Toronto, the market for abstract expressionism was just beginning to peak. In 1961 Harold Town sold out a big show of paintings at the Laing Gallery, and stockbroker Sam Zacks and his wife Ayala bought 18 major works on a single day's tour of the now flourishing commercial galleries. *Maclean's* magazine published a cover story on "The Bull Market in Modern Painting." Robert Fulford, leading critic of the day, proudly told a U.S. university audience during a 1961 guest lecture:

"In Toronto, rather belatedly, art has become fashionable. As a dealer told me recently, 'there's a whole new class buying art. When they get the house furnished and they get the expensive car and the expensive appliances, they decide what they need next is art.'"

These new patrons, mostly doctors and lawyers, adopted the comprador outlook of their wealthiest bourgeois clients. Painters Eleven had officially disbanded in 1960, but a whole 'second generation' of abstract expressionist painters, with their headquarters in the Isaacs Gallery, had grown up to supply the new market. Some, like *Richard Gorman* and William Ronald's younger brother *John Meredith*, maintained the intensity of the action painters, but planned each brushstroke more carefully in terms of an over-all composition; others, like *Tony Urquhart, Gershon Iskowitz* and *Gordon Rayner*, were exploring the relationships between abstraction and landscape forms that Jock Macdonald had opened up.

This 'abstract landscape' painting was beginning to develop into a minor colonial school of abstract expressionism. In Vancouver, with only a shadow of Toronto's patronage, *Jack Shadbolt, Gordon Smith, Toni Onley,* and *Takao Tanabe* were painting variants in this manner. In Saint John, Jack Humphrey was basing his canvases on his intimate experience of the New Brunswick woods, starting with landscape forms and then making them abstract.

None of this art, however passionately felt and powerfully executed, accorded with the new mood in Manhattan.

The tensions of the Cold War had somewhat relaxed. U.S. President John Kennedy proclaimed a 'New Frontier'. Cuba had just broken out of the Eagle's grasp, but U.S. neo-colonial policies seemed to be working well enough in the rest of Latin America, Africa and Asia. Caretaker governments in Canada had implemented the North Atlantic Defence Agreement (NORAD) in 1957, signed a Continental Defence Production Pact in 1959, and handed over invaluable water and power resources to the U.S. by the Columbia River Treaty of 1961.

New York critic Clement Greenberg articulated the new mood of confidence in *Art and Culture*, published in 1961. Although it was only a collection of articles dating back over twenty years, it was just what U.S. artists and collectors now wanted to read. From his beginnings as a Trotskyite advocate of art as individual self-expression in the late 1930s and early '40s, Greenberg had evolved a full-scale historical argument for the supremacy of what he called "American-style painting," documenting and justifying the transfer of the world art centre from Paris to New York. For this doctrine of 'manifest destiny', Greenberg was elevated far above Harold Rosenberg as the leading U.S. art critic.

Only one Toronto painter had kept in touch with Greenberg after his 1957 Painters Eleven visit. Jack Bush, then 48 years old, had taken Greenberg's criticisms even more seriously than Macdonald. Always an adept follower, he had begun as an 'empty landscape' formula painter, then tried to apply U.S. regionalist ideas to small-town Ontario subject matter. In the 1950s he had adopted the gestural manners of abstract expressionism so slavishly that Greenberg had ridiculed him for it.

But Greenberg had also praised some of Bush's watercolour studies, suggested he transfer the ideas behind them to canvas, and invited Bush to visit him in New York. Bush jumped at his chance. He began to paint works that were quieter in tone, without the strident brush strokes of the action painters, marking the surface only with smudges of colour, and gradually eliminating variations in texture. He also went to visit Greenberg, and the galleries and studios Greenberg recommended.

Bush was discovering the classic phase of U.S. abstract painting. A group of artists in New York and Washington, D.C. had begun using Jackson Pollock's notion of splashing paint directly onto canvas in a more disciplined and systematic way. *Morris Louis* stained long streamers of colour into his large, unprimed canvases, leaving the rest of them untouched. *Kenneth Noland* at first simply centred his colours in concentric circles, then stained bands of colour in chevrons, leaving raw canvas between each band. *Jules Olitski* used more irregular formats, but was also staining his pigments directly into huge canvases.

Bush learned to follow the recipe exactly. His smudges became artfully careless stripes, diagonals or rectangles, all adroitly balanced. Occasionally he adds a few touches of the brush here and there, but for the most part he leaves the flat, matte surface of acrylic paint stained into raw canvas, for a lush, decorative effect. This is *colour-field painting*: art reduced to the inter-relation of carefully modulated tones, arranged like a lipstick sample display.

Just as formalist tendencies had increasingly characterized the art of imperialism since the days of James Wilson Morrice in Paris, so these painters and their critics in the last brief period of confidence in U.S. imperialism were bringing formalist painting to its ultimate, empty conclusion. Greenberg pointed out that Claude Monet had begun this kind of painting with his enormous impressionist studies of colour and light in a pool of water lilies, and Henri Matisse had taken it much farther with large, flat

areas of colour in his later works. Now it was up to U.S. painters to 'advance' the French discoveries still farther, by staining colour directly into the canvas in simple, classically austere formats.

Each stylistic innovation is hailed as a 'breakthrough' and painting is said to have 'advanced' to a new level. Noland's chevrons automatically make instant art history out of his previous year's circle formats, and his subsequent stripe paintings in turn inflate the prices of his chevrons, as they too become 'historical.' The art market begins to look more and more like Detroit, with its annual 'revolutions' in automobile design. It is worth noting that this theory of the avant-garde, in one version or another, backed up what was the tenth largest industry in New York City, the art market.

Always painted on a large scale, most of these canvases look best in public galleries and museums, which function as security banks for art investors. And since they have neither ground nor texture, these paintings can be rolled up like a carpet for easy storage and shipping, to be re-stretched onto a framework built especially to fit a wealthy patron's wall.

With Greenberg acting as his agent, it is not surprising that Bush has been a success in the New York art market. In 1962, New York dealer Robert Elkon consulted Greenberg before opening his new gallery, and Greenberg recommended Bush.

Of course Bush's paintings are suitably modest examples of this school. Far from indicating any avant-garde, they are safe, conservative, confectionery. The U.S. painter Noland has produced bands of colour so long that a viewer standing at the middle of the painting can hardly see both ends, but the colonial Bush is always more refined, more gentle, just as Morrice was in his day. Bush has even based one series of polite paintings on the pattern of a green tie box wrapped with a red ribbon that he received as a Christmas gift!

In 1963 David Mirvish, son of a wealthy, Toronto retailer, opened a gallery that soon became a colonial headquarters for the new U.S. line. Mirvish has the capital to buy his paintings outright, instead of accepting deliveries on consignment from New York, so he can afford to buy judiciously, allow his purchases to accumulate some 'history' and then re-sell at a handsome profit to buyers in U.S. provincial cities, as well as to Canadians. Jack Bush is one of the very few Canadian artists Mirvish deigns to show.

Bush has gone on to a series of U.S. galleries, and now exhibits with a cartel based in New York and London, England. Still living in Toronto, he was 58 before he could quit commercial art for full-time painting. But he has outlasted and outreached much younger competition such as Riopelle, Ronald and Town, and is today without question Canada's leading comprador artist, a fitting heir to the mantle of Morrice.

CLASSIC PHASE II:
RE-TOOLING THE CULTURAL BRANCH PLANT

Most Canadian artists, especially outside Toronto, remained only dimly aware of the new direction in U.S. painting. The colony had fallen behind, and had to be 're-tooled' for the new art production line.

Saskatchewan provided the model branch plant for this re-tooling. In 1944 the farmers and workers of that province had elected the Co-operative Commonwealth Federation (CCF). Although this government was strongly supported for its badly needed social welfare measures, it also brought to Saskatchewan's educational and cultural institutions a left-liberal, continentalist outlook. Especially during the McCarthy period, many U.S. liberals and social-democrats were drawn to the province, some being offered key jobs in the university or the provincial administration.

In 1950 American artist *Eli Bornstein* came to the University of Saskatchewan in Saskatoon from Milwaukee, where he had been teaching a design course. He produced geometric reliefs in a three-dimensional grid manner that he called *structurism*. This was really just a revival of the more abstract ideas of the Russian constructivists, but by influencing a small number of his students Bornstein has managed to create a minor 'school' in this style. In 1960 he brought out a magazine called *The Structurist*, and three years later was appointed chairman of the art department on the Saskatoon campus. He continues to make most of his sales through commercial galleries in Chicago.

But it was the Regina campus of the university that was to be the real centre of the U.S. invasion. In 1955, *Arthur McKay*, an art teacher at Regina who had studied under Jock Macdonald in Calgary, and *Kenneth Lochhead*, his department chairman, began an annual series of two-week study sessions following a summer painting school operated by the university at Emma Lake, north of Prince Albert. For the first two years Lochhead invited Canadian artists to lead this seminar. But he and McKay had both studied in the U.S., where McKay had seen the Jackson Pollock retrospective at Rockefeller's Museum of Modern Art in the winter of 1956-57, following Pollock's death. So for the summer of 1957 McKay and Lochhead invited the first of a long series of New York artists. The Emma Lake Artists' Workshop became a cultural branch plant for New York art.

In 1958 *Ronald Bloore* arrived in Regina to take charge of the university's Norman Mackenzie Art Gallery. Bloore had been exhibiting landscapes in Toronto, but he also brought to Regina a sophisticated background in art history, acquired in graduate schools in the U.S. and Europe as well as at the University of Toronto. In 1959, with Lochhead away on sabbatical, Bloore, McKay and *Roy Kiyooka*, another ex-student of Jock Macdonald from Calgary, picked Barnett Newman's name out of *Art News*, the leading New York art magazine of the day, and invited him to Emma Lake.

Newman had long been painting radically simplified formalist abstractions in New York. His large paintings were vast fields of one colour, with only a few narrow stripes at distant intervals, sometimes in almost the same colour as the background. He had taken the big space of U.S. abstraction, and identified it literally with the painting's surface. Now hailed as a precursor of the U.S. classic phase, he was the first to bring word of the new line to Saskatchewan.

Fig. 183: Ronald Bloore (born 1925), *Painting, June, 1960,* oil on board, 48" square, National Gallery of Canada

Newman did no painting at Emma Lake, but encouraged the Canadians to approach their work in terms of a large, simplified 'image.' This use of the word 'image' is another example of U.S. art-critical jargon. An image is ordinarily *of* something. But Newman was using the word in exactly the opposite sense.

"I am not aware of any intention while painting with the exception of making a preconceived image function formally as a painting." This 1961 statement by Ronald Bloore indicates how this approach to painting removes the artist more than ever from the rest of the world. Not even the empty gestures of a William Ronald nor the landscape references of a Jock Macdonald are tolerated.

Bloore's *Painting, June, 1960* (Fig. 183) shows how well he understood Newman. Painted in off-white on white, it is simply an approximate circle of radiating lines embedded in pigment, with a vaguely spiralling series of interruptions in the paint. The "preconceived image" is the circle in the square; the spiral of flaws in the paint occurred in the process of making that image "function formally as a painting."

Newman had obviously done an effective job. But to get things going in earnest, Clement Greenberg himself was needed. In 1962 he was invited to Emma Lake, and *Canadian Art* magazine, now edited by a continentalist-minded graphic designer named Paul Arthur, extended Greenberg's influence by commissioning him to write a major article about painting on the prairies. The result was a visit whose effects are still to be found in studios in Saskatoon, Moose Jaw, Calgary and Winnipeg, as well as Regina.

Of course not all the painters whom Greenberg encountered were abstract artists. *Ernest Lindner*, for example,

Fig. 184: Arthur McKay (born 1926), *Attentive Image,* 1963, enamel on board, 48" square, The New Brunswick Museum

had come to Saskatoon from his native Austria, and had set out to paint the prairies in the 1930s with the same independence of the prevalent British landscape conventions as the Group of Seven had displayed in Ontario. By the time of Greenberg's visit, Lindner was concentrating on studies of foliage in the north Saskatchewan woods near Emma Lake. Greenberg encouraged him to focus exclusively on these close-ups, eliminating background entirely, so that the realistic aspect of his painting was subordinated to a concern for surface quality.

This was Greenberg's approach to landscape painting. Rather than rule it out completely, he indulged in it as a relaxing alternative to the abstract rigours of the avant-garde. He even dabbled in it himself. The main thing was that the landscape painter had to be preoccupied solely with formal problems, not with any significant subject matter.

Thus when *Dorothy Knowles*, another Saskatoon painter, showed him her early attempts in an abstract-landscape manner, he advised her to concentrate on the formal problem of translating three-dimensional space onto the two-dimensional picture plane. This is what impresses us most about her panoramas of the rolling hills and river valleys of Saskatchewan — not any sense of the life of the regions she is painting. Her pictures are the most refined and sensitive versions of the 'empty landscape' since the days of David Milne.

Greenberg encouraged a few other landscape painters, but his main impact was on the abstract artists in Regina. In a burst of enthusiasm he declared that the latest art there was abreast of the avant-garde in Manhattan. Kenneth Lochhead, *Douglas Morton, Ted Godwin*, and some younger members of the branch-plant school received praise

tempered with criticism. Top marks went to Arthur McKay.

In 1959 McKay had experimented with a series of oil-on-paper abstractions that showed the direct influence of Jackson Pollock. In the following year he had learned from Ronald Bloore how to let enamel run on masonite to produce effects similar to the dark-and-light contrasts he had achieved on paper. Like Jock Macdonald's canvases of about this date, McKay's paintings also appeared to go off all the edges of the picture.

With Bloore, McKay had learned from Newman's advice to concentrate on a single, simple image. Nothing seemed simpler than Bloore's circle-in-square format, so in 1961 he borrowed that too, and began to produce paintings like his 1963 *Attentive Image* (Fig. 184).

This 'image' is consciously composed in the form of a *mandala*, an ancient symbol for religious meditation. McKay was deeply attracted by Asian religions, and had also participated in some of the earliest experiments with hallucinogenic drugs at the University of Saskatchewan in the 1950s. His paintings are intended for meditation: on prolonged contemplation, with drugs or without, *Attentive Image* begins to spin, converge and radiate, as the whole surface becomes animated with the contrast of light and dark, and the contradiction between the illusion of depth and the hard glare of the enamel. McKay's painting is a far more concerted attempt than Varley's *Dhârâna* (Fig. 163) to escape from the harsh realities of life via eastern mysticism and, in McKay's case, the hallucinations induced by drugs.

Drugs are as destructive of an artist's creativity as they are of any other aspect of life. McKay, like many other artists who experimented with them, has been unable to develop his work beyond its starting point. His subsequent paintings merely vary the image — square, rectangle, lozenge — he has remained tied to this escapist illusion of trying to 'centre' his experience through a single unified image. Long periods of McKay's life have been totally unproductive, and his paintings of the early 1960s still constitute his only significant work, even for formalist critics. There have been no revelations, simply because this idealism is false: there is no magical entry into a world beyond, only the turning circle of the individual's own mind.

Real creativity comes from the social reality of a common struggle, but McKay had declared in 1961 that "people in general are not interested in art and therefore understand very little about it. An artist cannot be concerned with such people."

But artists like McKay have to be very concerned with people like Greenberg and his favourite U.S. painters. In 1963 and 1964 McKay and Lochhead invited Kenneth Noland and Jules Olitski to follow Greenberg at Emma Lake. Lochhead and other western abstract artists began to produce little Nolands, little Olitskis, and even a few 'little McKays.'

"There is no such thing as a distinctly Canadian art," McKay had proclaimed in 1961. "There are only artists who happen to be Canadian." In 1964 Greenberg rewarded such all-out adherence to the imperial standard by including

McKay, Lochhead and Bush with U.S. painters in an exhibition called *Post-Painterly Abstraction* that he had organized to illustrate his thesis about the U.S. art of the classic phase. The action painters of the preceding period were now described as "painterly" because of their reliance on brushwork and textural effects, and the new 'cool' image painters and colour-field artists of the early 1960s were heralded as having taken the historic step forward to "post-painterly abstraction."

It is a sign of the beginning of the decadent phase of U.S. art that this exhibition was generally judged to have failed to make its point. Further, as a blow to Greenberg's prestige, the exhibition was not shown in New York. But it was big news in the provincial U.S. cities and in the colony, so after opening in Los Angeles and travelling to Minneapolis, it ended its continental tour at the Art Gallery of Toronto (now Ontario) in 1965.

After that date, it is remarkable how little this branch-plant enterprise has produced. Lochhead has moved to Winnipeg, where he is painting confectionery colour-field work more vapid than that of Bush. Morton, Godwin, Kiyooka and the younger Regina artists have all disappointed early-'60s predictions of great things to come.

The one exception is Ronald Bloore, who had closed his studio when Greenberg came to Regina. Greenberg called Bloore's white-on-white paintings "French pastry," associating them with the School of Paris heavily-textured abstractions that New York colour-field painting was supposed to have surpassed. Greenberg went so far as to suggest that Bloore's work must be derivative of Paul-Emile Borduas' creamy-coloured canvases, even though Bloore could not possibly have seen Borduas' late paintings before making such panels as *Painting, June, 1960*. The critic from the imperial centre always assumes the right to fabricate the colony's art history.

Bloore had been in Egypt and Greece in 1962, studying ancient architecture, sculpture and low-relief carving in stone. When he returned to Regina, he destroyed all the work in his studio. He then began to reconstruct his paintings according to his interpretation of these classic standards. In 1966 he moved back to Toronto, where he has continued to paint white-on-white abstractions, and has extended his studies still farther with a visit to the ancient cities of the Near and Middle East.

Bloore has clearly been attempting to break with the U.S. imperialist origins of his art. But instead of turning to the people, he has turned to the art of ancient slave societies, and to the formal properties of the Canadian landscape tradition. These paintings (which are difficult to reproduce satisfactorily) look more like snow-covered fields with a few tracks across them in bright winter sunlight, than like abstract renditions of ancient relief carvings. Bloore has a deep respect for the later landscapes of Lawren Harris, and has even proposed to do all-white versions of Harris's Lake Superior paintings.

Thus Bloore's art has appealed to what is left of the national-bourgeois outlook among Toronto patrons, who have made each of his solo exhibitions a success. His paintings are pristine, reserved, and manifest their maker's

intense preoccupation with light values. They constitute, in fact, a 'pure' art of total restraint, the most extreme form of the colonial tradition of repressed expression that we have already encountered in the paintings of Harris and L.L. Fitzgerald. This is the tradition which Bloore distills in his white-on-white panels, and brings to an austere, dignified end.

DECADENT PHASE I, 1963-68:
POP ART IN NEW YORK/TORONTO

In Toronto, even during the heyday of the Painters Eleven, a number of artists had tried to adapt the conventions of abstract expressionism to the painting of people. In fact, all four artists who exhibited with William Ronald in the opening show at the Greenwich Gallery in 1955 were figurative painters. *Gerald Scott* painted thickly textured portraits; *Robert Varvarande* favoured luminous figures on misty grounds; *Graham Coughtry* painted isolated people, fraught with existential anxiety, in murky interiors; and *Michael Snow* did delicate pictures of nudes, composed of cut-out pieces of paper, and playful figurative works that showed the influence of Swiss artist *Paul Klee.*

Coughtry went on to paint bodies of lovers intertwined with the dripping and gushing impasto of the abstract expressionists in the early 1960s, and *Robert Markle* similarly depicted dancers and nudes in his brush drawings after graduating from the Ontario College of Art in 1959. But for Snow and his wife *Joyce Wieland*, whom he met while working with Coughtry at a Toronto film animation studio called Graphic Associates, the representation of people soon became a problem more closely linked with photography and film-making than with abstract painting.

As late as 1961 Snow and Wieland were both still experimenting with abstract expressionism, but in the following year they became disgusted with the inbred, petty art scene of colonial Toronto, and decided to move to New York. At the same time both artists began to apply their film animation experience in a series of figurative paintings. This use of the conventions of a popular entertainment medium was part of the wave of *pop art* that was sweeping out from the imperial centre about this time.

British painters had actually begun basing figure paintings on advertisements in the mid-1950s, but because they were not in New York they did not become 'the' pop artists. U.S. pop art was virtually created in the art-market season of 1961 when a rich and independent-minded Manhattan collector named Robert Scull suddenly started a whole new trend by going out and buying direct from the painters' studios (at very low prices) a number of the U.S. pop artists' works. By skilful promotion through a few key museum exhibitions and art trade magazine articles, Scull and a few critics were able to make this new trend into a full-fledged 'school' for the art history books. They found a fallow field, as the first full generation of academic art historians and university-trained painters were graduating about this time from the U.S. university art departments in large number. Scull has subsequently sold off much of his collection for astronomical profits, in one of the most impressive manipulations of the 'instant art history' racket.

These pictures were based on comic strips, advertising, movie stars, newspaper photographs, packaging designs and the U.S. flag. The U.S. pop artists presented their subjects deadpan. In most cases they did not alter or interpret their material, except to paint it on a much bigger scale than it ordinarily was, and to show it in a gallery as art instead of in a comic book or supermarket. Like a public relations man who is trying to hide his client's vicious exploitation of people, the U.S. pop artists present the world of mass-marketed commodities with a bland "No comment."

At first, some people thought this new style was a form of social criticism, or at least an ironic comment on the pretensions of the art market. One pop painting by New Yorker *Roy Lichtenstein* even blew up the action painters' famous 'expressive brush stroke' as just another mass-marketed commodity, which of course it is. But even this painting joined the others as merely a representation of the 'trade mark' of certain 'standard-brand' U.S. abstract expressionists.

Pop art, which arose in the U.S. classic period, signalled the beginning of the decadent phase of U.S. art. Already in 1962 the calm and confidence of the classic phase had been shattered. The Cuban people showed they were through with Yankee rule by defeating a U.S. invasion attempt at the Bay of Pigs. Black Americans were beginning to rise against their oppression. And by the time of President Kennedy's assassination in 1963, the U.S. was deeply committed to its war of aggression against Vietnam.

These years of rapidly accelerating contradictions both within and outside the U.S. required an art that was just as 'cool' as the colour-field painting of the classic phase, just as concerned with false 'images', but far more persuasive in conditioning people to accept without question the manipulation of news events in the media, and the gross exploitation of advertising. U.S. pop painting was only part of a pop 'youth culture' that aimed to surround students and young workers especially with a rock-music and psychedelic environment that would insulate them from the atrocities of U.S. imperialism. Asked what he thought about the war in Vietnam, *Andy Warhol* the 'high priest' of U.S. pop art, said "It's alright, I guess. It's happening."

The pop-art philosopher was none other than Marshall McLuhan, the Canadian professor of English literature at the University of Toronto who kept assuring us that "The Medium is the Message." McLuhan did ask some useful questions about the effects of print, radio, film and TV technologies on us, but he refused to ask who controls the media, and of course downplayed the question of content entirely. He was simply applying the principles of formalism to the public areas of broadcasting and advertising, as they had already been applied to painting and poetry. Since his exclusive concern with the power of technology was completely in line with the manipulative policies of U.S. corporation executives, McLuhan soon found himself being invited to their seminars and conferences, and featured in their magazines. He became a sophisticated propagandist for passive acceptance of whatever the media provided.

In 1965 Toronto artist *Dennis Burton*, formerly an abstract painter, created a minor sensation by using this pop-art approach to depict the 'packaging' of women's bodies as sex objects in his *Garterbeltmania* series of paintings, based on pictures of women in stockings and panties in pornographic magazines. He went on to a series of 'meditations' on the female form based on eastern religion, then through a succession of styles that included occasional social criticism and a reversion to abstraction. Having begun his career under the dominant influence of Painters Eleven, Burton has vocally assailed U.S. imperialist control of our culture, but he has not yet succeeded in breaking away from its effects on his art.

In New York, Joyce Wieland at first used a film-animation story-board format to paint simple stores of disasters, such as planes crashing or boats sinking. Like Burton, she betrays a warmth of feeling in these works that is not really consistent with U.S. pop.

It was Michael Snow who came closest. From 1962 to 1967, during his first five years in Manhattan, he was at work on a long series of paintings, drawings, prints, sculpture, photographs, films and even rubber stamps, all depicting a walking woman seen in profile. Her outline image is always the same, her arms swinging as she passes by, but always different, affected by the myriad ways Snow finds to present her. A framing line usually separates her appearances, and she is always cut off at top and bottom, as she would be in a cropped snapshot or screened poster.

In *Clothed Woman* (Fig. 185), subtitled *In Memory of My Father* because Snow's father died on the day it was completed, the walking woman flickers by us in seven separate manifestations, like the stop-motion frames of a film. Snow points to the manipulation of people in the image-making worlds of Hollywood and the Madison Avenue advertising industry, where pictures of stars or products are repeated over and over again, often in some cropped or subtly altered version, until everyone is familiar with them. But in accordance with the principles of U.S. pop art, Snow offers no criticism of this process; on the contrary, he merely repeats it.

In this example Snow retains the 'painterly' brush strokes and a few artful drips 'left over' from his abstract expressionist days, and uses them as 'clothing' to warm up the cool, neutralized image of the Walking Woman with a little texture and rich colour. As New York critics pointed out, Snow's version of pop art is always more thoughtful, concerned more with the implications of the technique of mass-produced and mass-distributed images of people than with blowing up brand names or movie stars. Like all colonial followers, Snow was more restrained than the U.S. originals, and as a result his exhibitions in New York were never more than a modest success. Just as predictably, he continued to exhibit to greater acclaim back in Toronto.

DECADENT PHASE II, 1968-74:
COSMETIC NATIONALISM

In 1968 the Ontario College of Art reduced its second-year classes in life drawing from 20 hours per week to two. When students rebelled, College principal Sydney Watson first offered them more "freedom of choice" in selecting their courses. Then he fired *Aba Bayefsky* and *Eric*

Fig. 185: Michael Snow (born 1929), *Clothed Woman (In Memory of my Father),* 1963
oil and lucite, 60 1/4" x 152 1/4", National Gallery of Canada

Freifeld, the two veteran drawing and painting instructors who had supported the students, and who had also helped to organize the College's first Faculty Association.

Over 700 of the 1,030 students occupied the College cafeteria, boycotted classes, signed a petition, and finally marched on the Ontario government in Queen's Park. After nine days, recognizing that they had brought the College to a standstill and were receiving support from many other student groups and the Ontario public, Education Minister William Davis (later to be Premier) capitulated, reinstated the two dedicated teachers, and set up a joint committee of students, faculty and administration to review and direct the College's operations.

Watson had taken up a favourite refrain of this period, the notion that drawing and painting are 'out of date' and can be completely replaced by other media. According to this line, students should not be asked to study such out-moded techniques, but should learn to "explore themselves and their environment." All aspects of an artist's life are now reduced to questions of style, and art students are told that they have to acquire a "creative life style" rather than such skills as drawing or painting.

The faculty-student victory in 1968 by no means saw the end of this theory at the Ontario College of Art. In 1971 British administrator Roy Ascot took over the College, summarily dismissed or drastically reduced the teaching hours of much of the Canadian staff, and brought in his own faculty, mostly British and U.S. teachers, who were all convinced of this 'avant-garde' art education theory. Within one year they had almost emptied the College of students. Teachers like Bayefsky and Freifeld again fought back, got most of the Canadians reinstated, forced Ascot to resign, brought in another supervisory committee of concerned Canadians, and after more than a year managed to reintroduce many of the basic courses in drawing and painting. Similar battles are being fought in college and university art departments across the country.

This idea that "painting is dead" is characteristic of the latest stages of decadence in U.S. imperialist culture. Thousands of younger artists and students have never tried to draw or paint seriously, but have drifted aimlessly through plastic environments to electric light shows to closed-circuit video presentations, and finally to what is called *conceptual art,* in which the idea counts for everything, its execution nothing at all! Many of these artists have taken to mailing postcards to each other, on which their ideas or activities, usually supported by a government grant, are recorded. Others have made personal exhibitions by binding their bodies with string, digging holes in the ground and filling them with paint, drooling in their hands, and other absurd actions.

This is the fine art of a period in which the United States empire has been defeated in Indochina, and is rapidly losing its ability to maintain financial domination over the rest of the world. Desperately making deals with the revisionist Soviet Union, now an imperialist power in its own right, the U.S. also has to compete with resurgent rivals like Japan and West Germany.

As many Americans have lost confidence in their political system, so artists in the U.S. no longer want to paint for the New York art market. They say they prefer to develop and document concepts or events that do not fit inside a commercial gallery. But of course the market is capable of trading on their documents, too, and exhibitions are now regularly made up of photographs, films, sound tapes, TV footage and colour slides, rather than paintings.

Michael Snow has developed one of the most sophisticated variants of this type of art. After 1967 he dropped his Walking Woman image, but continued his interest in how images are presented in the various media. His film and photographic studies analyze the formal properties of film and photography.

This kind of art is especially harmful in a colony. Many of its advocates are the British and U.S. professors who have taken over our art colleges and university art departments. It retards the growth of our painting, because it holds young artists back from acquiring the skills they need in order to draw and paint the life of our people. Further, since it occurred at the same time as a resurgence of the national liberation struggle in Canada, it has provided a vehicle for the revival of some of the worst aspects of cultural nationalism.

Like cultural nationalism among the native people or in the days of Napoléon Bourassa in Québec, contemporary

Fig. 186: Joyce Wieland (born 1931), *Reason over Passion,* 1968, quilted cloth assemblage, 101″ x 119″, National Gallery of Canada

Canadian cultural nationalism revives the myths and symbols of our country, without making any claim to political power. The primary myth in our visual arts tradition is the cult of the unoccupied landscape, especially in our northland. So Michael Snow has made a film consisting entirely of the landscape of one rocky location in the rugged north, and Toronto's *Gar Smith* produced a slide show in 1969 by shooting colour slides of sunsets and sunrises at equal intervals all along the Trans-Canada Highway for 30 days, beginning in Newfoundland and ending in Victoria.

The artist who has taken this cultural nationalism farthest is Joyce Wieland. Back in 1961, while she was still painting, she had titled one of her abstract works, *Laura Secord Saves Upper Canada.* By the time of the Centennial she had been living in New York for five years, and was no longer painting, but she produced a quilt called *Confedspread,* stitched of plastic and cloth, and featuring the Canadian flag. She began to make a series of these quilts with "Canadian content."

In 1968 she completed a film called *Rat Life and Diet in North America,* which shows clearly her concept of Canada during this period. It is a fable, in which her pet gerbils escape from New York to the green fields of Canada, only to be pursued by their enemy, the cat. The film ends ominously, with the U.S. invasion of Canada.

This is really a New York intellectual's view of Canada. Many U.S. draft-dodgers, deserters, artists, writers, and certainly U.S. professors, like the gerbils, look to Canada as a safe haven from the racism, militarism and police-state repression in the heart of the empire. Yet it is evident that the United States is also in control of Canada, and might very well destroy these convenient 'green pastures'. So these Americans are concerned to keep Canada safe — for them!

With their background in pop art and the media, Snow and Wieland were also easy prey for the ultimate image-

maker, Pierre-Elliott Trudeau. Compared to openly reactionary leaders like U.S. Presidents Johnson and Nixon, the stylish, cerebral M. Trudeau looked terrific to U.S. left-liberals and their colonial friends in 1968. It is significant that on the one occasion on which Canadian artists specifically organized support for a Prime Ministerial candidate, the movement was led from New York. The Snows threw a party for Trudeau on one of his well-publicized visits to Manhattan, and rallied expatriate Canadians' support for his nomination.

When Trudeau announced that he wanted to put *"la raison avant la passion"* ("reason over passion") in politics, Wieland produced two quilts embroidered with the slogans in each language. Although she intended them as irony, Trudeau himself bought the French-language version, and the National Gallery snapped up the English translation (Fig. 186). Wieland also did a film with this slogan as title, which New York critic Manny Farber called "a clutter of love for Canada, done in the nick of time before it changes completely into a scrubby Buffalo suburb."

Like many Canadians, Wieland and Snow in New York did not understand the national question in Québec. They did not recognize the Québécois as a nation, but pinned their hopes on this French-Canadian image-maker, and looked to bilingualism and biculturalism as if they were the 'saving grace' of Canada, our last cultural line of defence against complete U.S. takeover. In the middle of her film, which is mostly a landscape tour of the country, Wieland shows a portrait of Trudeau with an elementary French lesson on the soundtrack. "The French lesson is a direct reference to Trudeau's idea of bilingualism," she said, "We must all speak French so that the French-Canadian will feel at home in his own country."

But Trudeau showed what he really meant by *'la raison avant la passion"* in October, 1970, when he brought down the War Measures Act. The "French lesson" was revealed as a punitive military operation aimed at crushing the movement for liberation of Québec.

The following summer was therefore the ideal time for the National Gallery to sponsor a summer-long Wieland show called *True Patriot Love,* which cynically exploited all the worst aspects of her art. The translation of the show's title was *Véritable Amour Patriotique,* not *"Véritable Amour des Patriotes".* Wieland produced such insults to both nations as a bronze statuette entitled *The Spirit of Canada Suckles the French and English Beavers,* showing a mother with two beavers at her breasts.

Most of Wieland's works either maintained the 'untouched landscape' myth, or reduced cultural nationalist symbolism to the most trivial level, as in a colour lithograph of her lipstick prints made by mouthing the sounds of *O Canada* and pressing her lips down. The most degrading point was reached with *Sweet Beaver,* a "patriotic perfume' that sold for $10 an ounce!

This burlesque of our national symbols was a slap in the face to patriotic Canadians. It was actually U.S. pop art using Canadian symbols as mass-marketed 'images', just as Snow had used the Walking Woman, and U.S. pop artists had used soup can labels. As one student commented upon

entering the exhibition, "this is Canadian nationalism presented in U.S. style." Her constant use of traditionally 'female' objects such as lipstick, perfume and quilts, results in a 'cosmetic feminism' in Wieland's art as well.

At the opening, with a band playing "The Maple Leaf Forever" and Waffle leader Mel Watkins as guest of honour, a group of artists outside distributed a leaflet that asked "True Expatriate Love?" They exposed the show for what it was, and demanded that the Canada Council stop paying grants to U.S. citizens in Canada, and to Canadian expatriates who have settled indefinitely abroad, as Snow and Wieland had.

Whether the demonstration was effective in tipping the balance or not, Snow and Wieland began to act differently. The demonstrators were members of Canadian Artists' Representation (CAR), a new national artists' organization through which artists were beginning to participate in the growing national liberation struggle. In September of 1971, Snow and Wieland both went to the First National Conference of CAR, and contributed greatly to strengthening its patriotic character.

Since then, they have moved back to Toronto, and have been involved in many aspects of the struggle for Canadian liberation. Now in daily contact with the people again, they have become two of the patriotic personalities who are lending their support to anti-imperialist causes. Behind the cosmetic nationalism, despite the years of Americanization and preoccupation with style, were two strongly determined and genuinely patriotic people. Their new orientation will undoubtedly begin to show in their art in the very near future more consistently than in the past.

THE CONSERVATIVE ALTERNATIVE

The three phases of U.S. art that we have discussed consists essentially of paintings collected by rich U.S. liberals. But throughout the period since 1945, wealthy U.S. conservative imperialists have also collected and supported their own school of painting. They have their own museums, and although they do not dominate the art trade magazines, they promote a backward-looking representational art through lush coffee-table books loaded with expensive colour plates. U.S. President Richard Nixon's favourite artist, for example, is *Andrew Wyeth*, a well-known painter of rustic nostalgia.

The Canadian artist who has supplied this alternative market, ranking second to Wyeth, is *Alex Colville*. A war artist, Colville returned in 1946 to teach at Mount Allison University in Sackville, New Brunswick, where he had originally studied. There he has worked away slowly and carefully at paintings like *Woman at Clothes Line* (Fig. 185).

At first glance this painting appears to be a highly realistic picture of a woman working in her yard on an autumn day, with the fall leaves on the lawn around her. Only when we consider it more closely can we begin to see how misleading this apparent realism is. For one thing, the woman, the leaves and even the wash on the line are stock still, arrested in motion as they would never be in life, or even in a snapshot. This 'frozen moment' quality is Col-

Fig. 187: Alex Colville (born 1920), *Woman at Clothes Line,* 1957, oil on board, 47" x 36", National Gallery of Canada

ville's version of that static idealizing tendency that we have observed in the works of Ozias Leduc, Lawren Harris and L.L. FitzGerald.

In the foreground, the woman's right foot is raised in mid-step, emphasizing this 'frozen moment' and giving a startling sense of depth, as if she were stepping out of the painting. Whether it is a horse running away from us, a dog's tail raised toward us, or a woman looking at us through binoculars, Colville's paintings almost always include some such 'involving' device.

Compositions are artfully arranged to enhance the sense of permanence. In this example, the long ellipse of the clothes line is balanced by the oval rim of the wash basket below, and the tighter, opposing ellipse of the woman's headband above. The woman stands as erect as the line marking the corner of the house behind her; her arms and head form a perfect cone with the wash basket as its base.

The surfaces of most Colville paintings are covered with a meticulous checked brushstroke that employs conventional *cross-hatching* effects of darker over lighter strokes to model and shade the forms. This was a technique originally used with *egg tempera*, a powdery pigment mixed with egg yolk that dries more quickly than oils and therefore can only be shaded or modelled in this way. Although *Woman at Clothes Line* is in oils, Colville still uses this technique,

which he had revived after studying the works of the early Italian Renaissance painters of the 1400s, who were the last to favour it.

Colville retains this technique for a very specific reason. If we compare the sheet behind the woman with the flesh of her leg, we can see that even though he has allowed for the usual differences in texture and shadow, there is a basic sameness about the two surfaces. Similarly, each blade of grass is painted separately all across the lawn, and detail is just as sharp at the corner of the house in the background as it is between the woman's toes in the extreme foreground. Colville's patient consistency of paint application by cross-hatching results in an over-all even distribution of what is called visual *acuity* — our perception of distinct differences. Everything is equally differentiated into a system of minute cross-hatched strokes.

This highly mannered style of representation, in which we see more detail than we actually would in real life, is called *magic realism*. The so-called magic consists simply in this absolute visual acuity, and in the calculated depiction of a moment in which the picture "holds its breath," as a British critic observed.

Colville is not in fact a realistic painter at all. For most of his life he has lived near an area of New Brunswick where a great many people are waging a constant, desperate, heroic struggle against poverty. Tied down to small, poor land holdings, or living in villages or towns where there is never enough work, they have refused to emigrate or sell out. While K.C. Irving and a few other arch-compradors have become millionaires by exploiting them, they have stubbornly held on to the unpainted houses and seasonal jobs that are left to them.

Even though he draws his subjects from the people and scenes all around him, Colville isolates them from this reality. The neat white houses tell nothing of the grinding poverty or of the courage of the people. Colville pretends to reveal everything, but reveals nothing. His paintings amount to a whitewash for the decadent provincial bourgeoisie of an area that has been viciously repressed.

As a propagandist for imperialism, Colville is far superior to Jack Bush. Colville's pictures of a horse running toward a train, of a boy and dog in a field, or of a nude woman looking back at her clothes dummy in an attic, have all been widely reproduced. They are especially appealing to many people who are disgusted with the decadence of U.S. abstraction and pop art. But their world is an unreal one of classical calm, and they stimulate a sense of 'mystery' or 'magic' in our awareness of everyday life, rather than helping us to understand and change our world scientifically. As Robert Fulford commented, the people and even the animals in Colville's paintings all seem to be in some kind of trance. Colville does not paint a working woman in the midst of life, but removes her from the living, breathing context of contradictions and hermetically seals her off in time and space. By abstracting and composing his subjects in this way, he achieves only a cardboard classicism, the very opposite of genuine realism.

Colville held his first solo exhibition at the New Brunswick Museum in 1951, but his second exhibition a year later was in New York, and he has continued to show there regularly. In 1963 he was awarded the major prize in the Lady Dunn International Exhibition at Lord Beaverbrook's Art Gallery in Fredericton, being chosen above many leading U.S. and European abstract painters. The prestige of the prize assured him of continued high prices, so he retired from teaching.

Colville produces only a few paintings each year, and is able to charge in the tens of thousands for each one. He ships his finished works to New York, and sells no paintings in New Brunswick. In 1966 he represented Canada at the Venice Biennale, and three years later held his first exhibition in West Germany, where there are many rich collectors who would like time to stand still. In 1971 Colville obliged his growing audience there by going to live for six months in West Berlin, basing some paintings on his visit; he had earlier done the same for his U.S. buyers by staying a year as artist in residence at a California university.

In recent years the market for magic realism has attracted many other artists. *Ken Danby*, who lives on a farm near Guelph, has established the biggest reputation, even invading Colville's German market. *Tom Forrestall* in Nova Scotia and *Christopher Pratt* in Newfoundland, both former Colville students, show a genuine respect for rural and small-town people and places, and have associated the style still more closely with the Atlantic provinces. Forrestall in some paintings even reflects the people's harsh life of struggle against poverty, by depicting their barns, their scrub woodlots and vegetable patches. But what all of these artists have in common is the false air of permanence they give to their subjects, by which they isolate their art from the reality of constant change while appearing to be realistic; this is a magic that their collectors cherish.

PAINTERS OF PEOPLE IN THE WEST

While the repressed conditions of the Atlantic Provinces fostered magic realism, the prosperous farms and rapidly growing cities based on the resource industries in our four western provinces made possible a much more dynamic and generally progressive tradition of painting people. The large immigrant population in the west was especially important in enabling painters without formal training to set to work with skills acquired from European craft traditions. Western working-class and farm life also provided a rich and varied subject matter.

On the far west coast, on Vancouver Island, *E.J. Hughes* like Colville returned from his war art assignments to paint in the area where he had grown up. Hughes, with Paul Goranson, had trained as a realistic painter under Varley, and worked as a commercial artist in Vancouver before the war. Opposed to the flood of U.S. abstraction, Hughes in 1953 resigned from the Canadian Group of Painters, protesting the Group's "recognition of ugliness" in accepting abstract art for its exhibitions.

Hughes developed a realistic art that is the very opposite of Colville's static world. Paintings like Hughes' *Farm Near Courtenay, B.C.* (Fig. 188) are alive with action and the force of change. The brilliant light and cloud forms in the sky may remind us of *Thunder Clouds over Okanagan Lake,*

Fig. 188: Edward J. Hughes (born 1913), *Farm near Courtenay, B.C.,* 1949
oil, Vancouver Art Gallery

B.C. (Fig. 181); Jock Macdonald as teacher and artist was undoubtedly an early influence. But instead of abstracting the landscape forms, Hughes gives them the vibrant reality of growth and dynamic movement.

Like Emily Carr, Hughes paints our land from the viewpoint of people. Many of his canvases show the logging and fishing industries, people on a beach or the ferries crossing among the islands of the Georgia Strait. In this example the farmer stacking wheat in the foreground sets up an energetic rhythm that ripples across the land and soars to a magnificent interplay of tree forms. The theme is extended in the choppy waters of the bay, the vigorous forest flourishing on the peninsula across the channel, and the jaunty forms of the houses and farm buildings, smoke pouring industriously from their chimneys despite the fine weather. The drama of the distant mountains, clouds, and breaking light intensify and ennoble this inter-action of natural and man-made shapes. Hughes depicts the struggle for production with confidence, even joy; it is entirely fitting that he was one of the first to paint on an Emily Carr scholarship, funded from that great artist's posthumous sales.

Living and working in a small Vancouver Island village, Hughes has made a valuable contribution to our new-democratic culture. It is not hard to see how his work is national, scientific, and democratic, especially in these late 1940s and early '50s paintings, where working Canadians are so prominent. He has deliberately developed a simplified style of bright colours and directly realized forms, often with planes flattened in space, that looks like what is called 'primitive' or 'folk painting.' Despite his thorough training, this links Hughes' work to a broad tradition of people's art that has been particularly strong in western Canada. Thus there is a close comparison in spirit as well as in subject matter between Hughes' farm scene and *These Good Old Thrashing Days* (Fig. 189) by the Saskatchewan painter *Jan Wyers*.

Born in the Netherlands around 1890, Wyers came to Canada during the First World War, and eventually settled on a quarter section near Windthorst, east and south of Regina. During the Depression he began to paint through the long winter evenings at first as therapy after a serious operation.

These Good Old Thrashing Days (so titled in green crayon on a tin plaque applied to the frame) is typical of the paintings Wyers was producing by the 1950s. It is bursting with vibrant colour, set in a brilliant yellow wheatfield under a bright blue sky that goes white at the horizon. Gold, green and brown brushstrokes swarm through the grain, conveying the excitement of the harvest and the intensity of the warm sunlight.

The painting is the exact opposite of the old Barbizon-derived rendition of the exotic peasant: Wyers' farmers and farm workers, based on a lifetime of observation, energetically cooperate with each other in the use of the latest agricultural machinery of their day, which would customarily be shared by the owners of several sections in the region. The picture is animated not only by the magnifi-

The Struggle to Paint our People 217

Fig. 189: Jan Wyers (1891-1973), *These Good Old Thrashing Days,*
oil, 28" x 39", Norman Mackenzie Art Gallery, University of Saskatchewan

cently spirited horses, but also by the blue-black smoke that billows from the bright red machinery in the foreground, and by the flow of wheat that gushes onto a growing stack in the distance. Foreground and rear are connected by a long black driving belt that allows Wyers to establish his spatial recession at the same time as it emphasizes the mechanical force that is being harnessed along with the animals and people. All the wheels and parts of the machines are included by an artist who has obviously used and repaired them often. The flock of birds starting up and the engaging dog crouched in the lower left corner add still further appeal to this exuberantly happy painting of cooperative and mechanized agriculture.

Although Wyers has much less training than Colville, his picture is actually far more realistic in the true meaning of the term. Here is the social awareness and scientific understanding of a farmer-painter who has participated in the process he is depicting. Wyers' art upholds the dignity of Canada's working people, supports scientific and technical advances in farming, and celebrates the advantages of working together. It is social realist and new-democratic painting of a high order.

Nor does Wyers stand alone. *William Panko* was another artist of the prairies who painted realistic pictures without any training in art. Born in Austria in 1892, Panko came to Canada in 1911, five years before Wyers, and settled on a farm in the Rosebud River valley of Alberta, northeast of Calgary. He began to paint only in 1937, after being admitted to the tuberculosis sanatorium in Calgary, where he remained for ten years.

While Wyers had painted through his long Saskatchewan

winters, Panko had spent his winter seasons working in the coal mines around Drumheller, the probable source of his tuberculosis. He became part of the remarkable community of 2,000 Drumheller area miners, a group of workers with a highly developed social and political consciousness. These were the miners who went out in support of the Winnipeg General Strike in 1919, who supported the One Big Union movement of the early 1920s, who were a stronghold of the Workers' Unity League in the early 1930s, and who consistently fought for Canadian unions. Drumheller was for many years a centre of Communist Party activities: Slim Evans, one of the leaders of the 1935 On to Ottawa trek, came from Drumheller, as did many volunteers for the Mackenzie-Papineau Battalion.

Marion Nicoll, the Calgary artist who showed Panko how to mix watercolours but was otherwise careful not to influence him, noted that he was keenly aware of "economic, political and cultural" matters. His watercolours, of which there are about 30 in all, have frequently been praised for their naive but lively animation and their rich, all-over design. But it is clearly the content of his sketches that mattered most to Panko: he painted one diagram of the interior of a coal mine as if seen from above, and insisted that it be placed on the floor for viewing.

For his analysis of the community of *Drumheller, Alberta* (Fig. 190), Panko chose a sheet of blue paper, perhaps noting that it was closest to the colour of coal. Across the top of his picture he painted the economic base of the town, the miners' struggle for production: in the upper right corner is the coal face at the end of three mine shafts, with one miner drilling, another with a shovel, and a

Fig. 190: William Panko (1892-1948), *Drumheller, Alberta,*
watercolour on blue paper, Private Collection

third with a pick respectively in each shaft. Next comes transportation: the tracks to the minehead and the loading and piling machinery are shown, with the conveyor belt making a horizontal break across the picture, paralleled by the train that carries the coal to market, and a truck loaded with coal behind a car on the road below. Across the bottom are the houses and gardens that depend on the miners' labour: a woman pumps her well in one backyard, while a miner waves to his wife as he arrives home at another.

Despite Panko's complete lack of training, this is important new-democratic art, showing a worker's scientific understanding of his own community. It is noteworthy that there is no hint of class struggle. Perhaps the ruling-class

propaganda that condemns all strikes and proletarian political activities inhibited Panko from depicting them; or perhaps he simply did not get around to them in his brief painting career. His other pictures show a similarly detailed interpretation of farm life, along with some imaginative depictions of the hunting and fishing trips he took while convalescing at Harrison Hot Springs, B.C.

Panko's pictures were shown only once during his lifetime, at Coste House (forerunner of the Allied Arts Centre) in Calgary in 1947. He died within a year, of a heart attack. In 1959 his work, that of Wyers and four other artists was assembled into an exhibition called *Folk Painters of the Canadian West,* which was circulated by the National Gallery. One year later, *William Kurelek,* another

Fig. 191: William Kurelek (born 1927), *Hauling Grain in Winter,* 1964,
oil, 24" x 38", Mr & Mrs Gurston Rosenfeld, Toronto

artist from the prairies with apparently similar 'folk paint-ing' qualities, held his first solo exhibition in Toronto's Isaacs Gallery.

Born on a pioneer farm in the Willingdon area of Alberta north-east of Edmonton in 1927, Kurelek grew up in a Ukrainian-speaking Manitoba farm community. But he has had a far more sophisticated art education than most so-called 'folk' painters, graduating from the University of Manitoba in 1949, and then going on to visit the Instituto Allende art school in Mexico and to enroll briefly at the Ontario College of Art in Toronto. In 1951 he went to England, where he studied, exhibited with the Royal Academy, and spent a traumatic period in the hospital.

It was after his return to Toronto in 1959 that Kurelek began to recall his prairie origins in his art. His 1964 painting *Hauling Grain in Winter* (Fig. 191) is typical of the many pictures he has done recalling the hard work and heroic dedication of these immigrant pioneers. Kurelek's own description of the painting is memorable:

"My father had to work hard to pay off his passage. Because grain prices were poorest at harvest time, and the nearest railway and elevator town at that time was at Bellis (Alberta), 18 miles away, grain was hauled there all winter — winter being when there was also time to spare. It was an all-day job. Rising at four or five in the morning, two, three, or four sleigh boxes were shovelled full by hand, and after breakfast, the teams set out in convoy. In the picture my father is first, then my grandfather and my mother (who did a man's work). Horses struggling uphill across the frozen North Sask-atchewan River in 30 to 50 degrees below zero would bleed from the nose (without harmful effect, however). From time to time the drivers walked behind their loads to save themselves from being frost-bitten. After loading

at Bellis and having dinner, they would head back, to arrive at dark. Note the brakehooks on the sleigh runners and the ferry in storage, across the river."

Kurelek's panoramic viewpoint from the crest of the hill, the spiralling movement across and upwards toward us, and his realistic attention to details with which he is intimately familiar from his own experience lend a persuasive power to this monumental picture, which creates a big sense of space in its three-foot-wide canvas. It is a moving statement of the ability of working people, men and women, to overcome hardships in the struggle for production. This is social realist and new-democratic art to which people have re-sponded with enthusiasm. Kurelek's 1973 book of colour reproductions of his recollections, *A Prairie Boy's Winter*, is one of the finest children's books ever produced by a Canadian artist, and has sold extremely well.

"I don't quarrel with the right of other artists to dedicate themselves to the search for pure artistic expres-sion," he says, "but I myself couldn't honestly do the same." Until recently Kurelek supported himself as a frame-maker, and he has always kept the realistic outlook of a farmer and a worker. He is a painter with a strong sense of social purpose, and packs a message into each picture.

Yet there is a darker side to Kurelek's art. In 1957 he became an ardent convert to Roman Catholicism. From 1960 to 1964 he produced a cycle of 160 paintings illustrating the Gospel according to St Matthew, from which a filmstrip and slide set has been made for Catholic missionaries. He donated the entire cycle to a public gallery in Niagara Falls.

But the teachings of the Church have adversely affected the way Kurelek presents people. Many of his pictures preach a specific Catholic moral, and he has incorporated religious symbolism into many of his paintings, often hiding

crucifixes away in a corner of a landscape or under a distant tree. "To me," he says, "the Christian and Jewish teaching of original sin — that man is somehow fallen and twisted out of shape — rings true as true can be in the real life I see around me." Frequently people are treated merely as a mass of depraved sinners, who cannot help themselves, but are dependent on divine salvation.

This pessimistic and completely unscientific attitude conflicts sharply with the realism in Kurelek's art that is founded on his farm and working-class background. It denies entirely the possibility of people changing. As a result, the body of his work falls short of the great contribution to our new-democratic culture that Kurelek is capable of making.

PAINTINGS OF ALIENATION AND PROTEST

Not all western Canadian painters had their roots among farmers and workers. In the cities, artists were much more likely to feel alienated from the fast-developing capitalist structures around them, especially in view of the strictly marginal role to which the bourgeoisie assigned them.

Maxwell Bates, born in Calgary in 1906, grew up as a rebel against the conservative Protestant religion and the social attitudes that went with it in the Bible Belt of Southwest Alberta. In 1922 Calgary Public Library officials ejected the Calgary Art Club from its studio in the library basement because club members were found to be painting studies of the nude from life! As an art student at the Provincial Institute of Technology and Art, which opened in Calgary in 1926, Bates devoured art magazines and experimented in many art forms, getting himself disbarred from a local exhibiting society for trying out an abstract painting. His styles and subjects varied, but his main

interest centred on the expressive painting of people.

In 1931, just one year before the Alberta Society of Artists was founded, Bates gave up on Calgary and moved to England to study painting and architecture. While working as an architect in London after 1934, he exhibited with the anti-fascist Artists' International Association, and in 1939 volunteered to fight in the British army in the world war against fascism. Captured in France in 1940, he spent five years in a German prisoner-of-war camp.

It was 1946 before Bates could return to Calgary. His long captivity had only deepened his commitment to progressive values and his rejection of the restrictions placed on Alberta society by a smug church allied with a Social Credit government that was busily selling out the province's oil resources to U.S. corporations. In 1949, at the age of 43, Bates went off to study art again, this time under the German expressionist painter *Max Beckmann*, who had fled the Nazis in 1933 and was then teaching during the last year of his life at the Brooklyn Museum Art School.

Even after retiring to Victoria, B.C. in 1962 and suffering partial paralysis, Bates continued to develop the expressionist ideas he had learned from Beckmann. Bates' *Babylonian Emissaries* (Fig. 192), painted in 1966, records the arrival of a company of Hollywood movie actors and their director, in Victoria by motor launch to shoot part of a film.

In Beckmann's manner, Bates has grouped the figures tightly together, contrasting the working crew members at the left with the leering director and the cosmetic actresses. One starlet wears a dress printed with a pattern derived from a Mondrian abstract painting, while another is hard to distinguish from the cat sitting in the foreground.

Fig. 192: Maxwell Bates (born 1906), *Babylonian Emissaries*, 1966
oil, 48" x 72", Artist's Collection, Victoria

Fig. 193:　Ivan Eyre (born 1935), *White Collar,* 1969
acrylic, 62" square, Canadian Industries Ltd,
Montreal

Near the centre is a Bentley automobile grille, a most
suitable car for the director, and a stars-and-stripes yachting
pennant associating the origin of these "emissaries," Holly-
wood, with Babylon, the ancient capital of decadence in
the Old Testament. In the lower right corner he adds a
couple of Mounties wearing Ku Klux Klan hoods, to
reinforce the suggestions of racism and police state control
that the U.S. film-makers bring with them, as they are
admitted to our country by RCMP inspectors.

Babylonian Emissaries is consciously anti-imperialist.
Bates had witnessed the U.S. companies' takeover of Alber-
ta oil, and he must have seen plenty of U.S. citizens arrive
in Calgary, the Canadian city with the highest proportion of
American residents. But much of the rest of Bates' work
takes the view-point of an alienated 'outsider,' making
satirical comments on people and life around him. A
generalized feeling of alienation is characteristic of the
rebellious petit-bourgeoisie who oppose oppression but see
no clear identification between their interests and those of
the majority of the people. And so, they often turn to
expressionism, rather than social realism.

The Winnipeg artist *Ivan Eyre* is an expressionist painter
who has no conscious, specific statement to make, but
whose art exemplifies this generalized feeling of alienation.
White Collar (Fig. 193) features a typical fragmented Eyre
figure, and shows the influence of Picasso and the British
painter *Francis Bacon,* as well as the expressionists who in-
fluenced Bates.

Born at Tullymet, Saskatchewan in 1935, Eyre studied
in Saskatoon before graduating from the University of
Manitoba in 1957. Now a teacher there, his work often
expresses tension and a binding or whip-like sense of
oppression. His people are usually situated on a flat plane

that suggests the prairie landscape. Often, at least one of his
major figures is a bureaucrat or administrator, half-victim,
half-oppressor, in this example, tied to the ground by loops
of wire or string. He seems to be kneeling or riding on an
outline image of a second figure, just like himself, to which
he points, while an animal with a halter and a pig-like snout
nuzzles up against him.

Such paintings express feelings of anxiety, frustration
and dissatisfaction with ourselves and our jobs, but rarely
do they go further to identify any cause. On the contrary,
they suggest that " the fault is in ourselves," confusing the
victim with the oppressor. It is worth noting that Eyre's
White Collar was purchased by Canadian Industries Limited
(CIL) for its corporate collection.

Much of this art of alienation, including Eyre's, has
concentrated on relations between the sexes. Many of
Miller Brittain's later works, especially after the death of his
wife in 1957, centred on this subject. After the war, more
isolated than ever, Brittain had passed through an intensely
religious period, and then gradually developed a highly
personal symbolism to convey his sense of the relationship
between man and woman. Some of his pictures are of
flower-like people in a marshy landscape, others show
figures with limbs merging into one another. Only in a
brilliant 1961 portrait of his daughter, Jennifer, and in
some pastels recalling the female figures of his earlier work,
did Brittain again paint with anything like his realism of the
1930s.

The artist who stated the theme of sexual relations in
our society most graphically was *Claude Breeze* in Van-
couver. Born in Nelson, B.C. in 1938, Breeze, like Ivan
Eyre, first learned to paint in Saskatoon, inspired by the
example of realistic landscape artist Ernest Lindner, head of
the Saskatoon Technical Collegiate art department. Attend-
ing the University of Saskatchewan art course in Regina
under teachers like Arthur McKay and Kenneth Lochhead,
Breeze inevitably became an abstract painter. He was still
painting non-representational canvases during an unhappy
stay at the Vancouver School of Art in 1959, and for some
three years thereafter in Vancouver.

It was only in the winter of 1962-63 that Breeze was
able to make the crucial decision to abandon abstraction,
and to begin painting the figure seriously. This wasn't easy:
he was completely cut off from the Canadian figure
painting tradition, with even Varley's works in Vancouver
no more than a vague art-historical rumour. The young
artist had to look abroad for his models: he admired
reproductions of the satirical paintings of women as sex
symbols by the Dutch-American artist *Willem de Kooning*
and was interested to learn about British pop art from his
friend Gary Nairn, who returned from a trip to England
about this time. So desperate was Breeze for some figure
painting tradition that he even turned to a 1963 exhibition
of Indian and Persian Miniatures at the Vancouver Art
Gallery as a source of subjects and style.

By 1964-65, Breeze had transformed these disparate
influences into a major series of paintings called *Lovers in a
Landscape.* One large canvas in this group, entitled *The
Murder* (Fig. 194), shows a man crouching beside the

Fig. 194: Claude Breeze (born 1938), *Lovers in a Landscape: The Murder,* 1965 acrylic, 58 1/2" x 53 1/2", Dept. of External Affairs, Ottawa

smiling but limp figure of a woman. In the foreground is the outline of the woman's kneeling body, as if it had been flayed and decapitated while in supplication. The man, kneeling beside a dome-shaped structure, looks out at us as he gathers some bloody remnant, but his own legs from the knees down seem to be severed like the corpse before him.

With such gruesome images Breeze communicates forcefully how love can be turned into its opposite. Men pass on the oppression they feel by physically oppressing women. Women are taught to accept this as 'love.' The exploitation of sex in advertising, movies, TV, magazines and novels proclaims this inverted image of violence between the sexes as an acceptable form of personal feeling. In this way oppression reaches deep into our most intimate awareness of ourselves and other people.

The landscape in which these figures appear is sensuously painted, its colours rich and warm, but it is deliberately not recognizable. These lovers carry out their acts of passion in a non-specific setting that is really the space of U.S. abstraction, taken over from the abstract painting that Breeze had previously done, and which he was still seeing all around him. In many of the paintings flat abstract areas interact crisply with the landscape passages. On one canvas Breeze even painted his lovers into an abstract composition left behind by one of his former teachers, Roy Kiyooka, when Kiyooka left Vancouver for Montreal to take up another teaching post.

This indicates that Breeze, like so many young Canadians at the time, had not yet broken with colonial mentality. Canadians now lived in the abstract 'universal' space of U.S. international corporations, just as we had once inhabited the picturesque settings of the British empire. We could not even express our own sexual feelings, tangled as they are by relations of oppression, concretely in a Canadian setting.

Yet Breeze had made a decisive advance by taking up the painting of people. In the exhibition called *New Talent B.C.* that the Vancouver Art Gallery circulated to the rest of Canada in 1964-65, a significant number of the 18 B.C. artists included were again painting the figure. One canvas that drew the unfavourable attention of U.S. tourists seeing the show in Vancouver was *An American Tragedy* by Vancouver painter *David Mayrs* showing a doll falling on the stars and stripes. They complained that it desecrated their flag!

By this time many Canadians were active in supporting the civil rights struggle, which was really the fight of oppressed black Americans for justice. Some Canadian supporters travelled to battlegrounds like Selma, Alabama, while others organized large demonstrations at U.S. consulates across Canada. Growing out of the late 1950s protests against nuclear armaments in U.S.-controlled military bases in Canada, this was the beginning of a widespread movement, especially among Canadian students and other young people, against U.S. oppression.

These demonstrators had as yet no clear idea of U.S. imperialism. Racism, a fundamental prop of any imperialist system, was seen as a problem inside the United States.

Fig. 195a: Photograph from the Student Non-Violent Co-ordinating Committee (SNCC) poster, reproduced in The Ubyssey, University of British Columbia, 1965

Fig. 195: Claude Breeze, *Sunday Afternoon: From an Old American Photograph,* 1965, acrylic, 101 1/2" x 66", Dept. of External Affairs, Ottawa

Like *Lovers in a Landscape*, the space in which this generation's protests occurred was still south of the border.

In 1965 the University of British Columbia student newspaper *The Ubyssey* reproduced a photograph taken in the U.S. south during the 1920s, showing two lynched blacks hanging from a tree, which was being used as a poster by the U.S. Student Non-Violent Co-ordinating Committee (SNCC). Breeze saw it, and used it as the basis for his monumental painting *Sunday Afternoon: from an Old American Photograph* (Fig. 195).

This 8-1/2-foot-high canvas conveys in raging colours the atrocity of racism in the U.S. Breeze kept the hanging tree,

its foliage, and the position of the lynched bodies just as they were in the photograph. He added the mountain of flames that reach with pink and white hands to the hanging blacks and altered the landscape background so that its lines converge on the hanging couple, with a single vividly-coloured tree standing out on the horizon.

The difference between a painting and a photograph is well illustrated here. The photograph has an authenticity that the painting necessarily lacks: we know that the photographer stood before the original ghastly sight, whereas the painter was in his studio, long after the actual event. The figures of the lynched blacks are roughly clothed in the photograph, but Breeze has heightened the impact of his painting by showing them nearly naked. The great Spanish people's painter Goya had presented similar shocking scenes in this way in his *Disasters of War* etchings. At the same time Breeze brings out the grave dignity of his subjects by painting them life-size just as Courbet had done with French peasants, or Miller Brittain with the workers in his hospital mural cartoons.

The original photograph here is undoubtedly the better document; but the painter can deliberately incorporate a larger social meaning, which may or may not be present in the photograph. In this case a white man in a straw hat is seen from the back in the photograph, pulling on one of the hanging bodies. Breeze not only replaced him with the white hands of the flames; he also inserted a black man in his place, looking accusingly and self-confidently out at us. Although the primary emphasis of Breeze's painting is still on plight rather than fight, this man's head, at the same angle as the hanged man's but expressing determination rather than submission, at least suggests contemporary black Americans' courageous struggle.

By the mid-1960s the U.S. war of aggression against the Vietnamese people was the main issue around which the growing protest demonstrations gathered. Many Canadians joined in the international movement of solidarity with the Vietnamese, and thereby helped to hasten the Vietnamese victory. The Canadian government used its medical 'aid' missions and its seat on the International Control Commission to spy for the United States, but even our ever-obliging Prime Minister Lester Pearson had to tell U.S. President Lyndon Johnson that there was no possibility of a Canadian battalion to support U.S. troops this time.

Breeze's response came in his *Control Centre* and *The Home Viewer* series of paintings, produced in 1966-67. They were painted and framed in the shape of TV screens, sometimes with a panel of controls added. "Television pictures you can't turn off," Breeze called them.

The Home Viewer No. 1: Mother and Child (Fig. 196) is the most powerful statement in both series. It brings to passionate life in biting colour a scene that became a commonplace on TV news programmes: a Vietnamese mother clutching the napalmed corpse of her baby. Breeze simplifies the image, suggesting only flames for a background, and painting the two figures boldly with the garish contrasts of the colour TV set. The emotional impact of the painting is direct and overwhelming.

Breeze, as much concerned with our awareness of the

Fig. 196: Claude Breeze, *The Home Viewer No. 1: Mother and Child,* 1967, acrylic, 28" x 34", Private Collection

war through television as with the war itself, was subject to the limitations of the TV news viewpoint. Although he painted a companion piece contrasting a U.S. *Mother and Child*, and went on to a grim portrait of *American Determination* and a crew-cut *All-American Boy* in the series, he tended to concentrate on *Riot Victims*, dead bodies in the street, and scenes of intense suffering like this *Mother and Child*. He did paint one picture of a Vietnamese soldier firing a gun, but he did not show the great victories of the National Liberation Front (NLF), nor the subsequent Provisional Revolutionary Government (PRG), in caring for the wounded, bringing up and educating war orphans, and rebuilding vast areas shattered by U.S. attacks.

This paralleled a fundamental division that had opened up in the ranks of the demonstrators. "End the War in Vietnam", some cried, sympathizing with the plight of the Vietnamese but merely calling for an end to the bloodshed, even if that meant continued U.S. oppression of Indochina. "Victory to the NLF" others maintained, correctly observing that only an NLF and PRG victory could ensure an end to U.S.-backed exploitation and violence. Trotskyites and pacifists agreed on the first, opportunist slogan, while a new Vancouver-based organization of workers and students called Progressive Workers (PW) raised the second, anti-imperialist one. Founded by a group of B.C. Communists who had been thrown out of the Party for opposing revisionism, PW re-established the beginnings of anti-imperialist organization in Canada.

Breeze was largely unaware of the struggle between these two positions. In fact, he was isolated from support or patronage of any kind up to this time. He had held his first solo exhibition at the New Design Gallery in Vancouver in 1965, but sales were few. For years he made his living as a

medical illustrator and part-time teacher. His friend and fellow-student *Brian Fisher* was far more successful financially with his abstract paintings based on geometric renditions of a centred image picked up from their mutual former teacher, Arthur McKay. Fisher was selling out whole exhibitions, while many public galleries and museums were reluctant even to hang Breeze's paintings because of their content.

Breeze's potential public was clearly not among the bourgeois and petit-bourgeois collectors who were buying up Fisher's works. Yet in 1967 when he published a set of reproductions of drawings of a man's head called *Headlines* through Vancouver's Bau-Xi Gallery, no attempt was made to reach a wider audience with similar prints of his Vietnam subjects. In 1968 Breeze participated in the *Civil Liberties* exhibition in Chicago protesting police violence against demonstrators there, but the nearest any Canadian institution came to a similar manifestation was a travelling show called *On the Bias*, organized by the University of British Columbia's Fine Arts Gallery. The built-in expectation that such paintings were meant to appeal only to people with a certain 'slant' is evident in the very title of the show.

In 1967 Breeze's *Sunday Afternoon: From an Old American Photograph* was reproduced in colour in the first issue of *artscanada* magazine, which now replaced the former *Canadian Art*. After this national attention came several successful solo exhibitions at the Jerrold Morris Gallery in Toronto, and Breeze's inclusion in major international surveys such as the selection of Canadian art sponsored by the Canada Council at the Edinburgh International Festival in 1968. The Canada Council went further, and purchased both *Sunday Afternoon* and *Lovers in a Landscape: The Murder* for its collection, which has since been transferred to the new External Affairs Department building in Ottawa. But there are so many sensitive U.S. agents walking the halls that External Affairs "has not yet found a place to hang" *Sunday Afternoon*, so it is now deposited in the National Gallery.

The effect of his growing national reputation, combined with the dearth of patronage in Vancouver, has been to encourage Breeze to develop away from the explicit painting of people, and toward a more generalized figure-in-landscape art. In 1968, after a summer at an island cottage, he produced a series of shaped canvases (stretched over contoured or cut-out supports) called *Island*, in which sexual symbolism and abstract landscape forms were mixed by a spray gun that Breeze used to apply his paint. He went on to a series of panoramic landscapes seen from an actual wooden platform constructed at the base of the painting, with some 'human element' intervening, such as strips of flesh-coloured canvas dangling from a meathook.

Since then, Breeze has been artist in residence at the University of Western Ontario in London, where he has painted a *Canadian Atlas* series, in which he reverts all the way back to the abstract-landscape type of painting commonplace in Vancouver when he first turned to the depiction of people. A few figures are still to be glimpsed, with some obvious sexual allegories, but they are immersed in the currently fashionable revival of the abstract expressionist manner. The

"Canadian Atlas" of the title is an invocation of the cultural-nationalist cult of the landscape, not of a country in which people are living and struggling.

Not surprisingly, the first showing of these paintings was at the Marlborough-Godard Gallery, which used to be independent but has become part of the Marlborough-Gerson cartel based in London, England and New York. As of 1974 the great promise of Breeze's commitment to the painting of people, and to the expression of socially relevant subjects, is not being realized.

PAINTING THE PEOPLE AND PLACES WE KNOW

Breeze had taken a great step forward in the mid-1960s. Based on alienation and even isolation, his art was *for* the people, but not *of* them. To accomplish this goal, artists needed to combine the social and political commitment of Breeze with the sense of identity with their community of a Wyers or Panko. Such a combination was only possible where artists had rejected imperialist culture, and were ready to begin basing their art on the people and places around them. This happened in London, Ontario.

London is a centre of the insurance business, Ontario's next city after Toronto as a source of capital. London's bourgeoisie is intensely conservative, but has long had a strong national-bourgeois tradition. During the revolution of 1837-39 the London region was a major rallying point for the Patriots under the leadership of a rich land-owner, Dr Charles Duncombe. The farmers, workers, teachers, doctors and lawyers of the area are still predominantly patriotic. In this century a large working class has gathered in the east end of London, employed on the railway, in the breweries, and in many small factories.

Richard Curnoe, a Cornish immigrant, painted railway coaches in the London and Port Stanley Railroad sheds. His grandson, *Greg Curnoe*, born in 1936, grew up with an ambition to be a comic-book cartoonist, and went to the art school at the H. P. Beal Technical Institute after graduating from high school.

Just as Ernest Lindner was inspiring Claude Breeze and Ivan Eyre at Saskatoon Tech, so *Herb Ariss* and his staff at Beal gave fundamental direction to Curnoe and many other young London artists. Ariss was later to produce a series of paintings based on the heroism of the Canadian Corps in the battles of the Somme River during World War I. Although he acquainted his students with the whole range of modern art, he also set an example of taking people and history as subject matter.

Among Ariss's students just a few years before Curnoe was another intense young man, *Jack Chambers*. Winner of a prize in the Western Ontario Exhibition (the annual fall fair) at the age of 19, Chambers had set out in 1953 to tour Europe. Originally attracted to Madrid by the works of the great Spanish artists from *El Greco* and *Velazquez* to *Goya*, he was delighted to discover not only that the *Real Academia de Bellas Artes* (Royal Academy of Fine Arts) still offered sound instruction in the old techniques, but also that a popular tradition of realistic carving and painting persisted in the small towns and villages of Castile.

Chambers got a job as a glass cutter, saved his money, and entered the Academy. With the help of one Canadian and two Spanish scholarships, he stayed for the full six-year course and received his diploma in 1960. He then went to live in the village of Chinchon, south of Madrid, where he got to know some of the Spanish realists and folk artists.

Back in Toronto, Curnoe was having a less rewarding experience at another academy, the Ontario College of Art. Although realistic draughtman *John Alfsen* and print-maker *Fred Hagan* were helpful teachers, Curnoe was indifferent to the U.S.-style abstraction that was then beginning to fill the galleries. As for the fabled abstract expressionist teacher Jock Macdonald, Curnoe recalls that "he was sympathetic but he also confessed that he didn't know what I was doing."

In 1960, disillusioned with the imperialists' art world and the college, Curnoe went back to London. Many students from similar backgrounds have been intimidated by such mis-education, and abandon art altogether. But Curnoe felt confident of the worth of the patriotic, working-class community he had grown up in. He rented a studio and began to make paintings, drawings and *collages* (pieces of paper pasted together) that reflected his day-to-day life. His collages, for example, were composed of London city bus transfers and milk bottle tops picked up on London streets.

In 1961 Curnoe began publishing a magazine called *Region*, and joined with some friends to open the Region Gallery. His magazine included such features as an interview with a man who had decorated his bicycle with a great many reflector lights as a teen-ager during the mid-1950s.

In 1961 Jack Chambers returned to London. He had held his first solo exhibition in Madrid, but he had come to understand that the strength of the Spanish realist painters lay in their identification with and understanding of the society in which they lived. He had been painting Spanish peasants in the fields, but he now knew that he must go back to the people and places of his own southwest Ontario if he was to produce art that mattered. He and Curnoe became close friends.

While Curnoe worked as a helper on a Coca Cola delivery truck, Chambers managed to find a few patrons among University of Western Ontario English professors. He contributed poems and short stories to *Region*, and to another local magazine called *Alphabet*, edited by poet and playwright James Reaney, who was equally convinced of the necessity for artists and writers to find their subjects in their own community. Chambers illustrated a book of Reaney's poems, and Reaney published Curnoe's *The Coke Book*, a daily journal of his life on the job.

Curnoe's basic notion is that life comes before art, and that art must manifest life. This reflects partly his commitment to make everyday life as he lives and sees it more important than the international art world; but it also shows the influence of the 'anti-art' ideas of the dadaists, who had set out to 'destroy' bourgeois culture during and just after World War I. Encouraged by Michael Snow, who sent letters to *Region* from New York, Curnoe joined an international association for the study of dada, and along with Snow and Joyce Wieland participated in a Neo-Dada exhibition at Toronto's Isaacs Gallery in 1962.

A few months later Curnoe arranged for a *happening* to take place at the London Public Library and Art Museum, with Snow and Wieland on hand. These happenings, more or less chaotic events with audience participation, were based on similar theatrical evenings staged by the dadaists forty years before. They were fashionable in the early 1960s among New York artists associated with pop art, many of whom Snow and Wieland knew personally. It is striking that this dada influence led Curnoe to the only activity of his artistic career that could be described as continentalist.

It was also due to the anarchistic tendencies of dada that Curnoe joined with some London friends to form the Nihilist Party of Canada. This anti-organization was chiefly responsible for a good-natured annual picnic, and for producing "VOTE NO" stickers that were plastered between the eyes of other parties' candidates on election posters.

The "Party" generated The Nihilist Spasm Band, in which Curnoe, artists *John Boyle* and *Murray Favro*, several teachers and a librarian joined to play non-music on kazoos, drums, home-made guitars and bass. They made such a spirited racket that they became the weekly entertainment at a local tavern, and went on to play 'anti-concerts' aimed at driving their audiences out of halls all over the country. In 1967 the Spasm Band recorded *The Sweetest Country This Side of Heaven*, with lyrics like "Canada! I think I love you! But I want to know for sure!" Two years later, sponsored by the Canada Council, they played to bewildered audiences in Paris and London, England.

Curnoe painted the Spasm Band playing on the outside of a pyramid-shaped structure, which was large enough that the viewer could sit inside and read the Nihilist Manifesto, a largely anti-American speech made at a Nihilist picnic, the text of which Curnoe had lettered on the inside walls. Curnoe was learning to combine his everyday subject matter with a pointed political message. In 1965 he produced one of his finest works of this kind, an L-shaped panel designed to stand against the wall, called *For Ben Bella* (Fig. 197).

This is a remarkably advanced painting for 1965. In British Columbia, a new movement for independent Canadian unions had just begun, with the formation of the Pulp and Paper Workers of Canada. But the despondency of most Canadian intellectuals was expressed in George Grant's book, *Lament for a Nation*, which saw the struggle for Canada only as a noble lost cause.

Curnoe, by contrast, is full of enthusiasm for Canada, and makes savage fun of William Lyon Mackenzie King. Here is the Liberal Prime Minister who sold us out to the United States gradually from 1921 to 1930, and again from 1935 to 1948. He accomplished piecemeal what Laurier had failed to do with his proposed Reciprocity Policy in 1911. Curnoe paints Canada's arch-comprador in his favourite armchair in Laurier House, Laurier's Ottawa home that Mackenzie King took over, now maintained as a national 'shrine.'

The Struggle to Paint our People 227

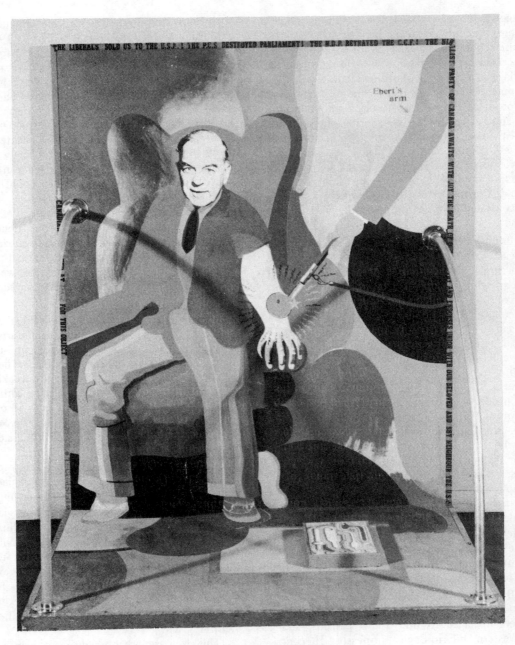

Fig. 197: Greg Curnoe (born 1936), *For Ben Bella,* 1965
oil, plastic and metal, 59 1/2" high, Edmonton Art Gallery

Curnoe shows this sly old sell-out getting a charge from an electric vibrator held by a friend of Curnoe, identified as "Ebert" on the painting. Mackenzie King's face is taken from an election poster photograph, pasted into place, and his shoes are painted out onto the floor of the structure, which is reinforced by exercise bars connecting the two panels.

Mackenzie King is not recorded as actually having used such a machine as this early form of a vibrator (other parts of which are shown in their box on the floor). But the slightly obscene suggestion that he did, along with the de-humanizing character of the bars, and the white flesh of his face and arm against the garish colours around him, are all quite suitable for a portrait of one of the most sinister traitors in our history. This is also the man who kept a light constantly burning before his mother's picture, and consulted her on matters of state in occult seances long after she was dead. He seems pinned to his armchair as if it were an electric chair. Between his feet Curnoe has added a patch of purple as a place for his beloved dog Pat, with an arrow indicating "PAT USED TO SIT HERE SOMETIMES."

Stencilled or stamped messages are an integral part of most Curnoe paintings. Along the left edge of this painting he emphasizes its status as a colonial commodity: "CANADIAN $ ACCEPTED AT PAR FOR THIS OBJECT." Across the top, and along the right side he adds:

Fig. 198: John (Jack) Chambers (born 1931), *Olga and Mary Visiting,* 1965, oil, London Public Library and Art Museum

To identify the issue of U.S. imperialist control so explicitly was a remarkable accomplishment in 1965. Like many oppressed people, Curnoe was able to do it only in the context of sarcasm, not unlike the bitter humour of black Americans. He tells the truth about our being "sold to the U.S.A.," but then makes the truth bearable with the heavy irony of his line about the Nihilist Party.

This sense of humour, and Curnoe's anarchism, also affects the list of names he prints on the floor panel to indicate a few of his many heroes. He stencils "DIEFENBAKER" prominently, because John Diefenbaker was a nationalistic Prime Minister compared to Mackenzie King. He includes "TECUMSEH" and "RIEL" as heroes of the native and Métis people, beside leaders of other nations' liberation struggles, such as "MAO", "HO", "LUMUMBA", "MALCOLM X", and the Algerian leader "BEN BELLA", for whom the painting is named. But then he adds "BERRA", the U.S. baseball player, as a continentalist pun after "BEN BELLA", and throws in "TROTZKY" (mis-spelled), who was in fact opposed to national liberation movements.

The over-all effect of this roster of heroes is to expose Mackenzie King as a traitor among the world's patriotic and anti-imperialist leaders. The Canadian sell-out's face is shown as he liked to see it, smiling out with vote-getting confidence. But the painting is titled *For Ben Bella*, not "For Mackenzie King."

This is a major painting that makes an important political statement. Most Canadians know that the country has been sold out, but there are many who have not yet clearly identified all the well-paid agents of the sale. Curnoe satirizes a man who is supposed to be a Canadian institution, and helps us to recognize him as the despicable character he was. This is national, scientific and democratic art with high spirits, and a lively sense of fun.

At this same time, Jack Chambers in his paintings was establishing the theme of everyday life and death in London, Ontario. Since his return, he had been painting pictures of his family and friends in fields around London, often mixing the living with the dead. Sometimes, as in *Olga Visiting Graham*, he actually located his figures in a London cemetery. More often, he simply integrated his ancestors into a blooming field with living relatives, to affirm his sense of the on-going rhythm of life, death and re-birth.

By 1965 Chambers was able to take a commonplace incident like his wife and a friend chatting in the living room, and make of it the impressive painting, *Olga and Mary Visiting* (Fig. 198). By fragmenting his figures, he

could suggest the passage of time. The picture is a simultaneous record of several moments; the coffee cup is missing from Olga's hand, but it appears above and to the right, as it would if she were standing. There is a sense that time has already passed, as when we look at a snapshot of just such a casual event, or as if we had bits and pieces of a home movie of the visit.

Like Snow, Chambers was interested in the implications of photography and film for the way we see. But he was concerned with the way these media influence our perception of *people*, especially our perception of the people and places we know.

In 1966 Chambers began to make films. In the following year he produced *Hybrid*, which showed time-lapse photographs of flowers opening, superimposed over the scarred faces of napalm victims in Vietnam. Although Chambers, like Breeze, clearly saw the subject as one of the plight of the suffering rather than the fight of an oppressed people, his short film is among the most evocative works of art produced in Canada in protest against the U.S. war.

Chamber's experiments in film began to affect his painting. His fragmented figures, always embedded in thick pigment, now became silvered reflections on a silver ground, sometimes with "colour options" added above, so that the viewer could 'mix' the colours in his imagination. Chambers was considering the effect of looking at people and things by means of the reflected light of the movies, so he was painting his figures in positive-negative contrast, as they appear on film. Experimenting with the differences between a black-and-white and colour print of a film, he was also separating out his colours in his paintings, the way printers do in the colour reproduction process.

In the winter of 1967-1968, Chambers took this use of photography and film in his paintings about London to its highest point. While searching for TV footage in the archives of the local television station for his feature-length movie *The Heart of London* (named after a Curnoe painting of the same title), he printed up a number of still shots for use in his pictures. *Regatta* (Fig. 199) is one of the remarkable works he completed in 1968 from this source.

Fig. 199: Jack Chambers, *Regatta No. 1*, 1968
graphite on paper under plastic panels, 51 1/2" x 48",
London Public Library and Art Museum

Regatta is actually a group of large drawings. On the right, arranged like the frames of a movie film, are positive and negative versions, some inverted, of a photograph that was used on the London TV station's news to identify a local boy who had drowned. The large picture of the family, not related to the boy, is taken from some other TV footage. The pictures of the regatta above and below are based on a TV newsreel of a boat race on Lake Erie.

Each of these drawings has been painstakingly produced by rubbing graphite into large sheets of paper. Instead of sketching directly on the paper, Chambers first prepared his surface with an even layer of graphite that approximates the middle tonal range of the still photograph that he printed from the TV film. Then he rubbed in more graphite, or erased, until the figures appear as darker or lighter contrasts on the silver-grey surface.

Chambers has then covered the whole work with layers of coloured plastic. These dull, slightly tinted shields put the pictures at a psychic distance from us, just as if we had turned on the six o'clock TV news and heard about the

drowning, watched some event which the family attended (they appear to be dressed as if for a party), and then saw the regatta on the sports news.

These are just the connections Chambers wants us to make. The family is evidence of the joy of life, dressed up, smiling, confident. The dead boy also smiles, in the one version where we can see the details of his expression; in the other frames Chambers takes out the middle tonal values (the 'mid-tones' of the printing process), so that only a silhouette, rendered in differing degrees of contrast, leaves a fading image of the drowned victim. The regatta scenes, like a frieze on an ancient funerary urn, again affirm the joy of life by showing us a gay sporting event on the water.

Here again is the idea that death is part of life, that living and dying form a constantly renewed cycle. We sense the spark of life in the picture of the drowned boy; then we are all the more keenly aware that both the boy and the family have been photographed in moments when they were as alive as we are now. Our own consciousness of living and changing through time is heightened, just as it would be by

looking at old family snapshots or home movies of friends and relatives. Chambers broadens that awareness to include other people, and deepens it to encompass death.

Chambers is doing for the people of a typical Canadian city what Gustave Courbet did for the peasants of his region of France, in his paintings with similar themes such as *The Burial at Ornans*. He is proclaiming the dignity of the life and death of these people as the subject for important works of art. This is a powerful basis for an art of the people. It is particularly valuable in a colony.

Yet there is an important difference. Courbet presented the life of the peasants realistically. Chambers approaches his subject through the conventions of TV. Of course, it is important to examine the effect that film, photography and television are having on our perception of people. But Chambers, like Snow, Breeze and Marshall McLuhan, still concentrates on the technological effects and formal properties of the medium. The question of content and the class outlook of the owners and advertisers of the media go unchallenged. Snow and McLuhan avoid any significant consideration of subject matter, while Breeze and Chambers allow their subject matter to be determined by the TV news programmes from which they draw their images. Everyone has seen countless news items about personal tragedies like the accidental drowning of the boy. But how often are the deaths and injuries of workers in factories or on construction projects reported in similar detail?

This tendency to avoid the material reality of the life of working people only reinforces Chambers' religious idealism of seeing life as a constant, unalterable cycle of death and re-birth. In these pictures, the regatta of life and death simply goes on and on. Courbet's realism cried out for change. The paintings of Chambers do not.

BEGINNINGS OF A NEW
ANTI-IMPERIALIST MOVEMENT

In 1968, Greg Curnoe became the latest Canadian artist to receive a commission from the Department of Transport to decorate our airports with a mural. Most such work has been done by the various U.S.-style abstract artists, with a few notable abstract-landscape compositions such as Jack Shadbolt's huge painting in the Edmonton airport.

Commissioned to fill a corridor at Dorval Airport in Montreal, Curnoe rose to the occasion with a large painting on the history of flight and its uses in warfare (Fig. 200). In his usual comic-strip manner, Curnoe painted the *R-34*, a 1919 British dirigible that had made the first trans-Atlantic crossing. His lettering on the painting included a quotation from the diary of a German airforce pilot on a 1917 bombing raid over London, England: "IT IS THE HEART OF LONDON THAT MUST BE HIT." Curnoe characteristically filled the dirigible with his own "heart of London, Ontario," his family and friends. He painted his son beside another World War I German pilot in the cockpit.

Extending the theme, Curnoe painted a man who looked very much like U.S. President Lyndon Johnson, flying through the air with bombs falling out of him and exploding below! Among his heroes he painted a portrait of Mohammed Ali, the black American boxer who was then refusing a U.S. military call-up to fight in Vietnam.

While Curnoe was installing the mural in Montreal, some U.S. Customs Officers came to look over his shoulder. They didn't like the Johnson figure, and they didn't like Mohammed Ali.

U.S. Customs Officers are powerful critics: they complained to Department of Transport officials, and within 36 hours, before Curnoe could even finish installing the mural, down it came! Curnoe's home town newspaper, the so-called London *Free Press*, which had earlier printed a favourable account of the painting by regular art critic Lenore Crawford, suddenly changed its mind in an earnest editorial that concluded:

"Mr. Curnoe exercised his artistic licence to reflect what must be deep-seated convictions against the war in Vietnam and American influence in Canada. He would be a poor painter of pictures if his work had no message. But this was the wrong message, delivered in the wrong place and at the wrong time."

In fact, Curnoe had offered to 'fix' the mural, by painting big black squares or grids over the offending portions, or else by stencilling the word "CENSORED" over them. The Department of Transport officials objected that "Everyone will see that the mural has been censored". Curnoe replied that that was exactly what had happened. The Department of Transport paid him his commission and deposited the painting in the National Gallery, which has subsequently mustered the courage to exhibit it.

While Curnoe was determining the limits of acceptable subject matter in the colony, the anti-imperialist movement in Canada was gaining strength, and organizational form. In 1968 Canadian workers led the way with the formation of the Council (now Confederation) of Canadian Unions (CCU), a new national centre of the all-important struggle for independent Canadian unions. Farmers, especially in the west, were demonstrating against the effects of government-backed U.S. agribusiness, and formed the National Farmers' Union (NFU).

On the campus, Robin Mathews and James Steele, two Carleton University professors, brought out a powerful book entitled *The Struggle for Canadian Universities*. It documented the takeover of our universities by U.S. professors. As many of our colleges and universities had opened or expanded to meet the rising demand for higher education through the 1960s, U.S. professors by the thousands had swarmed up to take over Canadian jobs. They were encouraged by the sell-out businessmen on the university boards and by the Canadian government. Both university administrations and the government invited U.S. professors on permanent appointments to take fraudulently a two-year income-tax holiday that was supposed to be for visiting professors only.

By 1970 Canadian professors were reduced to an absolute minority in our English-speaking colleges and universities, as U.S. department chairman and U.S.-majority faculties were hiring their friends in increasing numbers. After 1968 only one in four professors hired in Canada was a

Fig. 200: Greg Curnoe, *R-34,* (Mural intended for Dorval Airport), 1968, seen here with the artist
oil on board, National Gallery of Canada

Canadian citizen. As Mathews and Steele pointed out, fine art and art history departments across the country were among the most heavily dominated.

"There's no need to be afraid of undue American influences, because, after all, art transcends boundaries."

So Curnoe ironically proclaimed in one of his lettered paintings. He was quoting from Nova Scotia College of Art and Design president Garry Kennedy, who was in the process of reducing Canadian citizens on his faculty in Halifax to less than 35 per cent, while bringing in an almost 50 per cent U.S. teaching staff. Not a single member of the University of Windsor art department was a Canadian citizen! In the art schools and university art departments, British teachers also moved in wherever they could: even in London, Ontario, the new Fanshawe College of Applied Arts and Technology hired a British art department chairman, who then proceeded to advertise in England for

teachers, despite the active London art scene all around him.

In 1969 a group called the Waffle started to raise issues of Canadian independence within the New Democratic Party (although they 'waffled,' and thereby earned their name, on the vital issue of Canadian unions). And about the same time the Canadian Liberation Movement (CLM) was formed to unite all classes, groups and patriotic individuals to fight for an independent, socialist Canada. The CLM made the struggle for independent Canadian unions its highest priority, and in 1970 also launched the 85 per cent Canadian Quota Campaign, to fight for an 85 per cent minimum quota of Canadian professors in our universities and colleges.

Curnoe contributed to the growing struggle in many ways. "THIS IS TRULY GREAT ART BECAUSE IT WAS NOT MADE BY AN AMERICAN", he inserted into one lettered painting. He had already publicly refused to exhibit

his art in the United States, and turned down two offers of commissions to do both a *Time Canada* and a *Time International* magazine cover. When the U.S. tobacco firm Benson and Hedges brought up an all-American jury to select Canadian paintings to be reproduced as outdoor murals by imported U.S. billboard painters, Curnoe submitted proposals for huge lettered slogan paintings as outrageous as the occasion warranted, such as: "FIGHT POLLUTION – TELL AN AMERICAN TO GO HOME TODAY."

In 1968 Curnoe also produced a series of lettered panels called *The True North Strong and Free*. One panel from this sequence, "CLOSE THE 49TH PARALLEL, ETC.", became the title and cover of an important collection of essays subtitled *The Americanization of Canada*, which was published in 1970. In that same year Curnoe and Hamilton, Ontario poet David McFadden brought out *The Great Canadian Sonnet*, which was illustrated by such sketches as his 1969 ink drawing of a Canadian plane shooting down a U.S. invader, over the ironic caption "America is Truly Great" (Fig. 201).

But Curnoe did not limit himself to an individual artist's activity. From its beginning, the London scene, like the Group of Seven, had been a collective enterprise attracting many artists. The Region Gallery had been succeeded by the co-operative 20-20 Gallery (so named for its 'perfect vision'), and *Region* magazine was supplemented by *20 Cents* (25¢ in Canada), which reviewed the many exhibitions and events in the city. Sculptors, painters, print-makers, film-makers and craft workers suddenly abounded, as Beal Tech graduates followed Curnoe's and Chambers' example and opened studios above stores. Other artists moved to town, and Curnoe kept discovering people who had not thought of themselves as artists, but who were definitely a creative part of the London community.

Neither Curnoe nor Chambers encouraged imitators, nor any kind of a London 'school'. Much of the work done, especially in sculpture, was even continentalist in character. But while various directions among the artists contended, it was clear that the London art scene was not a colonial branch plant, as Regina had been. Above all, it was not dependent on approval from the imperial culture, but was largely self-sufficient and marked by a spirit of co-operation and mutual support among almost all the artists.

Meanwhile, the 1960s had seen a great proliferation of art museums and public galleries. Especially during the Centennial, these institutions had acquired new buildings, bigger budgets and more staff. The new universities, Trudeau-era government institutions both federal and provincial, and industries concerned with their public image were all organizing exhibitions, sponsoring tours, printing catalogues and distributing reproductions and slides in collaboration with these galleries and museums. It was claimed that Canadians shipped more art more miles per capita than any other country!

Cultural bureaucrats prospered. So did editors, printers, education administrators and insurance companies. But the whole enterprise was operated on the insidious assumption that artists should lend their work for exhibition, make their paintings available for photography and reproduction, and then go quietly back to their studios in the hope that the 'free' publicity would somehow, someday help sell a painting here or there. Well-known artists had their work travelling all over the country, but were unable to pay the rent on their studios. The little money available for culture in the colony was all going to the businessmen and the bureaucrats. The artist produced the paintings that made the whole system work, and everyone except the artist was getting paid!

In 1967 the National Gallery included a Jack Chambers work in its offering of colour slides to schools and colleges. Chambers, who was totally dependent on his art for his livelihood, noted that he legally maintained copyright in his paintings after they are sold, and requested a fee. When the Gallery at first resisted setting such a precedent, Chambers simply followed the co-operative and self-reliant outlook of the London artists by calling together a group of his colleagues, who began to negotiate jointly for fees on all reproductions, postcards and slides. In 1968, just as workers were forming the CCU and farmers were joining the NFU, this group of artists constituted themselves as the founding body of Canadian Artists' Representation (CAR). Curnoe became an active recruiter for the new national organization, and Chambers was its first national chairman.

Chambers had achieved considerable personal success in

Fig. 201: Greg Curnoe, *"America is Truly Great"*, 1969 ink, 11" x 12", Private Collection, Toronto

Fig. 202: Jack Chambers, *401, Towards London, No. 1,* 1968-9
oil on board, 72″ x 96″, Private Collection, Toronto

1968. *Regatta* had won a major award in a national survey show called *Canadian Artists '68.* He also won a prize in the film category for *R-34,* a film about Curnoe and the Dorval mural. But in that same year, Chambers was told that he had leukemia.

Chambers has said that the knowledge that he is suffering from this lingering but almost certainly fatal blood disease reversed his ideas about art and life. "My new paintings are reality," he said. "Reality is what you see out there." Calling his new approach to painting *perceptual realism,* he explained:

> *"I am not interested in art, I am interested in life. When you are interested in life more than you are in painting, then your paintings can come to life. This is perceptual realism, where life is a motivating force. . . ."*

In the shadow of death, Chambers was producing work imbued with his heightened perception of life. Able to remain in his studio for only a few hours each day, he had squared off a colour photograph of Highway 401 east of London, and proceeded to paint it with a vivid, purposeful intensity:

> *"You have in the completed painting an integrated unity . . . an integrated focus of intention at work here . . . which people in their own lives grope for and have a deep longing for when they turn to life itself, to their own lives, for meaning and focus. They try to understand their worldly life as they exist in it and as they are working in it, in a unified way, so that a particle of life, any particle, can be looked at and the complete meaning*

> *can be seen without having to see the whole. The whole can be envisioned by understanding the particle."*

401 Towards London (Fig. 202) is the kind of matter-of-fact landscape that we take for granted on any drive. The viewpoint is from above, and three-quarters of the painting is filled with a magnificent blue sky and its white cumulus clouds. It is a fine day in early autumn, judging from the rust-coloured deciduous trees among the evergreens. The background on the left is not unlike the landscape that Ebenezer Birrell painted just as realistically in the 1830s in Pickering (Fig. 62).

But it is high morning, 1968, at the Delhi interchange, with a truck rolling west down the majestic highway toward London, the sun behind and to the east casting shadows across the road. To the right, among the parklands of southern Ontario, are the typical light-assembly plants of colonial industry, and a truck warehouse. The workers are all inside, the parking lots full. This is the main artery through Ontario's heartland, as well as the main access for shipping to and from the U.S. mid-west.

Painted on a six-by-eight-foot rectangle, *401 Towards London* proclaims more clearly and triumphantly than ever that our land and people are suitable subjects for a major work of art. No formalistic considerations are allowed to obtrude or affect the panorama in any way. Here is an artist painting people and places we all know, as directly and as realistically as Tom Thomson painted our northland!

Chambers' painting is the very opposite of Colville's magic realism. Instead of isolating his subject from the on-going process of material reality, Chambers paints the

Fig. 203: Jack Chambers, *Victoria Hospital,* 1970
oil on board, 48" x 96", Private Collection

process itself. Rather than arranging his subject in a static, classical composition, Chambers follows faithfully the information he finds in the colour photograph. He does not try to treat the whole surface evenly, but emphasizes spatial depth and movement, just as Tom Thomson did in his late painting *The Drive* (Fig. 124).

401 Towards London is national, enhancing the dignity of Canada's places and people as the subject for major painting. It is scientific, realistically portraying the very guts of the economy of southwest Ontario. And it is democratic, extolling a common scene from the daily life of work and travel of the masses of the people. As our national liberation struggle was growing, our new-democratic art was also moving a step forward.

In 1970 Chambers painted an equally moving but much bleaker picture of *Victoria Hospital* in winter (Fig. 203), showing the eight-storey building in the distance along the frozen Thames River, with a few conifers standing out among the barren trees under a leaden grey sky. This was the hospital where Chambers underwent treatment when he was closest to death. Around the hospital are the smokestacks, houses and buildings of London. All is muted, hospital-quiet, and only the tangled boughs of the bushes and trees against the snow reflect the artist's anxieties.

Victoria Hospital was an understandable, perhaps inevitable choice of subject matter for Chambers, that led him to a major painting that incorporates his own experience with the life of the people around him, many of whom have been born, struggled against illness or injury, or have visited sick relatives and friends in this same building. But in many of his other subjects in the past few years, Chambers has turned either to domestic scenes, showing his sons watching TV in the living room on a sunny winter morning, or else turning back to the unoccupied landscape, as in a 1971 view of *Lake Huron*, which is a reversion to the unpopulated Georgian Bay landscapes of the Group of Seven.

Chambers' problems in moving ahead with his art have been aggravated by his difficulties with patronage. Since his terminal illness has become public knowledge, his few,

slowly produced paintings have become 'sure things' for investors, who anticipate their future scarcity. Prices have mounted to $10,000, $25,000 and now $35,000 per painting. Chambers welcomes the earnings as long-delayed payment for his many years of hardship, and as a form of insurance for the future of his family. But the buyers have necessarily been private corporations or wealthy individuals, so that Chambers is able to reach most people with his paintings only through reproductions, or in exhibitions like the 1970 retrospective showings of his work at the Vancouver Art Gallery and the Art Gallery of Ontario. And there are signs that the number of patrons who are willing to pay these prices for paintings in a colony is very small.

For this reason Chambers has been even more acutely aware of the problems of patronage than most artists, and has redoubled his efforts as first national chairman of CAR to advance what he calls the "principle of fair exchange", according to which artists get paid a fair return for the many uses to which their work is being put by public galleries, museums, magazines, book publishers, governments, industries, universities and school systems. Without being aware of the historic precedent of the Artists' Union demand of 1937, CAR has established a fee schedule (in fact, a very modest one), on the basis of which artists *rent* their works (rather than lend them) to exhibitions. CAR has also insisted that royalties be paid to artists for reproductions and slides of their paintings.

The implications of such a programme are far-reaching. No longer so dependent on the high-priced sale of a single original, the artist can begin to derive a portion of his or her revenue from the public use of pictures. The power of the dealer and the wealthy collector is reduced, and the artist realizes the advantages of collective action rather than individualistic competition. CAR has successfully opposed many of the old-style jury shows, in which artists actually paid a fee to enter, in order to compete for a few prizes, and then had to pay the shipping charges for rejected entries!

By 1971 Chambers recognized that the time had come for a qualitative change in the status of artists in this

The Struggle to Paint our People 235

country. What the Artists' Union had failed to do in 1937, what the Federation of Canadian Artists had set out to do in 1941 at the Kingston Conference before being swallowed up by the Massey Commission, the Canadian Artists' Representation would now accomplish.

Thirty representatives of 250 practising artists from Ste. Anselme, New Brunswick to Baker Lake in the Northwest Territories met in the historic Labour Centre in Winnipeg: CAR's first national conference was convened, and a new national artists' organization, controlled by and for Canada's artists, was a dynamic reality!

The delegates agreed on copyright royalties and an exhibition rental fee schedule. They set a deadline of January, 1973 for all museums and public galleries to begin paying these fees. And they insisted that the federal government start enforcing its legislation requiring that one per cent of the construction costs of all new public buildings be spent on works of art for the buildings.

This 1971 Winnipeg conference took a much more direct approach to the problem of U.S. domination than the Massey Report had, twenty years before. Keenly aware of the problem described in Mathews' and Steele's book from their own bitter experience in art schools and universities, where many had been denied teaching jobs that were taken by U.S. and British artists, they unanimously endorsed the petition for an 85 per cent minimum quota of Canadian professors in our colleges and universities, the petition of the 85 per cent Canadian Quota Campaign.

Still hobbled by vestiges of colonial mentality, the delegates initially rejected the proposal that all CAR delegates and executive officers must be Canadian citizens. Then Michael Snow, delegate for expatriate artists from New York, insisted that the issue be re-opened, and argued persuasively in favour of the Canadian citizenship requirement. Joyce Wieland supported him, urging the delegates to recognize the extent of U.S. control of our country.

"I speak from a long background of Canadian cowardice", Snow concluded. Both he and Joyce Wieland had especially good reasons to understand why this principle was fundamental to the success of CAR. By a narrow margin, the delegates reversed their decision and passed Snow's motion. This is now one of the basic strengths of this patriotic and progressive organization.

The conference sent a telegram to U.S. President Nixon, in which the delegates added their voices to the massive protest against the U.S. nuclear bomb test at Amchitka Island in Alaska. And they passed a motion that *artscanada* magazine deal only with art in Canada, be written only by Canadians, and include a section written by artists.

The able chairman of this historic conference was the founder of CAR, Jack Chambers. His commitment to life has extended a long way beyond his painting. He has led the way to a new national artists' organization that is capable of beginning a basic change in the patronage of artists in Canada.

THE PAINTING OF PATRIOTIC HEROES

"Coming to Toronto to be an art student? Be prepared for the big city art sell. You have to buy that stuff that says art, artists and true culture are the preserve of the large urban centres. Culture just can't happen in your home town."

So wrote *Sandy Fairbairn* in 1973 in St Catharines, which is just north of his home town of Welland, Ontario. Like Curnoe, Fairbairn had returned from the Ontario College of Art disillusioned with the international art world.

In St Catharines Fairbairn found a stimulating group of artists at work. Despite the official art schools, artists are beginning to apply the lessons of co-operation, self-reliance and independence of the imperial standard, lessons first learned in London. The painter who brought these ideas to the Niagara peninsula was *John Boyle*.

Born in London in 1941 to a family for whom higher education was a prohibitive luxury, Boyle became an elementary school teacher, and painted in his spare time without any formal training. Encouraged by Curnoe and other London artists, he began to cover eccentrically shaped wooden constructions with images of friends and people he admired. At first his coarse, rope-like textures showed his enthusiasm for the paintings of *Vincent van Gogh*, which he had admired in a travelling exhibition from the Netherlands, the first large-scale art show he had ever seen.

On his own in St Catharines, back in London for a year of university in 1964-65, and then in St Catharines again, Boyle gradually developed his own robust style. His unique apprenticeship in London had fitted him better for his new career than any fine-art diploma or degree. Instead of contemplating the idealistic precepts of artist-teachers domesticated by dreams of tenure, or learning to copy the latest New York style, Boyle benefitted from the practical, day-to-day experience of shrewd professionals like Curnoe and Chambers, toughened by contending in an environment similar to his own. Above all, he was never taught to despise his own background. Instead, he was encouraged to paint what he knew.

Boyle liked the paintings of Tom Thomson and the Group of Seven. Our U.S.-dominated art schools were teaching that the Group was merely a second-rate provincial variant of European painting, but Boyle had not been exposed to that mis-education. Thomson, another southwest Ontario boy who had learned to paint largely on his own, was one of Boyle's heroes. From Curnoe, who had named heroes on his lettered paintings and depicted his favourite hockey players and Canadian boxing champions, Boyle took over the idea of painting such an heroic figure.

Midnight Oil: Ode to Tom Thomson (Cover, Colour Plate XIII, Figs. 204, 204A) is the greatest of Boyle's many paintings of Thomson. Not only does a Canadian historical figure appear in a setting we can recognize; but that figure is heroic, both in scale and significance. Our history and our culture are embraced as a strong, healthy tradition on which to build.

Working from photographs made available to him during the preparation of a new book on the mystery of Thomson's death, Boyle portrays the great artist on all sides

Fig. 204: John Boyle (born 1941), *Midnight Oil: Ode to Tom Thomson*, 1969,
oil on board, 8 ft. high, London Public Library and Art Museum

of a complex, roughly Y-shaped structure that stands forth like an ungainly, home-carpentered version of *The Jack Pine*. The figure continues in perspective over joists and reinforcements of this structure. The hero is presented in a matter-of-fact, workmanlike way.

In the base, Boyle has installed a light that flashes on and off. This gives a simple, mechanical 'inner light' to the tree-like shape, making a contemporary, indoor equivalent to a campfire. The title, *Midnight Oil*, draws our attention to the use of light and darkness in this oil painting, and also to the hard, long-into-the-night work that lies behind both Thomson's achievement, and Boyle's.

On the front of the painting, in the stem of the Y, Boyle paints Thomson as he appears in a photograph taken in Algonquin Park, fishing in front of a beaver dam. In the

upper left, Thomson appears again, this time as in a photograph taken at a much earlier age; behind the artist, Boyle paints a landscape along the Welland Canal near St Catharines, complete with today's Canadian flag on the horizon. In the pointed right wing, Boyle adds another contemporary reference by depicting the canoe of the Canadian Broadcasting Corporation research crew at Canoe Lake, photographed while the CBC was preparing a TV documentary on Thomson's death there.

Thomson's working life as a fishing guide is emphasized again on the back of the painting (Colour Plate XIII), where Boyle has covered the stem of the Y with a magnificent portrait of Tom Thomson tying a fishing fly, based on a photograph taken at Canoe Lake. Like Chambers in his earlier work, Boyle represents his figures by taking out the

The Struggle to Paint our People 237

Fig. 204: John Boyle, *Midnight Oil: Ode to Tom Thomson*, 1969,
oil on board, 8 ft. high, London Public Library and Art Museum

mid-tones, giving them contour and modelled shape only by showing the deep shadows and highlights in contrast, as in some kinds of billboard and poster art. Again, this is a reference to Thomson, who used the commercial art techniques of his own time. The result for Boyle's painting is a highly dramatic, evocative surface, on which we readily combine the patterns made by these contrasts to complete the modelling in our imagination.

The Canoe Lake shoreline behind Thomson tying the fly is closest to Thomson's style in *The Pointers*, while the beaver dam in the front of Boyle's structure is handled with the luminous clarity of the painting that Thomson left unfinished, *The Drive* (Fig. 124). Both sources are late Thomson paintings in which that great artist was moving toward the depiction of people in the landscape. Boyle,

using photographs of Thomson himself, has taken up that theme again.

All over the painting Boyle mixes past and present. Thomson stands before the industrial St Catharines skyline, with today's Canadian flag on the horizon. In another work in this series, Thomson looks up from his desk at Grip, with several St Catharines artists standing behind him. The hero is seen as a person we know, in the context of life today.

The two portraits of a woman on the back of *Midnight Oil* have somewhat the same effect; Boyle has painted a St Catharines woman he knows, instead of portraying Thomson's fiancée, Winnifred Trainor. In later paintings Boyle puts his wife beside Chief Big Bear, or depicts his favourite musicians, St Catharines Athletics lacrosse stars of the past, a few nude figures, and revolutionary Canadian

heroes like Dr Norman Bethune, Louis Riel, or Riel's guerrilla captain, Gabriel Dumont, on the same panel. Sometimes this free association of heroic figures with others weakens the painting or even defeats its purpose altogether, as when he paints a nude girl on the back of a portrait of Bethune, or puts a naked Emma Goldman, the anarchist hero, beside Gabriel Dumont. Boyle is still nervous about introducing us to his heroes, and finds it necessary to present them in the company of people he knows, or in the context of the nude figure, suggesting that they are only artist's models. This reflects a small-scale outlook on Boyle's part: he has not yet completely shaken off colonial mentality, and attained the confidence to depict his heroes 'straight,' without these associations.

Why are heroes important? It is the people who make history, not great individuals. Outstanding personalities and leaders can only take action when the people as a whole have taken the struggle to a certain stage. Thomson, for example, could only achieve his great paintings in the period of rising national awareness that preceded and accompanied the First World War.

Nevertheless heroes are of great value to any nation, because they sum up, intensify and advance to their highest point the qualities of the people at that time and place. So Thomson gave expression to the patriotic upsurge of his time, resolved the struggle for the landscape, and made possible an independent art of the Canadian northland.

Heroes are especially valuable in a colony. We are taught to ridicule, ignore or belittle our own history, at best to accept it as inevitably a quiet backwater of the world's events. We are told that the great heroes of history all come from the imperial centres. Canadian school children are taught to respect Lord Durham, not Mackenzie, and learn far more about U.S. astronauts than about Dr Norman Bethune.

Paintings like Rita Briansky's *Dr Norman Bethune in China* (Colour Plate XI) have been rare in our colonial history; she herself did not advance the theme in her subsequent work. In the early 1950s Aba Bayefsky did paintings of Paul Bunyan, who was originally a New Brunswick and Québécois logging giant, before the Americans took over his legend. But Bayefsky's work lacked the bite of realism, being founded on a largely mythical figure.

Just as Curnoe had leaped ahead in *For Ben Bella* to make an important anti-imperialist statement, and Chambers had broken through to the realistic depiction of our own time and place, so Boyle in 1969 took a further step forward with his portrayal of Canadian heroes. These are landmarks along the way to a people's art.

A NEW STAGE IN THE ANTI-IMPERIALIST STRUGGLE

Like Curnoe, Boyle has consciously linked his art to the anti-imperialist struggle. In 1971 at Queen's University in Kingston, he and Curnoe read their *Refus Continental*, in which they replaced the anarchistic revolutionary message of Borduas' *Refus Global* with a pointed (though still anarchistic) attack on continentalism. The title of Boyle's 1974 series of paintings is a point-blank *Yankee Go Home*.

In his introduction to the catalogue for an eight-year retrospective showing of his work at the London Public Library and Art Museum in 1974, Boyle wrote:

"Those people who still look to Europe or the United States for their standards are, to me, putrescent vestiges from the colonial era, and their dogma misbegotten piffle. New York built a sham culture on the long dead cadaver of European art and produced nothing of any consequence. Its missionaries knowingly or unknowingly represent the vilest and most noxious elements in the American business aristocracy and preach to an unaffected and unreceptive population. Canadians are more aware of foreign cultures than any other people on earth. It is time now to look at our own art and study it carefully in the context of our own life experience."

Like both Curnoe and Chambers, Boyle has also helped to build the organizations needed for the independence and collective self-reliance of Canadian artists. Just as Curnoe had encouraged Boyle and many others in London, so Boyle in turn inspired younger artists and writers in the Niagara area to depict the people and places they know, and helped older painters like *Egidio Fantinel* of Niagara Falls to take their work more seriously. The Niagara artists have their own review magazine, called *Twelve Mile Creek* after a stream that runs through St Catharines, and have formed an extremely successful association, the Niagara Artists' Co-operative.

In 1970 this group staged its first exhibition, called *Niagara Now*, at the Rodman Hall Art Centre, St Catharines' public gallery. Two years later their exhibition took the form of reproductions of their paintings on 14 billboards all over the peninsula, hand-painted by commercial artists on the basis of squared-off photographs of their work. Paid for by industrial sponsors, this was a project to literally 'put the figure in the landscape' and bring art to the people. The Co-op arranged for buses and a car rally to tour the billboard sites, and exhibited the originals on which they were based at Rodman Hall.

In 1973 the Co-op produced a set of 12 prints, which they marketed through a St Catharines discount store at $3.49, four for the price of three. They also sold copies of the prints and their paintings through a rented downtown store, which attracted 4,000 to 5,000 people during the 23 days it was open. The artists gave demonstrations of their techniques every night, showed films and held concerts, and got the city to pay the cost of installing a gay set of banners on the lamp-posts along the street. A bus decorated with the banners then took the exhibition to other southwest Ontario towns.

The St Catharines artists have extended their fine collective spirit to the provincial and national level through active participation in Canadian Artists' Representation. The Winnipeg Conference had decided on a regionally-based organization for CAR, and the first region to develop, not surprisingly given its early initiative, was southern Ontario.' In 1972, with locals springing up in Toronto, Ottawa, Hamilton, Windsor, Peterborough and other centres as well as London and St. Catharines, Canadian Artists' Repre-

sentation, Ontario (CARO) was formed, and John Boyle was elected first spokesman.

By this time the National Gallery had recognized the artists' legal right to copyright royalty fees for colour slides, postcards and other reproductions. After prolonged negotiations most of the leading public galleries and museums recognized the principle of fair exchange, and many agreed to pay rental fees for their exhibitions, just in time to meet the CAR deadline of January, 1973. But organized artists now found themselves faced with sterner opposition.

Up to this point the U.S. imperialists had always preferred to work through their compradors in the colony to manipulate Canadian culture. But in June, 1972, 29 of them, including David Rockefeller, Henry Ford II, Armand Hammer of Occidental Oil, the chairman of IBM, the chairman of RCA, the chairman of Chrysler Corporation, the chairman of General Motors, the chairman of INCO, the chairman of *Time* magazine, and two of U.S. President Nixon's specially appointed "Foreign Aid" advisers, all met in Ottawa with Prime Minister Trudeau, Secretary of State Gérard Pelletier, and National Gallery of Canada director Jean Sutherland Boggs, and agreed to form a new organization called The American Friends of Canada, Inc.

As the Toronto *Globe and Mail* pointed out, this "cross-section of the corporate and cultural elite of the United States . . . control assets that probably exceed the gross national product of Canada." Why had they suddenly taken such an interest in Canadian culture? Their president, Hoyt Ammidon, chairman of the U.S. Trust Co. of New York, 'explained':

"At the dinner the other night, I and your Prime Minister got up and said a little something-or-other about the desire to provide better communications between the two countries, and I think we've got the desire to bring it about. As an indication of goodwill, we want to start by bringing some American art up here on a loan basis – it obviously takes time to arrange gifts. We also want to sponsor closer communications with our opposite numbers in Canada."

Ammidon predicted that the new organization would eventually get into "broader areas than the arts". A Canadian government spokesman in the Prime Minister's office admitted that:

"Basically, these people are calling the shots for themselves. It's an American group, run by Americans in the United States, and we're just reacting to it. You've got to realize that these people are all executive types, real moving people – it's really their show. . . ."

These "Friends" had been brought together by Bluma Appel, wife of a Westmount financier who had made some of his millions by investing in a filter that was indispensable to U.S. Army helicopters. Given a dollar-a-year "job" in the Secretary of State's office so that she could use Canadian government connections as well as her own, she had "persuaded" the U.S. treasury to extend U.S. income tax exemptions for donations of works of art to Canadian museums and galleries. This grossly continentalist change in

the U.S. tax laws opened the way for direct control of Canadian galleries and museums by these imperialist donors. "If you think of the top 200 corporations in the United States," she commented, "I've talked to most of these men, and almost all of them are intensely interested in the project."

Clearly, at least 29 top U.S. imperialists and their friends in the U.S. government had decided that it was time to step up their offensive in Canada. They could no longer rely on the amateurs to do it for them. With a national liberation struggle mounting, and Canada's workers, farmers and artists all forming militant, patriotic organizations, the compradors were no longer equal to the task. The imperialists themselves would have to take a pittance from their enormous holdings to lend, or even "give", works of art to Canadian galleries and museums. Like all big donors, they would then acquire direct control over the institutions. The Canadian government was to be the recipient of this U.S. "Foreign Aid", first in the arts and later in "broader areas".

Meanwhile in Toronto, Art Gallery of Ontario director William Withrow, who believes that "New York is where the action is . . . and has been since the late 1940s", had just announced that the Gallery would spend all of its $12,750,000 grant from the Ontario Council for the Arts on its new additions to accommodate the Zacks Collection of non-Canadian modern art, along with a large donation of sculpture by British artist *Henry Moore*, a friend of Ayala Zacks. "Now we'll be in the big leagues", Withrow gloated. He then topped that by revealing that the Gallery would replace its Anglo-American chief curator Mario Amaya with another U.S. citizen, Richard Wattenmaker.

Canadian artists rebelled, and their new organizations responded to the challenge. In February, John Boyle as CARO spokesman had participated in a meeting in Toronto on Quotas for Canadian Culture, sponsored by the Canadian Liberation Movement. With many Toronto CAR members present, the threat of the U.S. takeover of our key cultural command posts had been discussed.

Now Toronto CAR members moved against Withrow's announcement. Led by CLM and CAR member James Angus Brown, they constituted themselves into a Committee to Strengthen Canadian Culture, and circulated a petition to rescind the appointment of Wattenmaker. In June, 150 petitioners stormed into the Art Gallery of Ontario for a publicly announced confrontation with director Withrow, only to learn that Withrow had flown out of the country that very morning.

The Committee forced the first election of the Gallery's Board of Trustees, which had always before been appointed by the out-going Board. They managed to get one artist, Joyce Wieland, elected. On July 4, 1972, the appropriate day on which Wattenmaker started work, Committee members occupied his office and had to be dragged out by police.

In Ottawa, it was learned that Bluma Appel was to be appointed to the National Gallery's policy-making Visiting Committee. Canadian Liberation Movement members picketed the opening of the *Toronto Painters 1953-65* exhibition, and disrupted the speeches to expose her and

denounce the appointment. The next day Joyce Wieland, whose work was in the show, burst into the National Gallery director's office when she saw the director conferring with Bluma Appel.

Early in 1973, CAR Toronto protested a Rothmans' Corporation exhibition at the Art Gallery of Ontario, exposed the racist South African headquarters of that company, and demanded that the Gallery's proposed new Henry Moore Wing should in fact become a Tom Thomson Wing. At the 1973 Board elections, the compradors who control this supposedly public institution had to resort to using proxy votes for their official list of candidates for the board. Flaunting its own constitution, the Gallery claimed to have 1,100 proxy votes of Gallery members, which had been granted without any prior announcement of the Gallery's nominees. The Board members were desperate to stop a whole slate of people's representatives whom the CAR artists had proposed, including John Boyle, Greg Curnoe, Joyce Wieland, professor Robin Mathews, and Doug Carr, an organizer of independent Canadian unions. Carr later commented that the notorious U.S.-run Teamsters' Union is a "model parliament" by comparison to the Gallery meeting!

The result of all these actions as of early 1974, is that the American Friends of Canada, Inc. have slightly altered their plans: instead of shipping up tax-deductible donations of art after it is out of fashion in New York, they have proposed to organize an exhibition of Canadian paintings for the U.S., to be selected by British curator Bryan Robertson. While this more insidious means of trying to gain direct imperialist control of Canadian art is being planned with the National Gallery, Bluma Appel has been quietly dropped from the Secretary of State's office, and is now back in Westmount. In Toronto, the fight for a Tom Thomson Wing and a Canadian chief curator at the Art Gallery of Ontario goes on.

Yet partly as a result of these struggles, CAR has been growing. In 1973, at the second national CAR conference, held in Toronto, the 30 delegates represented some 1,200 members. They voted to boycott six Nova Scotia galleries that had refused to pay rental fees for exhibitions, ap-

pointed Edmonton artist *Sylvain Voyer* as national spokesman, and approved the first sections of a new national constitution.

CAR Ontario is now publishing an artists' trade paper called *Carot*, and CAR Alberta has also made significant gains. A large Edmonton local has succeeded in getting artists appointed to the Edmonton Art Gallery board, convincing the provincial government to set up both an Alberta Art Foundation ($50,000 yearly for the purchase of work by Alberta artists), and a Provincial Public Works Purchase Policy for works of art in new government buildings. Newfoundland CAR has protested the summary dismissal of Memorial University gallery director Peter Bell by the former British president of the university, and also made proposals to the government in St. John's for a planned provincial art foundation.

CAR's third national conference was held in Edmonton in 1974. The organization is actively considering affiliation with the Confederation of Canadian Unions, the independent Canadian union centre, and is also conferring with Québécois artists to make official its fraternal relations with the *Société des Artistes Professionels du Québec*, and with native artists to set up formal communication links with the Professional Indian Artists' Association.

As the anti-imperialist struggle in Canada has entered a new and more intense stage, Canadian artists are rising to meet the challenge of developing a new patronage. As John Boyle put it, in the first issue of *Carot:*

"Out of deep concern for the tragic condition of Canadian art and artists, for the strengthening and very survival of a Canadian nation and its culture, and for the establishment of the visual arts as a relevant, respected and contributing entity within Canadian society, artists within CAR and various co-ops are developing policies and programmes that are ambitious and comprehensive. We are learning at last to work together for the common good. While the "rugged individual" is by no means dead, we have tasted the fruits of united action and community involvement and there will be no turning back."

CONCLUSION:

Toward a people's art

In 1968 Québécois artists met in Montreal at a conference called *Déclic* (Trigger), in which they came to much the same conclusions about the need for co-operation as CAR artists were doing. In 1970 their *Société des Artistes Professionels du Québec* (SAPQ) first showed its militancy in a manifestation called *Balayage* (House-Cleaning) in front of the *Musée d'art contemporain* (Museum of Contemporary Art) in Montreal.

Yet by 1971 the Québec government's Ministry of Culture had responded so solicitously to the artists' demands that Claude Charron, a member of the National Assembly for the *Parti Québécois*, warned the 100 to 200 artists present at a conference in Vaudreuil that there is a very real possibility that a government-subsidized culture in Québec will become a new Church, and that the artists may be the priests of today, charged with making oppression bearable. Trade union representative André Leclerc asked the artists to decide whether they wanted to go on producing luxury commodities for the bourgeoisie, or to put their art at the service of the revolution in Québec.

The underlying question here for all artists is whether they are to serve themselves in their art, or to serve the people. If they serve themselves, our federal and provincial governments will certainly see to it that they end by serving the imperialists. From Théophile Hamel's career to William Ronald's, it is evident that the artist who turns his back on the people to pursue his own career ends by producing second-rate commodities for the compradors in the colony.

This is why collective programmes of reaching the people directly, such as those devised by the Niagara Artists' Co-operative, are extremely important. A few individuals, like *Kim Ondaatje* of Toronto, have also begun producing prints in large editions at reasonably low prices. Projects for mass-produced, mass-distributed, low-cost prints and reproductions are essential for the future of our new-democratic art.

It is impossible to predict the exact form that this new-democratic art of the future will take. But we can see how the three criteria of a people's art apply to today's conditions, and point up the challenges for contemporary artists.

First, an art of the people is national: it upholds the dignity and independence of our nations. For the native people, this means relating the great cultural traditions of the past to the struggles of today. For Québécois painters, the challenge is to revive not just the abstract form but the social substance of the Québécois tradition. Among Canadian artists, the need is clearly to extend the painting of patriotic heroes to the depiction of our history from the people's viewpoint, and to paint Canadians in our land.

A people's art is scientific, realistic, deriving its ideas from facts. This is not to be confused with the static hyper-realism on a large scale that is the latest stylistic import from the United States. The realism of a people's art shows how its subjects are part of the on-going creative process of life, and especially stresses the importance of working people.

The Cree painter, *Allen Sapp*, sets an example in this regard. Living on the Red Pheasant Reserve 30 miles from North Battleford, Saskatchewan, Sapp has consistently painted not only the hunters and farmers of his region, but has also shown women sewing moccasins and washing floors. Sapp understands the importance of the struggle for production for the dignity of his own community: on a reservation where 80 per cent unemployment is normal, he paints men and women at work.

Most Canadians now live in cities and towns, and the proletariat is the key productive force in our economy. A scientific, realistic art of the people must go beyond the recording of familiar people and places to the depiction of the working class. This direction was begun by painters like Miller Brittain, Leonard Hutchinson and Frederick Taylor

at the end of the Depression and during World War II. Now it is being taken up and advanced again, after the long period of recovery from the postwar invasion of U.S. abstract art. Even while this book was in preparation artists like *Jill Sargent* in Saskatoon and *Bev Kelly* in Regina have begun to paint and draw workers, while in Toronto *Robert Kell* has started a series on the Winnipeg General Strike of 1919.

A people's art is democratic: it serves the people by helping to arm us for the national liberation struggles we have to fight. Greg Curnoe's *For Ben Bella* was a milestone, and more artists are now coming forward. In 1973 *Lynn Hutchinson Brown* of Ottawa, *Margo Blackell* and *Shelley Graves Shaw* of Toronto, joined together to form WOMPA (Women Patriot Artists), "to more effectively challenge through art the male-oriented, American-dominated values imposed on Canadian life". The drawings they exhibited in Toronto and Ottawa showed some uncertainty as to whether national liberation or women's liberation was primary, but the bold assertion of such subject matter, and the intensive political education programme the three artists mounted during the exhibition, point the way for the growing ranks of Canada's patriotic artists.

The history of painting in Canada is a history of struggle against the oppression of life in a colony. Our art has been blighted by imperialism under three regimes. Careers have been broken, deflected and restrained, and many of our great painters have produced far less major work than they would have in an independent country.

But the history of our painting is also the history of the achievements of a Legaré, a Thomson, an Emily Carr. The future of painting in Canada is bright, because the future of our country is bright. U.S. imperialism is in its decline, and Canada may very well be its graveyard. The struggle will be bitter, but we will win. The art of a new Canada is in sight.

NOTES FOR FURTHER READING

Books on the history of painting in a colony are always scarce. British- and U.S.-owned publishers flood the market with lush volumes on the art of the imperial centres, and don't want to spend the money on colour reproductions intended for the Canadian market alone. Canadian-owned publishers (with the notable exception of NC Press) rely on government grants to subsidize their art books, and even then price them sky-high.

Readers who want to learn more about the history of painting in Canada will find the books mentioned in this section useful as a further introduction to the subject. If they are not in your library or bookstore, ask for them; most can easily be ordered.

The Founding of Canada Beginnings to 1815 and *Unequal Union* Confederation and the Roots of Conflict in the Canadas 1815-1873 by Stanley B. Ryerson (both Progress Books, Toronto, 1968) give a good general introduction to the early history of our country. Léandre Bergeron's *The History of Québec* A Patriote's Handbook (NC Press, Toronto, 1971) is invaluable on the history of that nation, and served as the basis for the class analysis of Quebec society used in this book. Another important general reference is Dr Charles Lipton's *The Trade Union Movement of Canada 1827-1959*, which was out of print but has been re-issued by NC Press in a new edition in 1973.

Of the many more specific historical studies that have been used, special mention must be made of *1837: Revolution in the Canadas* as told by William Lyon Mackenzie (NC Press, 1974). Edited by Greg Keilty, this book tells the story of the revolution in Mackenzie's words, gives a good description of the culture of the period, and includes a 24-page "Picture Gallery of People's History." Other valuable sources are *The Mackenzie-Papineau Battalion* (Copp Clark, 1969) by Victor Hoar and Mac Reynolds, and Bethune's biography, *The Scalpel, The Sword* by Ted Allan and Sidney Gordon, reprinted by McClelland and Stewart in 1971.

Painting in Canada A History by J. Russell Harper (University of Toronto Press and Les Presses de l'université Laval) was a milestone when it appeared in 1966, and is a source of data for this book, as for all subsequent publications on the history of our painting. Harper's life-long dedication to our art history has also resulted in his important reference work, *Early Painters and Engravers in*

Canada (University of Toronto Press, 1970). Dennis Reid's *A Concise History of Canadian Painting* (Oxford University Press, 1973) is trivial by comparison, but contains some useful information on later schools.

Until recently the only pretence at a scholarly periodical on Canadian art history was *The National Gallery of Canada Bulletin*, which devoted some issues to Canadian art-historical problems. Now, however, a *Canadian Journal of Art History* has appeared, published in Montreal, so that we may look forward to a general rise in the level of scholarship in this 'remote' field — of our own painting's history!

The best recent general survey of native painting in Canada is *Canadian Native Art* Arts and Crafts of Canadian Indians and Eskimos by Nancy-Lou Patterson (Collier-Macmillan, 1973). Selwyn Dewdney, who has explored and documented thousands of rock painting sites, has given an early report of his findings in a book co-authored with Kenneth E. Kidd, *Indian Rock Paintings of the Great Lakes* (University of Toronto Press, 1967). The contemporary native painter, Norval Morrisseau, tells the stories behind the pictures in his *Legends of My People, the Great Ojibway*, which was published by Ryerson Press in 1965 before it was sold out to the U.S.-owned McGraw-Hill.

There are many books on West Coast native painting and sculpture. One of the best is *Arts of the Raven*, a catalogue produced in 1967 by the Vancouver Art Gallery for a Centennial exhibition. It includes an essay by Wilson Duff, an appreciation of the art by Bill Reid, and an incisive analysis of the native painting styles by Bill Holm. Both Reid and Holm are contemporary native artists, and students of their own people's culture.

Material on early Québec painting is especially scarce in English. An article by Claude Picher on "Ex-Voto Paintings" in the July-August, 1961 issue of *Canadian Art* magazine is worth looking up for an enthusiastic description of the votives. The catalogue of *Two Painters of Québec* Antoine Plamondon Théophile Hamel, a 1970 National Gallery exhibition, by R. H. Hubbard, is still available, and the catalogue of the forthcoming Joseph Legaré retrospective should be of interest.

The standard source book on early Canadian prints and paintings, *The Face of Early Canada* Pictures of Canada which have helped to make History by F. St George Spendlove (Ryerson Press, 1958) is now out of print. But

the catalogue of a 1972 National Gallery retrospective, *Thomas Davies* c. 1737-1812 by R. H. Hubbard, can be obtained through Information Canada. Russell Harper's catalogue of a National Gallery *Homer Watson* retrospective is the best source of information on that painter, but is no longer generally available. Harper has also contributed a lush volume called *Paul Kane's Frontier* (University of Toronto Press, 1971) which includes the entire text of Kane's *Wanderings of an Artist among the Indians of North America*. Since Donald Buchanan's catalogue raisonné of Morrice's paintings is out of print, Harper's inventory of Kane's paintings is the only complete survey of a Canadian artist's work that is currently on the shelves.

Biographies of Canadian artists are almost as hard to find. *Robert Harris, 1849-1919* (McClelland and Stewart, 1970) is sub-titled "An Unconventional Biography" by its author, Moncrieff Williamson, being based on Harris's letters and diaries in the archives of the Confederation Art Gallery and Museum in Charlottetown.

The autobiographical books by Emily Carr mentioned in the text are almost all available in libraries and bookstores, published by Clarke Irwin. Her diary, which she did not intend for publication, has also been published in an edition prepared by Vancouver Art Gallery curator Doris Shadbolt, entitled *Hundreds and Thousands* (Clarke, Irwin, 1966).

A.Y. Jackson, self-reliant as ever, wrote one of the best artist's autobiographies, *A Painter's Country* (Clarke, Irwin, 1967), which relates the struggle for the landscape and the achievement of our national landscape art in Jackson's clear, vigorous prose. *Lawren Harris* (Macmillan, 1969) is just as characteristic, an expensive, beautifully-produced volume with an irrelevant introduction by literary critic Northrop Frye and yeasty, idealist theorizing by Harris opposite the colour plates.

Of all the books based on Tom Thomson's life, Ottelyn Addison's *Tom Thomson: The Algonquin Years* (Ryerson, 1969) fits the painter most realistically into the Ontario northland. For those who want to sleuth out who killed Thomson, William T. Little's *The Tom Thomson Mystery* (McGraw-Hill, 1970) is a paperback that gives most of the relevant facts.

The Group of Seven by Peter Mellen (McClelland and Stewart, 1970) is beautifully illustrated and well designed, but the most detailed and accurate account of the Group's development is Dennis Reid's 50th anniversary exhibition catalogue with the same title, published by the National Gallery. Reid has also produced *A Bibliography of the Group of Seven* (National Gallery, 1971), which lists major newspaper and magazine articles as well as book-length studies.

Paul Duval's book *Four Decades* The Canadian Group of Painters and their Contemporaries, 1930-1970 (Clarke-Irwin, 1972) is mostly an apology for the "empty landscape" manner. Charles Comfort's *Artist at War* (Ryerson, 1956) is an account of his experiences during the Italian campaign. But the best way to discover the art of the 1930s and '40s is to look up back issues of *Masses* (1932-34), *New Frontier* (1936-37), *Maritime Art* (1940-43), and the early issues of *Canadian Art* magazine; especially the last two of these can be found in various reference libraries and universities in our larger cities.

For contemporary artists, exhibition catalogues and articles in *artscanada* are the major source. William Withrow's *Contemporary Canadian Painting* (McClelland and Stewart, 1972) is written from the liberal comprador's point of view, while Paul Duval's *High Realism in Canada* (Clarke-Irwin, 1974) is a conservative comprador's account, centred on the magic realists. There is more simple truth in William Kurelek's *A Prairie Boy's Winter* (Tundra Books, Montreal, 1973) than in both these "art history" volumes together.

The first critic to take an anti-imperialist position on recent painting in Canada was Gail Dexter, whose essay "Yes — and cultural imperialism, too!" is to be found in *Close the 49th Parallel, Etc.* The Americanization of Canada (University of Toronto Press, 1970). Another important essay is Milton Acorn's "On Not Being Banned by the Nazis," in his book *More Poems for People* (NC Press, 1972). Mao Tse-Tung's essay *On New Democracy*, originally published in 1940 in the first issue of *Chinese Culture*, is now available in English in a 1967 booklet published by Foreign Languages Press, Peking, and in various collections and selections of Mao's writing.

Robin Mathews' and James Steele's book *The Struggle for Canadian Universities* (New Press, 1968) is now hard to find. But a recent booklet by Dr Jean Cottam, entitled *Canadian Universities* American Takeover of the Mind? (Gall Publications, Toronto, 1974) brings the issue of U.S. domination of our universities up to date.

This list is unsatisfactory: there is no book-length treatment of a number of Canadian and Québécois painters who clearly merit it. Students must piece together catalogue statements, magazine articles, newspaper reviews and references in general histories. In the current upsurge of patriotism, a few of the gaps are being filled; but the economics of publishing art books in a colony mean that many of them will remain for some time. It is only when we achieve independence that we will finally be able to come into full possession of our heritage of painting.

WHERE TO SEE THE PAINTINGS

A reproduction is not a painting. You can read about art in a book, but to know it you have to experience it at first hand. Here is a brief list, roughly west to east, of some of the leading public galleries and art museums across Canada, with some indication of what you can expect to see there.

The best collection of west coast native art in B.C. is in the Anthropology Department of the University of British Columbia in Vancouver. The Provincial Museum in Victoria also has some early examples of great interest. The world's best collections of this great native art, needless to say, are in the United States, with a few outstanding ones in Germany.

The Art Gallery of Greater Victoria has an excellent collection of Far Eastern art. Its Canadian holdings include some works by Emily Carr, but not as many as you might expect in her native city. She is better represented at the Vancouver Art Gallery, which also has a general collection of Canadian art history, but likes to set up big import shows from California, and favours U.S.-style art in Canada. The UBC Fine Arts Gallery and the Simon Fraser University art department also run to trendy contemporary shows with a heavy American influence, as do most of our U.S.-dominated university galleries across the country.

The history and culture of the Canadian west can be explored at the Glenbow-Alberta Institute in Calgary. The Edmonton Art Gallery, like its Vancouver equivalent, favours U.S. or U.S.-style shows, but also has the Poole Collection of Canadian art history, and shows an annual All-Alberta exhibition.

As Edmonton inherited Poole's paintings, so the Mendel Art Centre in Saskatoon got the Frederick Mendel collection, which was a mixed blessing. Yet this Saskatoon gallery has a good record of encouraging area artists with exhibitions. Not as much can be said for the Norman Mackenzie Art Gallery in Regina, which has done some major surveys of Saskatchewan art and some interesting one-man shows, but on the whole still reflects the U.S. domination of the University of Saskatchewan art department.

The Winnipeg Art Gallery has a large collection of the works of L. L. FitzGerald. It has also hosted an annual juried show, frequently with imported critics and curators as judges. The Gallery also maintains a circuit of travelling shows to smaller Manitoba centres.

The Western Provinces Art Circuit groups all these galleries and others, such as the Moose Jaw Art Museum, into an alliance that shows travelling exhibitions of mainly contemporary Canadian art. Similar organizations are the Northern Ontario Art Association, the Western Ontario Art Circuit, and the Atlantic Provinces Art Circuit. The National Gallery, the Art Gallery of Ontario and other provincial and civic galleries provide these associations of smaller galleries, libraries, universities and art clubs with exhibitions.

The National Gallery of Canada has by far the best collection of the history of painting in Canada. Two and sometimes three of its six exhibition floors usually display this collection, while the others are used to show European and U.S. art. The Gallery continues to be a comprador institution, serving the imperialists by promoting U.S. styles; yet it also continues in its historic role of patronizing and attempting to co-opt patriotic artists, treating their work as harmless cultural nationalism as far as possible.

The Art Gallery of Ontario is much worse. Directed by a self-avowed sell-out and his U.S. chief curator, it is really run by a tiny elite of Toronto's arch-compradors, who want the gallery to compete in the U.S.-run "international art history" racket. The newly-appointed Canadian art history curator, Russell Harper, offers a ray of hope, but artists and others continue to demand a Canadian chief curator and a Tom Thomson Gallery instead of the Henry Moore Wing at the AGO.

The Royal Ontario Museum has one of the finest collections of native art, but it's hard to tell. The west coast native cultures have been atrociously displayed for years, and seem to be at the lowest priority on the Museum's refurbishing programme. The National Museum of Man in Ottawa, due to re-open in 1974 after almost five years of reconstruction of displays, also has an outstanding native art collection, and is building an inventory of so-called "folk art", the culture of untrained artists.

Paul Kane's canvases at the ROM are mostly stored away, for lack of space, and are badly in need of cleaning. The ROM does, however, maintain the Sigmund Samuel Canadiana Gallery in a separate building. This is always one of the most attractive galleries in Toronto, enjoyable both for appreciating the environment of Canada's past through its decorative arts, and for poring over the huge collection of prints, drawings and watercolours there. The Archives in Ottawa, and the various provincial Archives across the

country are also good places to find seldom-seen works on paper, as is the Prints and Drawings section of the National Gallery.

The London Public Library and Art Museum was at first slow to recognize the achievements of London artists, but has now acquired a creditable collection and a fine exhibition record in support of local painters and sculptors. The Rodman Hall Art Centre in St Catharines has similiarly helped the Niagara artists, although it does not have the funds to make significant purchases.

Homer Watson's fine old studio, with some of his paintings in it, can still be seen in Kitchener, within walking distance of all his favourite painting places around Doon. But the canvases are in lamentable disrepair, and badly need a complete overhaul by a skilled restorer.

The Art Gallery of Hamilton has a conservative but convincing collection of Canadian art history, and the Windsor gallery has distinguished itself with a fine series of retrospective exhibitions over the years, including one of Hind arranged by Russell Harper. At Owen Sound, a Tom Thomson Memorial Gallery has been formed, but the major museum for the Group of Seven and related paintings is the McMichael Conservation Collection at Kleinburg, north of Toronto. Tom Thomson's shack and the graves of four of the Group artists are also there.

Most of the other galleries of southwest Ontario feature primarily the travelling exhibitions sent out from the major centres. But almost all of them manage to do one or two major shows a year, like Brantford's Robert Whale retrospective a few years ago. Building on the heritage that is often most visible in local historical museums, and uniting with artists in the area, residents of these cities can encourage their galleries to maintain independent programmes as much as possible, and thereby help stimulate the development of a healthy local art patronage.

At Stratford, the Rothmans Art Gallery is maintained only in small part by the South African-based cigarette company. Much of the gallery's operating budget is public money, and the people of Stratford have every right to demand that it feature more Canadian painting in its prominent summer exhibitions — and for that matter, change its hateful name!

Speaking of names, the Robert McLaughlin Gallery in Oshawa is of course named after the sell-out General Motors millionaire. Suitable enough, it has developed a specialty in Painters 11, the New York-oriented group.

On the Queen's University campus at Kingston, the Agnes Etherington Art Centre acquired the Sam and Ayala Zacks Collection of contemporary Canadian art, and also has a fine group of watercolours by Daniel Fowler. Hart House on the University of Toronto campus has a good collection of Canadian art purchased by student committees down through the years, and also runs an exhibition programme that features young artists of promise. Other Ontario campus galleries, like York University, feature a heavily U.S.-dominated programme that reflects their faculties exactly. The University of Windsor did not show a single Canadian exhibition for several seasons!

The Musée du Québec in Quebec City is the chief centre for Québécois cultural history. Votives are to be seen at the various shrines and churches, such as Ste Anne de Beaupré. Arthur Villeneuve maintains his house as a gallery of his own work in Chicoutimi, and many Québécois towns and villages show signs of the lively visual arts tradition in the architecture and decoration of their churches and other buildings.

In Montreal, the Château de Ramezay and the McCord Museum at McGill University have the main early historical collections. The Montreal Museum of Fine Arts is still an English-speaking Westmount club, but now it has a U.S. director and chief curator, and has added a window-dressing staff of French-speaking administrators — imported from Europe.

Sir George Williams University, Loyola, and the Saidye Bronfman Memorial Gallery, built with the whiskey millionaires' money, are all English-speaking centres, mainly for contemporary art. The only public centre for Québécois artists in Montreal is the Musée d'art contemporain, located in the old Expo '67 gallery. The Musée directly reflects the cultural policies of the provincial government that controls it, and has very little money available for the purchase of works of art.

At Fredericton, the Beaverbrook Art Gallery still shows its sell-out patron's pro-British tastes. The New Brunswick Museum at Saint John has a fine collection that is rarely seen properly, due to lack of adequate space and money. In Charlottetown, the Confederation Art Gallery and Museum has plenty of space but a tiny budget. It inherited a collection of paintings, sketches and documents left behind by Robert Harris.

The Université de Moncton has established an important new cultural centre for the Acadian people. The Nova Scotia Museum in Halifax has an interesting collection, but the Nova Scotia College of Art and Design and the Anna Leeonowens Art Centre have been strictly U.S.-oriented, both in staff and programme. In St John's, Newfoundland the mostly contemporary Memorial University Art Gallery recently lost its capable director, Peter Bell, to the wrath of a British university president. Memorial also circulates shows to smaller Newfoundland cities, and has helped to start a new cultural centre.

All these galleries across the country need your constant criticism. Most civic and some provincial ones sell memberships. If you can afford it, join. But in any case, attend their exhibitions (they're usually free), and try reviewing their programmes according to the criteria for a new-democratic art advanced in this book. Is it national, or patriotic? Is it scientific, realistic? Is it democratic? We pay for most of these institutions, so we should be outspoken in our demands that they serve the people, not their Boards of Directors. Artists' and citizens' groups together can get representatives on these Boards, and fight for change.

Patriotic curators and administrators will welcome such demands, while the careerist sell-outs will oppose it. But if Canada is to be independent, our museums and galleries, our culture and our history, must belong to us.

INDEX

Canadian Liberation Publishers!

NC Press is the publishing arm of the Canadian Liberation Movement. It is truly a people's publishing house, distributing books on the struggle for national independence and socialism in Canada and throughout the world.

THE HISTORY OF QUEBEC, A PATRIOTE'S HANDBOOK
Léandre Bergeron 245 p. 1.50

THE HISTORY OF QUEBEC - IN PICTURES!
Léandre Bergeron 48 p. 1.00

MORE POEMS FOR PEOPLE
Milton Acorn 120 p. 1.75
cloth 4.00

WHY IS CANADA IN VIETNAM?
Claire Culhane 125 p. 1.50

THE TRADE UNION MOVEMENT OF CANADA. 1827-1959
Charles Lipton 384 p. 3.95
cloth 7.95

1837: REVOLUTION IN THE CANADAS
as told by William Lyon Mackenzie
Greg. Keilty (ed.) 264 p. 2.25
cloth 5.95

BLACK CANADIANS, A long line of fighters
Headley Tulloch 2.50

THE PEOPLE'S HISTORY OF PRINCE EDWARD ISLAND
Errol Sharpe 200 p. 2.50
cloth 5.95

WHY THERE MUST BE A REVOLUTION IN QUEBEC
Léandre Bergeron 156 p. 2.50

Québec!

Two Landmarks in Québécois Culture

Refus Global
112 p. 2.50
First published in 1948, this manifesto rocked Québec and revolutionized the arts there.

Ceinture Flechée
Marius Barbeau 110 p. 4.50
First published in 1945, this is a history of the "arrow belts", one of the symbols of the habitant period in Québec, including designs and detailed weaving instructions.

Petit Manuel d'Histoire du Québec
Léandre Bergeron 253 p. 1.00

L'Histoire du Québec - Illustré 1
Léandre Bergeron et Robert Lavaill 1.50

Pourquoi une Révolution au Québec
Léandre Bergeron 185 p. 1.00

Docteur Bethune
Sydney Gordon et Ted Allan 313 p. 5.50

China!

Historical Relics Unearthed in New China
This official record of the breathtaking exhibit displayed at the Royal Ontario Museum this fall presents a collection of the historical relics from primitive society to the Ming Dynasty unearthed in New China
There are 200 illustrations - 92 in colour - arranged chronologically with explanations of each one.
Linen cover and colourful plastic jacket in box
$18.00 Available in English and French

New Archaeological Finds 72 p. 1.25

Rent Collection Courtyard 50 p. 1.25

Travels in China
Rewi Alley 588 p. 4.50

Selected Stories of Lu Hsun 255 p. 1.95

On New Democracy 71 p. .50

Quotations from Mao Tse Tung 312 p. .60

Selected Readings from the Works of Mao Tse Tung 504 p. 1.50

Tanzania Publishing House

Self-Reliant Tanzania
K.E. Svendsen & Merete Teisen (ed.) 322 p. 5.50

Adult Education Handbook
G. Rydstrom (ed.) 275 p. 8.00

Essays on the Liberation of South Africa
N.M. Shamuyarira (ed.) 95 p. 2.75

Towards Socialist Planning
J. F. Fweyemamu, J. Laxley, J. Wicken, C. N
C. Nyirabu (ed.) 200 p. 3.60

How Europe Underdeveloped Africa
Walter Rodney 316 p. 3.40

Join CLM !

Independence and Socialism

Canada is a colony. Our trade unions, our natural resources, our culture, our universities and our industry — all are controlled from the U.S. There are those who, seeing the extent of this colonialism, believe the battle to be lost. We do not see it that way. We see people across the country rising up against U.S. imperialism: workers struggling to forge militant, democratic Canadian Unions, farmers fighting U.S. agri-business, students opposing the takeover of the universities by increasing numbers of American professors.

JOIN THE CANADIAN LIBERATION MOVEMENT! Join the fight for independent rank-and-file controlled Canadian unions. Participate actively in the struggle to free Canada from U.S. imperialist control.

The CANADIAN LIBERATION MOVEMENT is devoted to building an independent, socialist Canada. It is up to you and to every progressive and patriotic Canadian to become involved to the extent of your resources and abilities in the saving of our nation and in the building of a new and better Canada.

TO: **CANADIAN LIBERATION MOVEMENT**
Box 41, Station E, Toronto, Ontario

.Please send me more information about the Canadian Liberation Movement.
.I want to join CLM.
Here is a donation of $. . . . to help you with your work.

NAME .
ADDRESS .
PHONE .